Contemporary Art
and Multicultural Education

Edited by Susan Cahan and Zoya Kocur

Contemporary Art
and Multicultural Education

Edited by Susan Cahan and Zoya Kocur

The New Museum of Contemporary Art
New York

Routledge
New York and London

Published in 1996 by
The New Museum of Contemporary Art
583 Broadway
New York, NY 10012

Routledge
29 West 35th Street
New York, NY 10001

Published in Great Britain by
Routledge
11 New Fetter Lane
London EC4P 4EE

Library of Congress Cataloging-in-Publication Data

Contemporary art and multicultural education / edited by Susan Cahan and Zoya Kocur.
 p. cm.
 ISBN 0-415-91189-3. — ISBN 0-415-91190-7 (pbk.)
 1. Art—Study and teaching (Secondary)—United States. 2. Art in education. 3. Multicultural education. I. Susan Cahan. II. Kocur, Zoya.
 N353.C66 1995
 707'.073—dc20

 95–10979
 CIP

Interview with David Hammons © 1986 Kellie Jones and David Hammons. First published in *Real Life* no. 16, Autumn 1986. Excerpt reprinted by permission of the author.

Interview with Keith Haring by David Sheff first published in *Rolling Stone* magazine, August 10, 1989. Adapted and reprinted by permission of the Estate of Keith Haring and *Rolling Stone* magazine.

"Bus Takes a Controversial Route" by Steve Schmidt first published in *The San Diego Union,* January 7, 1988. Reprinted by permission of *The San Diego Union.*

"With Freedom … responsibility" by Whitney Mandel first published in *The San Diego Union,* January 12, 1988. Reprinted by permission of *The San Diego Union.*

"Confronting Stereotypes" by Consuela Puente de Miller first published in *El Sol de San Diego,* January 28, 1988. Reprinted by permission of *El Sol de San Diego.*

"Public art not required to ape majority's views" first published in the *San Diego Business Journal,* January 11, 1988. Reprinted by permission of the *San Diego Business Journal.*

Cartoon by D. Butler first published in *Z Magazine,* June 1988. Reprinted by permission of *Z Magazine.*

Contents

105 Part 3: **Artists' Voices**

357 Part 5: **Resources**

Acknowledgments

This book is the collective effort of many people. The project grew out of The New Museum of Contemporary Art's High School Art Program (HSAP), established in 1980 as one of the first museum education programs in the country to engage young people in contemporary art. We would like to thank the students and teachers who have worked with us over the years for inspiring the book's themes and teaching strategies. We owe a particular debt of gratitude to Sharon Jacques, an artist and former artist/instructor in the HSAP, for writing a curriculum guide in 1989 which served as the precursor to this book. Without her efforts, this volume would not have been possible. We would also like to thank artists Simon Leung, Catalina Parra, and Danny Tisdale, the program's current teaching staff, from whom we have learned a great deal. Mayda Perez, manuscript coordinator, handled innumerable responsibilities, large and small, that often exceeded the call of duty.

Many educators used portions of the book in their classrooms and offered insightful suggestions which helped shape the manuscript. We are especially grateful to Andrea Levine, Toby Needler, Duane Neil, Jere Pettet, Elyse Rivin, and Shirley Safran; Mario Asaro, and the members of Artists/ Teachers Concerned; and Klaudia Rivera and the teachers and students of El Barrio Popular Education Program. Annette Gonzalez, Eric Landaverde, and Raphaela Francis, high school students at the time, reviewed and critiqued the artists' statements, providing valuable commentary.

Artists, educators, cultural critics, and friends throughout the country offered perceptive and informed responses to the manuscript at various stages. We would especially like to thank Stanley Aronowitz, Renee Darvin, Eugenio Espinoza, Brian Goldfarb, Olivia Gude, G. Peter Jemison, Evelyn Kalibala, Margo Machida, Amalia Mesa-Bains, Esther Parada, Helen Stambler, Alida Vega, Constance Wolf, and Sylvia Wolf for providing honest and constructive criticism. A special word of thanks goes to Margo for bringing the work of many artists to our attention and to Brian for helping bring the book to completion in his role as Curator of Education at The New Museum.

Elisabeth de la Ossa expertly handled the Spanish translations, offered knowledgeable advice on matters of publication, and became a cherished friend. We thank Sandra Long, Barbara Cicatelli, and Thomas Webster of Cicatelli Associates for reviewing the lesson plans about AIDS and ensuring that they contain the most up-to-date information available.

For her gentle, powerful, and indispensable editorial guidance, we are deeply grateful to Priscilla Ross. For seeing the project's early potential, remaining committed to it through thick and thin, and writing the foreword, we thank Christine Sleeter. Our editors at Routledge Press, Jayne Fargnoli and Anne Sanow, were a pleasure to work with. Our designer, Bethany Johns handled every challenge with expertise and a healthy sense of humor. Karin Vanderveer and Pierre Dupuy of Sandak, Inc. skillfully produced the slide set which accompanies the book.

The staff and board of The New Museum made an institutional commitment to this ambitious project at a time when all museums in the United States are challenged by limited resources. Our heartfelt thanks go to the director of the Museum, Marcia Tucker, for her passionate dedication to education as a core purpose of museums and her rock solid commitment to the realization of this book. The members of the Museum's Trustee Committee for Education, Raymond J. McGuire, Henry Luce III, Paul Harper, Sharon King Hoge, Stephania McClennen, Eileen Norton, and Laura Skoler heartily supported and encouraged the endeavor. Jerry Philogene and Claudia Hernandez assumed extra responsibilities in order to make the book possible.

A project of this scope required a lot of research and assistance. We would like to thank Deanna Caceres, May-Ling Chang, Nichole Johnson, Yvonne Koslow, Elisa de Souza Martinez, Renee Vanacourt, and Cuc Vu for their contributions at various stages.

We greatly appreciate the contributions of those artists and writers whose work we were unable to include. Through generously sharing their art and ideas, they helped us shape the contours of our own project.

Most importantly, we would like to thank the contributing artists and authors. Their work is the foundation of ours and remains a constant source of inspiration.

—*Susan Cahan and Zoya Kocur*

Acknowledgments

Funding for *Contemporary Art and Multicultural Education* has been provided in part by the National Endowment for the Arts, The Andy Warhol Foundation for the Visual Arts, Inc., The Nathan Cummings Foundation, the Norman and Rosita Winston Foundation, the Albert A. List Foundation, The Booth Ferris Foundation, Chase Manhattan, The Colgate Palmolive Company, The Hearst Foundations, The Horace W. Goldsmith Foundation, The Keith Haring Foundation, New York Telephone, The Rockefeller Group, The Samuel and May Rudin Foundation, and Iris and Jim Marden.

Preface

The New Museum of Contemporary Art is proud to publish its first curriculum guide for high school teachers and students. From the very beginning, The New Museum has placed education at the center of its philosophy. When the Museum opened in 1977, its educational activities included a docent program, an ongoing series of multicultural discussions among museum and arts professionals, and museum visits from New York and metropolitan area elementary and high school students.

Today, the Museum's education department has expanded the ways in which it makes contemporary art accessible to a broad public through publications, teacher training, direct interaction with students in and out of the classroom, lectures and symposia, online programs, and innovative projects designed to support public participation, engagement, and intervention in the Museum's activities and exhibitions. The New Museum's pioneering efforts in the field of education have become recognized nationally and internationally.

Contemporary Art and Multicultural Education is a natural outgrowth of the Museum's philosophy and provides thought-provoking and innovative materials that challenge the normative practice of art education and art history prevalent in the museum field. Like all of The New Museum's activities, this work has been produced by and is addressed to the multiracial, multiethnic, experientially diverse constituency that reflects the world in which we live. At the project's heart is the desire to create open-minded, critical, and independent viewers; this becomes a necessity if museums and contemporary art—the art of our own time—are to be relevant at all in the century to come.

—Marcia Tucker
Director, The New Museum of Contemporary Art

Foreword

> Multiculturalism does not simply involve the recuperation of "lost" traditions in order to prove the richness and diversity of "America." ... Rather, multiculturalism interrogates which traditions are valorized and by whom, which are devalued and by whom, which serve to empower marginalized peoples, which serve even further to disempower, which traditions provide strength, how traditions provide agency, when traditions provide knowledge.[1]

The community in which I lived until recently is wrestling with multicultural education in a manner similar to that of many communities today. Most of the schools are predominantly white, although populations of color are growing rapidly and student bodies in many schools are diversifying. The community itself historically has been a volatile "melting pot" for European ethnic groups. I am often called upon to provide information about multicultural education, and in the process encounter questions such as: Is it a "program" that "works?" Can I suggest some good international speakers or performers for a school's "cultural" week? Doesn't multicultural education retard rather than help the assimilation process? Isn't it just another form of "political correctness?"

The questions and ideas people articulate about multicultural education and multiculturalism in the broader society are bound up in their assumptions about the nature of difference, race, social class, the opportunity structure, and who is legitimately "American." Most residents of my own community use the template of the European ethnic immigrant experience to attempt to understand non-European groups. They define everyone as descendants of voluntary immigrants who chose to enter the U.S. from another country, and in doing so struck a bargain in which they would give up most of the "old" culture for an opportunity to work their way up. In this view, multicultural education becomes a celebration of cultural remnants from the "Old World," and of the immigrant experience.

In contemporary debates about multicultural curricula, this "neo-nativist" perspective is being promulgated vigorously in an attempt to deny

perspectives and questions about race relations and social inequality that might disrupt and unsettle the social order.[2] Yet I believe that order needs to be disrupted. It is a social order in which poverty rates are escalating, the gap between rich and poor is steadily widening, communities of color are losing jobs and economic resources, and immigrants of color are being scapegoated for economic hardships brought on by corporate exporting of bread-and-butter jobs.[3]

Multicultural education originated in the civil rights movement, as a challenge to America to live up to the ideals of equality and justice. Today these ideals ring hollow in the dominant discourse. But in oppressed communities,

> What we are witnessing here is the urge for renewal of the dynamic social movements of the sixties which accompanied the incalculably profound revitalization of organized cultural projects for the affirmation of dignity and the fundamental right of self-determination for peoples of color.[4]

Justice, equality, dignity, and self-determination: these ideals should be the centerpiece of multicultural education.

As a part of my work in teacher preparation, I collect curricula written for teachers in various subject areas, including art. I particularly search for materials that exemplify multicultural education as being critical, political, and action-oriented. Until two years ago, although I was aware of no published multicultural art curricula that focused on issues and concerns of oppressed groups in the U.S., I had also not systematically looked. Two years ago, Carl Grant and I were invited to a Getty Foundation seminar on cultural diversity in art education. There, I learned (to my surprise) that multicultural art education is a relatively new topic. At the seminar there were two rooms of multicultural art curriculum materials on display, so I looked vigorously for resources that embody multicultural education as I understand it. But to my dismay, I found that the great majority of the materials conceptualized multicultural art as the study of folk art, around the world (and usually "long ago"). Some materials presented African American or Native American art; while often well-done, these tended to focus on history and to lack incisive critiques of race relations. I didn't find

anything that drew on art produced by multiple American sociocultural groups, let alone that focused on social justice issues. I took home catalogues that were available, but the closest thing I could find to a critical, social-issues approach to multicultural art education was one set of slides. Several months later I was invited by a staff member of a museum to write an introduction to a multicultural curriculum guide. I then received a contract for the project which specified that the curriculum guide and my essay were not to be political at all, and were to offend no one. Another dead end in my quest to find the kind of multicultural art curriculum I was looking for.

Contemporary Art and Multicultural Education, on the other hand, exactly embodies my own conception of multicultural education. This book is multivocal, critical, vibrant, and timely. Progressive people speak about oppression, identity, and social change; the book encourages questioning, thinking, critique, and celebration. It shows teachers how to engage students in social analysis, examining art as a mode of communication about issues and concerns of diverse communities, and of compelling interest to young people. It is richly textured, offering theory, personal interviews, lesson plans, visual representations, and artists' statements about their work. What should multicultural education "look like?" It should look like *Contemporary Art and Multicultural Education.*

—*Christine Sleeter*
July 11, 1994

Notes

1. Perez-Torres, R., "Nomads and Migrants: Negotiating a Multicultural Postmodernism" *Cultural Critique* 26 (1994): 161–190.
2. Cornbleth, C. & D. Waugh, *The Great Speckled Bird: Multicultural Politics and Education Policymaking* (New York: St. Martins Press, 1995).
3. Martinez, E., "Latino Politics: Scapegoating Immigrants." *Z Magazine* vol. 6, no. 12 (1993): 22–27.
4. San Juan, Jr., E., *Articulations of Power in Ethnic and Racial Studies in the United States* (Atlantic Heights, NJ: Humanities Press, 1992).

Introduction

Over the past decade the body of literature on multicultural education in the United States has been rapidly growing. The range of perspectives reflected in this literature is broad, from the "heroes and holidays" approach and "celebrations of diversity" to radical critiques of institutionalized racism, sexism, and classism within the education system. Despite this scope, literature addressing the visual arts falls into a narrow range. While many promote the study of art from diverse cultures, they overlook the historical and political dimensions of cultural democracy. Conversely, within critical approaches to multicultural education, even interdisciplinary approaches, little attention has been paid to the substantive roles art can play.

Contemporary Art and Multicultural Education aims to bridge this gap through highlighting the role of art within a critically-based approach to multicultural education. Drawing from and expanding upon ideas in critical pedagogy, this book uses contemporary art as the focal point for an antiracist, antisexist, democratically-based curriculum, providing both a theoretical foundation and practical resources for implementation.

What is Multicultural Education?

Multicultural education emerged out of the context of social activism of the 1960s and '70s, drawing energy and inspiration from the struggles against oppression by racial movements, feminism, and the movement for gay and lesbian rights. On college campuses this activism has taken the form of demands for ethnic studies and women's studies courses and a greater sensitivity to cultural and gender biases. In primary and secondary education it has concentrated primarily on curriculum reform, in its broadest application calling for a total school reform effort designed to increase equity for a range of cultural, ethnic, and economic groups through such strategies as student-centered pedagogy, community involvement in policy making and governance, and equitable distribution of resources.[1] As educational theorist Christine Sleeter has pointed out, "multicultural education

has always been grounded in a vision of equality and has served as a mobilizing site for struggle within education."[2] Its purpose is to change the power structure in the wider society in order to foster social and political empowerment for all students.

Over the past decade, educators have tried to develop curricula that are more pluralistic. While most attempts have moved beyond the "heroes and holidays" approach, few models of multicultural education are geared toward transforming the conditions which create social and economic inequalities. Most multicultural curricula, though they may appear integrated, fail to challenge the curriculum's Eurocentric foundation. As Christine Sleeter has written, "they add representations of diverse groups into grand narratives about society—grand narratives that still privilege the positions and perspectives of those who dominate control over power and wealth."[3]

What is the Role of Art in Multicultural Education?

Within the movement for multicultural education, curriculum and instruction in art have been particularly slow to change. The models adopted in art education are often the least likely to transform social and political conditions. As Murry DePillars has pointed out, the two most commonly used introductory art history texts, H.W. Janson's *History of Art* (1971) and Helen Gardner's *Art Through the Ages* (1959)—both written at least a generation ago—distort or omit the history of black African art, the art of the African diaspora, and the art of many other cultures and groups.[4] In addition, these texts largely omit the study of contemporary art. The following summary illustrates the narrow scope of these and other commonly used approaches.

The additive approach, one in which previously neglected movements or styles are added to the traditional list of twentieth-century European art movements, expands the curriculum without challenging the Eurocentric, patriarchal, and exclusionary biases of the overall framework. The glorification of token "masters" such as Georgia O'Keeffe or Romare Bearden merely reinforces the prevailing art narrative of the "gifted individual" creating objects of universal value.[5] By this definition, art created outside of these limited (and limiting) criteria lacks value.

In contrast, approaches which focus on signs of cross-cultural contact

hold the potential to explore issues of biculturalism or cultural hybridization. However, they tend to emphasize a limited repertoire of historic events (such as the influence of African art on the development of Cubism), and almost always stress the incorporation of Third World influences into European art. Occasionally two-way flows of influence are recognized, such as the Portuguese influence on Benin sculpture in the 16th and 17th centuries, but rarely are artistic developments linked with historical and political events, such as colonialism, global imperialism, or the slave trade, which in many cases set the context for cross-cultural interaction. Furthermore, cross-cultural contacts between indigenous and diasporic groups are generally ignored, as "cultural diversity" is typically conceived as referring to "marginalized minorities" in relation to a white, European center.

Ethnically-based approaches shift the center of inquiry to the culturally specific criteria that a particular society uses in creating and appreciating its art. The most effective approaches integrate the study of art into a broader social, cultural, political, and historical framework. Yet in its usual emphasis, an ethnically-based approach presents art in ways that make it seem distant and "other," keeping at arms length questions pertaining to power relations in our own society.

Approaches to multicultural education that consider not only the art object and its function, but the culturally specific process by which it was made and the sociopolitical dynamics shaping its reception are more complex, because they take into account the cultural and social values and beliefs—including cultural biases—of teachers and students.[6] As Brian Bullivant points out, "culture" is not a set of artifacts or tangible objects, but how the members of a particular group interpret, use, and perceive them.[7] "Use" includes intellectual uses by teachers and students within the educational process. Education thus becomes self-reflexive as students become more aware of their role as cultural interpreters and the real ethical and social responsibilities accompanying that role. To date, work of this complexity has been mainly theoretical and not the subject of practical classroom application.[8]

The most common approaches for connecting the study of art with studio art production are based on medium and form. (For example, students study African masks and then are assigned to make their own masks. Or, students examine the use of circular forms in art from a variety of cultures

and periods, then create their own circular works of art.) Instead of enhancing cultural understanding, these approaches reduce cultural artifacts to empty forms devoid of historical or social significance. The superficiality of these approaches is apparent to students who rightly question why they should care about issues that appear to be fabricated simply for the purpose of classroom study. Such approaches also tend to subsume art from every culture and context under narrow formal or technical concerns which are themselves derived from European modernist aesthetic frameworks.

Generally missing from multicultural art education is an approach which connects everyday experience, social critique, and creative expression. When the focus is shifted to issues and ideas that students truly care about and that are relevant within a larger life-world context, art becomes a vital means of reflecting upon the nature of society and social existence.

Contemporary Art and Multicultural Education

Many teachers shy away from using contemporary art in their teaching because they do not feel confident about their own knowledge and are reluctant to introduce their students to anything they may not have mastered themselves. This response is not unique to educators. As art critic and historian Lucy Lippard has pointed out, the field of contemporary art "has become mystified to the point where many people doubt and are even embarrassed by their responses...."[9] To make matters worse, teaching resources are scarce. The absence of curriculum materials about contemporary art reflects the attitude that the only valuable art is that which has "withstood the test of time." This attitude, in turn, reflects the belief that it is possible to establish universal cultural standards which remain fixed and permanent.

The relevance of contemporary art to multicultural education cannot be overstated. Over the last few years, a significant shift has emerged in the sensibilities and outlooks of artists and critics, producing what philosopher, theologian, and activist Cornel West has referred to as a new kind of artist associated with a new "politics of difference." The features of this new cultural politics of difference are to challenge monolithic and homogeneous views of history in the name of diverse, multiple, and heterogeneous perspectives; to reject abstract, general, and universal pronouncements in light

of concrete, specific, and particular realities; and to acknowledge historical specificity and plurality. In this new art, issues of *how* and *what* constitutes difference have been given a new weight and gravity.[10]

The study of such art can enhance multicultural and socially activist education by helping to build students' understanding of their own place in history and emphasizing the capacity and ability of all human beings, including those who have been culturally degraded, politically oppressed, and economically exploited.[11] The work of Juan Sánchez, for example, combines syncretic references to indigenous Caribbean, African, and European cultural traditions; Spanish and English texts; autobiographical narratives and photographs; and images from contemporary mass media. Sánchez's complex iconographies function as signs of resistance to colonialism and all forms of oppression, insisting upon the complexity of cultural identity and the power of self-representation. Such art serves as a reservoir of "unofficial" knowledge, a critique of history, and an affirmation of life. It is a form of primary source material for interdisciplinary education in which art is understood as both a product of history and potential agent of social change.

Discipline-Based Art Education

One cannot discuss current approaches to art education without addressing one which has gained increasing influence over the last decade, Discipline-Based Art Education (DBAE).[12] DBAE was developed in response to a decrease in school art instruction and the elimination of many teaching positions due to budgetary cutbacks in schools across the country. It has attracted many supporters in part because it holds the promise of increasing art instruction and elevating the status of art within schools. Indeed, DBAE has been instrumental in strengthening art education by establishing an advocacy network of teachers, administrators, museum professionals, professors in higher education, and funders. Advocates of DBAE want art to be defined as an academic subject, analogous to science, math, or social studies, with its own established subject matter, canon, and rules of operation. These advocates point out that art is not merely a form of self-expression, but a body of knowledge with an academic foundation. Art education, they argue, should be more than simply giving students art materials with which to "express themselves,"

but teaching students how art forms have histories, specific criteria for critical judgment, and aesthetic and philosophical meanings.

While we agree that artmaking is an intellectually and historically grounded practice, we also see that the DBAE model has several problems. DBAE has been criticized most pointedly for its Eurocentric and patriarchal biases.[13] These problems reflect a deeper flaw in DBAE's logic. In trying to legitimate art, advocates argue that the "integrity of the subject is maintained by protecting it from dilution with other subjects."[14] According to DBAE spokesperson, Elliot Eisner, the special characteristics of art must be maintained in order to prevent art from being "swamped by subjects often regarded as more important."[15] He calls this "boundary strength." Yet, the boundaries of DBAE impose severe limitations. The separation of knowledge into strictly delineated disciplinary categories fosters the narrow view that art has no connection with other realms of experience, including the societies that produce and use it. Framing art in this way overlooks the reality that art itself is part of the social realm, often a site of contestation in which diverse interests can clash. It also neglects the fact that many forms of art have been made with social change explicitly in mind. DBAE's orientation is in conflict with a kind of education that acknowledges the particular political basis underlying any curriculum. As one group of critics has argued, "in presenting art and art education as politically neutral, DBAE is contributing to the disempowerment of students."[16] The DBAE model also conflicts with one of the most powerful emerging trends in the field of education, the movement toward interdisciplinary education, which is dedicated in its philosophy and method to dissolving the very "boundary strength" that the DBAE model has struggled so hard to create.

Can the DBAE model address cultural diversity and interdisciplinary studies effectively? Those who say yes have tended to skirt the issue by claiming that the art discipline itself has changed with the times. "Cultural diversity, postmodernism, political, social, and psychological perspectives in art, and deconstructionism are all central to current debate within the art disciplines. All of these ideas and perspectives are, therefore, readily available for art education curriculum within the discipline-based model."[17] Such a statement, while seeming to address criticisms of Eurocentrism and insularity, addresses cultural diversity as if it were merely a "theme" or curriculum unit, rather than a multi-faceted, global, sociopolitical reality. By con-

trast, the social reconstructionist approach to multicultural education employed in this book challenges the concept that cultural diversity is a subtheme of art education and that knowledge is fundamentally circumscribed by disciplinary boundaries.

We advocate an approach which stresses the vital connections between students' lives inside and outside of school within a framework of social and historical analysis. This approach not only encourages students to speak from their own positions and to represent themselves, but also encourages them to critique their environments, and confront social issues in ways that are synthesized with the study of art.

A Social Reconstruction Approach to Art and Education

The term "social reconstructionist" has been put forth by Carl Grant and Christine Sleeter to describe a type of education which prepares students to become active citizens who fully participate in society. In the words of Grant and Sleeter:

> Education that is Multicultural and Social Reconstructionist . . . attempts to prepare students to be citizens able to actualize egalitarian ideology that is the cornerstone of our democracy. It teaches students about issues of social equality, fosters an appreciation of America's diverse population and teaches them political action skills that they may use to deal vigorously with these issues.[18]

A social reconstructionist approach to art education requires not only a change in the content and organization of the curriculum, but a shift in instructional methods as well. Students are encouraged to bring their own preexisting knowledge and experiences into the learning process, lessening the privileging of one dominant "voice." This process of democratizing classroom discourse is of great importance, as Steven Goodman argues in his essay on media education in chapter 2, particularly given the increasing social marginalization of a growing percentage of our students.

Groups that have successfully incorporated these ideas into effective programs include the New York-based Artists/Teachers Concerned, a consortium of New York City public school teachers dedicated to helping students create and exhibit art based on social concerns; Educational Video

Center, an organization that provides public school students and teachers with training in documentary video production and media literacy; Border Art Workshop/Taller de Arte Fronterizo, a collaborative artists group based in San Diego whose work addresses border politics and culture; and The New Museum of Contemporary Art's own High School Art Program. Border Art Workshop, for example, organized the "Whitewash(ed) Portable Exhibit" and workshop program on racism and vigilantism which actively involved high school students in an examination of their own attitudes toward racism and the development of antiracism materials for other students. The artwork emerges out of the students' everyday lives as they are conceived within a broader social, political, and historical frame of reference. Thus art becomes a medium for enabling the students to see the larger meaning of their particular daily life experiences.

The teaching strategies presented in this book grew out of The New Museum of Contemporary Art's ongoing work with New York City public high school teachers and students. The Museum's High School Art Program integrates contemporary art into social studies, language arts, and studio art curricula with a focus on students' life experiences. In these courses, students determine which issues will be the focus of study within a framework developed jointly by the classroom teacher and the museum teacher/artist. The themes which the students have chosen to explore bear directly on the issues that confront them in their daily lives: the AIDS crisis, racism, family. The lesson plans presented in Part 4 are based on these experiences and, as you will see, each of the themes is explored through a variety of means including mass media analysis, oral history, research, studio art projects, and art interpretation.

Multilingualism and Multicultural Education

We have incorporated linguistic diversity into this approach by providing a central portion of this text in Spanish as well as English, and addressing linguistic diversity issues in the essays and lesson plans. As Sonia Nieto has pointed out, language is inextricably linked to culture.[19] It is one of the most important means by which people express their cultural values and the lens through which they view the world. Growing numbers of our students are not monolingual; the largest number of these speak Spanish.[20] Yet language diversity is often overlooked when thinking about multicultural education.

A serious discrepancy in our educational system has been pointed out repeatedly—that while a second (or even third) language is required at the college and post-graduate level, development of a second language at the primary level is discouraged and even punished. This book suggests that now is an opportune time to reassess policies of linguistic racism, for they affect our students, their school life, and their futures. We are currently in the United States in the midst of an anti-immigrant backlash, spearheaded by conservative politicians who have blamed our economic woes on "illegal aliens" who are "draining our resources." This strategy has mobilized the middle class majority population in support of "English-only" legislation and demands for stronger policing of borders and deportation of "illegal" immigrants. Conservative politicians have ignored economic research showing that immigrants do not reduce jobs for non-immigrants and that, on average, immigrant families contribute $2,500 more in taxes per year than resources spent on public services for them.[21]

Advocates of monolingualism, particularly those with the power to affect national educational policy, should be viewed with skepticism given this social and economic climate. To support monolingualism is to oppose cultural diversity in a most fundamental way.

Renewed Opportunities

In a context of spiraling budget cuts, art is often the first subject to come under attack and be seen as an unnecessary frill. The response among many art advocates has been to try to protect the small piece of turf that we think we control despite the fact that this piece of turf keeps getting smaller. Rather than strengthen the role of art, such a defensive response reinforces its marginalized position in schools. Multicultural art education provides a renewed opportunity to strengthen and reinvigorate the role of art in education. However, in order for this to become a reality, multicultural art education must include a vision of art that is grounded in an empowering social and historical perspective.

As you open this book and peruse the table of contents, you will see that we have included several introductory essays. Consider these essays as a space to breathe and think about teaching, as food for thought, as a place in which to reflect upon and challenge your notions of what education is

and what it ought to be. Even though you may not agree with every idea presented in the essays, use them as a starting point for rethinking your own practice. As educators we are all continually challenged to create new ways to teach and new curricula to respond to our ever more diverse student population and our changing society. It is classroom practitioners who need to be at the forefront of this endeavor.

The majority of the essays in Part 1 are written by experienced educators, and one essay has been written by a student, Raphaela Francis. All of the essayists contribute unique educational perspectives based on years of working with young people. We asked each to discuss the role of art in the classroom, and they responded in ways that integrate cultural perspectives, educational philosophies, and insights gained through practice. We believe that each of these essays puts forth ideas that will inspire important and much needed dialogue among educators.

Works by 49 artists and collaborative groups are presented in Part 2. The artists' statements comprising Part 3 contain ideas and biographical information, in both English and Spanish. We suggest familiarizing yourself with most of the statements and reproductions before going into the curriculum in Part 4. The statements may also be used on their own. You may choose to focus on individual artists and their works, or groups of artists in various combinations based on medium or style, issues or subject matter, ethnicity or gender, and so on. The thematic curriculum of Part 4 employs most, but not all, of the artists' statements. Therefore, we leave it to you to create your own ways to incorporate them.

The lesson series in Part 4 is organized by theme and presented in consistent, sequential formats preferred by most of the teachers we consulted. We have made the lesson units simple to use, with the necessary resources listed in the front of each, along with information on how to obtain them. Knowing that classroom practitioners seldom follow curriculum to the letter, we expect and encourage you to add to, substitute, and rearrange the material to suit your needs. The suggested time frames for implementing the lessons are meant only as guidelines. You may find that a project for which we have recommended two weeks may actually be more beneficial to your students if you spend six, or vice versa. You may choose to skip entire lessons in order to focus on the few that are most connected to what you and your students are working on in the classroom. Because every

classroom is unique and every teacher's goals different, the key to using this part of the book effectively is to become as familiar as possible with the resource lists, the artists' statements, and the content of the lessons so that they can be used flexibly and inventively.

You will notice in reading through the curricula that certain works are mentioned that may not appear in reproduction anywhere in the book. There is a slide set produced by Sandak, Inc. which contains all the works referred to in this book. Although the slide set is not absolutely essential, we strongly recommend using it. Slides create a visually stimulating environment and make it easier for the entire class to experience and respond to art together. Also, in many cases, details within individual works are much easier to see in slide form. Nonetheless, if you do not obtain the slide set, you can still effectively make use of the book through its illustrations and ideas. We suggest you and your students do additional research on the artists whose work you find most relevant, or collect similar information on pertinent artists in your community.

We have included two other important resources in the back of this book, an annotated bibliography subdivided by subject, and an annotated list of arts and media organizations across the country. Once you have identified which themes are the most relevant to you, you can use these two resources to obtain additional teaching materials and find organizations whose resources address topics of special interest which will augment your classroom. Many of the organizations listed were selected because they make available curriculum packets.

None of the materials in this volume are prescriptive. The book has been designed to encourage flexibility in use. Apart from the recommendations to read the series of essays in Part 1 and familiarize yourself with the artists' statements before delving into the practical materials, we encourage you to use the lesson series, the artists' statements, and the resource lists as movable building blocks and to let us know of your experiences.

—*Susan Cahan and Zoya Kocur*

Notes

1. For three excellent references see James Banks and Cherry A. McGee Banks, eds., *Multicultural Education: Issues and Perspectives* (Boston: Allyn and Bacon, 1989); Christine Sleeter, *Empowerment through Multicultural Education* (Albany: SUNY Press, 1991); and Sonia Nieto, *Affirming Diversity* (New York: Longman Pubishers, 1992).

2. Sleeter, p. 10.

3. Sleeter, "This Curriculum Is Multicultural . . . Isn't It?," unpublished paper, 1993, p. 3.

4. Murry Norman DePillars, "Multiculturalism in Visual Arts Education: Are America's Educational Institutions Ready for Multiculturalism?" in *Art, Culture and Ethnicity,* Bernard Young, Ed. (Reston, VA: National Art Education Association, 1990).

5. See Griselda Pollock, *Vision and Difference* (New York: Routledge, 1988) p. 3.

6. Robyn F. Wasson, Patricia L. Stuhr, and Lois Petrovich-Mwaniki, "Teaching Art in the Multicultural Classroom: Six Position Statements," *Studies in Art Education* vol. 31, no. 4 (Summer 1990): 234–246.

7. Brian M. Bullivant, "Culture: Its Nature and Meaning for Educators," in Banks, pp. 27–65.

8. See Robyn F. Wasson, Patricia L. Stuhr, and Lois Petrovich-Mwaniki and Ronald W. Neperud and Patricia L. Stuhr, "Cross-Cultural Valuing of Wisconsin Indian Art by Indians and Non-Indians," *Studies in Art Education,* vol. 34, no. 4 (Summer 1993): 244–252.

9. Lucy Lippard, *Mixed Blessings: New Art In Multicultural America* (New York: Pantheon, 1990) pp. 7–8.

10. Cornel West, "The New Cultural Politics of Difference," in *Out There: Marginalization and Contemporary Cultures,* Russell Ferguson, Martha Gever, Trinh T. Minh-ha, and Cornel West, Eds. (New York and Cambridge: The New Museum of Contemporary Art and MIT Press, 1990) p. 19.

11. West, p. 34.

12. The Getty Center for Education in the Arts, which initiated Discipline-Based Art Education, has published many books on the subject. The first of these was *Beyond Creating: The Place for Art in America's Schools* (Los Angeles: J. Paul Getty Trust, 1985).

13. See Melanie Davenport, "Discipline-Based Art Education: Issues from a Feminist Perspective" *Heresies* (September/October 1990): 7–11; and Constance Wolf, "The Multicultural Debate: Challenges for the 1990s," *Exposure* vol. 28, no. 1-2 (1991): 43–50.

14. The Getty Center for Education in The Arts, *Discipline-Based Art Education: What Forms Will It Take?* (Los Angeles: J. Paul Getty Trust, 1987) p. 14.

15 Ibid, p. 15.

16. The Getty Center for Education in The Arts, *Inheriting the Theory: New Voices and Multiple Perspectives on DBAE* (Los Angeles: J. Paul Getty Trust, 1990), p. 85 quoted in Constance Wolf, p. 46.

17. Michael Day, "DBAE as a Platform for Teaching Cultural Diversity," presentation abstract from "DBAE and Cultural Diversity," Third Issues Seminar sponsored by the Getty Center for Education in the Arts, August 6–9, 1992.

18. Carl Grant and Christine Sleeter, *Turning on Learning: Five Approaches for Multicultural Teaching Plans for Race, Class, Gender, and Disability.* (New York: Macmillan Publishing Company, 1989) p. 212.

19. Nieto, p. 212.

20. U.S. Department of Education, "The Condition of Bilingual Education in the Nation: A Report to the Congress and the President." June 30, 1992, p. 32.

21. Anthony Lewis, "The Politics of Nativism," *The New York Times,* Friday, January 14, 1994, A29.

Part 1:

Educators' Perspectives

Educators' Perspectives: Introduction

The question "What is pertinent to a curriculum?" lies at the heart of many debates about multicultural education. Some critics argue that multicultural education introduces "political" or "sociological" concerns that are "extraneous" to a given subject area. This has been particularly true of art, which according to some, is strictly separate from the social or political realm. The essays in this chapter offer theoretical perspectives and practical solutions for studying art in context. They introduce ways in which interdisciplinary educational approaches can be conceived, as well as discuss the interdisciplinary nature of art itself.

Adelaide Sanford, an educator with over forty years experience as a teacher, administrator, activist, and advocate, focuses on the values embodied in the educational process. For Sanford, multicultural education is an important means of instilling the ability to negotiate, to value oneself and others, and to be a caring participant in society. As Sanford points out, the violent history of colonialism and slavery is rarely acknowledged by arts institutions, although many have built their collections with goods stolen from people in colonial parts of the world. Forefronting humanistic values demands honesty about past failures to live up to these ideals. In order to promote responsible and humane values, Sanford urges teachers to design curricula that "speak the truth," even if it means challenging the views of recognized authorities.

Steven Goodman is the executive director of Educational Video Center, a media center which trains high school students and teachers in media production and analysis. Goodman emphasizes the importance of involving young people in art and video production as a means of examining and reenvisioning social relations and building a democratic culture based on critical reflection and dialogue.

Elyse Rivin provides a concrete example of what interdisciplinary, multicultural education looks like in her classroom. Rivin chronicles her experiences as an English as a Second Language teacher in one of New York

City's most ethnically diverse schools, a high school created for recent immigrants. Rivin underscores the importance of art as an educational support to language study and as a means of communication. She describes her students' "joy of discovery and pain of disclosure" as they engage in art making and learn to communicate in new languages.

Amalia Mesa-Bains, an educator and artist whose art is included in Part 2, discusses the importance of instructional methods that contribute to a supportive classroom environment for diverse learners, including those whose dominant language is not English. She urges teachers to critically examine their customary teaching methods and makes specific recommendations for drawing relationships between students' life knowledge and the "texts"—books, films, works of art—introduced in the classroom.

Rayna Green, a historian, folklorist, author, and artist, stresses the importance of art as a means of communicating multiple historical narratives. Green argues that the writing of history (for example, through textbooks, curricula, and museum exhibitions) is a subjective practice, rather than an expression of fixed, universal truths. Green points out how dominant historical narratives, including those promoted by most museums, have tended to portray Native Americans in terms of a distant, romanticized, vanished or vanishing past, while associating European culture with modern life and progress. Green challenges these biased representations and discusses the need to define ethnicity and culture in dynamic terms. Through art, she says, we can "create our own powerful and indisputable versions of historical truth."

Raphaela Francis, a former participant in The New Museum of Contemporary Art's High School Art Program and now a student at the State University of New York at Purchase, discusses the relevance of contemporary art to the lives of today's students.

Chapter 1:

Affirming Diversity and Humanizing Education

Adelaide Sanford: In the last three weeks I have been to three high schools in New York City. Two of the three would be considered "troubled schools" including Thomas Jefferson High School where a student had recently been shot. In those two schools there was absolutely no evidence of an art experience; not in the offices, not on the bulletin boards, not in the display cases. The physical environments were devoid of any kind of artistic symbolism that would be enhancing, that would be revelatory, that would be healing; devoid of any kind of materials that students could use to express some of the disconnectedness, some of the rage, some of the frustration or alienation that they may be feeling, so that the weapons would not be necessary. I felt that the absence of the refining, humanizing experience that art is—both as a discipline in which children can be expressive of the world as they see it, and also as a mechanism for teachers and other members of the staff to understand what is happening in the life of that child—was very much tied in with the self-destructive behavior that we sometimes see.

Why do young people come to school? What is it that we are trying to see as the end result of the education process? Unfortunately, our society has settled on "preparing our children for the world of work in the year 2000." That is commonly accepted as the goal of education. That's terrible, because just preparing people to fill the employment need in a mechanistic world is well below the level of what we should be doing.

We should be educating young people as whole human beings who value themselves, their world and other people, and who approach that world and its people with the desire to understand them. The end result of education should be a person who values the environment and looks at the pieces of the world not as separate, but as being irrevocably intertwined and interdependent. We don't talk about education like that, and therefore we are not getting there at all.

Interview with Adelaide Sanford by Susan Cahan and Zoya Kocur

Many children are saying, "Well, if it's the world of work that you're preparing me for, how am I going to match that up with the fact that I can't get a job now?" Employment is one of the things that students talk about most of all. They say, "We want a job." At the same time the media is saying that these people don't want to work; that's the problem. Young people see the world very differently from the way the world sees them. They say very clearly, "We don't have any way of telling you how we really are. The way you say we are is not the way we are." No one hears the students' voices. That is very painful to me, because I think that when we continue not to hear these young people who are very bright, very capable, have so much to say, and we don't give them verbal facility—we certainly don't give them manual facility—then they do become self-destructive, they become violent. Why are children presenting themselves to the world in this way? We don't ask the question "why?" We don't give children the opportunity to talk to us in many different ways. Art is one of the ways that people tell us how they view the world, a very important way. It is not a way that should only be available to the talented few.

Zoya Kocur: I heard of a recent study which found that the learning experiences that have the greatest impact on high school students are those that happen outside of school.

AS: I'm sure that's true, because much of what children do in school seems to be irrelevant to their lives, particularly in those schools where children are having the least successful experience. The curriculum has little to do with those things that are pushing on them in their lives.

Susan Cahan: How do you think the education process needs to change in order to make connections between students' lives outside of school and what goes on in school?

AS: I think we can make the education process relevant by affirming diversity and recognizing that there are different people who have had different experiences and that they express these experiences in different ways. I think it is the responsibility of the school to make subject matter relevant. If this is classical music, if this is classical literature, if this is valu-

able material then how are you going to get the child to see it in that way? If you can make it important for the child to learn the data then the child will learn it.

That is really what multiculturalism—or what I prefer to call diversity—is all about. It brings everyone in at the same level. We don't talk about primitive versus fine art, we don't talk about classical music versus modern music, we don't make such value judgments. Without the affirmation of diversity, you can bring cultures together but continue to maintain a hierarchical structure, so that one culture may be considered more advanced, or valued than the others, or to have contributed more than the others, or to have made the framework that everyone else must look on with admiration. Diversity allows each culture to enter centered within itself and bring all of its various aspects to the experience of life. Everyone is recognized as having played a role. We don't have to make a decision about which one is better.

Furthermore, there has been so much intermingling, it is very difficult to separate cultures and to say, "This is what Asia contributed, this is what Europe contributed," there are so many dynamics affecting each other. No one comes empty-handed and no one leaves without being involved in the exchange. Therefore, we must look at an incident in history from multiple perspectives, which we have not always done. That is difficult for some people. It is as though that multiple look will in some way diminish what has been said before. I think that in resisting diversity you are telling others that their experience is not important. And then you expect them to behave nicely about it. You tell them that they have less value and their voice has no meaning and that their artistic expression is primitive. What do we expect as a result of that statement? We haven't examined what we can expect, and what is happening now, as a result of that statement.

SC: So how would you respond to someone who says, but we've come such a long way over the past few decades, say since the civil rights movement. Why do we need to pay attention to this today?

AS: I wonder if we have come such a long way. I don't think that the people who have been subject to atrocities—whether you are talking about the Japanese people or Chicano people or the indigenous Americans or

people of African ancestry—would say that we have made great progress. I think that it is more difficult now being of African ancestry than it was when I was a child, infinitely more difficult because there is entrenchment. I think that from the time of the Reagan years through Bush's presidency and into today it has become acceptable to be prejudiced and racist. The language is out there. Look at the decisions being made at the federal level about diversity. You have complete acquiescence to elitism and I think that's where we are.

ZK: How can a curriculum of diversity affect students' ability to succeed?

AS: In terms of a description of success I'd like to tie that into more than just test scores. I think of the ability to succeed in terms of the humanistic definition of success, because if you think about the people of the Savings and Loans and the "junk bond" scandals, and those who run companies causing environmental pollution, I guess they would all be considered school successes. But I wouldn't consider them successful in terms of what we are talking about. I think it reflects another tragedy of our system: that we only test and give grades and acknowledgment to the skills of reading and writing and math, rather than saying, now that you have these skills, what are you going to do with them? Are you going to make designer drugs? Are you going to make chemicals that are pollutants? How are you going to treat people and the world? We don't ask that. Therefore one can be considered quite successful and at the same time be a totally destructive person. A curriculum of diversity can humanize our definition of success.

ZK: So then how does what you are calling diversity contribute to what being a truly successful person is, as you define it?

AS: Within the celebration of diversity we can look at the values of diversity. If you look at the values of many of the indigenous Americans—their value of the land, of everything in the natural world—that is a different value system than the value system that might be termed European. Now that is similarly true of the African American value system in the

classical African tradition, and I talk about the ancient African tradition because we are talking about a time when Africa was at its intellectual peak, when it had its highest level of government, when it made its greatest monuments, when its sacred literature was being written. In that system the goals of education were very clearly spelled out. The people who were teachers were priests. They studied forty years to be teachers and they didn't have churches because spirituality was a part of everyday life. They talked about the goals of education being character, propriety, truth, righteousness, justice, balance, and integrity. So that gives a whole different function to the education process. It is not that you are becoming educated to get a job, but you are becoming educated toward perfecting of your humanity.

If we look at diversity, we look at other functional value systems that people have tapped into and believed in and which have helped them to prosper in a humanitarian modality rather than seeing competitiveness and individualism, qualities that we call being American, as the highest and the most responsible values.

SC: You know, listening to you, what really strikes me is that what you are talking about is not just a move towards political equality, but spirituality in everyday life.

AS: It is the basis of our existence. Particularly for people of African ancestry, spirituality is basic and fundamental. Also, another value in traditional African systems is a uniting of the body and the spirit, a belief that you really cannot say one thing and behave in another way. You cannot lie and cheat and still be a spiritual person. You can't do that. You become dysfunctional and nonproductive unless you see yourself as a whole being.

I know these ideas are controversial in America today. While some scholars are saying we must embrace our African-centeredness, other people say, "How can I do that in America? It's irrelevant. Don't tell me about that. I don't want to hear anything about African-centeredness or Afrocentricity. I'm in America and I'm an American." But the truth of the matter is that people of African ancestry have never really been accepted as Americans anyway. Therefore, there are those who are saying, that is not going to work for you—that individualism, that competitiveness, that mate-

rialism, that feeling that power is the only thing that is important. It is not going to function for you, you won't be happy. Not that you won't get to the glass ceiling and get a Mercedes and so forth, but you won't be happy, you won't be fulfilled, there will be something missing inside of you and that is universally true for all people, regardless of their racial or ethnic background. Many of those who have approached that pinnacle are failures because they are destructive to themselves, and to the people around them. They are insatiable in appetites of all kinds. They are not happy, fulfilled people. But those people who have found a way to get back in their consciousness and in their lives to what we call "Maatian" principles of living and of raising their children are the most fulfilled, creative people.

I think that a curriculum of diversity can also help students in terms of test scores. In fact, in a book called *Affirming Diversity* Sonia Nieto quotes some studies that look at the fact that children who are culturally based, who know the history and culture of their people, achieve better academically.

SC: Why is it that having that cultural grounding makes a difference?

AS: Well, I think particularly for children of African ancestry who have come through the system that has said they are not capable, this can counter their internalization of that. Even in my own life, my sister and brother and I were all told that we were not college material. Then when our grades obviously showed that wasn't true, we were told that college wasn't for us. And you will find that endemic for people of African ancestry, whether you are talking about Malcolm X or Guion Bluford, the first astronaut of African American ancestry. His parents were told repeatedly, "He's not college material, take him out of an academic track, put him in a trade school." Gil Noble was told the same thing.

The underlying truth is that if you educate these people they will challenge the status quo in terms of employment, in terms of ideas and power. For many people, it is more comfortable to see them become the prison population. Students internalize that. So when you begin to say to them the prior data is not true, that not only are you capable but you come from people who have historically been capable and have done many wonderful things not only in classical African civilization but even during the institu-

tion of slavery—think of all the inventions of a person like Latimer, who did not have the advantages that Edison had, but whose advances matched or exceeded his—it is freeing to our children. It makes them think "It is possible; I can; It's not true that I am limited." I think for African American children that is the real basis for success. It is critical to hear this declaration of capability because historically there has been a declaration of incapability, including the use of terms such as "culturally deprived," "disadvantaged," and "at risk." All of those definitions limit and deny capability. Pejorative definitions are not motivating, to say the least. To establish a belief in capability, in spite of tremendous deprivation, is an enhancing recognition. It's not that there isn't the love of learning, but that this love is in many instances absolutely strangled.

SC: You raised the question earlier about the purposes of education. What kind of people do you want students to become?

AS: I think that unfortunately we haven't defined it. When you look at the nature of our society today in a global context, certainly we want to develop thinking human beings who are going to think critically about their own lives, make decisions about their own lives, and accept responsibility for the decisions that they make. You can begin to educate people in that way from kindergarten, helping them to think about whether or not they really want to punch another student in the nose. Is that really the best way? Have you thought about what's going to happen if you do that? Are there any alternatives?

You have to make the acquisition of information functional. You don't learn to read just because a teacher says, "Ted and Sally, here's the book, you have to learn to read." You learn to read in order to learn how to do other things that you want to do, whether it is to read the map to go downtown, or the recipe for making a pie or a cake, so that children develop the desire to be lifelong learners because they want to continue to acquire information about the world.

We have to be preserving of life, to help students learn to value life, all life, not just the lives of Americans. We have to look at the fact that in North America many of the things we want we don't have in this continent. We don't have the minerals, we don't have the oil. Now the time has

passed, I hope, when you could go over there and "konk" people over the head and force them to give you what you want. You have got to learn how to speak other languages, understand other cultures, negotiate with other people. How do you do that if you sit here and legislate English Only? I felt so embarrassed during the Persian Gulf War as a citizen of the United States when here were the people from that area of the world who had mastered English and we didn't have a single diplomat who thought enough about the value of those people to learn their language. This automatically said, "You're not important to me, all I want is the oil, and how am I going to get it?" You perpetuate war unless you put yourself in the position of learning about other people, valuing them, negotiating with them. Because the children would say, "Well what is the difference; if I want his jacket, why can't I just beat him up and take it?" That's what the United States did in the Persian Gulf, that's what France did in the Ivory Coast, that's what Belgium did in the Belgian Congo. They didn't worry about negotiating about the rubber, they just enslaved the people and took the rubber. We can't do that anymore. Perhaps we must admit that it was wrong in the past.

So the kinds of people that we want to create are people who know how to negotiate, who value other people. I think we want people who are merciful toward others. We want people who care about the young, who care about the aged and care about those who are in some way physically challenged. The kind of human being we are trying to create is not just an educated person, because educated people have done some terribly inhumane things. Education won't cure all of our ills. There have to be certain humanistic values involved in that educational process.

How do we educate people to function in a way that is humanistic, that is preserving? We have to help them understand the nature of what it is that they are doing, why they are doing it, what sort of historical precedents it has, and what the consequences are. We have to look at morality historically. For example, when we talk about people having children that they don't take care of, we have to look at where that began. Here in the United States, where did it begin that people bred children by women about whom they had no concern, who had children that they couldn't mother? What is the historical reason for that in America? It's very difficult to get some people to talk about the institution of chattel slavery, where women

of African ancestry were not allowed to marry, where the slave owner raped, where men of African ancestry were forced to breed. Was that a moral issue at that time? We have to confront that. Not only for the sake of those people who are now making it a moral issue, but also for the sake of the young people of African ancestry, who in many ways appear to be choosing that which their ancestors were forced to do. I must tell that to my children. Regardless of the opposition, I am responsible to tell these children what happened in order to help them become the kinds of people that I want them to be. That may be dangerous education, but I think that's what we have to talk about in order to create the kind of person we want.

SC: How can we teach the kind of humanistic values that you are describing through the study of art?

AS: Let me give you an example. Last summer I went to Cairo, London, and Paris, and one of the main things we did was to visit the museums. In the European museums the Nubian art, the art from ancient African civilizations, was way down in the basement, uncatalogued, poorly labeled, while the European things were centered with all of the lights, and all of the accouterments to give them that sense of prominence. And I thought about the way statements are made about which cultures are considered important just by the way the material is presented. It is so powerful and still it's subliminal. Unless you are very sensitive to it you could almost miss it.

In Paris there was a huge mural showing "what France gave Africa." We asked the guide, "Where is a room or a wall that shows Africa's contribution to France, all of the things that France became because of what it took out of Africa?" The guide was quite startled that we should raise that. So then the ultimate question was "How did you get all of these African art objects?" And the answer was, "We acquired them," and when we you pushed a little further, "Well, how did you acquire them?" "From people's private collections." "Well, how did those people get those private collections?" It's a basic question that I think they should answer honestly and say, "We stole this." But, by saying "we acquired it" they suggest that the people who had it didn't value it, didn't know what it was, and wouldn't have kept it if they could. All of those pejorative things suggest that you

really didn't have enough intelligence to value that which you created, so we had to take it from you to preserve it. That is very disrespectful. I think it's a moral issue that we have not confronted at all, the fact that all of those African treasures, the majority of those marvelous pieces of art, are not in Africa.

We may admire the art, but we must also acknowledge that the way it was brought into the museum is not something we want to continue. Likewise, we do not want to continue to keep the bones of the indigenous people in museums, keep them from being buried with their sacred rituals because they have some "scientific" value to us. We don't have the right to do that. That's audacious and arrogant.

SC: So how do these issues impact on a teacher who might want to use a museum collection or art objects found in museums in his or her teaching?

AS: I think that's an important question because in the new framework for social studies in New York State one of the recommendations is the use of primary sources, which means that you have to go to the museums, you have to go to libraries. I can understand the value of having African art objects at the Metropolitan Museum and pieces of art by contemporary artists of African ancestry in the museum. But, that doesn't mean that you use them without understanding and recognizing their sources and how they got there. We cannot pretend that these events didn't happen and give that thievery a kind of nobility. I think that is very wrong. I think it sends the wrong message to children. There must be a historical framework that speaks the truth about how the material was acquired and why it is presented in the way it is. And if this has been taken, if this was stolen, and now has become validated because the person who bought it from the thief says "Well, I didn't steal it, I bought it," then we must look at what that means and compare it with what it means if you buy stolen goods today.

It is very difficult for children to understand how at one time it was alright to steal and now it isn't, particularly when those people saying, "You can't steal" may have been the major thieves. Children have the right to raise this question and to treat these acts with disgust. I think teachers can handle that. I think the children would be much more connected to the reality of the school experience, and it would be an opportunity to say, "How does

this relate to some of things that happen to you in your life today? Does this have any relevance to what's happening on your street or your corner or in your house?" And it would make the educational process so relevant.

ZK: What do you see as the role of bilingual education in creating the student who is a whole being, who is truly educated?

AS: What I wish that we would do in the North American educational system is to provide from pre-kindergarten to high school opportunities for all children to learn additional languages. I think that is the only way to give bilingualism the kind of value that it should have, so that it's not viewed as a problem. Why is it that when a child enters school with a mastery of a language other than English it's viewed negatively? At the same time we say that by the time the child graduates from high school the child must have mastered a second language? It's contradictory. If we value that mastery then give the child the opportunity from its early entrance into school to see language acquisition as a plus, just as we do with anything else. Then I think that bilingualism would not be viewed as a problem. It would be viewed as an asset, because the majority of people in this world do not speak English. It's a fantasy to assume that the English language has some major importance that it just doesn't have.

SC: What do you see as the role of the teacher within the kind of education that you are describing?

AS: I think that of course we talk a lot about pre-service training, we talk about what we expect teachers to be able to do before they are prepared to go into a classroom. But I increasingly think that it's about what kind of person enters into the teaching profession. I think that is where we have to go eventually, because if you provide me with a human being who is compassionate and wants to learn, then it doesn't matter so much whether that person comes to me with all of the specific skills, because they can be helped to get those skills. The research data shows us that teachers generally teach in the way they were taught. They don't necessarily teach in the way they were taught to teach in the training institution. I think we are looking for a kind of human being who has had a very enriched experience.

In the education classes that I teach at Baruch College, I very often start the term by asking for a self-identification piece. In giving the assignment, I ask the students, tell me what you are like, who you are, but also tell me how I could find out about you on my own, where I could go, what I could read. You know many of them have a lot of difficulty with that and some of them say to me, "I've never thought about it before." I don't think you can teach well before you know that, I really don't, because you teach yourself. Before you teach a subject, you teach who you are. That is what the children feel.

SC: What would you say to a teacher who has not had such an enriched model, but who is eager and open to teaching in a different way?

AS: Oh, I think that I would be very grateful to have a person like that, because there are all sorts of opportunities available to this person to learn how to do it in a new way. I think one model that we haven't embraced in the North American educational system is the demonstration school. When we find a really viable relational, relevant program, that school should be a teacher training institution, rather than training teachers at a college away from everything.

I think that a person can best be taught in an institutional setting where they are with an exciting and vibrant teacher who then becomes the model. A person like that has great possibilities. What doesn't have possibilities is a person who is convinced that their way is the only way and then comes into a system that validates this attitude. That person goes on to teach for five, ten, fifteen years and in many ways closes off the wonder of learning for so many children.

ZK: What would a teacher do who is willing, but also is stopped by the realities of what it's like to teach in a public school in this country, a teacher who feels overburdened?

AS: I think that maybe I had the experience at one time of being in the system and feeling like that. You close the door and you do what you feel is right, irrespective of what the external demands are. Because actually, when you look at the external demands, when teachers say, "Well, I have

to teach because the test is coming and my district says I must do this," it's not that much. For really highly-motivated children and teachers you can say, "Hey look, we can finish this in about three-quarters of the time." The demands become burdensome if that's the only thing you see. If you can just see beyond those limitations, you can get to the essence that it's these kids that I ultimately have to satisfy. When I was teaching at P.S. 21 I found that it really didn't bother me. As long as the children didn't go out onto the street and shoot each other, or shoot the people on the street, the educational hierarchy really didn't care what I did. You could really close the doors of that school and do what you felt was right for the children.

If you look at the high schools that I mentioned earlier, the teachers there will tell you that there is so much that they can't do because they are locked into a system. Yet, one of those schools didn't have a single child who took a New York State Regents examination. What is the system that they are worried about? They are not conforming to any system's expectations anyway, so they might as well do something that is going to meet the needs of these children. The system has forgotten about them. The system has accepted the fact that they are nonfunctional, but they are still locked into thinking that is their excuse for not being creative.

I think many teachers are afraid. There is so much fear. Many teachers are locked into believing that they have to conform to something which they really don't have to conform to at all. If you could just free them to say, "No, I really don't have to do that," because they really don't.

One of my students said to me yesterday, "Do you really belive the things you say, that everybody is good ultimately?" I said, "I choose to believe that. I make a deliberate choice, because if I didn't, what would be the alternative?" It can be depressing if you don't make a deliberate effort to believe that things will be better, that we *will make* things better, rather than that they will become better. We will make things better.

Chapter 2:

Media Education:
Culture and Community in the Classroom

Steven Goodman Art education carries within it a broad range of opportunities for students to develop new ways of seeing and knowing, and the capacity to "read" and re-present their own world. Media education—the process of learning to create and critique the media—carries the same transformative possibilities. However, teaching with and about the media also presents educators with its own unique set of concerns, apart from other arts disciplines. It is important to give close consideration to the specific cultural and social relations that shape the media arts and how we bring them into our classrooms.

Although other art forms have historically reached mass audiences in churches, public spaces, and more recently through museums, today's electronic media are able to saturate the daily lives of people on a global scale unlike any before. Consequently, students already come to school with a considerable knowledge base about the mass media and have participated since infancy as part of its audience. Before they get to school, children have logged 5,000 video hours. It is estimated they go on to watch 1,000 hours of TV per year, and by the time they graduate, will spend more time in front of television than in school. They are conversant with the language of television, in its genres, codes, and conventions.

Media education is a young discipline struggling to find its place in our schools. To date, state departments of education do not mandate students to study it, nor do they certify teachers to teach it. To complicate matters, there is no agreement as to where it should be housed, as it crosses disciplines with little regard for previously established boundaries.

Much of the media education movement in the United States focuses on students as consumers of culture. The goal for education efforts both in school and in the home is to change young people from being "passive viewers to questioning consumers."[1] While such efforts have created an indispensable foundation for all of us working in media education in the U.S., I would argue that we need to further deepen and broaden their implications. Some educators tie themselves so closely to the study of main-

stream media that media art and other independent work tends to be excluded from the discourse. These educators' analyses then remain fixed within the framework of the dominant culture they aim to critique. A truly critical pedagogy would teach us to be more than "questioning consumers" with "good viewing habits." Such a pedagogy would dig at the roots of the dominant culture and the market culture that it promotes, and challenge the notion that we have no choice but to relate to the world as consumers. It would suggest not only that we change the way we watch television but that we change the television that we watch.

Such a critical approach transforms the market oriented paradigm and renames the student-as-consumer, student-as-artist. As a creator of art, the student gives life to his or her powers of imagination, expression, and social commentary. The student's work then assumes a use value for the audience for the pleasure it gives, the new worlds it opens, and the thought and dialogue it provokes. The work enriches our culture, because it comes from and gives back to the community. Resting on these notions, I suggest the following as strategic points of departure to guide our work and begin to reframe the debate, using media education as a paradigm for cultural education generally:

1) **We must present students with alternative models of expression and representation.** It is commonly stated that the mass media offers its audiences not a window on the world, but a filter that selectively screens, colors, and constructs a new reality. This construction is defined by a process of exclusion. It is therefore not sufficient for educators to engage students in critical analysis of the dominant mass media and its filters without also presenting them with alternative representations; not to do so excludes alternative forms of media from the larger debate and serves to further marginalize them, and reinforces the notion that culture is uncontested terrain, that there are no cracks in the system. We need to struggle to democratize classroom discourse, to open the classroom to marginalized voices, to present counter interpretations, and constantly challenge the "master text."

The urgency of giving students an opportunity to see authentic representations of their own communities that speak to their concerns is of particular importance given their growing social and cultural marginalization.

The gatekeepers of culture and learning in our schools—from the churches to the school boards to the teachers themselves—are increasingly denying students access to independent media and art. The perceived danger of introducing such work in the classroom is that it might spark discussion and critical analysis of the students own lived experiences. Education researcher Michelle Fine writes of the pervasive practice of silencing students, specifically low-income youth of color, in New York City schools. "... silencing, constitutes a process of institutionalized policies and practices which obscure the very social, economic, and therefore experiential conditions of students' daily lives.... In low-income schools both the process of inquiry into students' lived experiences and the content to be unearthed are assumed to be, a priori, unsafe territory."[2]

2) **Educators need to consciously work to broaden the public sphere through open school and community dialogue.** Our public spaces—our streets, highways, buses, sporting and entertainment arenas, buildings, malls, schools, and even the skies—have become increasingly privatized by commercial interests promoting messages of what to buy and how to be. The consumer consciousness extends to the political arena, where candidates and ideas are marketed and sold like any other consumer product.

Television's influence is so pervasive that, to a large extent, it has engulfed the public sphere. It dominates and frames the discourse of our daily lives. To be in the mass media is to participate in the public sphere. While the illusion of free public debate has been created by carefully managed television and radio talk shows, political "town meetings," and instant call-in audience surveys, in fact authentic dialogue in the public sphere has been drastically diminished. The result is a one-way conversation with the audience, the closing down of participatory democracy. The public has been largely transformed from one that critically reflects on its culture to one that merely consumes it.

The genre of the community documentary offers rich possibilities for building greater public participation and dialogue. For example, one can engage students in community research projects where they use the media to interview classmates, people on the street, neighbors, and community leaders about issues that concern them. In this way, students learn through

direct (unmediated) social interaction and experience, from the oral tradition of storytelling. They also learn to gather and weigh facts for themselves, synthesize information, tell their own stories and teach others in their school and community. The student's world becomes the primary text. Mass media constructions then become one (the most widely seen and heard) of several sources, put in perspective through the community inquiry.

Educators need to build collaborations with museums, libraries, and other cultural centers in their community to sponsor public screenings of student media work. Whenever possible, educators and students should work to bridge the gap between school and community, producer and audience, and develop a culture of public reflection and debate.

3) **The processes of artistic production and reflection must be dialectically engaged, not separated, in order to strengthen and enrich each other.** While many media educators join those in the school restructuring and reform movement when they call for interdisciplinary learning, they still remain stuck in a mode of thinking that separates analysis from production, thought from action. The emphasis of most media literacy efforts from abroad centers on media criticism and analysis, while the U.S. seems to put emphasis on production. Often, student productions are uncritical imitations of the mainstream media (commercials and magazine talk shows seem to be among the most popular).

The act of creation is an essential part of thinking. We work out our ideas, draw out our observations and feelings through the process of writing articles, research papers, poems, journal entries. We ask new questions and search for answers to the social conditions of our times through documentary making. Through the constant process of experience, reflection, and creative action we confront the world and create spaces to deepen our thought and make meaning of it.

This is not to ignore the built-in tensions between production and analysis that always exist. It is the teacher's responsibility to recognize and take up the challenge before him or her: to help his or her students navigate that process; to steer clear of academic analysis that leaves no room for student expression and experience; and to stay away from a purely derivative production that lacks reflection, artistic vision, or authentic voice.

Process should be at the heart of an alternative cultural pedagogy. It is the teacher's responsibility to preserve the integrity of process over product, to ensure that the students' intellectual and artistic growth is organic to the making of a project. Putting the power of the media in the hands of students in conjunction with a rigorous analysis teaches students a new way of seeing, expressing, and representing themselves. It also contributes to an alternative culture built on artistic production, critical reflection, and social dialogue as opposed to the dominant culture of consumption and the consumption of culture.

4) **As educators we must work to develop in our students, to paraphrase Dewey, the capacity to look at the world as if it were otherwise.** It has been said that naming the things that are absent breaks the spell of the things that are. We must struggle to expand the space for imagining an alternative way of being, a qualitatively different universe of discourse and action. Naming our students as consumers limits their thinking and being to that of the consumer (active or passive, with or without a critical consciousness). It takes for granted that existing social relations are fundamentally unchangeable. Students may learn to discriminate between truthful and false advertising, between cartoon and reality, and have more "positive viewing" experiences. Yet, they still remain consumers, perhaps questioning the product, but not the system that creates it. This kind of thinking denies students the possibility of being producers of culture and history. It confirms the generally accepted notion that the market culture is the natural order of being. British educator Len Masterman articulates this position in the following statement: "De-mystifying the world, seeing it not as a 'given' to be accepted, but as something to be critically worked on, to be shaped and changed by human agency, is a necessary precondition for a liberating educational praxis."[3]

The dominant media has spun out a vast and complex web of relations across our cultural landscape. The media and the market culture that produces it are so pervasive as to be almost invisible. To teach students to exercise their imaginations as producers and their critical abilities as viewers requires that teachers are vigilant in doing the same. As art educators we are constantly teaching our students to look at their world with multiple perspectives, to blend critical and imaginative sensibilities. These ways of seeing,

creating, and learning are often in direct conflict with the more one-dimensional teacher-centered approaches we find so prevalent in American schools.

Art education in general and media education in particular have important roles to play in changing our schools and, as philosopher Maxine Greene has observed, for opening "the spaces necessary for the remaking of a democratic community. For this to happen, there must of course be a new commitment to intelligence, a new fidelity in communication, a new regard for imagination. It would mean fresh and sometimes startling wind blowing through the classrooms of the nation."[4]

Here lies our challenge.

Notes

The essay is adapted from an essay which appeared as "Media Education Programs," a chapter in the *Encyclopedia of English Studies and Language Arts,* a project of the National Council of Teachers of English. Scholastic, 1994.

1. Barry Duncan, *Mass Media and Popular Culture* (Toronto: Harcourt Brace Jovanovich, 1988) p. 8.
2. Michelle Fine, "Silencing in Public Schools" *Language Arts,* vol. 64, no. 2 (February 1987): 157–158.
3. Len Masterman, *Teaching the Media* (London: Comedia Publishing Group, 1985) p. 32.
4. Maxine Greene, *The Dialectic of Freedom* (New York and London: Teachers College Press, 1988) p. 126.

Additional References

Alexander, W., *Film on the Left: American Documentary Film From 1931 to 1942* (Princeton: Princeton University Press, 1981).

Angus, Ian and Sut Jhally, eds., *Cultural Politics in Contemporary America* (New York and London: Routledge, 1989).

Chapter 3:

Enhancing English as a Second Language: Why Contemporary Art?

Elyse Rivin I am a teacher at International High School, a public school in New York City created as an experimental, magnet program for the immigrant population of the city. The school is open to any immigrant student who has been in this country less than four years, whose English language skills are below a certain level, and who feels uncomfortable in a large, urban school environment. All of our students speak English as a second or third language, and the courses at the school are sheltered content-area courses, meaning that the students are taught regular subject area material with modifications in the language so that it is easier to understand. My classes are specifically designed for improving language skills.

One of the issues that is critical for my students—who literally come from all over the world—is their need to acclimate to American society, its values, social cues, and codes of acceptable behavior. My students often feel insecure, hostile, fearful, and determined to belong—all at the same time. The students not only have to learn a new, difficult language, but must adapt to changed family structures and expectations. Many students have families in which everyone works, sometimes seven days a week, and they find themselves responsible for the household as well as their school work. Very often female students from Asia or South America find their lives more restricted here because of their parents' fears of robbery or violence. These students often perceive coming to the United States as a form of imprisonment. Male students tend to have less parental supervision than female students here and are confused about how to handle new liberty they might not have had in their old home. As teenagers, they are eager to adapt, to feel at home, even though the language and customs are often so different from back "home." At the same time, their parents express great fear of losing them to American ways, which puts enormous stress on their daily lives, and on their ability to create a cohesive identity for themselves.

A major part of our classwork involves the reading of stories and memoirs written by other students and adults who have lived through the

immigrant experience. The themes that the students explore deal with culture shock, racism, disorientation, confused identity, and parent-child conflicts based on two-culture tensions. After much reading and discussion, they also write their own stories. These stories tell of the challenges they faced in coming here, or of how they are adjusting to life in a new country.

No matter where they are from, these students are experiencing stress, confusion, and denial, so the more they can find to identify with and use as inspiration, the better. After teaching this class for a couple of years, I started to understand that reading stories about others who have lived through similar experiences sparked feelings of recognition, and helped students to open up and explore new potentials. I wondered if the introduction of visual elements might further enrich and broaden their understanding and responsiveness and increase their ability to express their ideas.

At first, I attempted to use art in the classroom as a "loosening" tool, hoping that it would help those students whose skills in English were still rudimentary to speak more freely. During the course of our art projects, I discovered that some students were most comfortable when drawing or painting, since art provided a means to express what their English language skills did not allow. It provided other students who were more proficient in language skills an added vocabulary for expression of their ideas. The projects we took on tended to be small, isolated assignments, perhaps a small collage of newspaper images to express their responses to New York, or a self-portrait, or a cartoon drawing about school.

Early feedback from the students indicated that these art projects were of some value, but were not structurally integrated enough into the rest of the curriculum to give a clear sense of purpose or cohesion to the work. Yet the students seemed to enjoy these projects, and were quite engaged in doing them. There seemed to be evidence of the positive role this work had on their self-esteem, and on their general responsiveness in class.

Visual information seemed especially effective with my students because it requires no specific knowledge of English to understand and because the impact of visual language is more immediate than that of written texts. In a class that may have students from Korea, China, Afghanistan, Poland, Colombia, and Ecuador, the image represented a potentially common language to which everyone could respond.

At first I wanted students to become familiar with images native to their own cultural traditions. This assumed an exposure to "classics" of each culture, whether European, Chinese, Persian, Islamic, African, or Latin American. I had access to many slides of these older examples of art, and we had several lessons based on looking and discussing these works. My students did not know very much about the traditional or classical artwork of their own cultures, beyond an ability to visually identify the works' origins (perhaps not unlike the average European American student), and many expressed feelings that this work was essentially uninteresting to them because it did not speak to their own life experiences.

I began to look for more contemporary art in the hope that I might find artists who were creating work that addressed issues specifically relevant to my students. I discovered that slides of very recent artwork are hard to find; however, I did find some slides, and the initial reaction I got from the students was positive enough for me to continue my search. I became convinced that through contemporary art I could create important linkages for my students, between social issues, visual expression, and their everyday lives, and between the two cultural identities they were learning to integrate.

Collage Project
International High School
at LaGuardia Community
College, NY, 1990.
Photo: Zoya Kocur

Throughout my teaching experience I have made efforts to develop ongoing relationships with arts and cultural institutions in my area, including The New Museum of Contemporary Art, and have used them extensively as resources, both inside the classroom and out. These organizations can provide access to information, materials, and educators, giving the added incentive to introduce students to materials on contemporary art I might not feel confident or expert enough to present on my own.

Many of my colleagues have expressed skepticism as to the accessibility or usefulness of much of contemporary art for adolescents who have not only very limited exposure to art, but to American society in general. However, it is precisely because so many contemporary artists deal with social issues and questions of identity, and create art as individuals who are part of a larger community, that these young people can relate to it. Often, these works address issues of racism, immigration, and alienation, all of which touch my students' lives very immediately. We discuss the artists' motivations, and analyze the personal, social, or political issues that are being expressed.

Educators' Perspectives

This idea of interconnectedness between what we live, who we are, and how we express ourselves, provides a key to my students' receptivity to contemporary art: it is a mode of expressing experiences in the world around us right now. My students are in transition from one culture to another, and from one age to another. Very often they have experienced the horrors of war, political repression, and poverty in their native countries, and then the pain of racism, ostracism, or otherness once they arrive in the U.S.. Much of the contemporary art they see seems to reflect the states of their own psyches. When I ask them what purpose contemporary art serves, they answer that art is for expressing one's feelings, or ideas about our experiences in the world. Among the most frequent remarks I hear from my students is that they like looking at this kind of art because it is about "real" things, not just about being pretty.

Through working collaboratively with museum educators, I have developed a successful model for incorporating contemporary art into my curriculum. Because my classes are not only mixed ethnically, but are also heterogeneous in language abilities, one of my priorities is to create a project that allows each student to participate and feel a sense of accomplishment about the work, no matter what their level of comprehension in English. Another very important factor is the need to create a project that allows for individual and group work. I want each student to have a sense of belonging to a communal art effort, and at the same time have an individual piece of the project that can be identified and pointed out to others. After several years of doing these classes, I have examples of previous students' work to show, and present these as illustrations of what has already been done, and what they might do. By concretizing the process, giving students something tangible to look at, they are stimulated to think and plan for themselves.

Collage Project
International High School
at LaGuardia Community
College, NY, 1990.
Photo: Zoya Kocur

I have also learned to make sure that the class discussions and the reading and writing assignments develop a network of themes that can be used in a fully integrated way with the art projects in order to give a clear sense of purpose and cohesion to the work. Within the first two weeks of class, I incorporate into the classwork some viewing of slides and/or examples of contemporary art. The art shown is either a collection of work of several different artists, or the work of one particular artist, if that person's work is varied in style.

In the process of developing our projects, I spend considerable time making sure that whatever decisions are finally made, the class, as a whole, will be happy with them. This can sometimes be an arduous process because students who come from many different cultures have different learning styles and different codes of behavior. Some are very quiet and passive, while others are very outspoken and dominant. Once in a while, a whole class will be fairly quiet and shy.

In general, working on a collaborative art project involves the same considerations as work done in our other classes in which understanding of cultural diversity is a central topic. We strive so that language limitations do not hamper comprehension or willingness to participate, students from very different cultures accept working alongside of each other, and the work always addresses topics relevant to the students' lives.

Collage Project
International High School
at LaGuardia Community
College, NY, 1990.
Photo: Zoya Kocur

Most of the time our projects are executed entirely in the regular classroom, and because of our space and storage limitations, I have had to learn what types of art projects are feasible. We use simple materials such as paper and foamcore, a lightweight board useful for mounting or creating sculptural effects. Everything must be inexpensive and easily storable. My students help me amass printed material in every language for collages and design. In this way we maintain a manageable project and keep everyone involved.

Evaluation of progress is, of course, important. I believe it is crucial to have feedback from all the students during the process of their work, to know when they are having problems, and to understand how they feel about the work. In order to help them organize their thoughts and write in English I ask them to keep a weekly worklog in which they describe what they have done that week, their ideas, and their feelings about the work. This exercise also helps me chart their progress in learning English. The students know that their grades are based upon participation and cooperation, not on artistic skill. At the completion of the project, they write a final evaluation report giving their assessment of everything the class has done, offering suggestions for the next project.

Everything the students write is considered part of their schoolwork. Writing assignments are related to the artwork, and there is always time allowed for revision and feedback of the writing from other students. As with the artwork, completion of assignment and evidence of creative thinking counts more than specific technical skills.

When the work is finished, we have a reception displaying the art projects for other students and faculty. The students act as hosts, discuss their work, answer questions in English, and happily show all interested viewers their proud accomplishments.

In one of the projects done by my class with The New Museum, students chose to execute a mural based on their concerns as teenagers and as immigrants. As a group, they selected themes that they considered most important to their lives: friendship, racism, family, the past, language, music, combining two worlds, and love. The class had agreed that these themes were relevant to everyone, no matter where they came from. There were students from Brazil, the Dominican Republic, Mexico, Korea, Afghanistan, Malaysia, China, and Poland. Their task was to write essays that reflected their thinking on these subjects, and to incorporate these essays into a 40-foot paper image of the planet which had been broken down into individual continents with each continent representing one theme.

The project required extensive personal writing, as well as collaborative work on the design elements of the mural. Surrounding each "thematic continent" was a collage of images, photographs, drawings, and pastings that enhanced the text by offering visual statements. The overall form of this project echoed the greater lesson I hoped to share: that we can value and appreciate differences, individual and cultural, while at the same time working together to create our society, making a whole that is greater than the sum of its parts.

On the final feedback sheet at the end of the course, students have often indicated that it is the art project that they have liked best or found the most meaningful. I have had students stop me in the hall, two or three years later, to remind me of the project we did together. The physicality of working with their hands, using and refining their visual skills, combined with the fact that the work reflects their own concerns and interests, serves to engrave this experience in their memories. Whatever level of language skills they began with, they improve, and whatever their capacity to understand or express themselves in English, they remember their art project for its relevance to their own experiences and for its dynamic quality.

Not only do my students best remember the classes in which we worked on our art, I also find that these are the classes and students I remember best, well after the course has ended. This is partly due to the

visceral quality of the experience, to the amount of physical activity and emotional investment involved. It is also due to the genuine collaborative nature of the classroom experience, where we all, students and teacher, have to function as an organic unit, to choose and execute the project in the best way possible. The classes I have conducted, which include this art component, feel alive and connected to the world.

There have been times when it was a struggle, when there was need for a great deal of compromise, when it seemed as though we would never finish the project, or that it would not hold together. These difficulties parallel the challenges that my students face every day of their lives here. There are moments of frustration—when the students do not function as an organized group, for example, or when I fail to reach a particular student whose limited English language skills and culture shock are overwhelmingly incapacitating for him or her. But my overall experience is that doing these art projects helps my students define their own experiences and express their feelings in a constructive and self-affirming way. They do not have a sophisticated vocabulary with which to express their ideas, but they charge their work with honesty and genuine enthusiasm.

Working on these projects has helped me open myself up to many types of art and ideas, and has forced me, both as a teacher and as an individual, to throw away my complacency and reassess the notions of value and aesthetics that are part of the established standards of mainstream American culture. I have seen the joy of discovery as well as the pain of disclosure in my students' work, and I hope to experience these same emotions as I continue to explore with them. And, finally, I hope that what they see and do in this class will help them be more open, more tolerant, and more reflective both inside and outside of the classroom.

Chapter 4:

Teaching Students the Way They Learn

The current debate on multiculturalism in America's public schools runs the gamut from issues of culturally inclusive textbooks to Afrocentric curriculum. Whatever the model, there is no doubt that there is a cultural classroom revolution taking place. The greatest wave of immigration since the turn of the century, accompanied by escalating birth rate, has brought a diversity of language, culture, race, and class never before seen in this country. The school has become the front line in this demographic revolution. Consequently, we as teachers have to be even more flexible and ready to innovate in response to changing student needs.

Amalia Mesa-Bains

Beginning with the civil rights era of court-ordered desegregation, human relations training, and the move to cultural celebration models of holidays and customs, we have struggled to find ways of teaching to reach the diversity of our students. Often, we have watched education aimed at cultural awareness and sensitivity fail to provide essential links to instructional content, curriculum, and classroom practices.

While earlier multicultural models of instruction and curriculum simply filled in "color" (i.e. minority information), more recent approaches promote a deeper change. Educators have begun to reconsider some of our more traditional approaches to instruction and curriculum. In times of dramatic cultural change and economic scarcity we must work even harder to provide connections between home and school, community and institution. In this essay I hope to show how the arts can build bridges between the cultural backgrounds and resources of our students and their full participation in learning in order to create an enriching classroom environment for all students.

Instruction and Connected Learning

When we begin to examine how learning takes place in our classrooms, we often realize how much our instructional practices rest on our routine interactions with students. It is often in this personal interaction that we create

receptivity or resistance in our students. At the same time, we struggle as teachers with an increasingly complex system of expectations with textbook adoption cycles, state subject area frameworks, and the new demands of diversity and inclusiveness in the resource materials that we use. We must begin to look at how even our basic means of teaching—lesson planning, presenting information, and involving students in learning—can be changed to reach all of our learners.

Much recent research[1] underscores the elements that contribute to a supportive classroom environment for increasingly diverse learners. The teacher's respect for cultural differences, belief in the learner, and knowing and valuing the cultural resources students bring to class are significant elements. But perhaps the most challenging task of all is the bridging of instructional content, materials, and methods with the cultural backgrounds of the students in our classes. Adolescence offers us either tremendous problems or opportunities, depending on our classroom practices. Recognizing the cultural resources and experiences students bring to the classroom and connecting these resources and experiences to our instructional material is key.

The equation EXPERIENCE + TEXT = MEANING refers to the importance of knowing your students and drawing relationships between their life knowledge and the text you are about to introduce. Whether it be a lesson, a book, a film, or a work of art, your "text" must be related to your students' experience in order for meaning to take hold.

We can make use of the experiences of students by introducing activities before the main lesson that can help make students conscious of what they already know about the topic. Setting the stage from their own life experience can lessen the hesitancy students have about new knowledge. For example, in introducing a lesson on Puerto Rico we might find out what students already know about the island or a Puerto Rican barrio in their city, or what they know about Puerto Rico's status as a U.S. territory. Then we might present the work of Juan Sánchez or Marina Gutierrez, which explores the relationship between Puerto Rico and the mainland U.S.

Second Language Support

A growing part of the diversity we must address are the needs of language minority students. As funding for bilingual programs is cut, teachers must

increasingly teach students who are not fluent in English. Acquiring new skills for working with limited English speaking students is a priority, but understanding the complexity of student situations is also crucial. A disproportionate number of at-risk students are language minority students as well. These limited-English speakers often fall behind academically and lose the expectation of achievement. As newcomers they struggle with a sense of cultural difference reflected in social isolation. Our students must cope with the stress of immigration as they try to adapt to their new social and school setting. They are trying to learn both a new language and a new culture at the same time.

English dominant language minority students (EDLM) are often second-generation immigrant youngsters who have mastered neither English nor retained their first language. Unlike newcomers they are unable to qualify for bilingual services even though they face difficulties in learning.

Our new immigrants, U.S.-born with limited English proficiency and English dominant language minority students, need special strategies to make the most of their learning. Even while our students are trying to acquire English as a second language, their own native language and cultural experiences remain important in maintaining their sense of who they are. Creating classrooms that refer to their experiences through curriculum and materials is vital. Art education offers a visually stimulating, sometimes nonverbal opportunity for learning. For students who are limited in their English language skills, the introduction of art can lead to rewarding and effective learning experiences.

The emphasis on visual supports, such as classroom symbols for activities, picture files, and audio-visual activities, are all part of creating a visually dense environment that can provide supportive cues for students. The use of culturally relevant images and references also signals to students that they are important to you and to society. The use of materials that reflect the students' community life creates a sense of connection, increases interest and provides students with knowledge about each other.

Making a place for youth culture is a form of multiculturalism and should not be ignored in school life. Our immigrant students often experience a bicultural world in which they struggle to integrate new social beliefs with the cultural values of their families. The tremendous phenomenon of youth culture—MTV, BET, hair styles, fashion, language, and social

Rigoberto Torres
Julio, Jose, Junito, 1991
Oil on fiberglass
105" × 26" × 9 1/2"

behaviors can often be more significant than the traditional idea of culture we have come to expect from multicultural curriculum. Ironically, the influence of black culture through rap, dance style, social language, and fashion affects all students despite the continued prevalence of racial conflicts between groups. These common youth experiences can be used as a link between students of different backgrounds, and as example of cultural expressions that are connected to diverse cultural histories and traditions. All of these can be integrated into lessons which provide the new immigrant with some ways to belong in a new social world.

Attention to grouping can also help immigrant students socially and linguistically. Pairing, buddying, group rapping, role playing, and consistent daily bridging can help prepare students for lessons. When working with limited-English speaking students it is extremely important to support key vocabulary and concepts with visual material or to buddy them with fluent English speakers to prepare them for lessons.

Culture and the Curriculum

As we look at the ways in which communication and culture affect learning we also have to consider the social and historical realities of different cultural groups. Our struggle to bring together our teaching and learning to respond to specific cultural groups and their ways of learning means we have to begin to understand the experiences and histories of these cultural groups.

The shrinking of economic opportunities has served as a lightning rod, contributing to new tensions between various groups. For example, the perception of Asian Americans as high-achieving members of a "model minority" masks both the history of racist anti-Asian violence in the U.S. and the incidence of poverty among Asians, as well as the complexity of differences between Chinese, Japanese, Korean, new Southeast Asian immigrants and other groups. American Indian groups have been profoundly affected by the historic government practices of resettlement onto reservations, isolated schooling, family separation, and language prohibition. The alarming rate of teenage suicide among American Indians is a grave indicator of the failed educational system. The disproportionate representation of blacks and Latinos in the dropout statistics is an indication of the historic disenfranchisement of their communities.

Understanding the motivations, expectations, hopes, and relative social status of different groups is an important concept. Making some of these distinctions helps us to look at some of the motivations and situations, even the aspirations of our students. Anthropologist John Ogbu[2] distinguishes between "voluntary" and "involuntary minorities" depending on whether the group's presence in this country was by choice. Ogbu describes American Indians, blacks, Chicanos, and Puerto Ricans as "involuntary minorities" whose experiences include slavery, internal colonization, extermination, and reservations. "Voluntary minorities" include those who flee extreme economic hardship and whose immigration may have historically been beset by indentured servitude, but who at the present time come by choice, however stressful the circumstances. Recognizing the effects of racism is essential to understanding the view different groups may hold of education. If we can begin by recognizing some of the conditions and needs of different groups of students we can begin to make our teaching more relevant.

However, looking at the circumstances of particular cultural groups must always be applied with awareness to the complexities of region, class, and generation. For example, the term "Hispanic" has contributed, unfortunately, to a vague blending of what are the distinct experiences of Chicanos, Caribbean Latinos (including Cubans, Dominicans, and Puerto Ricans), Central Americans and South Americans. General knowledge can turn into stereotypes if it is not applied with an eye to individual differences and generational factors.

Cross-Cultural Curriculum
Differences in time and space, physicality, language, and communication affect the way students enter school, the way they are received there, and the ways in which they learn. How we receive students from diverse communities and how we learn from them has been largely ignored because we have come to think of differences as a problem, not as a resource. The challenge now is to integrate the knowledge that diversity is a strength into curriculum that will move beyond token multiculturalism. So many of our curricular approaches have been content to rely on a holiday mode of history or celebration. But the complexity of the urban setting demands that we move past this model. Many of our multicultural education models

were based on early civil rights goals and nationalist concerns which justifiably focused on racism, stereotypes, and discrimination, but have also promoted integrationist models of race relations based on binary center/margin frameworks. We must now begin to take into account the new urban demographics. Major city school districts are no longer "white" and "minority," but are, in fact, composed of multiple minorities or what are now termed "new urban majorities."

Since schools are at the forefront of this new situation of cross-culturalism we must consider the implications for intercultural teaching. To build intercultural bridges we have to be alert to the possibility of new racism between Asians and blacks or blacks and Latinos and so on. Developing an intercultural curriculum that is rich with the unique contributions and shared histories of many groups is no easy feat. For black youths to understand how racism and discrimination affects groups other than their own is an important intercultural lesson. Conversely, helping all students, including new immigrants, to understand and appreciate African American history and culture is a significant goal for an intercultural curriculum. Becoming knowledgeable about the traditions, values, and languages of diverse cultures is important to the contemporary curriculum.

We can provide multiple viewpoints by using materials produced by community-based organizations, contemporary literature, popular media, and the incorporation of the students' own experiences. Even as the controversy over culturally relevant textbooks continues, teachers are collecting and developing materials to broaden the curriculum. For example, the Portland School District's African American Baseline Essays provide foundational essays in art, music, science, math, history, and social studies. The Rochester City School District produced a social studies curriculum series on Puerto Rico, the Dominican Republic, and Cuba. The vigorous response of American Indian and Chicano communities to the Quincentennial has generated materials which challenge the accepted Columbus "discovery" premise and provide new information on the demographics of the Americas at the time of the Spanish Invasion. New scholarship across the field of history is beginning to produce more inclusive perspectives that can be applied to our own curricula for schools. This book provides another approach to culturally inclusive curriculum.

Multiple Aesthetics

Changing the arts curriculum is easier with the active participation of artists whose experiences are intercultural. The acute lack of teachers of color to serve as symbols of potential for young students makes the role of artists of color even more critical; their very presence serves as a model of intercultural value. As art practitioners these artists bring a living cultural aesthetic to the classroom.

The debates over artist as teacher often fail to recognize that in many non-Western traditions, artists are scholars and community models. Artists of all backgrounds have long been advocates, activists, and scholars in cultural advocacy movements, ethnic studies programs, and community cultural centers, and have worked to make systemic changes in schools and community institutions. In this sense, these artists serve as the connectors from community to school to arts institutions. Artists also function as connectors with the international arts communities in the countries of origin for many of our immigrant students. Many have had long careers in cross-cultural art networks both in the U.S. and as part of larger global communities of Latin America, Africa, and the Pacific Rim. The artists' statements in this book attest to the social responsibility of artists. Art that has come out of the struggle for better living conditions is art that speaks of history, human condition, and hopefulness. Its form and content reflects a multiplicity of aesthetics that can be woven through an integrated curriculum.

In the work of David Avalos, and in my own work, there are references to both Chicano visual culture and the political movement for human rights, better education, fair labor practices, and issues of identity. Masami Teraoka's *AIDS Series/Vaccine Day Celebration* is a complex interweaving of the traditional wood-block printing technique historically associated with the Japanese nineteenth-century "Floating World," or subculture, of prostitutes, gambling, and drugs. This use of a traditional form to speak of a contemporary issue in a work which depicts a strikingly Anglo-American subject facing a classic Japanese male figure is open to many areas of meaning. Japanese literature from the age of the Floating World, contemporary health concerns around AIDS, the history of United States-Japan relations, classical Japanese music (the female subject plays the

samisen), and even classical Japanese dance-drama (Noh, Kabuki) are all interrelated interdisciplinary areas of learning.

When we talk about an aesthetic perception or value, we are not talking about superficial categories but about experience layered through time and aesthetic values deep in meaning and rooted in regional, topographical, and material realities. The case of the multiple aesthetic, in some ways, allows us more flexibility in using arts materials across disciplines by linking social content, aesthetic form, and cultural meaning.

When we begin with an art education application that is based on multiple aesthetics we simply give ourselves more opportunities to teach and more opportunities for our students to learn. Diversity is an unfolding reality. We are only now becoming comfortable with diversity. The resources we bring to bear and the craft we apply as teachers will make this "becoming" an opportunity, not a problem. The classroom is our cosmos and we are learning a new cosmology that will help us establish what the philosophy of this universe entails. New phenomena, new elements of understanding are before us and all learning in this new universe is possible.

Notes

1. Villegas, Ann Maria, Educational Testing Service, 1991. *Culturally Responsive Pedagogy for the 1990s and Beyond.*
2. Ogbu, John U., "Minority Status and Schooling in Plural Societies," *Comparative Education Review,* vol. 27, no. 2 (June 1993): 168–190.

Chapter 5:

The Texture of Memory: Historical Process and Contemporary Art

Each culture has its own version of how we came to be on the earth. My own people, the Cherokee, believe we were born out of the body of Corn Mother, who cut her body for us; corn to feed the people was also born out of her body. When we see an ear of corn, we remember how we came to be and who brought us here. The Iroquois story calls upon us to be born out of the Great White Pine Tree of Peace, the tree that grew in the mud on the back of Grandmother Turtle, with all of her clan creatures in the branches of the tree. It is very comforting to know where I came from, to know that Corn Mother gave me birth. It is also very comforting to believe that god took seven days to create the earth. We all like our systems. But if our systems are impervious to other possibilities, we become trapped in a very limited world.

No matter how much historians say that history is simply the process of observing objective reality, in fact it is a process of observing and documenting all sorts of realities, none of which are ever wholly objective. They are the collective reflections of people who are in the middle of the experience. Art lives to let us have different versions of vision and imagination, different versions of who we are, where we come from, where we are going, and what we might be.

Why are we reluctant to admit different views of reality? What harms us about multiple versions of the same historical moment? How will we ever know how many doors are open to us if we cannot even see those doors? When do you stop wanting to know? When do you stop reading? Competing versions of history are about power and who owns history—who owns the version that gets put in the books, who owns the version that gets put on the evening news, who owns the version that gets taught in the schools.

There are people who deny that the Holocaust ever existed, deny that anybody died on the Trail of Tears or during removal. There are versions of history that say thousands of settlers were massacred by Indians during

Rayna Green

the nineteenth century as they went west. There is a Thanksgiving story in which good Indians helped nice Pilgrims survive the winter. If you believe this story, then you are going to continue to have Thanksgiving celebrations in schools in which everybody wears feathers and makes Pilgrim hats and holds hands and pretends that something happened in 1620 which did not.

Schools should be places where students can explore the full range of historical realities, where they can bring the whole of their experience and imagination. How is it possible to create this kind of learning? I think it is possible only if we are willing to have a curriculum that says everyone has the potential to understand, and everyone brings meaningful experiences to the classroom. If we say, for example, that art can only be made out of marble or that art is only the experience of things very wealthy people can ever see, then it is not possible. Who says that marble is the most noble of materials, and not pieces of cast metal from car parts and mufflers? Is marble the tool with which we enter universal consciousness? Mud may be a more universal tool. Isn't mud the basic material of the earth? If we have a curriculum which says art can and is made out of what you know—whether it's your past, your people's past, or even an imaginative projection of the future—then it is possible to explore a range of historical realities. Somebody, somewhere, has taken your street and the things you see every day and made art out of it. You, too, can create that vision.

I think that multicultural education means looking at the possibilities for locating identity and experience in different ways. For example, native art is coming from a particular base and a particular kind of community—or communities—with a core of shared experience. But those same people who at one moment are called Indian artists could just as well be called environmental artists. It depends on the cut you are looking for. There are many ways in which we all cross paths. I am certainly an American Indian, but I am also a German Jew. I grew up in a household in which my relatives spoke German. I am not untouched by growing up in a world that was white in all kinds of ways—Czech and German in Texas, Southern white, mountain white, Texas cowboy white, whites of different religions. The diversity of white is staggering, although most people won't admit it. I think we must let those possibilities come forward as well.

Educators' Perspectives

When people choose to identify themselves in terms of a specific aspect of their identity, I think they do so because it is often the strongest part of their experience. Often, the aspect of identity that leaps out is the one you have been most punished for, the most assailed part of your identity, and the one most singled out by others. It may also be the one that you are in most need of exploring.

In my younger life I was more punished for being Indian; in my middle life I was much more punished for being a woman. In my academic and professional life, I was punished for being a Westerner by Easterners who taught their standards of how one should speak, dress, and act. During these various stages in my life I have become more militantly aggressive about different parts of myself, depending on which aspect was being assaulted or which aspect I needed to pay most attention to. I kept my regional accent, perhaps, as a form of protest against Eastern dominance. I explored and wrote a lot about the female part of my identity at the time when my role as a woman was questioned more than my ethnicity or my regionality. I constantly explore the Indian part of myself because it won't go away; it is the thing that calls most loudly and most often because it is a historical voice, a voice about presence and identity.

I am afraid that the word "multicultural" is often used to talk about brown people, and not about everybody who inhabits this increasingly frail planet. "Culture is what little brown people have. Culture is not what we of the academy have." I think a truly multicultural universe would take into account a whole range of ways of being so that people are not pigeonholed into the narrowest sense of being.

I think the reason multiculturalism frightens people—if they really take it seriously—is because it opens up the world and cracks its shell in ways that are perhaps too extensive, too frightening. If we maintain stereotypes, the world is narrowed in a way that seems to make it comprehensible, graspable, smaller. To take the concept of multiculturalism seriously is to shatter that shell and begin to explore reality in very different ways.

Anthropology has often defined ethnicity and culture in very static terms. Museums do this, too. We take a piece of people's lives and we spray it and mount it forever. You can go to the Natural History Museum and see people of color fixed in space and time. Many people still have a romanticized view of Indians. They think Indians should be packing horses

James Luna
Take a Picture with an Indian, 1991
Polaroid photographs, three life-size photographic cutouts, and signage
Dimensions variable

to Gallup, New Mexico, rather than driving pick-up trucks to town. These people bemoan the world they have created and want others to stay fixed in time and space, sweet and innocent. White people change. They grow and they move. They don't get sprayed and mounted. Why do white folks get to move through culture and history, whereas others are seen as bound by it? Perhaps a solution is to put a twentieth-century blond American carrying a briefcase in the display case, too.

James Luna's performance works comment on this contradiction. During his pieces Luna literally changes from somebody wearing a loincloth to somebody wearing a three-piece suit. He moves from living in a world that once had trees and water, to living in a world that is surrounded in barbed wire, to living in a world that is condo-ized. It is extraordinary that in a twenty-minute performance piece we can move through four centuries of history, all still going on, all still going forward. It is very much an Indian experience, yes, but it's also the experience of worlds of people who have been stripped of their homes, identities, names, gods, and religion.

There are many people like Luna who are deeply responsive to the world around them. American Indians often frame that responsiveness in Indian terms, although they are commenting on a much larger world. When Richard Ray Whitman photographs Indian homeless people in Oklahoma City, Tulsa, and Ponca City, he's placing their situation in a much larger context of an Indian homelessness which is historic. Our people have been driven to homelessness; we are not just homeless today, that is, without a dwelling, in Oklahoma City. We are not without a dwelling because we are winos, or mothers in poverty without jobs, without any forwarding address. We are historically homeless since our dispossession which began five hundred years ago. It is a short historical context; five hundred years is like the blinking of an eye in the context of history. But in placing these marvelous photographs of Indian homeless in present-day Tulsa and Oklahoma City, Whitman is saying that the problem of homelessness and rootlessness and no forwarding address will not be solved by taking a few people off the street and providing a dwelling for them. There is a longer historical context with something more at stake, and through his art Whitman is projecting the Indian situation into the future.

Educators' Perspectives

Jean LaMarr's prints explore nineteenth- and twentieth-century American Indian experience of imprisonment, the experience of loss of land, the experience of near-loss of people—extermination—the threat of complete historical loss. LaMarr begins to put these issues into a contemporary context. She puts her figures in missile fields—once again, a way of taking the land and fencing it off into places that do not feed but kill people—MX missile fields in the middle of the Shoshone reservation in Nevada. LaMarr shows us the Shoshone people there. They are modern people now, facing techno-death.

Jean LaMarr
Some Kind of Buckaroo, 1990
Serigraph
24″ × 36″

Artists like Richard Ray Whitman, James Luna, and Jean LaMarr use their work to talk about larger-scale environments. Indians who regard themselves as keepers of this universe, whoever we are, whatever culture we come from in the Indian world, believe we have been asked to be custodians of this place. When you depend on the universe you care for it. When you depend on it to eat, when you depend on it for water, you care for it as in an intimate relationship. You pray for the universe's renewal every day; your prayers are essential to its renewal. Many artists are exploring the terror that comes when the whole natural universe is under siege, is assaulted, and begins to collapse around us. You see, Indians think of themselves as just another piece of the environment. We—along with animals, spirits, the rest of the earth—are simply part of the whole environment. And when the environment is threatened, we too are vulnerable, we too are threatened.

Indian art has always talked about the destruction of land. Land is what feeds you. Land is what nurtures you. Land is your Mother. And your Mother can tolerate just so much of this assault. Therefore, even if we look at the work of these artists as evocations of an actual contemporary historical moment—for example, the siting of MX missile bases on Indian reservations—we can also look at them as explorations of other moments in history and the ways in which Indian people have reacted to them. This is what specific history is about: letting art act for us and letting ourselves act through art to create our own powerful and indisputable version of historical truth.

I am not interested in people's ability to generate a list of famous artists or repeat back the characteristics of French Renaissance painting. I can tell you what the various art heresies were in the late nineteenth and early

twentieth centuries, I can recite Picasso's various periods—and it doesn't mean a damn thing. But to be able to experience works of art, to be able to move continually through process and understanding, through texture— the texture of memory, the texture of imagination, the texture of speculation—is to open up learning instead of closing it off. I am not suggesting we throw Michelangelo out; I am just putting Jimmie Durham in. To have a history, to be something, to fight homogenization, is threatening to the status quo. But homogenization is an easy out. Homogenization has not worked for the last five hundred years, and it will not work for the next five hundred.

Chapter 6:

A Message for Youth

As we move into the twenty-first century and are confronted with problems such as racism, poverty, AIDS, and crime, most young people in our society do not know about movements that are going on right now to end these problems.

When young people learn about art, they learn about DaVinci or Botticelli. These artists are important but they do not suffice for representing life in the present. Not many high school students know about contemporary art. It should be known by every student that there are thousands of people out there trying to better our society—now and for future generations to come—through their artwork. Many voices go unheard, many lives vanish without a thought, people go unseen and unjustified. The messages of art become information, remembrance, resolution, and stories untold. History becomes a part of the future and present. The "norm" becomes the "odd" and lives change. These are the reasons why artists and art are important.

As I read the statements from various contemporary artists (see Part 3), I learned a lot about the languages and expressions of today's artists—how they feel, what they feel, and why they create art. I also learned that there is more to art than just sculptures and paintings. By recognizing art as something positive and thought provoking, students can create their own art as well as relate to other works of art. Through photos, sounds, images, words, and other forms of expression we can begin to see other people, countries, struggles, opinions, and ideas.

Society often portrays artists as "out of this world," hippie types, but I have found this to be unfair stereotyping. I feel that the motivations of contemporary artists are understandable and dignified. I have learned about what art means today: it means knowledge, courage and love—things that everyone can relate to. It doesn't just take good technique or a great sculpting hand to be an artist in our society today. It takes a great deal of love for others and, most of all, compassion.

Raphaela Francis

Part 2:

Artists' Works

Artists' Works: Introduction

This chapter presents works by artists of all ages and many different backgrounds who currently live in the United States. The process of selecting artists for this book was a difficult one. There is no group of fifty or one hundred artists who could adequately represent the range of contemporary art produced in the United States, nor was this our intention. Instead, we focused on art that suggests the variability of the "American" experience as individuals negotiate their relationship to various communities—local, national and global.

In consultation with a varied group of art education professionals and artists, we selected a group of approximately fifty artists, including five collaborative groups. The subject matter of much of the art was chosen with a heavier emphasis on urban than rural life, although the group as a whole includes artists who live in many regions of the United States. Although cultural identity is an important element in many of the artists' statements many other aspects of identity are addressed, including: gender, geographic home, education, age and socio-economic status. Depending on the circumstance, we may identify ourselves through our job, our religion, as parents, or as children—categories change throughout our lives, yet serve to identify us in important ways, some relating directly to our ethnicity and others not. In choosing which works by each artist or group to include we took several factors into account:

1. We selected works we felt would be comprehensible and of interest to high school students;

2. We attempted to balance subject matter in the overall selection (i.e. we did not want a disproportionate number of works on any single theme);

3. We selected works that are readable in reproduction, and favored those which lend themselves for project models;

4. We tried to select works which are representative of the artist's overall concerns.

We aimed to choose art that addresses issues of importance to young people. Much of the art examines the history of the United States from "unofficial" or not often emphasized perspectives. Other works explore women's and men's changing roles, the balancing and/or conflict of living in dual or multiple cultures, and issues surrounding the family. Some of the art can be called activist and explicitly deals with issues such as AIDS, racism, homophobia, and sexism. Much of this activist art is not produced for a museum or gallery setting, but is intended for a mass audience, taking the form of posters, billboards, video, and other various forms of public art, including performance.

We also chose artists who take a more intimate approach. This includes artists who use self-portraits (Elizabeth Layton); loosely autobiographical narratives and storytelling (Faith Ringgold and Clarissa Sligh); or a combination of personal and public (John Ahearn and Rigoberto Torres' body casts of neighborhood residents). While encompassing a wide range of aesthetic styles, artistic aims and social issues, the art has been chosen and presented in a way that facilitates accessibility and understanding for a broad audience. To this end, a quick glance through the images will make apparent the emphasis on figurative work and the limited number of abstract works. The captions which accompany the images are the artists' own words unless otherwise indicated.

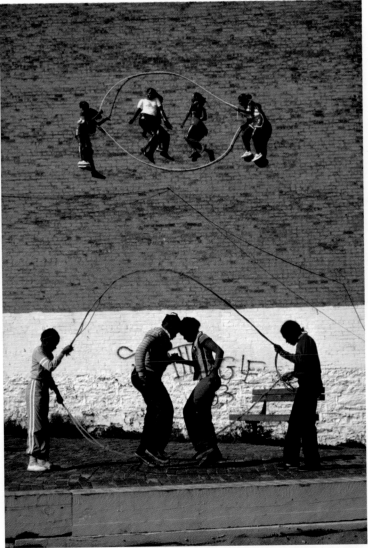

©1983 Martha Cooper

**John Ahearn and
Rigoberto Torres**

Banana Kelly Double Dutch,
1981–82
Mural, Oil on cast fiberglass
54″ × 54″ × 12″ (each figure)

Banana Kelly Double Dutch is
an outdoor relief sculpture
made in cooperation with a
local block association. The
piece, which portrays four girls
jumping rope, is located in a
site that used to be a play-
ground on the outside of the
building where the girls lived.

S.C.

Melissa Antonow

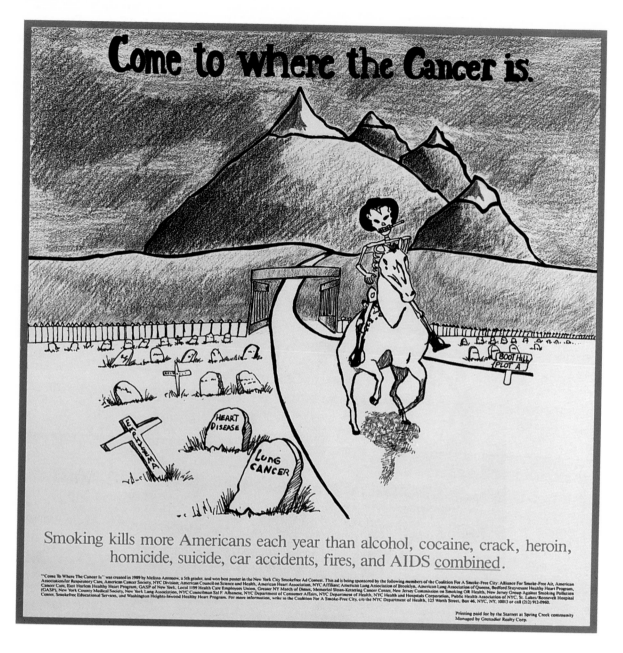

Melissa Antonow

Come to Where the Cancer Is,
1989
Subway car poster,
Advertisement: Kids Say Don't
Smoke Book
21″ × 22″

The poster *Come to Where the Cancer Is* was originally a homework assignment. The subject was chosen from a *TV Guide* advertisement for Marlboro cigarettes.

Kristine Yuki Aono
Issei, Nisei, Sansei, ... , 1990
Mixed media installation
28' × 16' × 8'6"

Issei, Nisei, Sansei, ... is a piece about acculturation and the evolution of an American subculture. It derives from the experiences of three generations of Japanese Americans. One enters the piece by walking toward the first of three doorways, each representing one generation.

The first section represents the Issei (e-say), my grandparents' generation. One removes her shoes and walks on glass over a pathway composed of raked sand with stepping stones. Traditional geta sandals are placed at the beginning of this section. At the end of the section, one passes through a shoji-paneled doorway.

The second section represents the Nisei (ne-say), my parents generation, symbolized by the years they spent in the internment camps during World War II. Beneath the glass panels the path is composed of mud. The sandals at the beginning of the section are crude, hand-made geta. At the end of this section one passes through the doorway of a tar-papered barracks.

The third section represents the Sansei (sahn-say), my generation. Under the glass are rubber flip-flops and a section of concrete sidewalk. The final doorway is flanked by a facade covered with aluminum siding. One continues walking through this doorway to an interior living room space. The main focus of this room is a large bookcase. The bookcase contains several artifacts: books about the history of Japanese Americans, photographs, and several sculptures addressing issues relating to the experiences of Japanese Americans.

Eduardo Aparicio

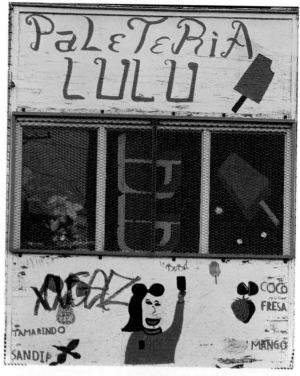

Eduardo Aparicio

La Hacienda
911 North Ashland Ave,
Chicago, 1989
Cibachrome Print
19″ × 15″

Paletería Lulu
1249 West 18th Street,
Chicago, 1989
Cibachrome Print
19″ × 15″

Rinconcito Sudamericano
2529 North Milwaukee Ave,
Chicago, 1989
Cibachrome print
19″ × 15″

These photos are from the series *Estados Unidos* which documents Latino storefronts in Chicago. The locations were deliberately chosen to cover a full range of city locations, not just those neighborhoods typically thought of as "Hispanic." Different degrees of acculturation into mainstream American society are evidenced by the mixture of Spanish and English and the predominance of one or the other language in different locations. The presence or absence of the national colors associated with the country of origin (such as the red, white, and green of the Mexican flag) indicates the degree of acculturation. The documentation of these storefronts offers a record of vernacular art.

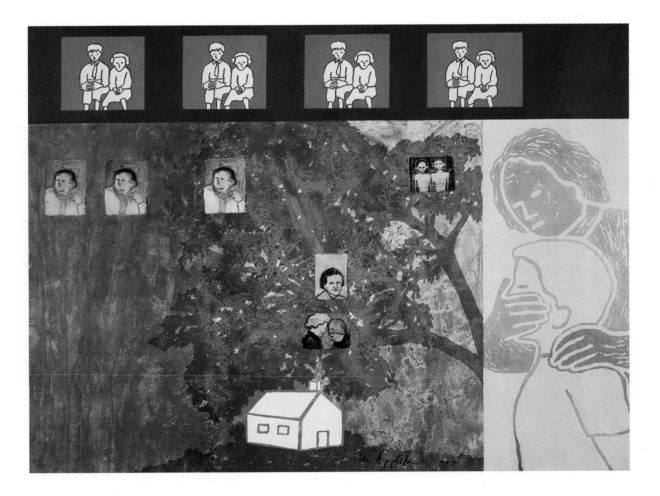

Ida Applebroog

Promise I Won't Die?, 1987
Limited edition lithograph with
linocut and hand coloring
38″ × 48″

Tomie Arai

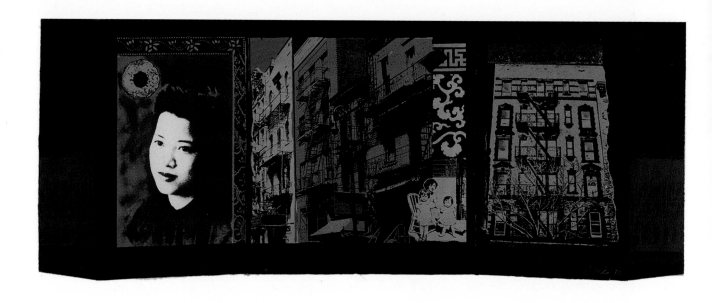

Tomie Arai

Chinatown, 1990
Silkscreen construction mixed media
22″ × 40″

My nineteen-year marriage to a second-generation Chinese American has provided me with a perspective on ways in which diverse communities of Asians share similar stories of growth and survival. In 1989 I completed a series of silk-screened prints based on the photographs and oral histories of Asian women living in New York. The stories told to me by Chinese, Korean, Japanese, Burmese, Indonesian, Southeast Asian, and Indian women became the bases for silk-screened prints that celebrate the lives of Asian American mothers and daughters.

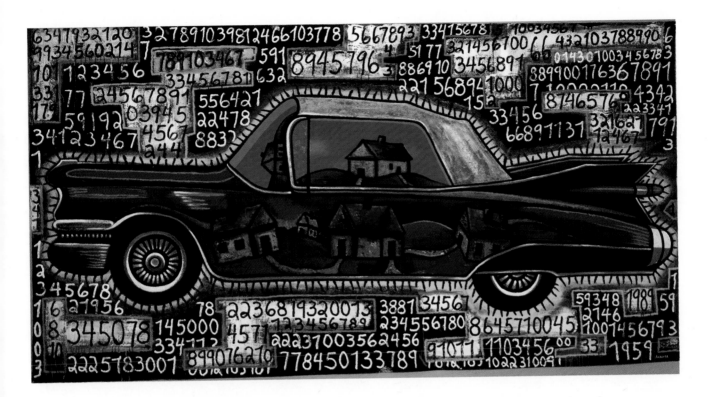

Luis Cruz Azaceta

Lotto: American Dream, 1989
Acrylic on canvas
77 1/2″ × 144″

**Today the only hope for poor
people to own their own home
is to win lotto.**

Border Art Workshop/Taller de Arte Fronterizo

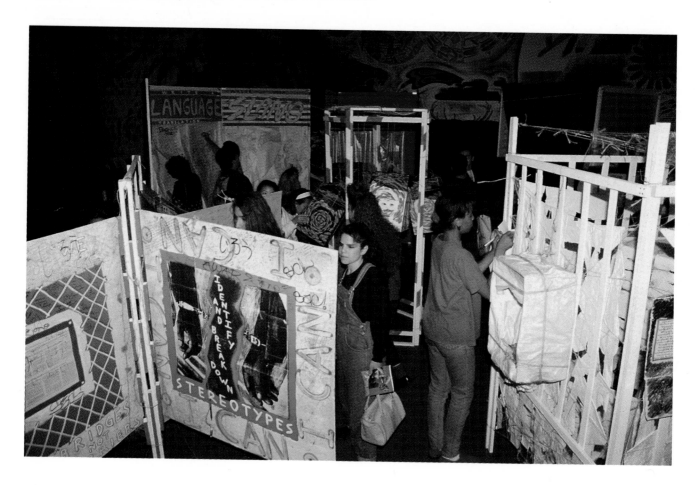

**Border Art Workshop/
Taller de Arte Fronterizo**

Whitewash(ed) Portable exhibi-
tion, 1991
San Diego High School
Students, BAW/TAF - artists

A portable exhibition that trav-
eled to San Diego high schools
and challenged students to
confront their involvement in
institutional racism.

Coqui Calderon

Marcha de Pañuelos Abriendo el Camino, 1987
Acrylic on canvas
46″ × 60″

Marcha de Pañuelos Abriendo el Camino is part of *The Winds of Rage, Panama Series, 87–89.* Most of the paintings commemorate historical events. Here people are venting their outrage during the funeral of the last elected Panamanian president. For three days, they manifested this outrage by demonstrations, outcry and waving their white scarves. The flying white scarves were the symbol of civility, a cry for justice and freedom.

Ken Chu

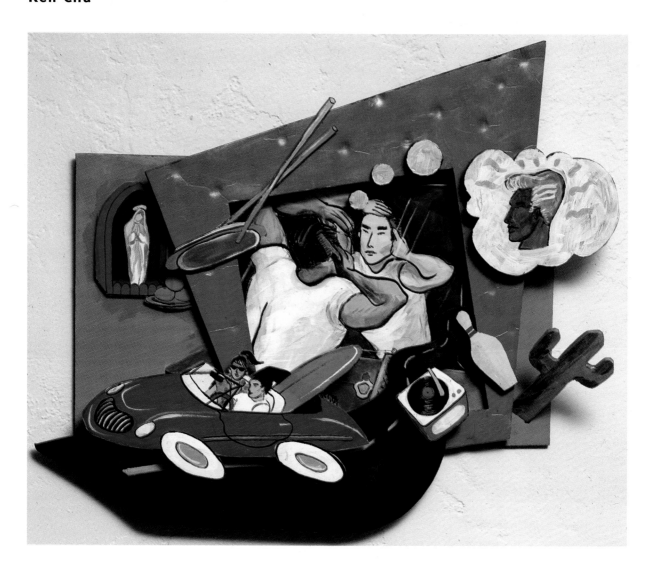

Ken Chu

I Need Some More Hair Products, 1988
Acrylic on foamcore
21″ × 25″ × 5″

For Chu, *I Need Some More Hair Products* (1988) revives memories of summers as a teenager on the West Coast. Lightly mocking a teenage longing, Chu portrays himself grooming before a mirror while perceiving himself as part of the American mainstream. His reflection is of an Asian man while in his mind he visualizes being blond and "white." The dual images present a conflict between who he sees and how he perceives himself. By surrounding this image with signs of the "good life" and pairing Asian and Western symbols— chopsticks grasping a hot dog; Buddhist offerings before a Christian shrine—Chu both suggests the successful adaptation of many Asians to American culture and their simultaneous inability to transcend the ultimate barrier to complete acceptance—not being Caucasian.
—Margo Machida, *The Decade Show: Frameworks of Identity in the 1980s* exhibition catalogue, 1990.

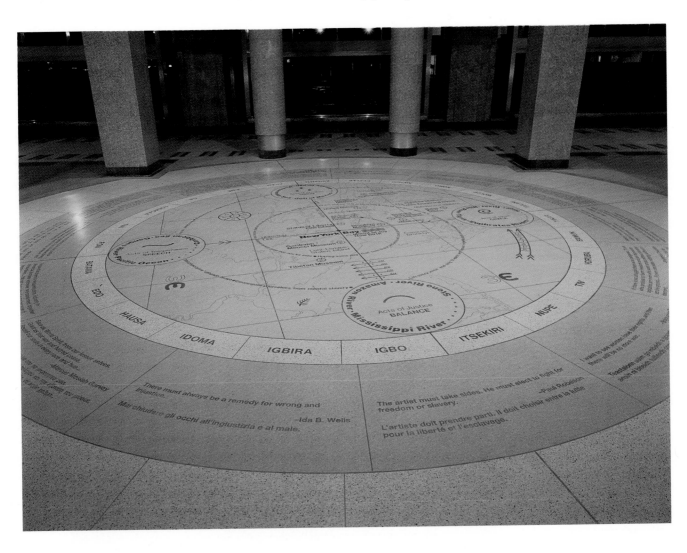

**Houston Conwill,
Joseph DePace, and
Estella Conwill Majozo**

The New Ring Shout, 1995
Illuminated polished brass and
terrazzo floor
40' diameter in 36' high rotunda

The New Ring Shout is a site-specific public art installation commemorating the eighteenth-century African Burial Ground in New York City partially excavated in 1992. The work is a tribute to thousands of Africans, Indians, and Europeans buried there. Sited in the new Federal Office Building, the work is in the tradition of world ceremonial ground markings.

The New Ring Shout is named after the historical ring shout dance celebration performed throughout North America and the Caribbean.

The floor is marked with a circular multilayered and multicultural cosmogram transposed onto a map of New York City. Its outer blue ring, signifying water, is marked with fourteen quotations by heroic men and women in English and in fourteen international languages. The horizontal axis of the cosmogram is aligned with the northernmost boundary of the six acre Burial Ground. The inner white ring holds the names of twenty-four African nations victimized by the enslavement trade.

The central earth-colored ring is marked with a collage of symbols and a multilingual spiral songline composed of lyrics from twelve songs directing a transformative journey along twelve global water sites that mark the migration of diverse cultures and peoples to New York City. It continues through fourteen significant signposts in the city's geography to the African Burial Ground.

Jimmie Durham

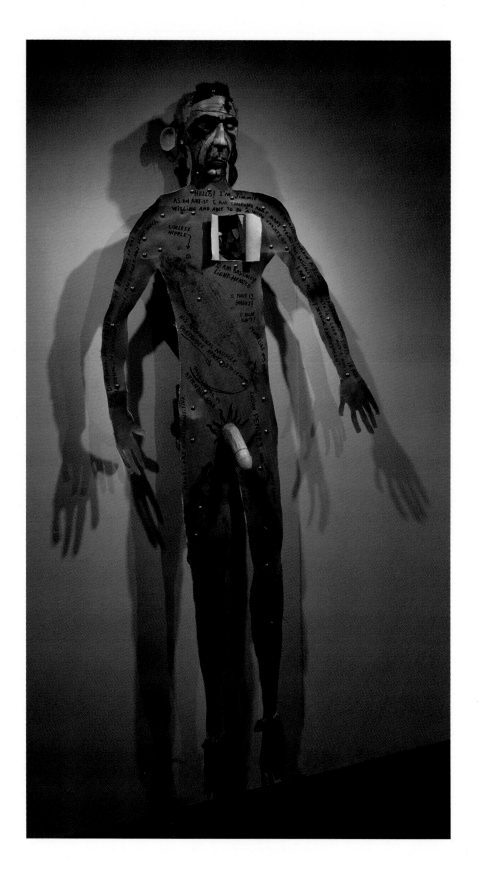

Jimmie Durham

Self Portrait, 1986
Mixed media
78″ × 32″ × 5″

Self Portrait—a flayed, full body nude, a red "skin," a hide or hiding—is a bitter and witty icon displayed on the wall. As though illustrating the dilemma of the "invented Indian," the self portrait is all surface. Durham, who has proudly called himself a "double Red," has branded a red star on his forehead, imprinted his chest and thighs with fish and his ankles with fern. He has seashells for ears, bits of animal hide hair; one turquoise eye is just to show a little "Indianness," and the feathers revealed by an open chest cavity imply a certain "light-heartedness." "I have 12 hobbies! 11 house plants! People like my poems," are among the "captions" mapping such landmarks as an appendix scar, and defiantly "large and colorful" genitals.

—Lucy R. Lippard, in *Jimmie Durham: The Bishop's Moose and the Pinkerton Men,* Exit Art exhibition catalogue, 1989.

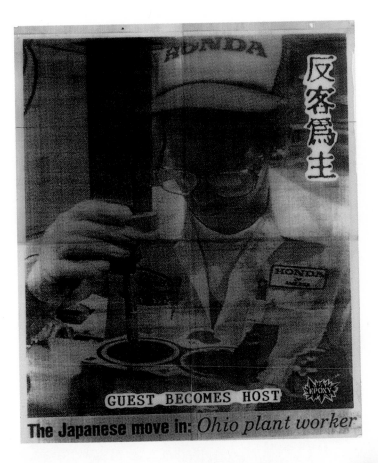

GUEST BECOMES HOST

The Japanese move in: *Ohio plant worker*

Epoxy Art Group

36 Tactics, 1988
Epoxy over Xerox
36 prints each:
22″ × 34″

36 Tactics incorporates proverbs derived from ancient military texts like Sun Tzu's *The Art of War.* Such sayings, which are part of Chinese folklore, speak to issues of political deception, confrontation, and opportunism as strategies for survival. By juxtaposing often-reproduced images from recent history and proverbs written in English as well as Chinese, Epoxy posits that traditional commentaries anticipate contemporary political machinations.
—Margo Machida in *The Decade Show: Frameworks of Identity in the 1980s,* exhibition catalogue, 1990.

Guillermo Gómez-Peña

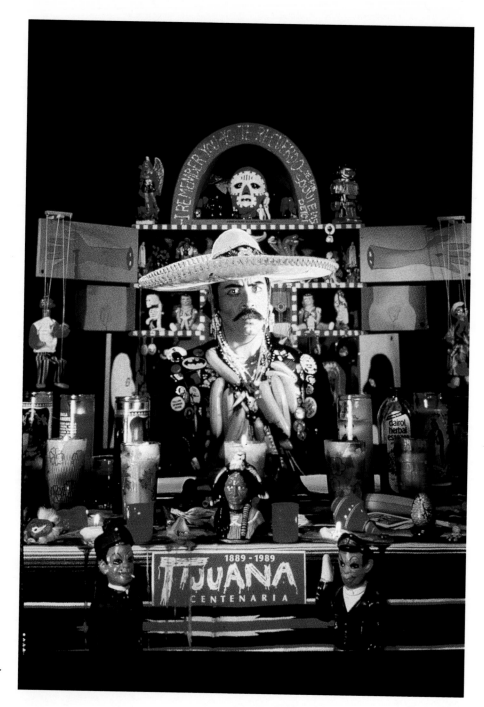

Guillermo Gómez-Peña

Border Brujo, 1989
Performance still

***Border Brujo* is a performance
piece and film about the border
experience.**

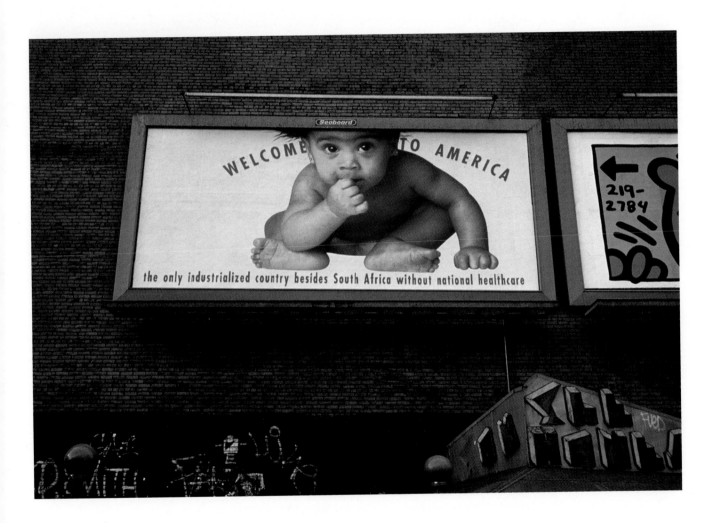

Gran Fury

Welcome to America
December 1989
Laserprinted billboard

The absence of a national
health insurance in America is
rooted in racism. The billboard
points to the plight of many
newborn children with AIDS,
88% of whom are African
American in the United States.

Group Material

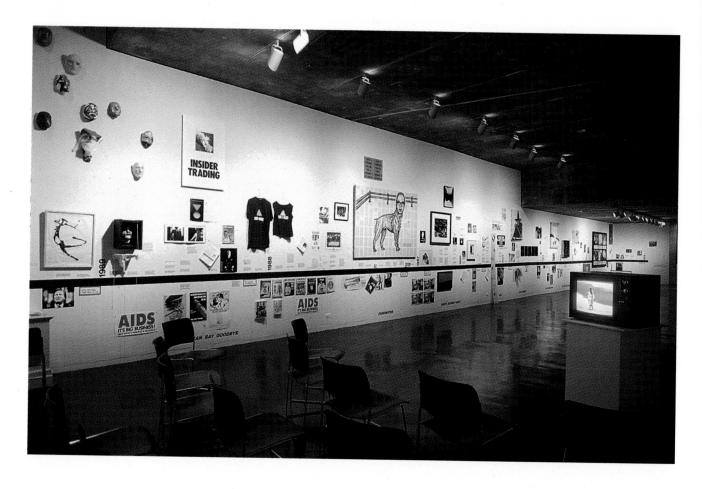

Group Material

AIDS Timeline, 1989–1990
Mixed media
Installation at the University Art
Museum, University of
California at Berkeley

The *AIDS Timeline,* a mixed-media installation by the artists' collective Group Material, reconstructs the history of AIDS as embedded within a web of cultural and political relations, primary among them the federal government's response to the syndrome. According to Group Material, the timeline 'indicts the government's inaction [on AIDS] and society's complicity in that inaction.'
—Richard Meyer, AIDS Timeline exhibition brochure, University Art Museum, 1989.

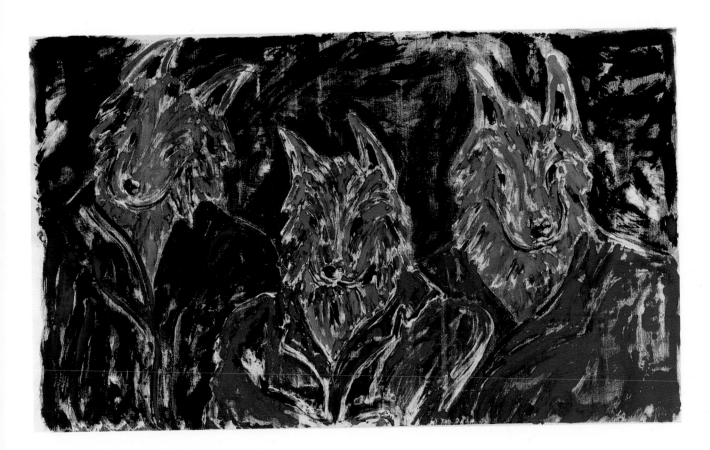

Dolores Guerrero-cruz

Clarence Thomas and Members of Senate, 1991
Mono silkscreen
35 1/2″ × 25″

Clarence Thomas and Members of Senate is part of *The Mujeres y Perros* series, which addresses the harassment of women by men. Men are depicted as red *perros* or dogs and women are portrayed in a variety of ways. Although not all men are *perros*, society still needs to develop a different attitude toward women and men need to stop looking at women as though they were merely objects.

GUERRILLA GIRLS' POP QUIZ.

Q. If February is Black History Month and March is Women's History Month, what happens the rest of the year?

A. Discrimination.

BOX 1056 Cooper Sta. NY, NY 10276 **GUERRILLA GIRLS** CONSCIENCE OF THE ART WORLD

Guerrilla Girls

Pop Quiz, 1990
Poster
17" × 22"

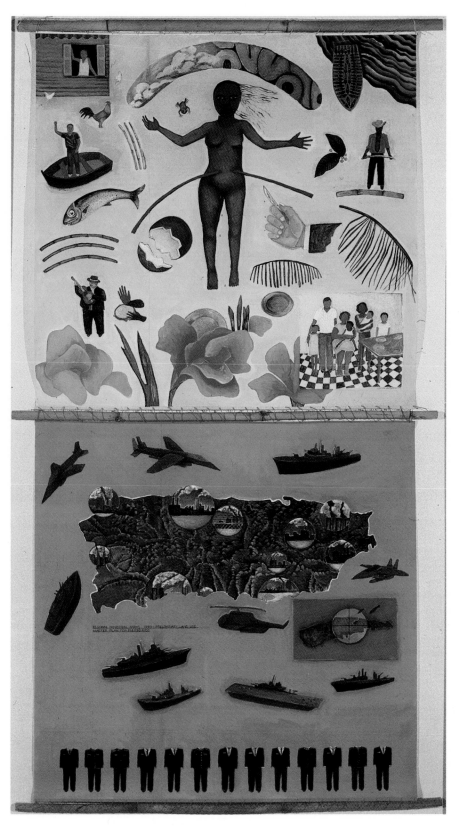

Marina Gutierrez

Isla del Encanto, 1986
Acrylic on canvas
60″ × 30″

Isla del Encanto combines archetypal and stereotypical images of Puerto Rico to evoke both historical and contemporary contexts. The visual references range from Taino carving and Goya food product labels to strategic military industrial planning maps.

David Hammons

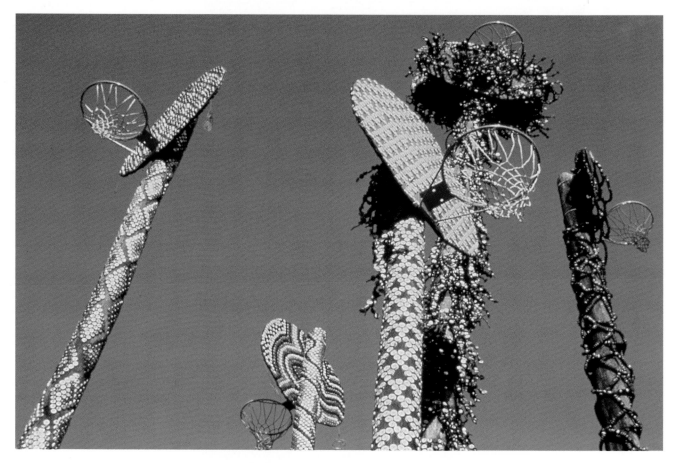

David Hammons

Higher Goals, 1990
40-foot tall basketball hoops,
bottle caps, mixed media.

**It's an antibasketball sculpture.
Basketball has become a problem in the black community
because kids are not getting an
education. They're pawns in
someone else's game. That's
why it's called *Higher Goals.* It
means you should have higher
goals in life than basketball.
—David Hammons quoted in
Sports Illustrated, December
24, 1990.**

Yolanda M. López

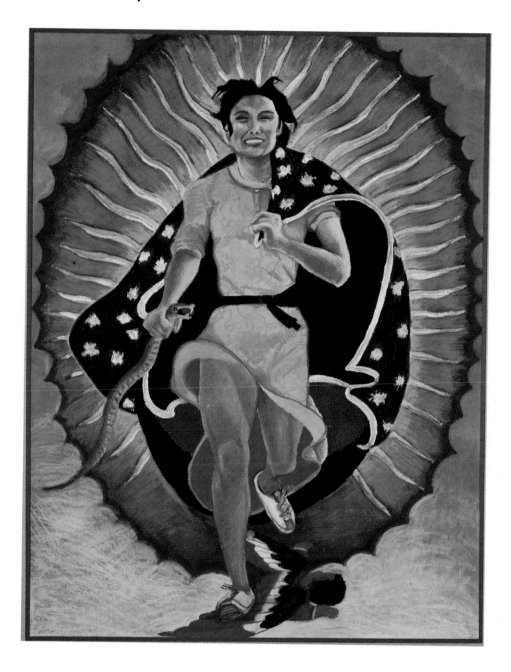

Yolanda M. López

Portrait of the Artist as the Virgin of Guadalupe, 1978
Oil pastel on paper
28″ × 32″

The *Portrait of the Artist as the Virgin of Guadalupe* series was my way of questioning a very common and potent icon of the ideal woman in Chicano culture. At a time in our history when we were looking to our past historically and culturally I wanted the Guadalupes to prompt a reconsideration of what kinds of new role models Chicanas need, and also to caution against adopting carte blanche anything simply because it is Mexican. By doing portraits of ordinary women— my mother, grandmother, and myself—I wanted to draw attention and pay homage to working-class women, old women, middle-aged over-weight women, young, exuber-ant, self-assertive women. Church groups that were offended by the work were absolutely correct. The works are also an attack on the authoritarian, patriarchal Catholic church.

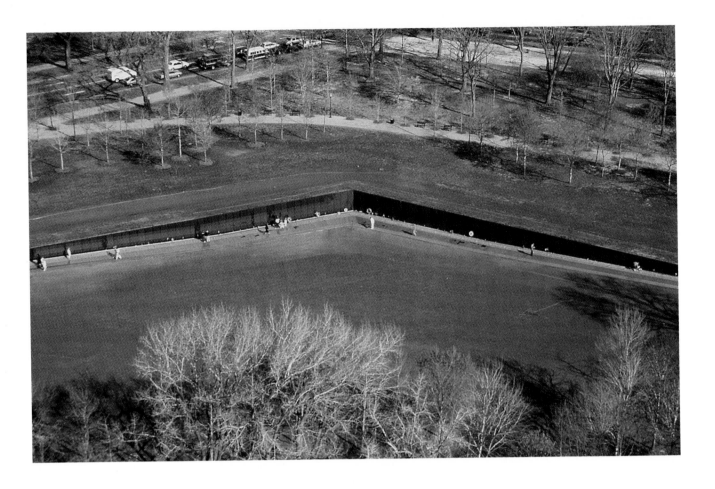

Maya Lin

Vietnam Veterans Memorial
Washington, D.C, 1982
10′ × 250′
Black granite

Located on the Mall in Washington D.C., the Vietnam Veterans Memorial consists of two polished black granite walls, 10' high and 250' long, joined in the middle at a 130 degree angle. On the wall are inscribed the names of 58,175 veterans who were casualties of the war. The names are inscribed chronologically starting in the center and continuing around both walls, with the last casualties ending up in the center again. Maya Lin's design was chosen out of 1,421 entries in an open nationwide competition initiated by the Vietnam Veteran's Memorial Fund.

Z.K.

Dinh Le

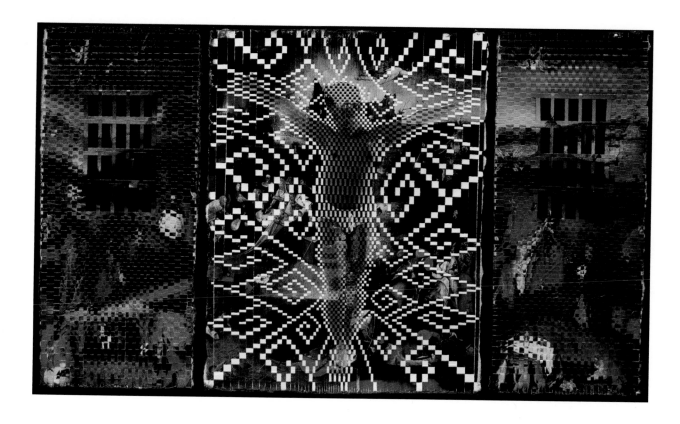

Dinh Le

Altar Piece: "The Temptation of Saint Anthony," 1991
C-print, archival and scotch tape
40″ × 57″

The tapestry is a combination of two images, a copy of a classic Christian image and a new self-portrait. The work is about the interweaving and exchanging of (East/West) cultural and psychological identities. By placing myself into this mythological image, I place myself in somebody else's mythology, somebody else's culture. By dissecting the existing mythology, I create a new mythology for my own needs.

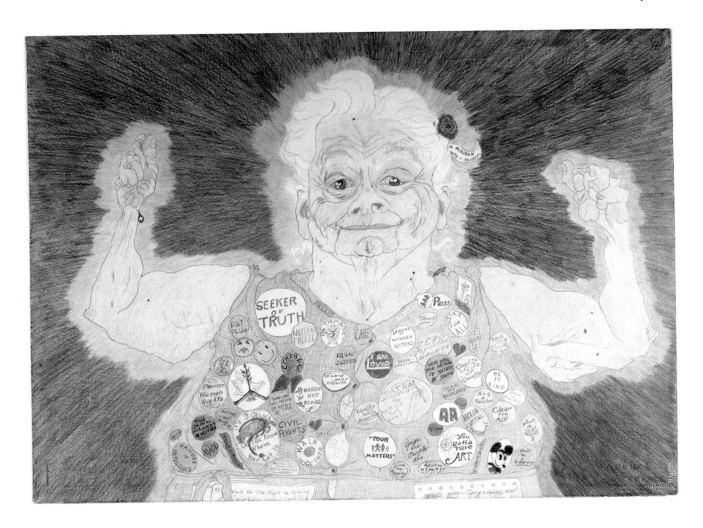

Elizabeth Layton

Her strength is in
her principles.

Buttons, 1982
Drawing: crayon, colored pencil.
22″ × 30″

Jean LaMarr

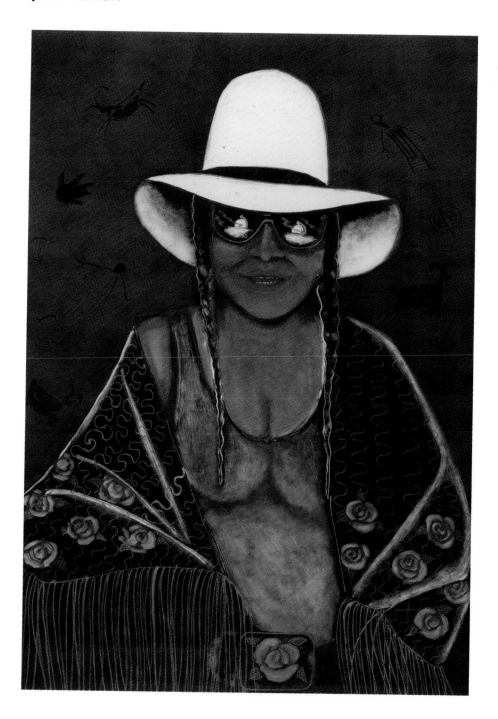

Jean LaMarr

They're Going to Dump It Where?!?, 1984
Monoprint
18″ × 24″

The image exemplifies the Indian resistance to the nuclear dumping on sacred places on Indian land. The reflection in her glasses shows Diablo Canyon Nuclear Power Plant.

Urbanized (Dave Elliot), 1973
Silver gelatin print 35mm
9 1/2″ × 6 1/2″

Born in the cities is a whole
new generation of urban
Indians, some work in the con-
crete jungle, others just barely
get by. Yet, most are very
proud and forceful in express-
ing their Indian identity. Some
other Indians put urbanized
Indians down as cultural inferi-
ors. However, I've seen urban-
ized Indians do some amazing
things in defense of Indian
people. They usually work real
hard at being involved—in fact,
they seem to really like being
Indians.

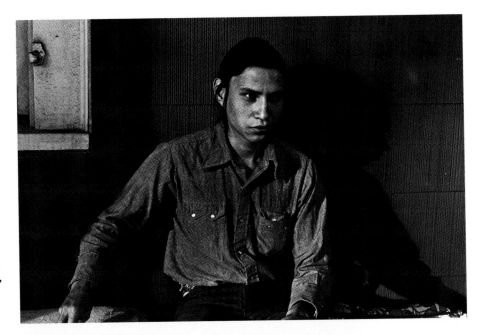

My Son Randy, 1974
Silver gelatin print 35mm
9 1/2″ × 6 1/2″

Father and Son. We confront
and console each other by a
momentary glance into each
other's feelings. My son grew
up without me, even though I
grew up because of him. It is
hard to feel like a father just
on weekends and holidays.

Women often feel that
I don't care. In my innermost
visions, I am a father, but like
I said, visions and reality are
often worlds apart.

Richard Hill

Richard Hill

*My Grandmother
(Charlotte Hill),* 1976
Silver gelatin print 35mm
9 1/2″ × 6 1/2″

Whenever I went to my grand-
mother's house in Ohsweken,
she instantly began to cook.
She would have a big meal in
minutes. She would have pies
baked, just waiting for some
hungry soul. Meals turned into
roundtable discussions on the
family. She loved her family.
She nourished our spirits. We
miss her in our lives.

My Father, My Friend, 1972
Silver gelatin print 35mm
9 1/2″ × 6 1/2″

All my white friends grew up
hating their fathers. As soon as
my friends turned eighteen,
they took off for California and
I haven't seen them since. I
went to art school with the
help and support of my father
and my grandmother. I grew up
thinking that I would be an
ironworker, just like my dad.
We both realized that my life
would lead me somewhere
else. Although my father didn't
understand the need for art at
that time, he encouraged me to
seek my artistic aspirations.
Fathers often try to relive their
lives through their children.
My father has become one of
the best artists I know, best
because he works harder at it
than I do.

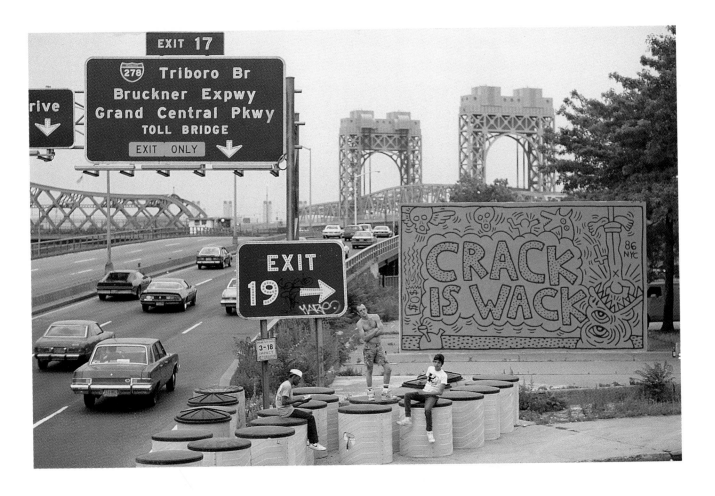

Keith Haring

Crack is Wack, 1986
Mural, industrial paint
on concrete
15′ × 30′ approx.
FDR and 128th St.,
New York City
Handball Court

The first time I did [the mural], I got arrested [for defacing public property]; the second time was commissioned [by the Parks Department]. I did it because I had always wanted to do something on that one billboard.... [V]isually it was great—right on the highway. It was done firstly just out of a desire to make some big statement against crack because of how much it was starting to affect me and the people around me. Not only from crime, but personally....

[Doctors and counselors] were really naive in the beginning about what crack addiction was.... It was phenomenal to me that there was so little awareness of what the thing even was, that there was no help. That's part of the reason I did it....
—Keith Haring, Interview with Daniel Drenger, *Columbia Art Review,* Spring 1988.

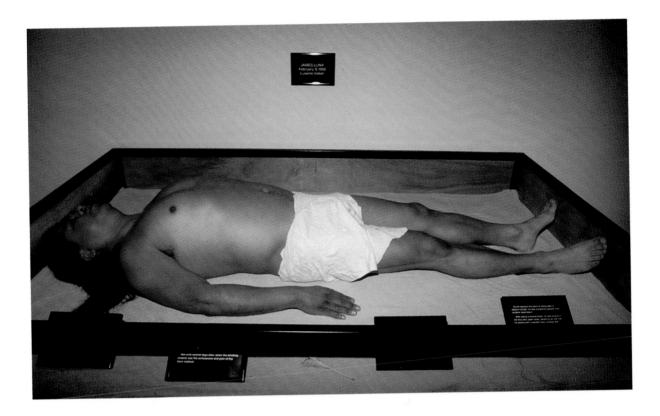

James Luna

The Artifact Piece, 1990
Performance and mixed media,
Installation shot
Dimensions variable

The Artifact Piece, was a performance/installation that questioned American Indian presentation in museums— presentation that furthered stereotype, denied the contemporary society and one that did not enable an Indian viewpoint. The exhibit, through "contemporary artifacts" of a Luiseno man, showed the similarities and differences in the cultures we live, and by putting myself on view, brought new meaning to "artifact."
—James Luna, Interview with Steve Durland in *High Performance,* Winter 1991.

Amalia Mesa-Bains

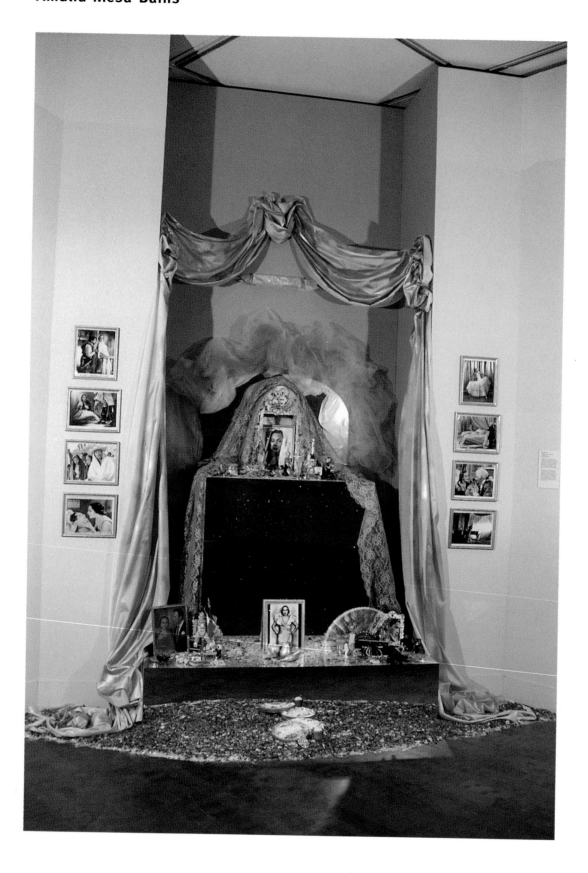

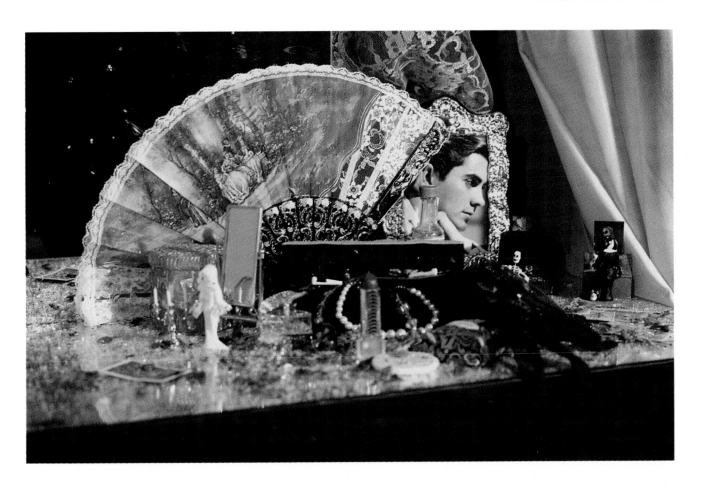

Amalia Mesa-Bains

Dolores del Rio VI, 1990
Mixed media installation
6′ × 10′ × 4′

The series of Dolores del Rio
altars (1984–1990) are
homages to both the beauty
and cultural endurance of this
legendary screen actress. This
piece is based on a woman's
vanity dresser, a home altar,
and a Day of the Dead offering.

Kay Miller

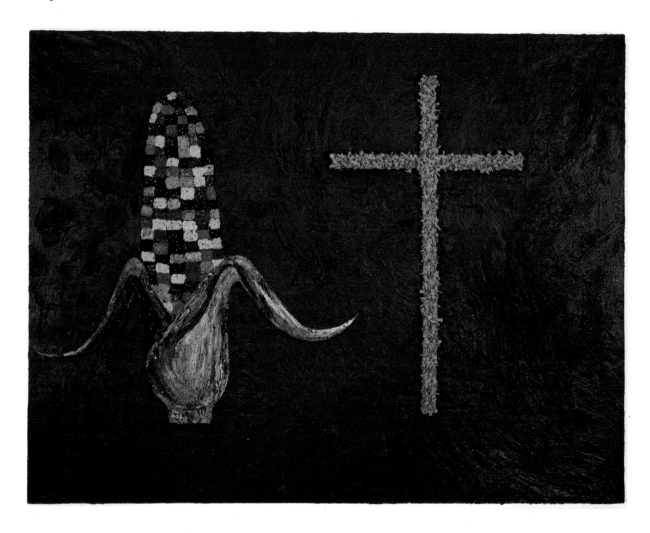

Kay Miller

Seeds, 1992
Oil on canvas
48″ × 60″

The central puzzle for the viewer of Miller's work is to see what the two unlike images really "have to do with" each other, and what that says about their "offspring"—the meaning they produce.
—Lucy R. Lippard, *Mixed Blessings,* 1990.

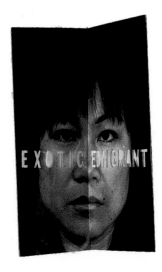

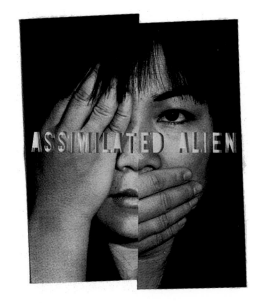

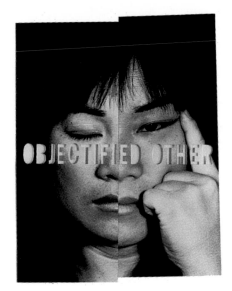

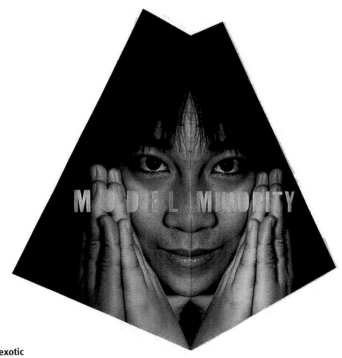

Yong Soon Min

Make Me, 1989
Photograph with incised text
8 panels, overall 96″ × 120″

In *Make Me* (1989) bisected
images of Min's face, upon
which are incised phrases like

"model minority" and "exotic
emigrant" dare the viewer to
see the artist through a haze of
Asian stereotypes.
—Margo Machida, *The Decade
Show: Frameworks of Identity
in the 1980s,* exhibition cata-
logue, 1990.

Lorraine O'Grady

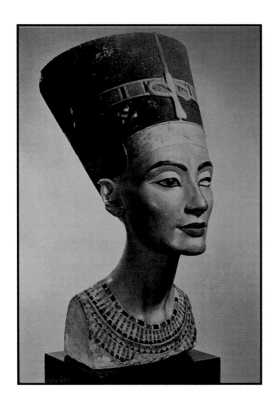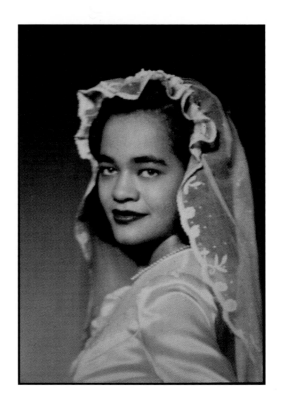

Lorraine O'Grady

Sisters I, 1980/88
from Miscegenated Family
Album
Left: Queen Nefernefruaten
Nefertiti
Right: Devonia O'Grady Allen
Cibachrome, 28" × 39"

**From *Miscegenated Family
Album,* a series of 16 diptychs
comparing the lives and fami-
lies of the Ancient Egyptian
queen and the artist's late
sister.**

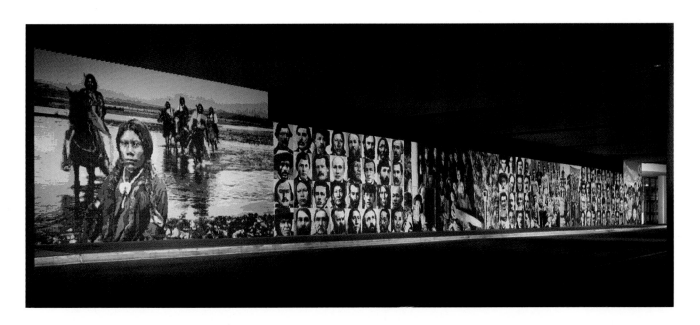

Barbara Jo Revelle

Colorado Panorama: A People's History of Colorado, 1991
Computer screen scanned image/tile mural
8′ × 600′

Colorado Panorama: A People's History of Colorado is one of the largest murals in the world, running two city blocks long. Constructed of one-inch square tiles, it consists of representations of the faces of 84 men and 84 women as well as larger images taken from historical photographs from an "alternative history" of Colorado.

Jolene Rickard

Jolene Rickard

3 Sisters, 1989
Black and white photo and
color Xerox

There is a predominance of respect for the live earth in our Native American communities. This view of the world is informed by our cosmology. This view of the world nurtures and guides young minds into being respectful human beings. The closer people in our communities are to these concepts, the closer they are to the earth. Indian people are perhaps perceived as being more respectful of the earth, not because it is mystically in our genes, but because we developed a way of life which made living an ecologically sensitive existence a priority. It is important to identify the difference because it may help young minds outside of our communities to discover for themselves alternative methods of living on this earth.

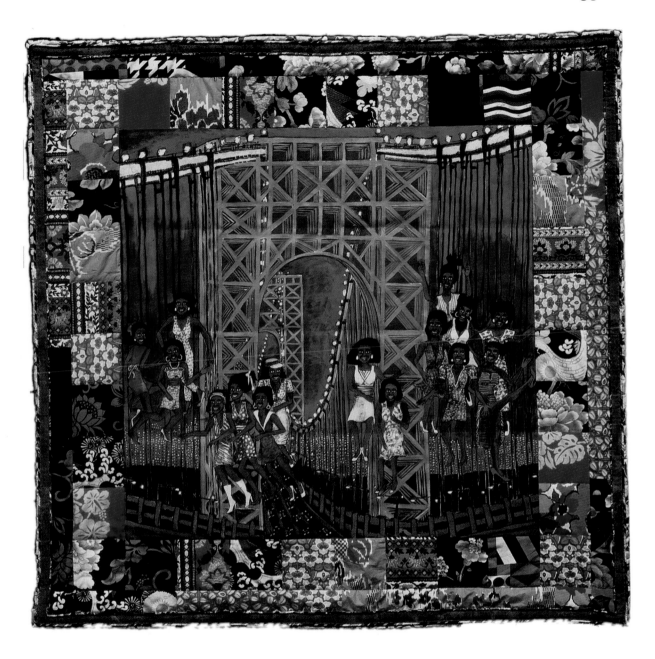

Faith Ringgold

*Dancing on the George
Washington Bridge,* 1988
Acrylic on canvas, dyed and
pieced fabric
68″ × 68″

I wanted to do a series of
women and bridges. Now a
bridge, we all know, looms
over the city and commands
attention. I wanted to create an
image of women as powerful
and creative and able to stand
up to a bridge. I also associat-
ed the design of the bridge, its
structure, the ways in which it
is interlaced, its triangles and
squares and gridwork, with the
same kind of design that is
often seen in quilts.

Juan Sánchez

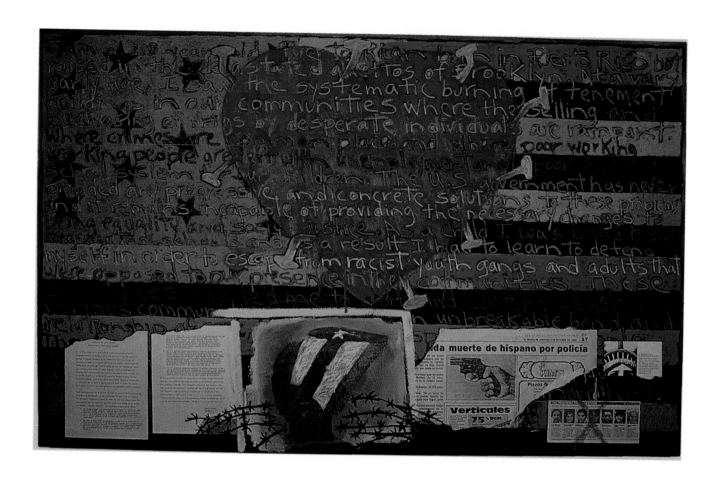

Juan Sánchez

NeoRican Convictions, 1989
Oil, mixed media on canvas
42″ × 66″

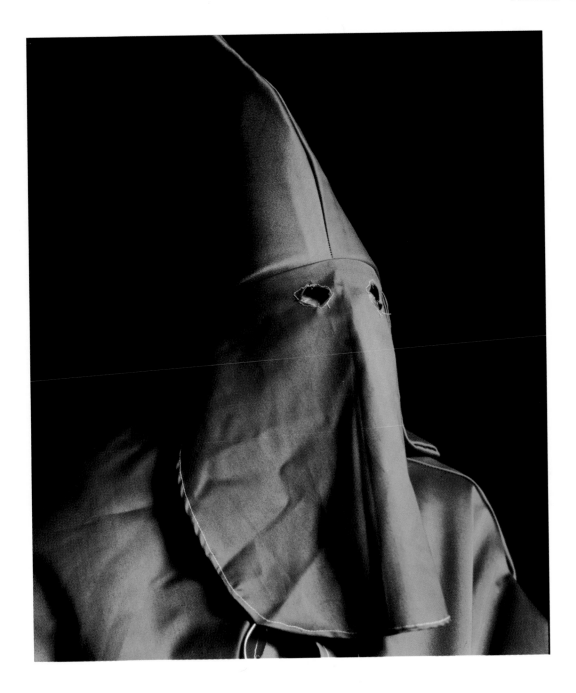

Andres Serrano

Klansman (Imperial Wizard),
1990
Cibachrome, silicone, Plexiglas,
wood frame
60″ × 49 1/2″ Edition of 4

We tend to think of portraiture as a means of zeroing in on identity or individuality. But this work, which is from a series of the Ku Klux Klan, grew out of my desire to make unusual portraits, pictures of people wearing masks. *Klansman (Imperial Wizard)* is a portrait of James Venable, the ex-Imperial Wizard who was 83 years old at the time (and who died a year after this photograph was taken). As a designate leader, the Imperial Wizard wears a green Robe. Of course, because of who I am racially and culturally, I found it a challenge to work with the Klan—a challenge for them as well as for me. A lot of Klan members said no to being photographed at first, but I was persistent, as well as being lucky and persuasive.

Helen Zughaib Shoreman

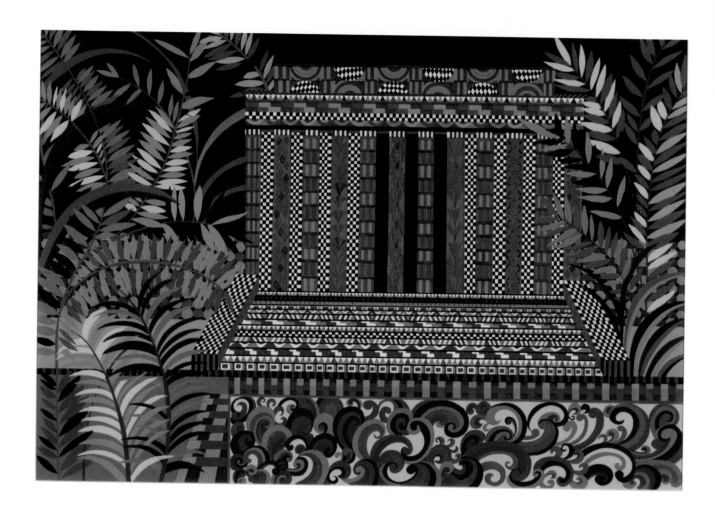

Helen Zughaib Shoreman

Lincoln Memorial, 1990
Gouache and ink
19 1/2" × 27 1/2"

My major influences have come from my background in the **Middle East. The detail, patterns, brightness of color are all reminiscent of the Arab world. The nontraditional perspective that I create can be found in much of the old Arab art. I basically transform the subject matter into pattern and color, thus rendering a certain optical illusion that draws the viewer into the painting almost like a puzzle.**

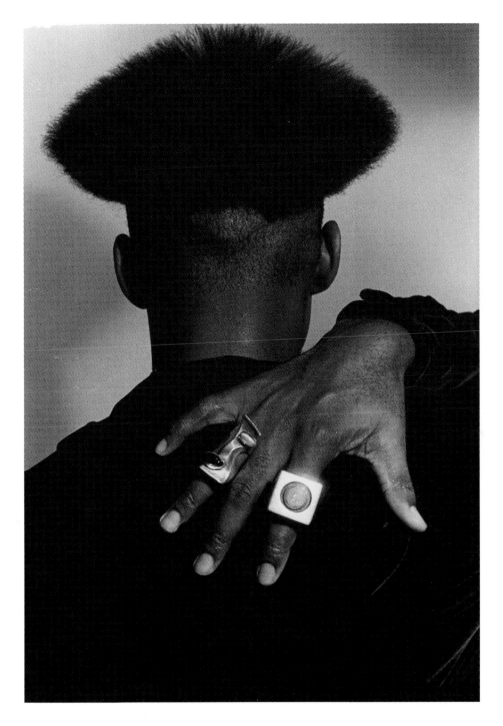

Coreen Simpson

Vic, 1986
Silver gelatin print
20″ × 24″

Vic is part of a series of photographs documenting the work of jewelry designer Arthur Smith (1923–1982), a Jamaican metal smith. As a photographer and jewelry designer, my work is influenced by the art of self-adornment, and personal style as issues of self empowerment.

Elizabeth Sisco, Louis Hock, David Avalos

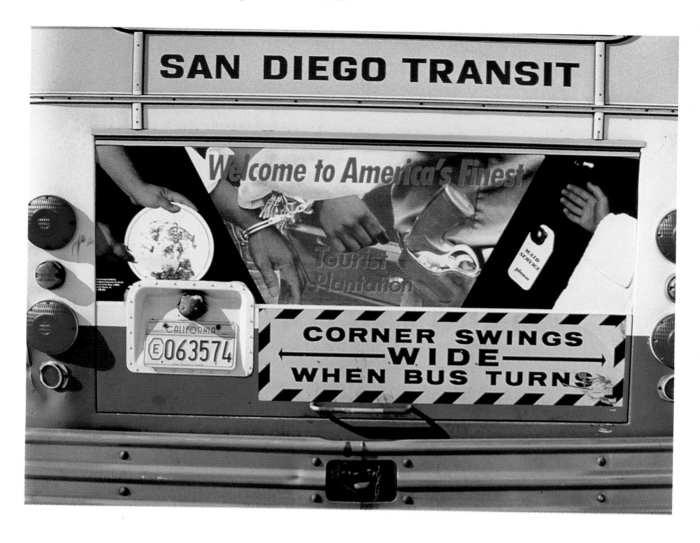

**Elizabeth Sisco,
Louis Hock,
David Avalos**

*Welcome to America's Finest
Tourist Plantation,* 1988
Commercial silkscreen
photo-montage with text
21″ × 72″
External Bus Poster

***Welcome to America's Finest
Tourist Plantation*** is a site-spe-
cific and time-specific public art
"ambush." It takes the form of
a bus poster which provoked
controversy and stimulated dia-
logue and debate about the
exploitation of Mexican labor
by the City's tourist industry
during San Diego's first Super
Bowl. The central image is a
documentary photograph of a
Border Partol Agent handcuff-
ing two individuals being

removed from a San Diego
Transit bus in La Jolla. The
photograph is one of a series
made by Sisco between March
and July 1986. The images of
the hands of a dishwasher and
a chambermaid are a posed
tableau representation of the
restaurant and hotel/motel
industries.

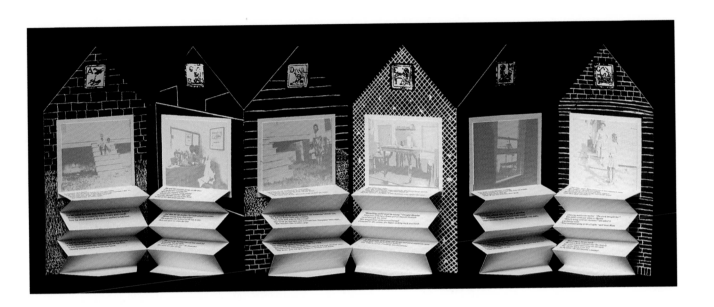

Clarissa Sligh

What's Happening with Momma?, 1987
Van Dyke Brown print
11″ × 36″

It's really a mystery story. The main character is a seven year old girl. She's in the house and hears these weird sounds that she's never heard her mother make before. She runs in the room and her mother's on the floor. Her mother says, "Go find your grandmother," and she goes next door but her grandmother isn't home. So she finds an older brother and brings him back, and they begin running up and down the steps.

The book is made to have the viewer running up and down the steps just like this kid. Finally, at the end of the story, the mystery is resolved: she finds out that her mother was having a baby in the bedroom. And it all happened before the doctor came.
—Clarissa Sligh, Interview with Laura U. Marks, *Afterimage*, December 1989.

Diosa Summers

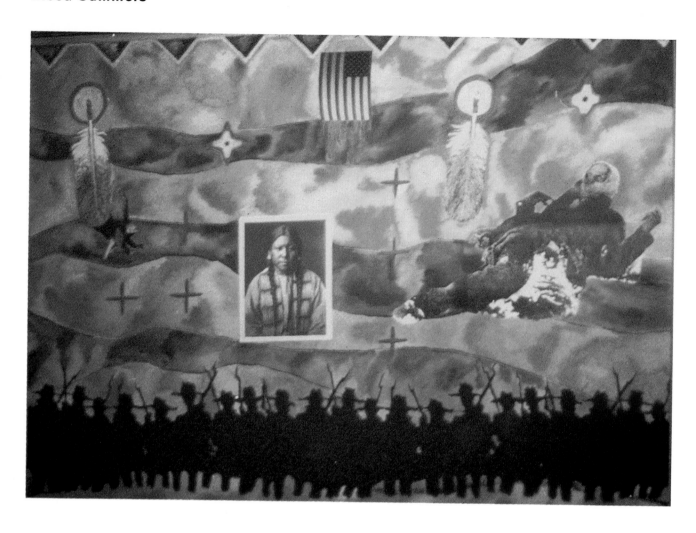

Diosa Summers

Ghost Dance I, 1989
Water color, pen ink, collage
27 1/2″ × 22″

Masami Teraoka

*AIDS Series/Vaccine Day
Celebration,* 1990
Watercolor Study on paper
29 11/16″ × 43 13/16″

A couple is picnicking at
Makapuu beach in Hawaii.
They have just received a fax
announcing Vaccine Celebration
Day. They dance. She plays her
shamisen and he flies a kite
reading Celebration. Faxes and
condoms blow away in the sea
breeze with the ever-present
cherry blossoms. This painting
reflects the artist's hope that
we will have some good news
about AIDS soon.
—Masami Teraoka exhibition
catalogue, Pamela Auchincloss
Gallery, New York, 1990.

Danny Tisdale

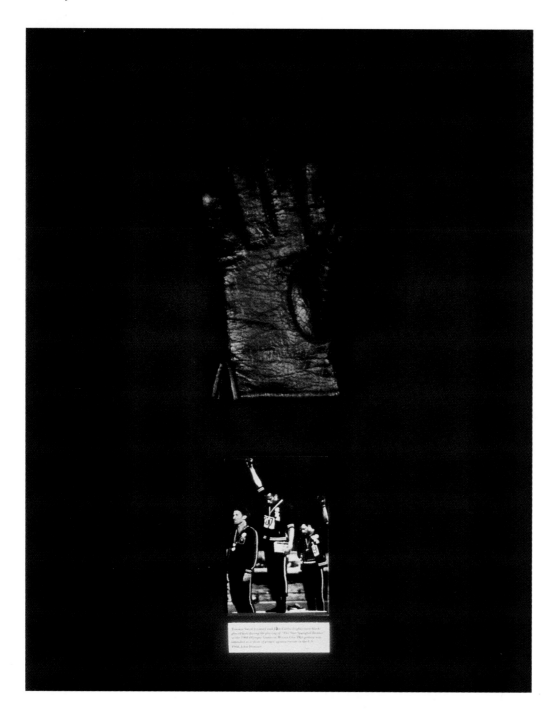

Danny Tisdale

The Black Power Glove, The Black Museum, 1990
Mixed media installation
18 1/2″ × 25 1/2″

This work is from *The Black Museum,* an art installation by Tisdale featuring simulated museum displays of objects from black culture of the 1960s and 70s and the civil rights and Black Power movements. In the installation the piece is accompanied by a text which highlights the way in which culture is represented in museums: "*The Black Power Glove* was used in the 1968 Olympic Games in Mexico City by John Carlos, along with Tommie Smith (see photo) as a symbol of Black pride and protest against racism in the U.S.A. A similar glove was worn by the Black Panthers organization during this time. Research shows the color black in and of itself was a symbol of Black power. Watts, CA. c. 1965. Leather and wool."

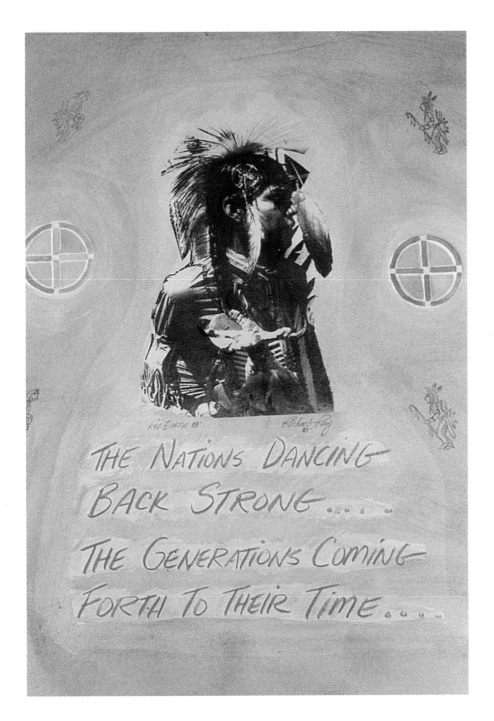

Richard Ray Whitman

Dancing Back Strong, 1989
Photo-emulsion transfer,
hand-tinted
26″ × 34″

The dichotomy of dancing for continuance (ceremonial, earth-based, spirituality) and the economics of dancing (commercialization, entertainment).

Pat Ward Williams

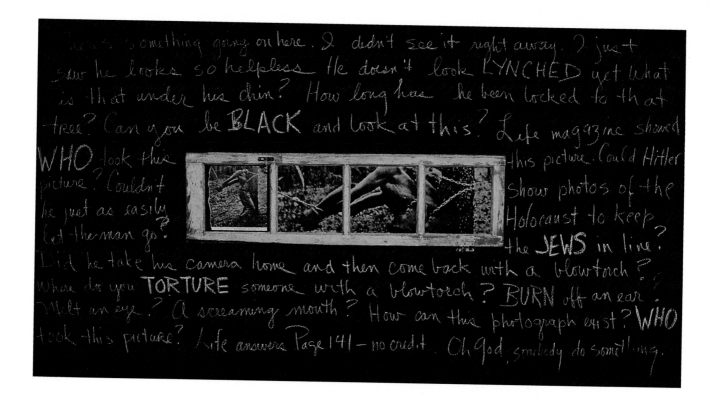

Pat Ward Williams

Accused, Blowtorch, Padlock,
1986
Magazine page, silver prints,
window frame, film positive,
text
6′ × 5′

I was in a secondhand book-store, and I was looking through old books when I came across a book called *The Best of Life Magazine* (1979). I turned the pages and saw this photograph of a lynched black man, and I was horrified, as anyone would have been. I put the book back on the shelf and left the bookstore. But this image stayed with me for weeks and weeks, until I felt that I had to go back to the bookstore and actually own that photograph so that I could really work out the feelings I had about it.... I looked at the photograph for a long time and I really tried to analyze it. What is it exactly that I'm feeling when I see it? What do I think about when I think about this photograph? I thought that the best way to get all this across was with text—the writing on the wall, so to speak—and to be as precise as possible about the questions it raised in me. That led to the chalkboard effect.... My handwriting acts as my voice, my own voice. By using handwriting instead of print I hope you can hear a tone and a human inflection.
—"Interview with Pat Ward Williams" by Moira Roth and Portia Cobb, *Afterimage,* January 1989.

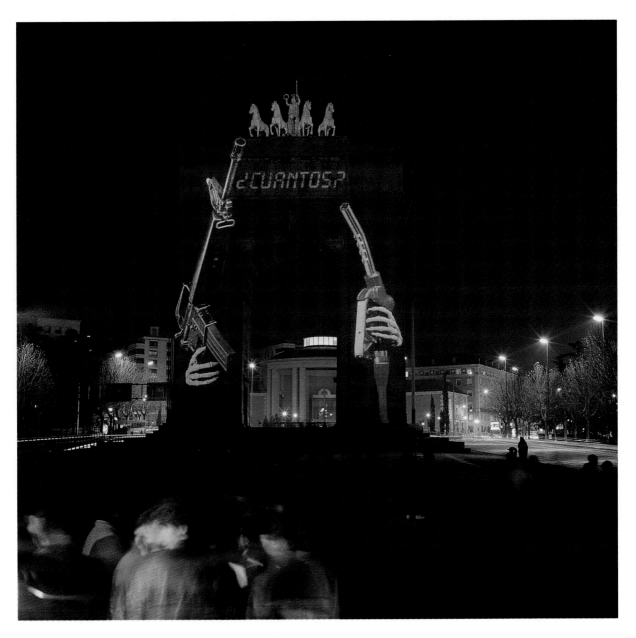

Krzysztof Wodiczko

Arco de la Victoria, Madrid, 1991
Organized by the Circulo de
Bellas Artes, Madrid in conjunc-
tion with the exhibition
El Sueno Imperativo
(The Imperative Dream).
Images projected on the Arco
de La Victoria, Madrid, with the
use of four 9,000-watt slide
projectors.

**I did a projection in Madrid
during the Persian Gulf War
that was quite effective
because it was adopted by
antiwar demonstrations, which
were massive in Spain. It was a
projection of a set of icons that
I adopted and transformed for
the moment of the outbreak
of the war, projecting them
onto a fascist monument to
Franco's army.**

David Wojnarowicz

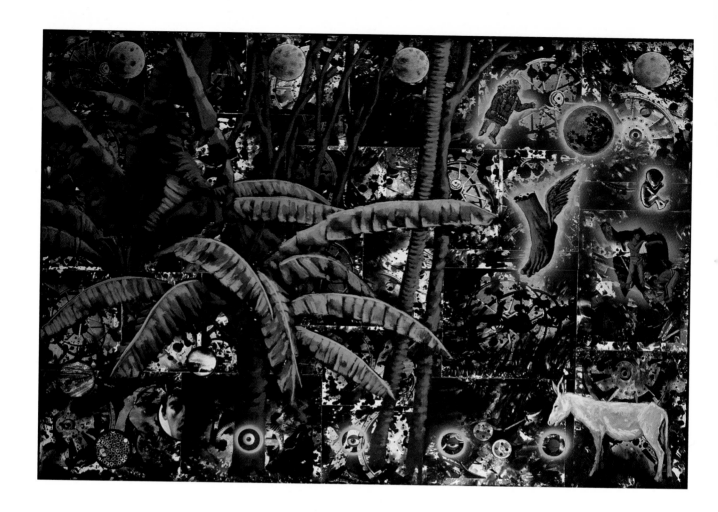

David Wojnarowicz

Where I'll Go If After I'm Gone,
1988-90
Acrylic, b/w photo on canvas
45" × 64"

A year and a half ago I was in
a hospital room witnessing the
death of Keith Davis. He'd been
involuntarily hooked up to a
series of machines made of
hissing pumps and oxygen
compressors. He'd died twice
already and a team of jerk doc-
tors had brought him back

each time by jumping up and down on him and subjecting him to electric blasts. He stayed in a coma with various infections forming and rampaging through his body for four days more with the entire world circling outside the window. I thought of death and what takes place in the aftermath of it. How different cultures imagine different possibilities for the aftermath of death. I'd pretty much believed that all energy in the body just disperses like an invisible flood and spreads out into the world and becomes part of everything; becomes nothingness at the same time. I thought if there was indeed a place one goes after death then it could only be a place determined by one's vision of the world; of life; of concerns. Hell is a place on earth. Heaven is a place in your head. The garden is the place I'll go if I die. I don't believe in afterlife really; it's just another sucker-trap to allay the anxieties of people who are forced by the machinations of the preinvented world to leave their living for later. Afterlife is a con for the enslaved. But that doesn't mean I don't like the idea of tiny angels or ghosts accompanying people in life and death and offering them small comforts in unimaginable ways. Gimme a dozen angels; sweet sexy angels; little creatures that fly around like dumb bugs in the wind outside the windows coughing in the exhaust of the buses that stop below. So this garden is where I'll go; the gears are the residue of the manufactured world I was born into. The train is the acceleration of time; the tornado the force of displacement in death; the Indian chief a cheap WWII doll that for me translates culture into something that can be owned—less than a century ago the wholesale slaughter of Indians was commonplace and they'd have been completely exterminated if not for organization and resistance; today the homosexual in America sustains the same slaughter which is socially acceptable in most areas; witness the judge in Texas that recently reduced the life sentence of a guy convicted of shooting two men to death because they were homosexual. People in various cultures take to bodies of water for purification rites; southern pond baptisms; Indians along the Ganges river; Haitians in voodoo rituals of cleansing: thus the bathing men; something also richly erotic to me.

The four eyes opening or closing mirrors the four pale blue moons in something like eclipse; maybe the final motion of dying. I have no plans to go but if I do, this is the partial structure of my frame of references.

—*David Wojnarowicz: In the Shadow of Forward Motion* by Felix Guattari. Exhibition Catalogue, PPOW Gallery, New York, 1989.

YA/YA, Inc. (Young Aspirations/Young Artists)

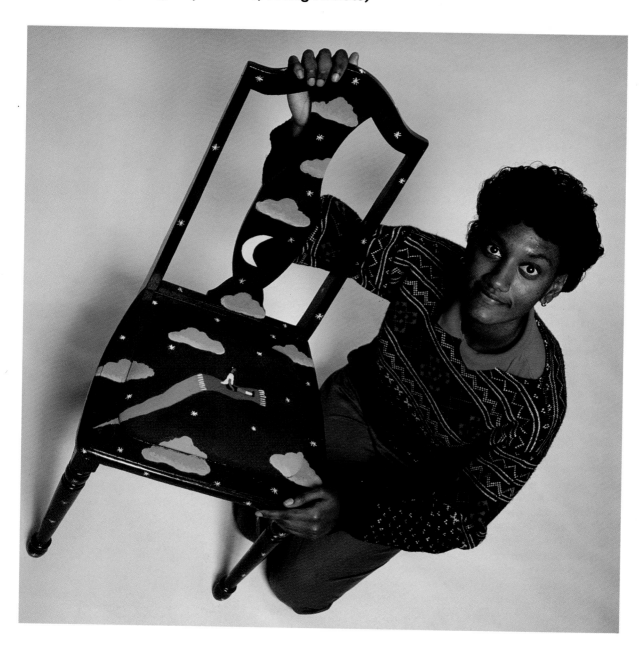

**YA/YA, Inc.
(Young Aspirations/
Young Artists)**

Darlene Marie Francis
The Magic Carpet Ride, 1990
Latex acrylic on wood,
polyurethane coating
35″ × 17″ × 17″

When I started drawing
Bonchee, my dreams began to
express the way I think about
life. Bonchee is a little black
girl that believes in her heav-
enly father who takes her on
many journeys. She befriends
all types of mankind and beau-
tiful animals and sees wonder-
ful places. She is full of peace
and happiness. If everyone
could race with a comet on a

magic carpet and float in the
air light as a feather through
puffy cotton clouds, they would
be happy, too.
—Darlene Marie Francis,
Catalogue for Young
Aspirations/Young Artists, Inc.

Part 3:

Artists' Voices

Artists' Voices: Introduction

This section uses autobiography to help understand artworks within a larger social and historical context. The material focuses on the relationship of the artists' lives and backgrounds to their art work.

Each artist was asked to respond to a series of questions:

- Who are you? Where did you come from? What is your culture?
- How does your work relate to young people?
- What is the artist's role in contemporary society?
- What are your major influences?

The answers to these questions provide relevant information for understanding the artwork and motivations of each artist or collaborative group.

The texts in this Part may be used in conjunction with the images included in Part 2 and the lesson plans included in Part 4, or on their own.

Because the artists' statements are intended primarily for use in high schools, we felt it important that the material be reviewed by the intended users. A small group of interested public high school students drawn from The New Museum of Contemporary Art's High School Art Program reviewed drafts of all the artists' statements. Their comments were taken into consideration in the final editing of this material.

John Ahearn

Born: Binghamton, New York, 1951

Lives in Bronx, New York

Rigoberto Torres

Born: Aguadilla, Puerto Rico, 1960

Lives in Bronx, New York

John Ahearn: I come from a middle class background in upstate New York, third-generation Irish Catholic. One important thing is that I have an identical twin brother, Charlie. During childhood I was one of a pair, one of "the twins." So, I have a need to collaborate with other people. My father was a doctor. He delivered babies. Almost all the materials we use in our art are medically oriented. I think the casting situation is a lot like an operating table. The casting process is also a lot like giving birth. Robert and I are like the doctors who help this person give birth to a new creation.

John Ahearn & Rigoberto Torres
Walton Avenue Block Party, September 1985
Casting process

Rigoberto Torres: No matter how you put it you are learning throughout your life. The reason your parents put you in school is for you to learn, to be aware, to use your mind, to open your mind. But later on, you will want to do things that you have never done and nobody has taught you, and that's where I am now.

I recently went to Puerto Rico for six months and looked deep inside myself to discover whether or not I was an artist. I went to Puerto Rico to do some creative work at my own pace and my own skill level. I moved to the mountains, bought some equipment, and did things that made me feel great. No TV, no radio. If you think a lot about it you can figure out who you really are.

I found out—yes, I am an artist. I found it deep inside myself. When I do art, it is me. I feel like I have the world in my hands. I can create what I want. I feel strong about it. I feel happy and healthy. The idea is to be able to get yourself to do it, create from the energy that you have inside. Many people say, "No, I don't know how to do this" and "No, I do not understand this." That negative side is the part that stops everybody. Being positive is what helps. There is a kind of crazy energy that can make you do things. That's the part you must learn to control and take out when you need it. Even if you are down,

you still try. Inside as an artist you must pick yourself up and continue because you know that later on you will get some kind of feedback and you are going to feel great.

John and I started working together in 1979. We met at Fashion Moda, a "storefront" museum in the South Bronx. John was living downtown and I was living uptown.

JA: A friend of mine had just opened Fashion Moda. I was interested in what was going on there because it was such a different world than the artist scene downtown. I had just begun doing this series of face casting projects and I decided to try it uptown. About midway through the project I met Robert. He first joined as an assistant and he patiently helped me with what I had to do. He then asked me for some of the casting materials to take back to his own neighborhood. He was pretty showy, though. Didn't you do the casting right out on the sidewalk?

RT: Yes, I did it on the sidewalk. The first project we did together on the street were simple heads. We set up a studio in the street. We were like a team. He met my family, my people, my friends and we worked together. After a while, people came to us asking, "When are you going to do us?" You do one person and that person tells somebody and before you know it, the whole neighborhood knows.

Our work is something that everybody likes, something that everyone can understand in the sense that they would like to try it one of these days. There is something about art there that they enjoy.

JA: Our collaboration works because we are in strong agreement as to what is fair, what is not fair, what is nice, what is bad, what is good. I think we have common ground in a lot of areas. I have a deep trust in Robert's basic intuition about people and I think that is the number one reason why I work with him.

Melissa Antonow

Born: Queens, New York, 1978
Lives in Queens, New York

I was born on Feb 12, 1978 at St. John's Hospital in Queens, New York. I have lived at the same address all my life. My father is a house painter supervisor for the Health and Hospital Corporation. My mother is involved in food service. I attend school at Our Lady of Hope in Middle Village.

The poster *Come to Where the Cancer Is* was originally a homework assignment. The subject was chosen from a *TV Guide* advertisement for Marlboro cigarettes. The ad had the saying, "Come to where the flavor is," so I just changed the ad around to say "Come to where the cancer is."

I was very excited about having my poster in the subway system—also very surprised. I had no idea that the response would be so great. I felt like I was caught in a surge of popularity. It was nice but a little annoying because I was young and not really prepared for any of this. However, the press and reporters were very nice and professional in their manner and words. I am a little shy of the limelight, but I feel that the antismoking campaign is a very important issue.

When the poster was banned from the subways because of objections from a cigarette company I felt denied the right to tell the public about the dangers of cigarette smoking. At first the poster was just another homework assignment. However, Mr. Joseph Cherner, President of Smokefree Educational Services, showed me that my poster was the truth and the cigarette posters were lies.

My interests are math and rock 'n' roll music. I enjoy being with my cousins and friends. I also like to collect minerals and fossils. My favorite subjects are math and French. I also enjoy the country with all its trees and lakes, fresh air and animals. I also like to look at the stars in the night sky.

I will continue to make art for fun and a hobby. My father influences me when it comes to art. I would like to be an accountant because I like math and money.

Born: Chicago, Illinois, 1960
Lives in Cheverly, Maryland

My name is Kristine Yuki Aono. I was born in Chicago, Illinois, on December 31, 1960. I am a "Sansei" (sahn-say), a third-generation Japanese American. My grandparents are "Issei" (e-say); they belonged to the first generation to emigrate from Japan to the United States. My parents are "Nisei" (ne-say), or second-generation Japanese Americans.

Ever since I was a child art has played a part in my life. My parents encouraged me to draw and be inventive. My grandfather's interest in the traditional arts of Japan, such as brush painting, ikebana (flower arranging), and kite making made a strong impression on me. Making art is an individual act. For me, it offers both a vehicle for self expression and a means to meet certain personal challenges.

My sculpture is narrative in nature. I draw on a wide range of sources for information and inspiration. I have read many books about Japanese American culture and history. I also have long had an interest in the traditional arts of Japan, and those of Western civilization. All these influences come together in my work.

For the past several years, my artwork has been heavily autobiographical. My sculpture gives me a method for working through and expressing conflicts in my identity as a Japanese American. Through my art I have been able to express my personal views on topics such as the internment of Japanese Americans during World War II, acculturation, racial and sexual stereotypes, and my family's history.

I think it important that the strength in my work be more than just the message. The work itself must be visually interesting, to draw the viewer in. Then the content of the work can be experienced. I often use unconventional materials in my work: earth, rusted nails, concrete. It is important to me that my work be beautiful, but beauty is a subjective value.

My first step in the art making process is to find a concept I want to express. Then I decide what materials I can best use to tell my story. For example, *Hashi/Fork* is a work I made to illustrate my dual Japanese American upbringing. I drew upon my memory that my mother always set the table with both hashi (chopsticks) and forks. The art work is a wooden fork that splits into two equal halves, like chopsticks; I think of it as an allegorical self-portrait.

Deru kugi utareru. Translated literally, this Japanese proverb, which I found in a book I was reading, means "the nail that sticks up the farthest takes the most pounding." From this saying evolved an art work consisting of the pattern of an American flag formed by over a thousand nails, rusted to show age, time, and pain. The proverb illustrates the Japanese cultural pressure for social conformity, whereby an individual is looked down upon for calling attention to him or herself. This work answered my questions about how the Issei, and especially the American-born, U.S. citizen Nisei, could have entered the concentration camps so quietly. I know that my generation would have protested vociferously.

My artwork is initially done for myself. It is a thrill when other Asian Americans tell me I am expressing their story too. I find that for the most part Americans are very interested to learn more about their polyglot society. Art is the perfect vehicle for communicating these messages.

Eduardo Aparicio

Born: Guanabacoa, Cuba, 1956
Lives in Miami, Florida

My photographs are part of an ongoing documentation of Latino communities in the United States. The project began with the series, entitled *Estados Unidos,* which concentrates on the Spanish-speaking communities of Chicago, particularly the Mexican and Puerto Rican communities. About a year ago, I started to expand the project to cover the Latino communities of San Francisco, New York, and Miami. I lived in Chicago for fifteen years and recently moved to Miami. I intend this to be a life-long project that will also include in the future the Latino communities of Los Angeles and rural areas of the Southwest.

The primary purpose of this documentation is to represent the Latino communities of the United States as an integral and vital part of American society. The selection in this book documents Latino-owned stores in Chicago. The locations were deliberately chosen throughout the city, not just in those neighborhoods typically thought of as "Hispanic." Different degrees of acculturation into mainstream U.S. society are evidenced by the mixture of Spanish and English and the predominance of one or the other language in different locations. In some cases, the presence, or absence, of national colors (the red, white, and green of the Mexican flag or the red, white, and blue of the Puerto Rican flag) indicates the degree of acculturation.

The documentation of these store fronts offers a record of vernacular art. Often representations of real or mythical rural landscapes, are superimposed on the urban setting. These landscapes suggest the idea of living in two places at the same time: the land of one's birth and the adopted land. What do all these images mean? Are they reminders of a lost past or expressions of a longing to go back? Do they assert an old identity or are they a way of taming an unknown and often hostile new environment?

Spanish is not a foreign language in the United States. As of the 1990 U.S. government census, the total population of "people of Hispanic origin" in the U.S. was over 22 million. The names of many of our states (California, Nevada, Texas, Colorado, New Mexico, Montana, Florida) are a constant reminder that the Latino experience is a familiar part of life in the United States.

Born: Bronx, New York, 1929
Lives in New York City

I was born in 1929, in the Bronx, New York to a Jewish immigrant family.

I make art because really I have no choice but to make art. Being an artist is a major component of my identity—it's what I am. Therefore, I basically make art for myself. My art represents who I am, how I see the world, and how I then respond to it. In this way, my art very much relates to my life.

I have always identified with the powerless in our society. From having been raised in a very rigid household, I found out early how power (and the lack of power) works—the power of parents over children, of males over females, of doctors over patients, of one ethnic group over another, of governments over citizens. As a woman, my art very much reflects the injustices perpetrated upon women in the past, as well as now. I am especially concerned about family issues, particularly the abuse of children within the family. The abuse of children can take many forms—not only the physical and sexual abuse of which we are becoming more aware, but also the psychological abuse, which is more subtle, but often just as damaging. It is the children who are the most powerless in our world, who are most often the victims, but who are also our future. And so, my art represents a microcosm of the world we live in, and the way in which power is abused in this world.

My art is about how I see our society now—in the moment in which I live. I look at this reality, take it apart, and lay out all the pieces, frequently ending up with what seem to be meaningless and disconnected fragments. I present these by using repetitions, unreal images, and unexpected violent dislocations. And yet, the landscapes and figures in my work belong to and refer to the everyday world, to real life, where frequently you can't tell what is really going on, and where much seems based upon random events.

Among the individuals who have influenced me is the modern writer Samuel Beckett, who in his writings uses one-liners and clichés to express the fears and anxieties we all deal with. Among other artists who influenced me I would include Francisco Goya, Käthe Kollwitz, and John Heartfield, all of whom tried to represent the horrors and injustices of their times. Finally, I should mention the strong female movie stars of the 1940s and 1950s, women like Barbara Stanwyck, Joan Crawford, and Ida Lupino.

While I am a woman, and an artist with feminist concerns, my subject matter is universal. Thus, my source materials come from everywhere. I am really an image-scavenger; I will use images and ideas from television, films, newspapers, magazines, the *National Inquirer*—whatever is at hand. I then recycle and repackage the images, and if things work well, the painting makes itself. I would also like to note that I am not exclusively a painter; I also do books, sculptures, videotapes, and films. Basically, I am an art maker.

Tomie Arai

Born: New York City, 1949
Lives in New York City

I am a Japanese American visual artist. I was born and raised in New York. I have lived in neighborhoods all over New York City—from the Bronx and Harlem, where I lived as a child, to the Lower East Side, Chinatown, and the Upper West Side of Manhattan. My husband of 19 years, a Chinese American, grew up behind a laundry in the Bedford Stuyvesant section of Brooklyn. While we may be by definition Japanese and Chinese, our experience has been a uniquely American one; an experience unavoidably interconnected with the black, white, and Latino lives we encounter daily.

The author Salman Rushdie refers to this condition as a process of hybridization, a reconciling of the old with the new: "The migrant's eye view of the world; the uprooting, disjuncture and metamorphosis that is the migrant's condition." As the great granddaughter of Japanese farmers who settled in this country in the early 1900s, I am several generations removed from the immigrant experience. Yet like many Asian Americans, my life continues to be defined as forever foreign, uprooted, and marginal.

My work approaches this experience, and issues of cultural identity, from the perspective of an Asian woman. I am especially interested in exploring the relationship of art to history and examining the role that memory plays in the retelling of a collective past. Through the use of autobiography, family stories and photographs, historical material and oral histories, I create pages of "living" history which help establish a sense of place and continuity for the Asian American community.

Throughout my work, I make visual references to the screens, scrolls, and motifs found in traditional Asian art. In this work, tradition and family form the principal connection between the past and the present, between "there" and "here," the link between the life left behind and the endless possibilities of the life that lies before us.

As a mother of two, I have always worked between an ever-present stream of interruptions, the interruptions of ordinary life. The demands of family and the clash of cultures on the streets where I have lived have forced me to reexamine the way in which I make art and who I make art for. I feel this is a constant and exploratory process. Over the years, I have also been developing a creative process that includes many participants and points of view. In the 1970s, I became involved in the community arts movement in New York's Lower East Side. This served as a catalyst for expanding the audience for my work and introduced me to the collaborative process. Since then, I have worked collaboratively in a variety of mediums, mural projects, collaborative print and poster projects, banner and book projects, and artist-organized exhibitions within a community context.

My work is renewed by the energy that emerges from these projects and from the ongoing dialogue between artists and nonartists, the foreign and the familiar, men and women, children and adults, and the past and present.

Born: Havana, Cuba, 1942
Lives in New Orleans, Louisiana

I'm a Cuban in exile living in this country for the past 30 years. I became an artist because I had a great need to say something and to gain an identity for myself in the big city called New York. I make art for myself with the hope that the work will be seen by a large audience.

I think I'm one of those few artists who believe art has the force to change the world for the better. Sometimes books, films, art, philosophy, and religion can change one's life, one's outlook on the world, and one's opinion of one's self and society at large. In other words, I think art is a way of communicating love, compassion, and knowledge about ourselves.

Reality informs my work. For example, reading the newspaper, watching the news on TV, riding subways, walking around the city, all are daily experiences that affect me personally or affect us collectively. I'm drawn to the ills of society as an inspiration for my work—urban crime, racism, homelessness, the AIDS epidemic—things that we try to ignore or cover up.

As for the choice of materials, I prefer paint on canvas or paper. It gives me pleasure and satisfaction to apply and manipulate paint on those surfaces. I also like my work to reflect the hand of the artist.

In terms of economic survival, I've always worked full time as an artist with part-time jobs to assist paying bills. Later in my career I applied for and won a number of local and national grants that helped to support me. I've also given talks as a visiting artist at art schools and universities. Since 1983 I've been making a modest living as an artist through the sales of my work.

Border Art Workshop / Taller de Arte Fronterizo

Founded in San Diego, California, 1984
Work in Tijuana, Baja California/San Diego, California

The Border Art Workshop/Taller de Arte Fronterizo is a binational collaborative group of men and women from both Mexico and the United States who create art from the history and current events surrounding the borderline which separates the United States from Mexico. Our aims are: 1) to attempt to establish new areas of communication between the two countries; 2) to see this border and any border between peoples as an arbitrary and inherited concept; 3) to discover methods of collaboration which allow views and perspectives other than our own to be put into circulation; and 4) to go beyond the boundaries of traditional art-making practices.

BAW/TAF members include professional artists, teachers, and people in a variety of disciplines related to education, art and community activity; students of many different backgrounds; writers; and people who are committed to social and political activism. At any one time we have been a mix of Chicano, Mexican, Anglo-American, Japanese American, and a variety of all these and more.

Our culture is the culture of internationalism, keeping in mind the reality that we walk the line between Latin America and United States. We are interested in exploring the dynamics of the border, in both critical and creative ways.

We use art as a catalyst for whatever activity or intervention is needed. We produce art to encourage a wider audience to participate in current issues which are affecting the development of our community. Sometimes we use art to attempt to make changes within the art world related to racism and sexism; sometimes our art is an attempt to engage perspectives other than our own; sometimes it is used to help expose the power relationships between the media and the government and industry.

Art is important in that it can be seen as a part of the social structure in which collective and individual choices can be made. It is a system in which the everyday can be seen from a diverse range of views. It is particularly important in thinking about the presentation of history, and the need for institutional and community documentation. Art is a device to overturn conventional images, texts, and events in order to examine history and popular culture from different perspectives.

BAW/TAF's initial collaborations came out of being in the right place at the right time. There were many people doing related work, but as individuals. We gained experience, knowledge, and power by coming together. In no way has the process been idyllic, but we have developed effective processes through working together. There are tremendous difficulties in working collaboratively. There are shared ideas, shared responsibilities, shared mistakes, and shared joy. In the history of BAW/TAF there has been perhaps an additional struggle because of the variety of cultural backgrounds and experience levels. We are no model, only an ongoing process that continues with some successes. At the end of what has been the world's most totalitarian century, a focus on "collaboration reality" rather than individual artistic ego is perhaps a fitting conclusion and an appropriate beginning to the next century.

The social and cultural fragmentation of our current era should force us to look back at older models, not in order to relive past experience or see from some romantic cloud "the good old days," but to find methods of learning and adapting which can lead to new solutions. Historically, most collectives were formed because of a special interest or stylistic and philosophical similarities. These inspired the beginning of BAW/TAF as well. The problems of group dynamics, the star system, and hierarchical structures have threatened artists working collectively for decades. There are no immediate solutions. Periods of instability will always threaten the conditions of collaborative work, but friction can be a good thing.

Born: Panama City, Panama, 1937
Lives in Coconut Grove, Florida

I grew up in Panama, and I now live in the U.S. I feel fortunate to have been exposed to many cultures. My father is a Panamanian and a graduate of the Massachusetts Institute of Technology. My mother is an American from Georgia. My first studies were in Panama followed by college in the United States and France. I identify strongly with Latin American culture yet having had an American mother I am bilingual and not an alien to American culture. My interests in college were history and art history, and the latter led me into an art studio were I was forever seduced into the adventure of art making.

I have been working and showing in Miami since 1983. I also show my work in Panama periodically. I have for the last ten years concentrated on the landscape and the human figure. I am fascinated with the light and color of the tropical landscape, it is an endless source of inspiration. My semi-abstract style has been influenced by the American Abstract Expressionists, while in terms of color I am fascinated by the German Expressionists and the Fauvists. I am interested in the female, her fertility, her sexuality and her nature *in nature*, in landscape and in mother earth.

My emotional attachment to Panama and the explosive political events my country was undergoing during the last few years radically changed the imagery of my canvases. During the reign of Manuel Noriega, as the country was being raped, corrupted, and ruined, the Panamanian people vented their outrage by flying white handkerchiefs as they marched in protest. The paintings in the series *Winds of Rage* are a testimony to the struggle against oppression. These paintings celebrate the tenacity of the human spirit, and its will, throughout history, to be free. The paintings pay homage to the thousands of people who, armed only with a white flag, dared to come out in the streets and manifest their disgust, even at the risk of having to confront platoons of fully armed soldiers who could and did cause them painful bodily injuries. These mass gath-

erings were beautiful spectacles where pent-up energy was released in the hope that intelligence would triumph over corruption.

Now that Panama has returned to a democratic government, I plan to move back to Panama and have returned to my former subject matter and images: landscapes and figures within landscapes.

I feel there is no better way to fulfill my need to express personal experiences and perceptions than by the use of color, line, shape, and form. I love the adventure of harnessing feelings and transferring them onto a canvas. It takes discipline, patience, and passion. This subjective process is not totally satisfying until it is shared with others. Showing one's art to others is an important part of art making. Since art is and has always been transmission of human thought, showing it to others is an integral part of its making.

Ken Chu

Born: Hong Kong, 1953
Lives in New York City

I am American. I speak and think in English. I carry a United States passport. Despite the fact that I was born in Hong Kong and grew up living in several Asian countries, I was raised with an American identity which I had adamantly protected. Physically, I do not resemble the image of the typical American as created by the mass media, so in compensation, I have become hyper-Americanized. As a youth, I rejected the Asian cultures around me because I perceived them as a threat to my Americanness. When I returned to the States, I thought the battle was over. I am finally home, where I need not highlight my citizenship.

I would experience firsthand the Americana of Hawthorne, Thurber, Anderson, Twain, and Faulkner. I could wallow in the painted visions of Wyeth, Dixon, Hopper, Wood, and Sheeler.

My, you speak English so well.

Why shouldn't I? I'm American, like you.

I would become the boy next door in the weekly trials and tribulations of *Ozzie & Harriet, Father Knows Best, Bachelor Father, Beaver,* and *Lucy and Ricky.*

You're so tall for an Oriental.

I'm six-four. I'm just plain tall for an American. And it's Asian, not Oriental.

I could hitchhike across the restless landscape of *Rebel Without A Cause, Beach Blanket Bingo, Easy Rider, Woodstock,* and *American Graffiti.*

Hey Jap! Go home.

Wha? They couldn't be yelling at me. Can't they see that I'm Chinese? Besides, I am home.

Elvis, Gary Lewis & the Playboys, Dylan, Simon & Garfunkel, and the Beach Boys.

Hey, gook!

Aw, man. I'm not a gook, I'm an American. How many times do I have to tell you that? I choked down quite my quota of those McDonald's, I near drowned myself in the Pepsi Generation, I inhaled nicotine-stained Marlboro country, Walter Cronkite was Prophet and *Reader's Digest* the Bible.

Yo! Chinktown! You killed my father!

Oh, not you, too. Chill, dude. I didn't kill your ol' man. The federal government declared the wars; they killed your father. I was the person who marched next to you and your parents during your civil rights movement, remember? That was our voices united.

But how can I expect you to see? I'm just waking up myself. After years of passive and aggressive assertion, I still am not perceived as an American.

My artwork addresses the issues of acculturation. It is about claiming a history and creating role models in the process. It is about going back to square one in order to reprocess the heterosexist white male agenda which we all have been subjected to through our biased educational system. It is about the process of *Asian* Americanization and the empowerment of all marginalized groups because this society won't let us be just plain 'Merican folks.

Multiculturalism is not a trend. The United States was built on racism. In this twisted sense, we have always been a multicultural nation. We are now approaching the end of the 20th century—isn't it about time everyone got clued in?

Founded in New York City, 1985
Work in New York City

Houston Conwill, Joseph DePace, Estella Conwill Majozo

We are an interdisciplinary team of collaborating artists concerned with the function of art in bringing meaning to our lives and serving as a catalyst for social change. Houston Conwill is a sculptor, Joseph DePace is an architect and graphic artist, and Estella Conwill Majozo is a poet. We create site-specific public art installations that rechoreograph the history of a place with an impulse toward freedom. Our works are multilayered and are intended to open the exclusivity of the historical canon to multiple perspectives. We are interested in the preservation and communication of wisdom across generations and cultures and intend for our works to serve as vehicles for education, reversing stereotypes and presenting positive role models.

We seek to form a synthesis of multicultural sources including world art, music, dance, architecture, poetry, music, theater, film, popular culture, folk and festival arts. We use languages, light, water, natural elements, glass, as well as video, photography, and performance.

We create maps of language that present symbolic journeys of transformation fostering greater cultural awareness, racial harmony, and understanding. They are composed from collaged and edited lyrics from world music including Spirituals, Blues, Gospel, Soul, Jazz, Funk, Samba, Merengue, Reggae, Calypso, Rock and Roll, Rap, and Freedom Songs, and multilingual quotations from speeches of heroic models.

Their humanistic words address issues of world peace, social justice, human rights, and ecology. They also address the universal enemies: oppression, racism, violence, and poverty. They challenge us to break down barriers between people of diverse backgrounds, to build bridges of compassion, clarifying a common meeting ground for all humanity.

Jimmie Durham

Born: Arkansas, 1940
Lives in Brussels, Belgium

According to some official documents I was born in Arkansas in 1940, but that state is a recent invention. The "united states" were all invented against American Indians, and as a Cherokee I was born in Cherokee territory under the aggressive political act called "Arkansas."

In a long war that still continues, hundreds of thousands of brave Cherokees defended our people and died so that my generation would live and continue the defense.

Would it, then, be "patriotic" for me to say that I am an "American," of the "minority" called "Native American?" No, I am Cherokee, and have no other way to be.

That does not mean, however, that I must follow some other person's definition of what I am or what I do. I have lived in Europe, New York City, and Mexico as well as on reservations. It is kind of a duty to be free, intellectually and in any other way, to break totally out of the isolation in which we are kept.

It is probably that idea that makes me do the kind of art I do. As a little kid I made toys and objects for myself, and used them to make my own pretend world because the real world I lived in was not always a good place. Because I showed a kind of talent for making things I was later trained to make things we used in ceremonies and also things to sell to tourists. So on the one hand I was participating in important parts of our culture and on the other hand I was participating in our degradation. But in both cases I learned that it is necessary to connect one's personal world with the public world. There is a concept in Cherokee that might be translated, "It is necessary to speak well and to listen well in the council of the world."

I cannot sit in my studio, in my private world, and think up good art ideas, make them, and shove them in the world's face; I must make my art socially, for common use and the common good. But if I do not speak well, if I am not serious about myself, I cannot make anything useful to society.

It also seems necessary to me, for the same reasons, to try to combine the art world—the galleries, museums, and art magazines—with the rest of the world. Art has real functions in human life. We know things and we know in ways through art that we cannot know through what we call language. If we could say art or write art we would not make art.

For complex reasons, modern political systems have told us that art either has no function or that its function is to support a political system. I think of art as a combination of sensual and intellectual investigations in reality. The fact that governments want to control art is certainly part of the reality that art must investigate. The fact that a foreign government (the United States) wants to control me as a Cherokee is a part of reality that my art must investigate.

Yet I do not wish to become like those governments. I want my work to give energy and encouragement to any fellow human who might encounter it.

The "public" has its own responsibility, too. Normally, people do not try to read a serious novel the same way they might read a comic book; we take time and care, and we do our own investigations. Why would anyone approach art differently?

Language is a set of skills we know we must continue to develop simply because it is delightful to speak with more people. The vocabularies of art bring us the same delight.

The Epoxy Art Group came into existence when six artists from Hong Kong and China met in New York City in 1982. As painters and sculptors with Eastern backgrounds, we joined forces in the culturally diverse environment of New York to work collaboratively for the purpose of creating artistic opportunities. The name "Epoxy" was chosen to signify the strong chemical bonding power of cross-cultural adhesion.

Projects by the Epoxy Art Group are collaborative efforts by a variable group of artists, numbering from two to nine people. Ideas for projects come about through discussion among members until a concept becomes defined as a specific activity. By working as a group, personal creative energy becomes a collective effort to discuss issues that are of common interest. At the present time, members of the group prefer to be anonymous so that each individual's work loses its own identity and emerges as Epoxy's collaborative work.

The positive end of collaborative effort is the feeling of comradeship and exchange of ideas and energy together. The disadvantage of working as a group concerns time, space, and energy balance, which is difficult to coordinate on a long-term basis. As time evolves, different members' interests and priorities change, which causes the chemistry of the bonding elements to shift, and in turn affects the outcome of the collaboration. Balancing and managing the changing elements within a group can be a very taxing experience.

Guillermo Gómez-Peña

Born: Mexico City, Mexico, 1955
Lives in New York City

I was born in September of 1955, at the Spanish Hospital of a Jewish quarter of Mexico City, the most densely populated metropolis on earth. I was the darkest of three children. Darkest in terms of both skin complexion and personality. My father was darker than I, a gallant sportsman with a quintessential mestizo look. My mother was as white as can be. She looked like a Spanish *doña,* though she was filled with Mexican tenderness. Having a red-haired sister and a blond brother, I always felt slightly odd, for I had to be "twice as clean and well dressed" to look *decente.*

I attended Jesuit schools. There I became aware of skin privilege. *Los niños bien* (the good boys) were fair-skinned and European looking. And *los nacos* (the sleazy ones) were darker and shorter. As a mestizo, I was a bit of both, *cafe con leche,* let's say. Racism in modern-day Mexico is not like the militant versions found in the U.S. or South Africa. It is rather a by-product of the country's inflexible social structure. Nonetheless, as a teenager I knew that my looks weren't totally acceptable. The mother of my *novia* (girlfriend) Adriana once said, "Guillermo is not *feito* (ugly), but unfortunately he is *prieto* (dark)." I still carry that thorn in my heart, and the U.S. has infected that wound.

Today, I wake up as a Mexican in U.S. territory. With my Mexican psyche, my Mexican heart, and my Mexican body, I have to make intelligible art for American audiences that know very little about my culture. This is my daily dilemma. I have to force myself to cross a border, and there is very little reciprocity from the people on the other side. I physically live between two cultures and two epochs. I have a little house in Mexico City, and one in New York, separated from each other by a thousand light-years in terms of culture. I also spend time in California. As a result, I am a Mexican part of the year, and a Chicano, the other part. I cross the border by foot, by car, and by airplane. My journey not only goes from South to North, but from the past to the future, from Spanish to English, and from one side of myself to another.

My experience is not unique by any means. Thousands of artists of color in the U.S., Canada, and Europe are currently crossing different kinds of borders. And as they do it, they are making a new kind of art, an art of fusion and displacement.

I am a writer in Mexico, where writers are respected and listened to, and a performance artist in the U.S., where writers are marginalized. I choose an epic tone for both my writings and performances for I believe that the contemporary Latin American experience, framed by diaspora, economic despair, police harassment, and cultural exclusion is of epic dimensions. I crisscross from the past to the present, from English to Spanish, from the fictional to the biographical. I fuse poetry, sound and text, art and literature, political activism and experimentation. My works are simultaneously essays and manifestoes; performances and social chronicles, bilingual poems and radio pieces. In them I try to exercise all the freedom that my two countries have denied me.

Carlos Fuentes has said that the political hope of our continent lies precisely in the cultural models developed by its imaginative writers and artists. The great challenge is how to transfer these models into the political arena. If we want to be makers of the culture of the 1990s in a country that constantly pushes us to the margins, we have to fight constantly for the right to have a public voice.

We must also challenge the anachronistic myth that as "artists of color" we are only meant to work within the boundaries of our ethnic "communities." Our place is the world and our "community" has multiplied exponentially. In the 1990s, I feel a strong kinship with everyone in this and other continents who is trying to find new ways of interpreting the dangers and changes of the times.

Gran Fury is a collective of AIDS activists. Together we make artwork which addresses the political and social underpinnings of the AIDS crisis. We hope to increase awareness of the prejudices, inequities of class and race, and the politics of power and economics which contribute to and define the nature of this health care emergency. By identifying the problems and exposing these factors to scrutiny, we add information to the public debate about AIDS. Through public pressure, governments may be persuaded to take action.

Many of Gran Fury's members are gay, many of us are male, many of us are white. Not all of us are artists. All of us have felt our lives affected by the AIDS epidemic, which has led us to our activism.

Gran Fury uses the access and money provided by the art world to mount public information campaigns. Our work often appears on buses and subways, billboards and posters, stickers and bus shelters. It is often disguised to resemble the advertising which people are used to seeing in these locations.

People are influenced by what they see. Public images and public words, from advertising to the arts, are groupings of cultural ideas. Every package design, every building advertisement we glance at is, to some extent, propaganda.

We are supposed to believe what we are told—for instance, that the government is doing everything it can to fight AIDS. Since Gran Fury questions the truth of this belief, we replace it with guerrilla information, information which seizes the voice of authority. Inserting our message into public spaces is one of the ways of influencing public debate in this country. That is why we "advertise" our political ideas, why we choose to project them in public spaces. Art is only important to us insofar as the techniques of art help to attract and hold the viewer's attention. The seductiveness of well-turned phrases or good graphics can speak by using the "look" of authority. The message, which is the true content of our work, is what is most important to us.

Times of crisis stimulate a collective response. Since collective decision-making more comfortably leads to collective action, and collective action is needed to end the AIDS crisis, Gran Fury works collectively.

Because of the many issues and groups affected by AIDS, individual voices are inadequate to paint a full picture. The challenge of many voices forces us to analyze our own understanding of the political and cultural meanings of AIDS. With more voices contributing to the final product, it is likely to ring true for a larger audience.

Our collaborative process begins with lengthy conversations about which issue or strategy we want to tackle. Once the issue or audience is agreed on, we haggle over the language and images of the piece, discussing the politics and/or tactics involved. These discussions may last weeks, occasionally months. When the content has been decided upon, we begin production. Ordinarily, the production is managed by a few members, although participation is never closed to the full membership. Tasks are distributed according to resources and areas of expertise.

The collaborative process is arduous, time-consuming, and occasionally painful. The disadvantage of our particular collective is that we do not fully represent the spectrum of the communities affected by AIDS. Much time is spent discussing this reality. The women and people of color who work within our group are frequently put in the position of having to speak for their entire community. To expand the scope of our voice we have done several collaborations with groups working within other communities affected by AIDS.

Group Material

Founded in New York City, 1979
Work in New York City

Group Material is made up of a core group of individuals which has included Doug Ashford, Julie Ault, Karen Ramspacher, Félix González-Torres, and Tim Rollins, among others. We collaboratively organize art exhibitions and projects that address socially relevant themes and issues. Group Material was founded in 1979 and continues to operate from New York City as a home base, producing exhibitions there as well as in other parts of the country and occasionally abroad.

Group Material rejects the traditional notion of the artist as lonely outsider. As artists, we see ourselves as vital participants within society. We want an active rather than a consumer role in the making of our culture. We are interested in using aesthetics and visual culture to convey meaning and suggest alternative ways of imagining society.

Group Material produces temporary exhibitions and projects rather than art objects. Our exhibitions question accepted notions of what art is, who it is for, and where it should be seen. By combining fine art, mass-produced objects, television, and artifacts, we expand the definition of art to include a wider array of cultural production. These diverse materials are installed in a precise exhibition design which allows for connections to be made between the various elements. The exhibitions function as forums which encourage and express diverse artistic approaches and points of view. The whitewashed representations painted by dominant culture and its institutions advance specific social and political agendas and exclude others. Group Material presents a broader and more inclusive picture of society through represention of cultural diversity and the overt investigation of social and political issues. Above all our work is influenced by a process of collaboration—among ourselves and with society at large. One of our earlier public collaborations, *The People's Choice,* invited people in our neighborhood to contribute what they considered a "valued object" from their own homes. The resulting exhibition was a collective portrait of the block that included personal mementos, religious icons, folk art, reproductions, and original works of art.

We began working collaboratively to extend the sense of community experienced in school. Once out of school, we did not want to allow competition and economics to determine our motivations and how we made art. Ideally, collaboration can be an experience of learning from one another—of listening and sharing perspectives and ideas. One advantage of working as a group is that you have the opportunity to test your ideas through discussion and (often) argument. An idea develops and mutates with collaborative process, yielding something that could not be conceived by an individual. The process of discussion that occurs is time consuming and often difficult as we need to set aside individual egos in favor of the group identity and purpose. In such a situation one learns to listen intently and respect other people's ideas, opinions, and agendas.

Our projects are made for a variety of audiences. Some projects such as *Inserts,* a booklet consisting of ten artists' pages that was inserted into 85,000 copies of the May 22, 1988, Sunday *New York Times,* addressed a broad audience in a random manner. Exhibitions in a particular space, such as *AIDS Timeline,* an installation which included objects from popular culture and information related to the AIDS epidemic in its political and economic context, are intended for viewers visiting a museum setting. A museum audience encompasses a wide range of people, with an equally wide range of interests and interpretive powers. We make our projects with a sense of expected audience in mind, but have learned from experience not to stereotype viewers.

As artists, we value our activity as personally rewarding. It provides us a process of investigation, critique, learning, creativity, and growth. And we value our artistic practice for the opportunity to engage in an exchange of ideas and the ability to make meaning in the public domain. Hopefully we contribute to social change through our work.

My name is Dolores Guerrero-cruz. I am a painter. I was born in Rocky Ford, Colorado, and I'm a Chicana. My mother died when I was three years old. After my mother's death my older sister, younger brother, and I went to live nearby with our paternal grandmother. In 1954 the family left Colorado for Los Angeles. I have kept the name of Guerrero, after my grandmother, who raised me, taught me to be independent and self-sufficient, and helped me to mold my creative spirit. Growing up in my grandmother's home, I was immersed in Mexican culture. My grandmother was from Guanajuato, spoke only Spanish, and served beans and tortillas as the daily staple. Catholic santos were part of my home environment.

The inspiration for my art is drawn almost entirely from my upbringing as a Chicana, from my family life, from children, other mothers, lovers, and Chicano symbolism. I have also been influenced by Paul Gauguin's painting and subject matter. I like the looseness of line and the brightness of Matisse's paintings, and I love the style and colors of Diego Rivera's work.

I create art as a means of self-expression and survival. Since I was a child I've recognized that I have no choice; I have to create art as part of my daily life. Although there have been periods in my life when I've been challenged by circumstances which kept me from painting, I have always managed to return to what I now accept as my calling and my gift. My audience is at once personal and universal. My art is directed toward the Chicano community as a form of positive self-identity and self-imagery, but also speaks to the general community so they may learn about my culture, and women within my ethnic heritage, as well as women in general. My vision and dreams for the future are to use my art to explore and validate the Chicano experience as well as the experience of being a woman in the 20th-century Americas.

I pursue the images that I think will make other people be more conscious of their behavior. I reject society's confinement of women through harassment that restricts our choices about lifestyles. The *Mujeres y Perros* series addresses this harassment of women by men. I depict men as red *perros* or dogs. The women are portrayed in different ways. Each painting has its own story about the woman and her relationship with the "dog." Although not all men are *perros*, I feel that there are just too many that are. Society needs to develop a different attitude towards women. Men need to stop looking at women as though they are merely objects.

Since my childhood, home environments have always been important to me. The *Serape Series* is made up of paintings which depict indoor scenes, the focus of which are colorful Mexican serapes draped over pieces of furniture. These "cultural landscapes" bring up memories of the past and reaffirm our connection to tradition.

Art is an essential element in everyone's daily life. It is impossible to recognize any facet of contemporary society without acknowledging the presence of art. Art is the substance of my existence, the principal vehicle through which I express my emotional, spiritual, and intellectual values. Art is what I do, how I feel, who I am, what I think, how I live my life. Through my art I ask society to understand itself, to risk self-examination, to address issues, attitudes, and behaviors, and finally, to challenge itself to change. I see the gallery or museum as a means to present my art to a larger public, but only the public and my peers can offer a valid critical judgment of my work. I reject the notion that galleries and museums determine the importance of art. Rather, art gives galleries and museums the opportunity to enlighten, in partnership with the artist.

Guerrilla Girls

Founded in New York City, 1985
Work in New York City

We are a group of anonymous women artists from New York City who formed in the spring of 1985 to combat racism and sexism in the art world, using the media and the streets to do this.

We poster the streets with statistics about the inequalities pertaining to the exposure (or nonexposure) of women and minorities in the galleries and museums. We also attack art critics and collectors for not writing about or buying enough work by women and artists of color.

Since we are women artists, we all have experienced discrimination in the art world and realized that our lack of acceptance wasn't necessarily due to the quality of our work, but rather, reflected a cultural dilemma. The art world, which consists of gallery owners, critics, artists, and collectors, is controlled mostly by white males and, unfortunately, shows only a limited scope of art.

We know that art is essential to life, and because people are different and have unique sensibilities and experiences, this is reflected in their artwork. Therefore, it is essential that this range of work be shown and that people have access to more than one kind of art.

We work collaboratively because it takes more than one person to do all that we do. There is no one person in charge. Everyone has equal power. Our ideas are a result of many minds. When an issue arises that we feel deserves attention we toss our opinions around at meetings. These ideas get finely tuned until we come to a group decision.

The advantage of working in a group is that there is a greater supply of information and viewpoints. Because of the support we give each other, working together we are able to channel feelings of powerlessness and anger into constructive actions.

The disadvantage of working in a group is that sometimes it takes longer to get things done because everyone has their own strong ideas.

One of our goals as a group is to create an environment where each individual artist has an equal chance for exposure, regardless of gender and race. Therefore we place high value on the commitment of each artist to her own work.

I am from New York City, one of the second generation of my family to be born and raised here. When asked my nationality in other countries I identify myself as Nuyorquina holding a U.S. passport. My culture is a hybrid, a mixture of Puerto Rican, European, and United States, formed within the pervasive influence of African cultural retention, enriched by contact with communities of Chinese, Italian, Indian, Jewish, Greek, Arab, Korean, and West Indian cultures that coexist in my city.

As a child I always drew and made things and I have never stopped. But it took a while to realize that survival as an artist was possible (it is!) and it has taken time to develop to where I can "visually speak" my own words in my own voice.

I remember drawing as a little girl—faces, eyes (too often blue). I remember making houses of sand and leaves and metamorphosing paper bags into puppets. I remember toys—old enameled metal printed out of register revealing rainbows, the aroma of new pink plastic babies. I remember pins and threads and scraps of fabrics on wooden floors. And drawing stories, infinitely unwinding stories that spread off the edges of paper.

The stories continue evolving, infinite and complex, the images of my vision in frozen moments. Tableaux inhabited by familiar people in places and spaces where perspective is ordered by content the representation of time. They are narratives of memories, comments, connections, explanations, instigations, revelations, and analytical distillations.

I grew up being taught a very narrow, one-sided version of history, an inaccurate, boring myth that excluded my ancestors. I choose to reclaim the past, to explore "history" as "our" story and to work as a visual storyteller remembering and reinterpreting past and present.

I am troubled by the consumer culture in which we live and by the non-thinking conformity it promotes. My response is to be an artist, to think and create and communicate with people. I exhibit in galleries and museums, sometimes selling my work. But I have also created posters for trains and art in the form of street signs and animation to reach different audiences in different ways. Forms change but content and intent are constant in my work.

In a society where art often becomes an investment commodity for the wealthy elite, there often is a tendency to restrict the scope of "appropriate" artistic subject matter.

The subject matter of my work derives from themes which move me—the struggle against racism (here, as well as in South Africa), issues of war, exploitation and ecology, as well as the joys that life offers and the richness of people's cultural heritage and history.

My art also includes working with young people. In my teaching I present options and support my students' searches for self, career, and a place in the world. Even those who don't become artists will be empowered by the creative process.

David Hammons

Born: Springfield, Illinois, 1943
Lives in New York City

I can't stand art actually. I've never, ever liked art, ever. I never took it in school.

I was born into it. That's why I didn't take it in school, because I was born into it. All of these liberal arts schools kicked me out, they told me I had to go to trade school. One day I said, "Well, I'm getting too old to run away from this gift," so I decided to go on and deal with it. But I've always been enraged with art because it was never that important to me. When I was in California, artists would work for years and never have a show. So showing has never been that important to me. We used to cuss people out—people who bought our work, dealers—because that part of being an artist was always a joke to us.

I was influenced in a way by Mel Edwards' work. He had a show at the Whitney Museum in 1970 where he used a lot of chains and wires. That was the first abstract piece of art that I saw that had cultural value in it for black people. I couldn't believe that piece when I saw it because I didn't think you could make abstract art with a message. I saw the symbols in Mel's work. Then I met Mel's brother and we talked all day about symbols, Egypt and stuff. How a symbol, a shape, has meaning. After that, I started using the symbol of the spade; that was before I did the grease bags. I was trying to figure out why black people were called spades, as opposed to clubs. Because I remember being called a spade once, and I didn't know what it meant; nigger I knew but spade I still don't. So I just took the shape, and started painting it. I started dealing with the spade the way Jim Dine was using the heart. I sold some of them. Stevie Wonder bought one in fact. Then I started getting shovels (spades); I got all these shovels and made masks out of them. It was just like a chain reaction. A lot of magical things happen in art. Outrageously magical things happen when you mess around with a symbol. I was running my car over these spades and then photographing them. I was hanging them from trees. Some were made out of leather (they were skins). I would take

that symbol and just do dumb stuff with it, tons of dumb, ignorant, corny things. But you do them, and after you do all the corny things, and all the ignorant things, then a little bit of brilliance starts happening. There's a process to get to brilliancy: you do all the corny things, and you might have to go through five hundred ideas. Any corny thought that comes into your head, do a sketch of it. You're constantly emptying the brain of the ignorant and the dumb and the silly things and there's nothing left but the brilliant ideas. The brilliant ideas are hatched through this process. Pretty soon you get ideas that no one else could have thought of because you didn't think of them, you went through this process to get them. These thoughts are the ones that are used, the last of the hundred or five hundred, however many it takes. Those last thoughts are the ones that are used to make the image, and the rest of them are thrown away. Hopefully you ride on that last good thought and you start thinking like that and you don't have to go through all these silly things.[1]

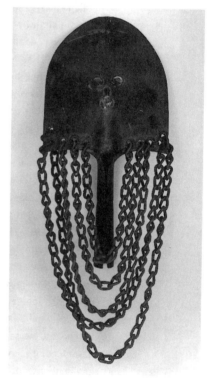

David Hammons
Spade with Chains, 1973
Mixed media
24″ × 10″ × 5″
I started using the symbol of the spade. I was trying to figure out why black people were called spades.... I started getting shovels (spades); I got all these shovels and made masks out of them. It was just like a chain reaction. A lot of magical things happen when you mess around with a symbol.

What made you want to be an artist?

My father made cartoons. Since I was little, I had been doing cartoons, creating characters and stories. In my mind, though, there was a separation between cartooning and being an "artist." When I made the decision to be an artist, I began doing these completely abstract things that were as far away from cartooning as you could go.

When did you decide to go to art school?

I'd been convinced by my parents and guidance counselor. They said that if I was going to seriously pursue being an artist, I should have some commercial art background. I went to a commercial art school, where I quickly realized that I didn't want to be an illustrator or a graphic designer. I quit the school. I went to a huge retrospective by Pierre Alechinsky at the Carnegie Museum of Art. It was the first time that I had seen someone who was older and established doing something that was vaguely similar to my little abstract drawings. It gave me this boost of confidence. It was the time I was trying to

figure out if I was an artist, why and what that meant. I was inspired by the writings of Jean Dubuffet, and I remember seeing a lecture by Christo and seeing the film of *Running Fence.*

How did these artists inspire you?

The thing I responded to most was their belief that art could reach all kinds of people, as opposed to the traditional view, which has art as this elitist thing.

How did you begin drawing in the subway?

I moved to New York City when I was twenty. One day riding the subway, I saw this empty black panel where an advertisement was supposed to go. I immediately realized that this was the perfect place to draw. I went back above ground to a card shop and bought a box of white chalk, went back down and did a drawing on it. It was perfect—soft black paper; chalk drew on it really easily. I kept seeing more and more of these black spaces, and I drew on them whenever I saw one. Because they were so fragile, people left them alone and respected them; they didn't rub them out or try to mess them up.

The subway drawings became a media thing, and the images started going out into the rest of the world via magazines and television. I became associated with New York and the hip-hop scene. which was all about graffiti and rap music and break dancing. It had existed for five years or more, but it hadn't really started to cross over into the general population. It was incredibly interesting to me that it was reaching all kinds of people on different levels from different backgrounds. Then, in 1982, I had my first one-man show in New York at a big gallery.

Keith Haring
Untitled, 1983
Chalk on black subway paper

Did your parents know you were gay from the beginning?

My parents have been so amazing about the whole thing, but in their own way—knowing but not saying anything. I never tried to hide it from them, and they never asked me about it. Because of the work that I was doing, they know that I had turned my life into something good, and that's what they cared about.

Are you emphatic in your belief that people should be open about their homosexuality?

Normal about it. It's not an issue to me. But I think one of the most difficult things about AIDS is what it has done to kids growing up now, who are trying to figure out their sexuality in an unbiased way, because homosexuality has been made to be synonymous with death. That's why it's so important for people to know what AIDS is and what it isn't. There are so few people who are good openly gay role models or just good people who are open about their sexuality. Now there *has* to be openness about all these issues. Kids are going to have sex, so help them have safe sex.

How has having AIDS changed your life?

The hardest thing is just knowing that there's so much more stuff to do. I'm a complete workaholic. I'm so scared that one day I'll wake up and I won't be able to do it. The thing about all the projects I'm working on now—a wall in a hospital or new paintings—is that there is a certain sense of summing up in them. If you're writing a story, you can sort of ramble on and go in a lot of directions at once, but when you are getting to the end of the story, you have to start pointing all the things toward one thing. That's the point that I'm at now, not knowing where it stops but knowing how important it is to do it now.[2]

I have had the good fortune to have been born a Tuscarora Indian and a member of the Beaver Clan. My identity is an inheritance from my mother and her female ancestors. My father is a Mohawk of the Turtle Clan, and is now a full-time artist after a thirty-year career as an ironworker. As a young Indian boy, my heroes were ironworkers. My father and brother followed the steps of Iroquois men over the last century to make a reputation and a living building this country. To be an Indian meant to be an ironworker. It also meant to be in the city. I was born an urban Indian of sorts, living in Buffalo, New York, until I was five years old.

Then I became a "suburban" Indian, living on the largest fresh water island in the Great Lakes, between Buffalo and Canada. It was a good place to grow up, even though we were the only Indians in that community. It was an experience that helped to make me more aware of my unique identity, or rather, more aware of what I was not. We could roam the woods, fish, and swim in less polluted waters that we have today, and we were destined to become ironworkers.

I started working for my dad, Stan Hill, when I was sixteen. My first experience was a small railroad bridge in Rochester. We were met by two Mohawk ironworkers and worked hard all day to finish that small bridge. I carried my camera with me and took photographs of the ironworkers. In a sense this too was a family tradition. My dad often photographed his job sites. I grew up looking at his old photo album with tiny black and white photographs of Indian ironworkers climbing around, clowning for the camera. They were my cultural heros. They were the Indians I knew.

At sixteen I also became interested in photography as an art form. I had always been an artist, from my first days in school, and became an art major in high school. With photography, I could show my own view of the world, as an Indian individual. In the summers I continued to work as an

ironworker, and tried hard to please my dad, but after my brother fell, the work seemed less heroic. Men would get killed on the job and my dad would be sad for weeks. It began to seem more like a punishment for being Indian rather than economic necessity.

I decided to go to art school after high school and was a bit afraid to tell my dad, so I had my art teacher come to visit and explain. My father, in one of his many surprising moves, told me to be the "best damned artist I could."

I make art because it is something that I have to bring to the world so that Indians can be better understood as real people of today. The prejudices and racism that I faced as a kid made me determined to let people know that I am an Indian, and motivated me to accomplish something in the world. The major influences on my art are my real-life experiences, my extended family, and the perspective that I have on being an Indian in the modern world.

Materials for my work come from what I have assembled over the years, and I often sit and study them at great length before a work is begun. I collect other art as a source of information and inspiration. I swing back and forth from traditional crafts, to photography, to painting, to writing. I like many forms of expression. I particularly like to recycle objects that surround us and place them in a new setting. I like to know how something is made before I can paint it, or photograph it. It becomes more real to me.

My influences have been Ernest Smith, a Seneca painter who taught me that painting has a role to play in the education of the Indians of the future; Jesse Cornplanter, Seneca artist whose work taught me that we have a grand tradition in storytelling and that the visual artist has become the storyteller of this generation; Huron Miller, Onondaga traditionalist who has taught me about ceremonies and the Iroquoian way of thinking;

Handsome Lake, nineteenth-century Seneca prophet, who showed me that everyday activities are our culture; Walker Evans and Robert Frank, who encouraged me to photograph my own people; and Edward Hopper, whose lonely visions of American life made me further seek out Indian ways of living.

How does society relate to my art? I try to provoke thought, to challenge stereotypes and to show Indians as they exist, not frozen in time. Americans are educated to think in strange ways about Indians. They often carry little or no information but what they learn in comic books, cartoons, Hollywood films, textbooks, and other transmitters of disinformation about Indians.

Context for Indian art is essential, but Indians have to define and explain that context, not anthropologists and art historians. The underlying philosophy is not earth, the buffalos, the eagles, or the circle. The underlying principles from which we need to approach Indian art are that Indians exist in the modern world, maintain a viable culture, and have successfully coped with change. Our tradition is creativity; otherwise we would have disappeared many moons ago.

I am not a caveman. I do not live in a bark longhouse. I was educated by the white man. I am not Christian. I am not a traditionalist. Along with many generations of Indians I am the result of a social experiment conducted on Indians since 1492. Despite many mutations, I am still an Indian. We are still Indians. We have survived and are creating evidence of our existence. We make art.

Born: Susanville, California, 1945
Lives in Susanville, California

My personal experience is directly responsible for the statements in my work. My art deals with cultural survival within my community. The largest part of my work is directed to the non-Indian audience in order to generate awareness and concern for the Earth and our future generations' survival. This communication also addresses indigenous rights as well as the native woman's experience, thereby bringing the art back to the personal.

My concerns evolved while growing up and going to public school. I often wondered why very little history of Native Americans was taught. I felt great racism during this time, and in asking myself what happened to the Indian people, this became a catalyst for my work. The accessibility of the print medium fulfilled the need to inform both my community and the non-Indian world. My first public work as a teenager was to design flyers and posters announcing to the community the celebration of the annual Spring Bear Dance. I saw art then and now as a means to disperse information and as a tool for education. My mural work today addresses the cultural survival of my community.

The various concerns addressed in my work are interrelated. Sacred places of native people are being destroyed by industry, by recreation needs, and by the government. Nuclear dumpsites are being planned for the purpose of economic development. My art makes possible visual experiences that communicate between the Indian world and the non-Indian world. This visual communication blends philosophy, world view, and stereotypes of Indians, all presented in contrast to often-held preconceptions of my community.

Elizabeth Layton

Born: Wellsville, Kansas, 1909
Died 1993

When I took my first contour drawing class at age 68 the teacher asked us to tell who we are and what we want to be called. I said, "My name is Elizabeth Layton, but everybody I know your age calls me Grandma." So I still sign my work Grandma Layton.

For most of my 83 years I've lived in Wellsville, a little town in a farming community in Kansas, near the center of the United States.

The people here had families who came to the United States three or four generations ago, mostly from Northern Europe. I felt somewhat cheated because we had few opportunities to know friends of other cultures. There was usually one family of Mexicans in town, otherwise no African Americans, Orientals, Native Americans, or other minorities.

It is a wonderful feeling to make art. I love doing it. I make art for my own satisfaction and quite often other people like it too. That's a plus.

Art is very important to me. It puts my life in balance.

My art is not traditional because of the method, contour, that I use. When you draw by the contour method you look at your subject, but never draw while looking at your paper. The result is a caricature, a cartoon.

My art is my life as I see it and set it down in lines on paper. Everything I draw is very personal. In art the personal becomes the universal. I draw my feelings, and they are the same as your feelings. The same as the feelings of a stranger miles away. Common feelings connect us all.

"Write about what you know" is often given as a good rule for a writer. This same rule could apply to an artist. If the artist offers his own world it enriches the world of his viewers.

I am an old woman—this is what I draw, because this is what I know best, along with my family and my surroundings.

Born: Vietnam, 1968
Lives in Brooklyn, New York

I was born in Vietnam and lived there until I was eleven. In Vietnam, I was taught Eastern history, the values of Confucius, and Buddhist religion. The other half of my life was spent in the United States, where I was educated in Western educational institutions. Here, I learned Western history, philosophy, religion, and art. From television, I absorbed popular culture. So who am I? I am a product of both the East and the West. My culture is a hybrid of both cultures.

One of the interesting aspects of my work is the weaving technique I use. My aunt, who made beautiful grass mats, taught me to weave. Although it is a traditional practice, it is hardly a uniquely Vietnamese tradition. Weaving, from baskets to rugs, exists in all cultures. When I decided to incorporate weaving in my work, it was not just a reflection of my heritage. The weaving technique in my work is derived from the idea of revealing the interweaving and ultimate forcing together of two different cultures.

The first time I created something I did it because it was fun. As I get increasingly involved, making art becomes more and more a way for me to conceptualize, visualize, and communicate how I think and feel about what is important to me. The issues in my work come from many aspects of my life. Sometimes the issues I choose are extremely personal; sometimes I tackle societal issues that I care about, issues that confuse me or interest me. Making art provides the time and the means to work out solutions for myself.

Maya Lin

Born: Athens, Ohio, 1959
Lives in New York City

Born in 1959, I was raised in Athens, Ohio, a small rural town. Both of my parents were faculty members of Ohio University. I have an older brother who is a poet.

Originally my parents are from Beijing and Shanghai. I am a first generation Chinese American. Culturally, I was one of a few Asian Americans raised in a predominately white midwestern town.

I am an artist/architect. Art and architecture are my way of communicating—through form and not words. The work is felt/experienced through the manipulation of space and surface.

The work ranges from public to private. The architecture, due to the collaborative relationship between architect and client, is public. The sculptures I make in my studio are private—for my own personal exploration.

All of my work is site specific. I am interested not only in the physical nature of the site, but also in the psychological indications. A common thread that runs through all of my work is my interest in the empathic response on the part of the viewer.

My approach is intuitive and experiential, not theoretical. Architecture is a manipulation of people through space. Through changes in light, materials, scale, and texture I set up a series of experiences that interact on an unconscious level.

Earthworks, done by artists such as Robert Smithson, Michael Heizer, and Richard Serra, have been influential on my work. In searching for an understanding of the relationship between the land and the built form, the architecture of Louis Barragon, Louis Kahn, and the gardens of Kyoto, Japan, have been extremely important.

In both my art and architecture, I use natural inorganic materials such as stone and wax. Color and texture come from the material itself, they are not applied. Through the use of space, light, and surface, I engage the viewer and give a new or different perspective.

Born: San Diego, California, 1942
Lives in San Francisco, California

Yolanda M. López

I am Yolanda M. López. I was born in San Diego, California, during World War II. I was raised in Logan Heights, which is the "Mexican Part of Town." My mother had three girls from her first marriage at twenty-two and was divorced before she gave birth to her third child. I was the oldest of three girls. We lived with my maternal grandmother and grandfather and assorted uncles until I was eleven years old, when my mother married for the second time.

My mother worked as a presser in various dry cleaners and laundries. Eventually she got a job at the Naval Training Center in San Diego where she worked for twenty-six years in the tailor shop altering uniforms for the new recruits.

Both of my grandparents were born in urban Mexico. My grandfather (Senobio Franco) was born in Guadalajara to an entrepreneurial family of small shop keepers and my grandmother (Victoria Fuentes) was born in Mexico City to a family of flower vendors in a suburb called Santa Anita, which had floating gardens like Xochimilco.

My grandfather worked as a tailor; my grandmother was a housewife. Like many people of my generation I remember growing up with the unspoken but understood hierarchy of men's and women's roles, and whites' and Mexicans' places in society. San Diego, which was economically dependent on the military industry, was a very oppressive environment to grow up in.

My grandparents spoke to me in Spanish and I responded in English. My mother only spoke to me in English. Since Tijuana, Baja California (Mexico), and San Diego share a border they have always had a strong influence on each other culturally and economically and I was obviously influenced by both.

Why do I make art? And who do I make it for? I believe I consciously decided to be an artist twice in my life. The first time in my early teens when I was pestered by adults to name what I was going to be when I grew up. I said at the time I wanted to work for Walt Disney—the magic and lushness of animated images was very seductive—or I wanted to be a costume or set designer for the movies. The second and final time was when I was in high school near graduation. At that time I really wanted to be a history professor in an Ivy League college or a historical consultant working for Hollywood. But since my reading and writing skills were not very good I decided to do what I did best—to draw. I had no idea how to go about studying for a career in art. In my senior year I had tried to get into mechanical drawing or drafting but was turned away because girls were not allowed in those classes. I didn't know how to start, although I did know art was taught in college. With the help of a teacher I enrolled myself at a junior college.

I should also mention I had no desire to marry right out of high school, and although I had many crushes on boys and several boys were friends, I was never part of the dating scene. I ran with a bunch of boys and girls who were multiethnic (including whites) and were considered what we call nerds today. As painful as it was for me at the time not to be one of the "pretty" girls at school, I think my friends and I had more fun through group dating and sharing our varying interests than some of the "popular" crowd. I know many of the interests I developed in high school still influence my work as an artist today.

I guess I still haven't answered why I make art. There is no rational reason for it. On the one hand, I need to. And on the other hand, I like it. Making art for me is the way I practice being a good citizen.

Who do I make art for? Well, of course every piece I make I do for myself, because it interests me. Beyond that I make art for other Chicanos, especially those I know, California Chicanos. It is with them I share the jokes in my work, our common anger and rage, our sense of what is kind and compassionate in a world fraught with irony and injustice.

Art is important. The artist is the person in society who dreams out loud.

James Luna

Born: Orange, California, 1950
Lives in La Jolla Reservation,
North County San Diego, California

When I am asked, "Who am I?; Where do I come from?" the answer tells what separates the Native Tribal cultures of America from others. I come from here. I am Payoukeyum (Luiseno Indian) from the La Jolla Reservation in the North County San Diego, California. Our creation story begins and ends here in this land; I am from nowhere else.

American Indian is not a term I like. It is incorrect, as we are not peoples from India, so I use the term Native Tribal peoples and cultures. My culture is tied to the environment in which my people survived and progressed. My tribe is similar to, but also different than, the many tribes that inhabited this land of diverse cultures and environments.

One of the primary reasons I make art is to inform others about Native peoples from our point of view—a view which because of history is rich in native cultural tradition, and both influenced by and influential in contemporary American society. I truly believe that Native Tribal peoples are the least known and most incorrectly portrayed people in history, media, and the arts. I want to change those perceptions.

I have coined the term "Contemporary Traditionalist Tribal Artist" to describe myself, as what I have achieved in some of my major works has been to incorporate cultural traditions from both the Native and the contemporary societies in which I live here in Southern California. There is not one tribe in North America that has not been touched by Western society. We are today a product of both cultures and need not be one or the other. I am a college graduate, an education professional, but I also make an effort to learn and practice Native Tribal culture and traditions in my everyday life and pass that knowledge on to my children.

In my multimedia installation and performance art work, I feel I have found the mediums with which I can best express my cultural and personal concerns. I use sounds and images from my rural reservation home; I make use of Indian music and story; and I use photography and video to enhance and document the work. I have broken with traditional Native forms only to present them in a contemporary way.

Born: San Jose, California, 1943
Lives in San Francisco, California

I am Amalia Mesa-Bains. I am the first generation of my family born in the United States. My parents were born in Mexico but came to this country when they were very young. I have spent all my life in California and I describe myself as a Chicana—an American of Mexican descent whose identity was formed in the Chicano movement of the 1960s and 1970s. I knew I wanted to be an artist from the age of five and my parents were very helpful in providing me with art supplies. My education as an artist continued through high school and included a college degree in painting. Most important to my development as an artist was my involvement with other Chicano artists. We came together to form our own galleries and to create art for our Chicano communities.

My own work as an installation artist comes from my childhood experiences watching my grandmother keeping her home altar and watching my godmother keep her yard shrine. In addition, the reclamation of cultural and spiritual practices of Day of the Dead, the commemorative celebration of ancestors, has been an important influence on my work. My early altars were community celebrations that served people, and I have continued using elements of the altar in my current installations. I work in specific places with ephemeral or impermanent creations which often tell a story about my personal and cultural life. I believe that art can bring insight to the social world around us and at times can even heal the spirit. The Southwest part of this country was once part of Mexico and the larger world of the Americas, and because of this often overlooked history we as Chicano artists strive to bring back the legacy of our culture. My own artwork continues to be dedicated to the history and life of my cultural community. As a Chicana my work is tied to a sense of advocacy. My artwork is only one of the ways I serve my community and it is the most satisfying and important part of my life. I believe that artists are a special group in any society and that artists who are seeking to improve the human condition for their communities are driven by a sense of purpose that gives meaning to their art.

Kay Miller

Born: Houston, Texas, 1946
Lives in Boulder, Colorado

Many artists create "art" out of "life." For me, art has created my life. My art helps me see more clearly who I am, how I act and feel, as well as what I value and desire in life.

The symbols I use most frequently are inspired by nature. Although I grew up in the urban environment of Houston, Texas, my family was very close to nature. My parents were raised in rural Texas and longed to maintain their connection to the earth. We lived near the port of Houston where all the ships came in so I saw and met people from all over the world. We cultivated tiny gardens that were like urban jewels and sometimes fished and trapped our food. We bought our vegetables and fruits from a man who still used a donkey cart.

In my works I usually use two different forms (for example, a cross and an ear of corn). Sometimes these images relate harmoniously, sometimes they are in conflict or confrontation with one another. The paintings are thickly painted and very heavy (some can weigh up to 150 pounds). The thickness of the paint makes the works appear fixed, but the richness of the texture conveys movement and energy. These contrasts suggest the range of possibilities in life itself. I make these paintings so that the viewer (and I) can learn from the different meanings we give to the relationships between forms.

I usually spend about three years on each of my paintings so that art making becomes a meditative tool through which I am able to reflect upon myself and the world. Through art, I am able to reexamine my existence on a daily basis, envision my future, and consciously decide what to bring into my life (while also being alert to the unexpected). Recognizing my own inner voice helps me harmonize and balance with the spiritual energy that is part of every other living thing.

Born: South Korea, 1953
Lives in Los Angeles, California

My name is Yong Soon Min. I am referred to by other Koreans as a "1.5 generation" Korean American. This means that I fit somewhere in between a first generation Korean who is an immigrant and a second generation Korean American, one who is born here. Even though I was born in Korea, the fact that I immigrated as a child and have lived here most of my life renders me too "Americanized" to be considered a "full-fledged" immigrant. I find that as I grow older, there develops a more complex and delicate relationship between Korean and American ways of being, one that is constantly shifting and mutable. The cultural identity stemming from this situation is necessarily hybrid, a fluid mix of multiple influences and perspectives.

Art making for me is a process of discovery and learning about myself and my relationship to the world. This art-making process also involves my desire to communicate and to share this exploration and understanding with others and thereby complete the dynamic. I make art for an audience that includes myself. Ideally this audience is inclusive of everyone and anyone. There are some works which will hold particular relevance to certain audiences due to their culturally specific information or language. But this should not exclude other people who are not equally as knowledgeable from appreciating the work in other ways or from making an effort to learn. A work is successful in my estimation if it stimulates a response ranging from mere curiosity to genuine concern leading to a desire to learn more.

My art making has evolved with time from being initially an extremely enjoyable pastime to becoming a career pursuit, to being at this time an essential tool for processing knowledge and experience. It's as vital and integral to my life as other life sustaining activities. What I do as an artist involves not just the creative production but other related activities of organizing and networking and writing—in other words a more holistic cultural life—which I hope may effect some change in the status quo.

My work is primarily content driven. I am interested and inspired by art that comments on the human condition in which both the intellect and the heart are engaged and challenged at the same time, in the Brechtian mold. I was particularly influenced in my formative college years by film makers such as Jean-Luc Godard who stretched the possible relationships between the didactic and the metaphoric, the poetic and the political.

My subject matter is drawn primarily from history—official documented history and my own—a juxtaposition that often entails a critique or a contestation of existing power relationships.

My materials are at the service of the idea or the content of the work. I have no particular adherence to any media. Due to my usual lack of or low-level funding, I often choose the most economical means to realize a work which, for instance, might mean using photocopy instead of photography. I am not concerned with preciousness or the commercial viability of the work. Rather, I'd like the work to convey a certain humble integrity and a resourceful experimental vigor.

There are all kinds of beauty. The concept of beauty is highly subjective and in many cases, culturally determined or informed. I regard truth and integrity as compelling equivalents to beauty. Any work that reflects an honest endeavor and effectively conveys the creator's heartfelt aspirations and experience is meaningful, rendering concerns about its originality to be irrelevant. Originality is a greater issue in the commodification of art, not in the creation and appreciation of or the respect for it. The concept of originality, like the Euro-American obsession with individuality to which it is closely related, is a prevailing dogma in the contemporary mainstream culture here that needs to be questioned and contested.

Lorraine O'Grady

Born: Boston, Massachusetts, 1942
Lives in New York City

My parents both came from Jamaica in the 1920s. They met each other in Boston, at the tea table during a cricket match in which one of my uncles was bowling. Although the postwar period was that of the great West Indian migration, most of their compatriots had settled in Brooklyn. In Boston, the West Indian community was barely enough to establish and fill one Episcopal church, St. Cyprian's.

At some level, I understood from the beginning that as a first-generation black American I was culturally "mixed." But I had no language to describe and analyze my experience: not until years later would words like "diaspora" and "hybridism" gain currency for the movement of peoples and the blending of two or more cultures.

As a teenager with few signposts and role models, I had to negotiate between: (1) my family's tropical middle- and upper-class British colonial values; (2) the cooler style to which they vainly aspired of Boston's black brahmins, some of whose ancestors dated to before the Revolution; (3) the marriage of Yankee and Irish ethics taught at the girls prep school where, after six backbreaking years that marked me forever, I was the ranking student in ancient history and Latin grammar; and (4) the vital urgency of the neighboring black working-class culture, constantly erupting into my nonstudy life in spite of all my parents' efforts to keep it at bay.

I rebelled against the conflicting values instilled in me. Looking back at this and at my later efforts to reconcile them, I see my experience not as unique (however arduous it may have been), but as increasingly typical. Soon we will all have to become bi- or even tricultural.

My work has been affected less by the details of my cultural background than by my process of trying to understand them. Art for me is part of a lifelong project of finding equilibrium, of becoming whole. I have had to learn to simplify while giving complexity room to breathe. Like many bi- or tricultural artists, I have been drawn to the diptych or multiple image, in which much of the important information occurs *in the space between.* And like many, I have done performance and installation work where traces of the process are left behind. In my work "miscegenation," the pejorative legal word for the mixing of races, functions as a metaphor both for the mixed media I employ and for the difficulties and potentialities of cultural reconciliation.

I believe that every culture is complex and differentiated by its history and that artists arrive at the universal only by attending to the specific, which is inevitably ambiguous. That is why I object to such concepts as "the authentic black experience" and "the spokesperson." I want my work to be an example of difference—not of difference *between* cultures, a theorem which should be obvious by now, but of difference *within* cultures. The latter idea remains unnecessarily embattled with respect to black culture, seen often as a monolithic whole. But complexity is true to reality, just as there is no inherent conflict between the beautiful and the political.

The artists and writers I have learned from are Jean Rhys, Flannery O'Connor, Toni Morrison, Man Ray, Adrian Piper, Rene Magritte, and John Heartfield. I am also grateful to such neo-colonial and diaspora critics as Stuart Hall, Kobena Mercer, Coco Fusco, Homi Bhabha, Trinh Minh-ha and Paul Gilroy. They have helped me contribute to the reclamation of black female subjectivity and have given me models for life in the 21st century.

Born: New York City, 1946
Lives in Boulder, Colorado

I am a 49 year old woman, a mother, feminist, and artist who has worked in photography, film and related media, and public art. I was raised in the woods of upstate New York on a small lake by parents who were very reclusive. The sign on the dirt road which led to our house read: "Private Drive. Keep Out. This Means You." Underneath was a picture of a skull and crossbones. My culture? Well, I am Caucasian and some of my parents' ancestors were Huguenots, but I would say that the culture which most influenced my early life was a sort of "North American School of Rugged Individualism."

I make art because it is a way of communicating with other human beings. For me, art making is the best way to express the ideas that form in my brain. I like what Buckminster Fuller said: "You either make money or you make sense." I think art is a good way to make sense.

Art is about creating meaning and I think meaning lies in the relationships between things. For me single images, like glimpses of life from an elevated train, are poignant, but have little to do with understanding. A long time ago I began to construct meanings by combining images. First I combined photographs. Then I began to put pictures with all sorts of other things: words, audio taped stories, animal noises, gravestones, eggshells, wedding cakes. Film with food. One's experience always exceeds one's vocabulary, so art making is a way to name the unnameable or make visible something that wasn't visible before.

My work provides alternative views of history. Most history books tell about presidents and governors, laws and wars, and the comings and goings of usually white, male, famous people. With the public mural *Colorado Panorama: A People's History of Colorado,* I tried to do something else. Kit Carson is represented in my mural but so is Juan Carson, Kit's Native American captured servant, and there are miners and labor activists and farmers and teachers, suffragists and immigrants, nurses and Vietnam vets, Black Panthers and Chicano activists, and people who died from AIDS. And there are as many women as men, which is, of course, the state of affairs in the world but you would not guess it from reading any official history of any place.

Images are powerful and when people have images of themselves this gives them power. That, for me, is the main reason censorship is so odious. It allows one group to dictate what can be represented by everybody else.

Jolene Rickard

Born: Western New York (Tuscarora), 1956
Lives in Sanborn, New York

My name is Jolene Rickard and I am Turtle Clan from Tuscarora. Tuscarora is located in western New York. Originally the Tuscarora were from "the land of the floating pine," also known as North Carolina. We were forced to migrate in the 1700s to survive. The Iroquois people adopted us into their confederacy and we currently have the role as a "younger brother."

It is important for me to identify my clan. That is how my people organize themselves. I am a member of the Turtle Clan by birth and received my clanship from my mother. This type of inheritance is identified as matrilineal. Amongst my people it means that land ownership and material possessions pass through the women of the clan. Property rights and one's identity as defined by your mother's family assured the status of women in our communities. Although seriously deteriorated today, the voice of the people, the clanmother and the chief's council negotiate their way through time by the process of consensus. My photography is, in part, a statement about securing the role of the women in our communities as one source of strength for the future.

I make photographic statements because it helps me to remember and shape our identity as Indian people. My people have been involved in a type of cultural reconstruction for the past 300 years. This has meant that we adopted the specific cosmology of our brothers and sisters of the Iroquois. My photographic work becomes a path for me to put the threads in place that were once Tuscarora. These connections linger in the nuance of our daily life waiting to be recognized. Mine is not an idyllic notion of a romantic past. Instead it is an acknowledgment that my people, as well as other indigenous people, have the oldest surviving continuous cultures.

Art, as it is defined by Euro-Western society, is a fairly recent expression in Indian communities. I make a distinction between what my people created prior to contact and post contact, after Europeans invaded, settled, and engaged in trade within our territories. Prior to contact Indian people did not have a specific word or category that was understood as "art." But the process of "thought making" was integral to all indigenous people. The role of the "made object" was significant in both the political and spiritual realm for Indian people. If one is to create a cross-cultural comparison it would be correct to say that "art" was integral to the wellness and continuity of our cultural life.

I believe one has to envision the future to have one. I can not sit back and lament about what could have been if we were not invaded by imperialist cultures. But I can imagine promoting and shaping the acceptance of difference. I can help my people identify and reject values which feed the idea that Europe is the "center." My art can help people find the questions and look for answers. My images are made with an Indian audience in mind, but I believe they also appeal to those people interested in the thought of indigenous people.

My work acts as a first warning signal: wake up, look hard now, what do you see? Is your life really better today because of better gadgets? Contrastingly, sometimes I concentrate on exposing glimpses of our precious truths. In a way all of my images are marks of resistance and continuance at the same time. The narrow slit my people slid through in the face of genocide deserves a watchful eye. The lens directs my attention to the prospects and deterrents for our survival. I am reminded of something my father's brother, my Uncle William, said: "Indians are the canaries of humankind, when we go, it's too late."

Depending on how one defines "society," the meaning of my work shifts. In the context of Indian or indigenous communities my work is a reflection of

Tuscarora cultural continuity and interruption. If you look at my work with "Eurocentric" eyes it may seem distant. But I think on a human level my work speaks to the fair-minded, to people who are looking for paths to live a healthier, saner, more honest life. Those people have stepped off society's pyramid and joined the circle of life.

Societies organized as pyramids, which includes most nation-states, are based on the premise that it is permissible for some to have much and others to starve. Societies based on a more circular concept of organization have a focus on feeding, providing shelter, and caring for all people in the community. If you lost your job, couldn't find work for over a year, had children to feed, lost your home, and were put out on the street, which society would you want to be a part of? I make art to make people think about our options.

Faith Ringgold

Born: New York City, 1930
Lives in New York City

My name is Faith Ringgold and I am an African American woman artist. I identify myself that way because art is a discipline which is communicated out of experience and also uses visions or visualizations. It is very important that artists know how to see. As a matter of fact artists are the ones who do see, like musicians are the ones who hear.

There are specific cultural characteristics or attributes that affect the work of any visual artist. I believe that being an African American woman artist, my classical art form is not Greek, but African. People do art out of their own experiences. They do art that looks like themselves. So I, being an African American, am doing art out of my own experiences. My experiences are that of being black and a woman in America. I also go back to Africa for the basis of my art influences. I am influenced by the mask. I am influenced by African designs. I am influenced by the way the women used fabric to create appliqués and pieceworks which later became the foundation for quilt making in America. I began making fabric pieces in the 1970s while searching for a distinctly "woman's art." I began to look at what African women did and I found all of this work with fabric. Of course, it is not just African women who work with fabric, but certainly they are leaders in this area. I am fascinated by all those things. It gives me a sense of pride to use African art forms in my work.

I have made art all my life, since I was a little child. I always had dreams that I could change everything. As a child, I felt that I had the power to reverse a situation. Today I feel that speaking up for ideas can improve the lives of people and is a way to make change. Speaking up for social change is vital, necessary, important, and should be done. I have dedicated my career as an artist to doing that. However, I don't feel that everybody has to do that. I wouldn't want to be dogmatic about it and say that it is not art if it doesn't do that.

I would like, I guess, still, to change the world. I don't think art will do it, but I am still trying. It makes me feel better that at least I have said something, I have made an attempt. I don't believe that art creates revolutions. Anybody who wants to create a social revolution should probably do something else. But I feel that artists have power in having their work looked at, understood, and made available to people over long periods of time. In other words, they can document a historical period; for example there was a lot of art that came out about the Gulf War, and that is important. If all artists just ignored the history of their own time, there would be no one to give us the feelings we need. That is one of the real purposes of art, I think.

It is very difficult to be an artist for a lot of reasons, though being an artist is really like being anything else. You still run into the same problems as you run into in the rest of the world. There are structures of the art world that are very difficult to get into if you are a woman, a person of color, or poor. These classifications place you outside the mainstream. In order to create art that enjoys an appreciative audience and a market, you must work very hard. You must inspire a good many people to be interested in your work. It is a very complex business, very difficult, and I might say very racist and very sexist. I think students need to hear that because most people don't think that is so. Maybe it's because art is not a popular thing.

But it is very important for students who have that special kind of fire and energy needed to become a visual artist to go ahead and do it. However, they need to know more about the obstacles. This can sometimes inspire people. I think it inspired me. If you tell me I cannot do something, then that is exactly what I want to do. Maybe if it had been really easy for me I would not have been an artist. I think if students go into this field and don't realize the extent of the challenge, if they are not ready to deal with it, I think it can turn them off, and turn them out. If they are ready, I think it can be a great inspiration.

Faith Ringgold

My advice to students is the following: real hard work. See everything. Go to every museum. Look at everything. Look at all the art and then look around you at everything, because what you want to do is art from life, not from other people's art. But you must know about all the other art, so you can look at all the ways that artists have made art from life. Look at everything everybody has done and don't let them tell you that only white men make art. It is not true. Art is made by people all over the world. Important art has been made by all peoples for all time, and all of it is worth looking at and knowing about and thinking about. Then you can go ahead and do yours, because you have all of theirs in your head. Actually the whole world of art belongs to all of us in our hands and in our heads. It's okay to use it. As we make our art from life we can be inspired by everything else.

Juan Sánchez

Born: Brooklyn, New York, 1954
Lives in Brooklyn, New York

I am a second-generation Puerto Rican born and raised in Brooklyn, New York. My parents migrated from Puerto Rico to New York in the early 1950s and settled in Brooklyn. We have always lived in predominantly African American and Puerto Rican communities. My first language is Spanish and I began to learn English when I started going to elementary school. In the community where I live, the language, food, religious mores, music, and attitudes come out of Puerto Rican roots. This is a community where people from Puerto Rico, Santo Domingo (the Dominican Republic), and other parts of Latin America can live and speak only the Spanish language without learning English.

The people have transformed these communities into tiny Spanish-speaking countries with all the comforts, problems, and contradictions that go along with it. My art is influenced by all this and more. I make art because it gives me a sense of self-worth in defining who I am. It is my way of expressing and sharing my mind, heart, and soul with a broad public.

What informs my art is Puerto Rican, Latin American, and African history, politics, and culture. The subjects to which I am drawn are the things I experience on a daily basis. In making my art, I choose materials I can manipulate easily. I am very familiar with the photographic process as well as painting and drawing. Text, whether poetry, literature, history, or personal testimonies, also fascinates me and provides many possibilities for my art.

The role of the artist in society is very complicated, but I believe the artist should explore and get as close as possible to some form of truth. Humanity cannot survive without creative, artistic expression. Society has not yet been able to accept the artist as a productive, responsible, and important member. The artist is sometimes feared because she or he insists on expressing concerns society does not want to face.

The relationships between art and politics, art and religion, art and culture, and art and education are integral. They all influence and feed into one another. Governments should not dictate or censor art. Government has never been the true voice of the people of the United States.

My ideal audience are those people who are willing to see, feel, and think. People who are willing to face things that may even hurt for the sake of awareness and growth.

My work both embraces and breaks from traditions. I think that many young people have taken to my art because I speak of things and experiences that came from my youth. The concerns expressed in my work are connected to young people's present reality, and their historical and cultural roots. My people, Puerto Ricans, are perhaps my most treasured audience because of the many fulfilling responses they have had to my work.

My work is not conceived with the museum or gallery environment in mind. I create art that can be placed in an environment outside of the mainstream art circle because a great majority of my people do not go to museums and art galleries. The aesthetic and formal concerns in my paintings reflect the environment and experience of my people.

To be an artist is a very honorable and wonderful experience. One can express what's in one's mind and soul, and be a reflector of society. At the same time, the artist can leave a great impact on society. It takes much courage and honesty to be an artist. It also demands firm commitment and discipline. As an artist, you must develop an open mind. You must be knowledgeable about many human and world issues and figure out how they affect you. You must be an extremely caring and sensitive human whose prime concern is to give and to share.

Born: New York City, 1950
Lives in Brooklyn, New York

Andres Serrano

Being born a person of color is political in itself. Everything you do from that moment on is political without necessarily being labelled so. My work has social implications—it functions in the social arena. But I think it was politicized by forces outside of it and as a result people expect to see something "political" in my work.

When I was a kid, we were all Spanish. As I've grown older, the terms have changed and we became Hispanic. I have always felt that I am the sum-total of my parts. One of the things that I am happy about in my life as an artist is that I am not considered a "Hispanic artist." I am just an artist. That is the way it should be. My work is intensely personal. I try to do my work as I see fit, from a personal point of view with broader implications. I don't think that because I am Hispanic I should therefore do Hispanic work. Is it Hispanic to photograph the Klan? People try to find ways of explaining and categorizing the work.

I have always felt my work is religious not sacrilegious. In my work I explore my Catholic obsessions. An artist is nothing without his or her obsessions. One thing that bothers me is the fundamentalist labeling of my work as "anti-Christian bigotry." As a former Catholic and as someone who is not opposed to being called a Christian, I resented being told that I could not use the symbols of the church, and felt that I had this right. I am drawn to Christ but I have real problems with the Catholic Church. Often times we love the things we hate and vice versa. Unfortunately, the church's position on contemporary issues makes it hard to take them seriously. My problems with Catholicism began at puberty. My work has been spoken of in terms of the sacred and the profane. My feeling is that you can't have one without the other. You need both. There have been times in my life when I have been fairly antisocial. I have never been part of the system. I have never voted in my life.

Whenever possible I operate outside of the system. Now I realize that I can no longer function as a human being in a vacuum.

I am an artist first and a photographer second. My medium is the world of ideas that I seek to present in a visually cohesive fashion. I think of myself as a conceptualist with a camera. In other words, I like to take the pictures I see in my head that may or may not have anything to do with photography.[3]

Helen Zughaib Shoreman

Born: Beirut, Lebanon, 1959
Lives in Washington, DC

My name is Helen Zughaib Shoreman. I was born in Beirut, Lebanon, in 1959. I have lived in Beirut, Kuwait, Iraq, Greece, and Paris. Though I am an American, I have a strong Middle Eastern background. My father is Lebanese, now a naturalized American citizen. Because I grew up overseas, I was immersed in Arab culture, history, and art. I feel this has influenced my art work in a profound way. Arab culture is rich in art, language, and religion. One is reminded of this while wandering through the old sections of town, the souks (markets), or visiting the ancient ruins.

I consider myself lucky to have lived in the Arab world when all was relatively calm politically, except when we were evacuated during two wars and one coup d'etat. The coup was in Baghdad, the wars were both in Lebanon, in 1967 and 1975. Since then the situation has deteriorated, but the people remain amazingly optimistic. I saw many tragedies and much sadness, in my own family as well as in the families of relatives and neighbors.

I cannot imagine life without art. I feel it is the one area of my life over which I have complete control. I create art mostly for myself. Whether the painting is deeply personal or of a busy and hot vegetable market, it is always somewhat difficult to have people view the work. On the other hand, I realize the importance of exhibitions, exposure, and acknowledgment. Therefore I do all I can do to achieve this. I also use the exposure to help people understand the Arab culture, perhaps clearing up some misconceptions they may have.

My major influences have come from my background in the Middle East. The detail, patterns, brightness of color are all reminiscent of the Arab world. The nontraditional perspective that I create can be found in much of the old Arab art. I basically transform the subject matter into a series of patterns and colors, thus rendering a certain optical illusion that draws the viewer into the painting almost like a puzzle. I am inspired by places I live and visit. For example, for a recent series of paintings I transformed the facades of three monuments in Washington D.C.; the Lincoln Memorial, the George Washington monument and the Capitol building. I primarily use gouache, though occasionally acrylics, on canvas, board, unprimed linen, and wood. I like using gouache because it affords me a clean and bright color.

Art is very important, whether the artist tries to make a statement to increase public awareness or simply to create for beauty's sake. I believe artists have two important roles today, the first being the responsibility to examine and portray contemporary issues and problems in society, and the second to lift peoples' spirits. There is so much sorrow and unhappiness in the world that a moment's relief, perhaps taken in a museum, gallery or living room can do a lot towards a more positive attitude.

Born: New York City, 1942
Lives in New York City

WHO ARE YOU?

I am an artist. This is both a blessing and a responsibility. The Supreme Artist is the Creator. One who arts should have a spiritual connection to this One. If this bond is personal and familiar, one's art will have power and spirit.

WHERE DO YOU COME FROM?

Born in New York. Raised in Bed-Sty/BROOKLYN
Father: Musician
Mother: Schoolteacher DIVORCED/ ... Foster Child.

WHAT IS YOUR CULTURE?

African American

WHY DO YOU MAKE ART?

Because I feel closer to the Great Artist.

WHO FOR?

For Him, myself ... and others who find the art valid.

IS ART IMPORTANT?

If one is hungry, food is important. It is up to the artist to reveal a hidden hunger for art.

HOW DOES YOUR ART RELATE TO YOUR LIFE/SOCIETY?

My art is inspired by the life about me. It relates, reflects, and records the cultural forward thrusts.

DOES YOUR WORK RELATE TO YOUNG PEOPLE?

Yes.

A great deal of my work in the medium of photography is about young people. I find young people of tremendous inspiration in moving culture forward to the next century.

WHAT ADVICE WOULD YOU OFFER TO STUDENTS ON BECOMING ARTISTS?

Think of what you have to give, offer and say to others—whether visual, literary, musical, or performance. James Baldwin said, "go the way the heart beats." Find your voice ... your own path. Seek direction/guidance.

WHAT DOES IT TAKE?

Vision

Elizabeth Sisco, Louis Hock, David Avalos

Started collaborating on projects in San Diego, California, 1987
Work in San Diego, California

Could you discuss your collaborative process?

We are active members of San Diego's art community who have had many opportunities to see and discuss each other's work. Over the years we have established ongoing communication. Our collaborations begin when someone tries to get the others interested in working together on an issue of immediate public interest. A group then forms on an ad hoc basis. The group decides how the responsibilities will be shared: calling each other to organize meetings, writing proposals, creating and producing the artwork, developing strategies for dealing with various sectors of the public (funding sources, community groups, art organizations and the mass media), and finally documenting the project. As public artists, our purpose is not to make art for the public but rather to express ourselves *as* the public. We believe that the creative act involves not only the artist's initiative, but the community's response. Our contributions around public issues of local concern insist that community identity is the ongoing creation of a multiplicity of voices. We attempt to play an artful role in this process of community self-definition, forging a truly public vision of our city.

What importance do you place on the artist as individual?

We work with each other because we see each other as individual artists who have consistently created strong work on their own. Paradoxically, collaborations work best when individuals with strong beliefs debate with passion the best ways to achieve their commonly held goals. These debates encourage us as individuals to use all of our individual talents for a common good. The work is then always presented as a group effort, acknowledging the individual participants.

Why do you choose to work collaboratively? What are the advantages and disadvantages to working as a group?

The biggest advantage to working in collaboration is increasing our power as artists through the sharing of resources. These resources include our different points of view based on race, age, and gender; our different attitudes about how to make art; and our different ideas about how to solve the problems we create for ourselves. Our group includes artists with expertise in various media: photography, video, graphic art, mural painting, and installation. All of us together have more skills and knowledge than any one of us alone. We also each bring networks of supporters, including journalists, community activists and organizations, funding agencies, artists, curators, and others. As a group we take on bigger projects and can challenge politicians and bureaucrats because we know we will hang together in any confrontation.

The other advantage to collaboration is a social one. It's fun working with others, cracking jokes when things become tense and overbearing, going out to eat together, trying to support each other emotionally through art problems and everyday problems.

Our art focuses on democratic participation in the public realm (in other words, art that envisions our society as a giant collaboration). Because of the type of projects we do it is important that our process be about participation, not about the mastery or "genius" of a lone individual.

The biggest disadvantage is working on public projects as a collaborative group when the art world still prefers to deal with artists as individuals working in a museum or gallery. Even though we tell people our work is a group effort, many still want to know which one of us really thought up this or that idea or who was in charge. So we must constantly reassert the genuinely collaborative nature of our work. Another disadvantage is that art-school training does not prepare artists to work as collaborative groups. We are constantly learning

methods and procedures that have been used
for a long time by theatre artists and community
organizers to apply to visual art.

*How does your work relate to the history of
artists working collaboratively?*

We see ourselves as members of a society with
democratic ideals. As such, we look to the ideals
and practice of social movements to understand
collaboration: the civil rights, Chicano, antiwar,
women's, and labor movements. We also see parallel
social intentions in the histories of the Constructivist
art movement in the Soviet Union during the 1920s,
the Situationist movement in France during the 1950s
and 1960s, and Chicano art movements in the U.S.

Elizabeth Sisco

Born: Greenbelt, Maryland, 1954
Lives in San Diego, California

I am an artist, photographer and teacher. I was raised in Greenbelt, a small town in Maryland not far from Washington, D.C. I have lived in San Diego, California, since I was eighteen. I am a second-generation U.S. citizen from a Jewish family of Slavic European descent. Like all U.S. citizens, my culture is made up of a mix of people and ideas. I teach at a college close to the United States-Mexico border, an environment where Spanish is as familiar as English to most of the students. My neighborhood has Chinese, Mexican, African American, Vietnamese, and Anglo residents. Contrary to the popular myth that the United States is a big melting pot where people from various backgrounds blend into a single homogeneous identity, my experience has taught me that our culture is composed of distinct as well as shared identities, beliefs, and customs.

Making art is my way of both exploring the world and explaining the world. The process of making art is at times a very social experience, and at other times a very solitary activity. I usually begin a project by getting to know my subject and taking photographs. In the process of talking to and photo-graphing people, my ideas about them are continually expanding and changing. In documentary work, if you want to depict a person, group, or activity as honestly as possible you have to keep a very open mind so that your work is not simply an illustration of a preconceived point of view. The most compelling and interesting projects are made after I have spent a lot of time observing, studying, and reading about my topic.

My work deals primarily with social themes: racism, xenophobia, and the ongoing struggle in our society for social and economic justice. I strive to create art that encourages the viewer to examine relationship and perceptions about the inequities that exist in U.S. society.

Born: Nogales, Arizona, 1948
Lives in San Diego, California

In 1915 my great grandfather began a mule-drawn freight line in Nogales, Arizona, on the U.S.-Mexico border. When I began school, I moved sixty miles north to Tucson with my mother and grandmother. I grew up sandwiched between the cowboy and Mexican cultures. In my remote Southwestern city, I always imagined authentic "culture" was to be found elsewhere, like the library or movie theater, but never around me. Later, when I began to make art, I realized my youthful fascination with Native American ceremonies, corral construction, and Mexican wood toys was as powerful a cultural influence as any Shakespearean play or French film.

After struggling in high school and most of college to get my thinking to come out clearly in writing—and failing—I began making films as a hobby when I was twenty. I was ecstatic with my first productions. It was as if I could speak with my eyes. After almost ten years of making films, I became troubled by the exclusiveness of the museums and art-film theaters in which my work was shown and went looking for a wider audience. It wasn't enough that the ideas were visible in the films; the films themselves had to be seen. I constructed a large film mural that was shown on city streets. The screen was the side of a white semitrailer that changed locations every few days. I sought to make the film have the same relationship to audiences as a painted community mural.

At the same time I was showing the film mural in various cities, I began to record my neighborhood on video. Over the course of seven years I completed a four-hour video series concerning the life and times of my undocumented Mexican neighbors. The images of undocumented Mexicans I had seen in the newspapers and on television never matched my experience of living in the community of undocumented workers. The media image had been created by senators, academics, and the police. My primary aim in making the tapes was to invite my neighbors to speak for themselves, to create their own visibility on television.

In 1988 I began collaborating with other artists to make public art and extend the desires in my previous work—to seek a broader audience, to participate in producing community images, and to use popular media. The aim of this work is to generate a dialogue through provocative bus posters, billboards, performances, and bus-bench advertisements. The controversy the work produces is a means to engage the news media, thereby drawing the issues addressed by the projects into public view.

Over time, although the subject matter of my work has expanded, I still see the power of art as a means of making the invisible visible.

David Avalos

Born: San Diego, California, 1947
Lives in National City, California

Who are you?

A Chicano doing his impersonation of an artist.

Where do you come from?

My mother is Maria Torres Avalos. She was born near Guadalajara, Mexico. My father is Santos Urquizo Avalos. He was born in Durango, Mexico. I'm from a neighborhood called Old Town National City in Southern California, south of San Diego and north of Tijuana. I now live in another part of National City with Veronica Enrique and our children: Xima, eleven years old; Tona, nine years old; and Graciano, six years old.

What is your culture?

I'm a Chicano—someone of Mexican ancestry who is making the future within U.S. society. I'm a mestizo—someone of mixed ancestry, mostly Indian and European. Many people of mixed ancestry know exactly what the mix is, but in Mexico people have been mixing it up for about five hundred years, so you can understand how we might lose track. My Tia (Aunt) Maura says that one of my great grandfathers was a Tarahumara Indian and his wife was Italian. I'm sure there are other ingredients. Today, when we have family get-togethers at my mother's you can see how we're still mixing it up. Her grandchildren and great-grandchildren are all beautiful and all different: blond hair and blue eyes, nappy hair and brown eyes, black hair and no front teeth. They are children of Indian, European, and African ancestry.

My culture is a living story. Every morning we wake up and make new chapters. For five hundred years we have endured colonization, racism, and brutality and refused to let it damage our spirit. For five hundred years we have relied on our minds and our hearts to confront power and embrace the terrors and ecstacies of the world. For five hundred years we have celebrated our power to survive and to thrive with a sense of humor and a sense of dignity.

My culture is a culture of liberation. I share it with everyone past or present who has refused to be either master or slave. I share it with everyone who understands that "*Tú eres mi otro yo*—You are my other self."

Why do you make art?

Because it lets me participate in the world on my own terms.

Is art important? Why or why not?

Art is one of the things that defines and makes society. Art has something to do with believing in the possibility that all things are connected somehow. Maybe it helps us to keep our wits about us when we are frightened or baffled. Maybe it helps us to maintain hope in the face of doubts. Maybe it helps to open our hearts to the sweet while we maintain a sense of humor about the bitter.

If any of this is true, art draws its inspiration from the creativity of everyday life, not from the galleries and museums. As a Chicano who sometimes makes art, I am all the time trying to be as creative as possible, whether I'm making a sandwich or making love. Art can be important if it enables us to know each others' creative power and encourages us to dance with it.

Born: Washington, DC, 1939
Lives in New York City

I am an African American woman. I am also a visual artist, lecturer, writer, and teacher. Additionally, I am co-founder and National Coordinator of Coast to Coast National Women of Color Artists' Projects, which is a group organized to give visibility, support, and national attention to women of color artists.

I come from Arlington, Virginia.

My culture is African American working class. I was reared in a small town as a black Southern Baptist in the 1940s and 1950s. I participated in the civil rights movement of the 1960s, became a mother, was employed in various professional jobs through Equal Employment Opportunity programs, lived in many parts of Africa, and currently live and work in the field of visual arts in Soho, New York City.

I make art for my self (two words). When other people can get something from it, I feel good about having been able to contribute something to their lives.

Art is important to me. Through making images I connect the past to the present. It has become a way of knowing what I know, a way to uncover how and why I learned it, and a way to unlearn it. I strive to release my inhibitions and to free my soul.

My art is my life. I communicate the connectedness of my own existence to the universe through my work.

I like it when people tell me that they no longer feel weird or ashamed about themselves after they have seen my work. People have also told me that my work inspires them to confront social myths and taboos.

My work relates to young people. Things that happened to me as a young person are still very much a part of my adult life. I would say to a student who is thinking about being an artist, "your life is important; you have something to say and it's important that you say it."

Some of the things it takes to be an artist are:

(1) support
(2) focus
(3) commitment
(4) willingness to trust yourself and
(5) positive feedback.

Diosa Summers

Born: New York City, 1945
Died in 1992

In my language I am "Anishinabeykwa"—an Indian woman. I grew up in Rhode Island between the Indian communities in Providence and Charlestown. My father is a Mississippi-band Choctaw, but I have spent very little time in Mississippi. I am much more closely involved with Algonkian speaking Indians in southern New England. The cultural traditions that took place in my home when I was young included eating corn soup, fried bread, and fresh-killed deer, doing beadwork, tanning hides, sewing leather into clothing, processing natural materials for weaving, and gathering medicinal plants.

Native American cultures have provided their people with special skills in order to survive. Survival, as I speak of it, is not necessarily limited to basic needs. While basic needs do have major importance in anyone's life, there are many other things that are often more important to Native Americans. I am referring to spiritual things. If the spirit within you, and the spirits outside you, are not fed, you will truly die. You cannot survive even if your body appears to be living.

Just what are some of those skills that we have and use often to insure personal survival? We all have a vision, sometimes multiple visions, and these visions originate from the place that is our center. Sometimes those visions have to do with our present lives, sometimes with our past lives, in this current body or another body, and sometimes with happenings that are so very old that the age of a feeling cannot be described. These visions often provide answers, and help us solve problems. They give us understanding, patience, and an acceptance of the reality that surrounds us.

The articulation of these visions is a tool that Native Americans have used for centuries. The painted tipi, the painted shield, the painted parfleche, the beaded bag, the painted robe, the painted and incised rocks are just a few examples. Often, some of the most beautiful traditional Native American artworks, like beaded dresses, moccasins, and pouches, are referred to as crafts. But any object that includes a clear aesthetic, that requires skill in planning and execution and that results in a thing of beauty is a work of art.

Through my art I investigate Native American history and my place within that history. My artistic/creative process is a continuation of Native American traditions in combination with the many personal things that go into making me, me. I am a woman, a mother, a grandmother. The children I have borne, and the children I have buried, have altered my existence in a way so powerful that I have no alternative but to give in to it. And in giving in to it I have gained in ways that have allowed me to give with a goal, an intent, a dedication, and a constant prayer that all I believe important in the world will continue to exist. That there will be a world with air and water, trees and birds, and the eagle to take messages to the Creator is my obsession. That this world will exist for my grandson's grandson's grandsons is my obsession.

I only hope that as I look within my visions, as I look at the pain and suffering that has happened and continues to happen, as I look at the happy things, the wonderful things, the beautiful things the Creator has given us, as I sing the songs, and dance the dances, I can show the world the preciousness of it all. I try to do this with my artwork, and hopefully make people aware of, and obsessed with, my obsession, too.

Born: Japan, 1936
Lives in Waimanalo, Hawaii

Masami Teraoka

I come from Japan but have lived in the United States for 34 of my 59 years. I therefore have had the benefit of experiencing two distinctly different cultures.

I make art because I like to paint. I make art primarily to understand myself. Art is important because it is a method to learn about life, myself, and the world. Painting reflects my thoughts. If I don't paint, I feel sick. I also express my experiences through art in order to communicate with other people. I use aesthetics and humor to make the whole vision more accessible to the viewer. Social and political issues that I feel are undercurrents of changing values are my primary sources of subject matter. Issues such as pollution, the AIDS crisis and the aggressive Western fast-food conquest of the globe inspire my imagination. It is important to me that I reflect the historical times in which I live. I am obsessed by where the world is going and what we will gain or lose along the way.

The contrast between the past and present in the cultures of Japan and America is the focal point of my work. There are two major sources that I draw on to express this theme: American Pop Art and Japanese ukiyo-e or woodblock prints. These two seemingly divergent fields of art are, in actuality, close expressions of the same concept from two different worlds. The subject matter of both is popular culture.

Ukiyo-e woodblock prints are equivalent to posters or other mass produced art. Ukiyo-e was dominant in the Edo period in Japan, which corresponds roughly to the 17th to the 19th centuries. Ukiyo-e reflect the affluent society of the later part of Edo Japan, a time that was dominated by the merchant class and a decadent lifestyle. Pop Art of the 1960s is one of the most uniquely American art forms. It represents a consumer-oriented society. There is no other country like America when you look at the extent of our consumerism. To me the marriage of these two forms is an obvious way to combine the cultural influences I have felt in my life, and allows me to make comments on both cultures.

My new works average six by nine feet and are painted with watercolor on canvas sized with rabbit-skin glue. I use watercolor as my primary medium because it allows me to recreate the feeling and textural effect of traditional woodblock prints. Actual woodblock printing on such a large scale would be impossible.

In a successful painting, statement and aesthetic go hand in hand. Neither one of these points can be neglected. The final goal of painting is to balance the two and therefore form an uplifting poetic statement. Although artists are inspired by many sources, the originality of art is in following one's own inner thoughts, feelings, and philosophy and in the interpretation of influences to one's own time in history.

Danny Tisdale

Born: Compton, California, 1958
Lives in Harlem, New York

My name is Danny Tisdale. I was born in Compton, California. I am African American. I create art because I feel a need to bring certain images and perspectives to the attention of the public and the art world. Through the power of art I can do that.

Art is important, it's our gauge for society and culture. If the art is open then the society is open; if it is closed, then that society is closed. If society does not censor its art, and digests it without prejudice, that society is on the right track.

Art is my life; there is no separation between the two. I create art from my life, from my experiences, from my politics, and from people I have met who have influenced me and who I love.

Art is my therapy, my release, my involvement in the world. Through art I have communicated to individuals and groups that I would not have had an opportunity to communicate with.

My work relates specifically to young people because it deals with the same kind of misunderstanding and alienation that they go through—struggling to have their own voices and to be heard.

The relevance of my work to young people is the understanding that we are all part of the world that we live in, and if someone around the world or right next door to us is having trouble, those problems reflect directly on us. We can no longer afford to step over someone or close our eyes to someone who needs our help, because one day it may be us. We are part of the problem or part of the solution.

In a society that preaches democracy, it is important to have an art that expresses and illustrates diverse perspectives, even if it means producing visual images that some people do not like. In a true democracy art speaks all languages, to all ages, all genders, and all races.

Art is hope in people's lives that they can achieve their goals and their desires, and to participate. Art lets people regain their self-confidence, lets them live their desire, makes fantasy a reality.

What does it take to be an artist? Well, I think it takes the same thing to be an artist as it does to be a lawyer or doctor: time, commitment, talent, and love.

My advice to young people (and older people) who want to be artists would be to go for it! You have to follow your heart and mind, make a commitment to those things you believe in, and then make them real. There is NO ONE to stop you from doing what you want to do, EXCEPT YOURSELF. We all control our destinies; we cannot afford to let our destinies control us. Do not expect anything that is worthwhile to happen overnight. All things worthwhile take time. If you want to be an artist, make the commitment and come out fighting.

Born: Claremore, Oklahoma, 1949
Lives in Norman, Oklahoma

Scientifically cohesive—I am the atoms, molecules, blood and dust of my ancestors—not as history but as a continuing people. We describe our culture as a circle, by which we mean that it is an integrated whole, a circle of many circles. My artistic expression derives from this legacy. It is the circle of my cultural traditions and experiences that allows me to be a human person. Our—and my—way of being human is to be a Yuchi person, not only human to human but to other forms of life. My Yuchi people aren't interested in converting other people to our culture and spirituality but in how we can contribute to the human society according to our philosophies, ideas, and value systems. This we can share and have always been willing to share. But our ceremonies and spirituality are specific to us as communities, tribes, and nations. That is our concern. In our continuing struggle to keep being who we are, our relationship to the earth, and to regain our place in the world, the more we struggle the more we learn of things in the world. In the spirit of that struggle.

Pat Ward Williams

Born: Philadelphia, Pennsylvania, 1950
Lives in Valencia, California

My name is Pat Ward Williams. I am an African American woman, born in Philadelphia, Pennsylvania, in 1950. I am the fourth generation of my family in this country. I am the daughter of Southern-born parents—my mother is from Virginia and my father is from North Carolina. The preceding three generations of my family include inventors, artists, doctors, factory workers, and homemakers. Prior to that, no records exist. But my mirror tells me that I am an African and somebody in my family made that Middle Passage. I honor that unknown person. I feel I can draw inspiration from the struggles and triumphs of my known family, as well as claim any African culture (Kongo, Yoruba, Ashanti) as my own.

Everyone has passions, politics, hopes, and dreams. Art is what organizes ideas and gives a voice to an individual. Art can serve a personal identity and/or that individual's unique position within a larger cultural group. I make art because I live in this world and try to make sense of it. I see racism, greed, and political manipulation and I have something to say about what I see and feel. The visual is my language, art is my voice. In my photography and in my installations, I try to get people to think about what they're seeing. I ask my audience to consider the possibilities of meaning contained in a photograph. I ask them to contemplate the message inherent in the image.

I don't have a specific audience in mind when I make art. I think that if you only have one audience in mind when you make art, you tend to limit yourself, and keep your art from circulating among people who may have different perspectives or viewpoints about it. I don't believe there should be categories for looking at or evaluating art. Although there is a black aesthetic, I don't believe that there is a characteristic black art style. Black artists like myself are inspired by certain patterns, textures, or response styles. But these styles are chosen and are not obligatory. Artworks produced by black artists reflect the broad range of interests and life experiences among black people. The knowledge of the roots of black image making is important to all groups of people. It acknowledges a vibrant and creative community of art makers and their art.

Born: Warsaw, Poland, 1943
Lives in New York City; Cambridge,
Massachusetts; Paris, France

Krzysztof Wodiczko

The question "What is my culture?" is something I must examine from scratch. My immigrant experience, with all of the difficulties I have had to overcome, combined with the advantages of being a stranger, all of this constitutes my culture. I immigrated first from Poland to Canada and then to the United States and no matter how much I am American and Canadian, I am definitely Polish. The Polish part of me is what everyone immediately recognizes. But I cannot say that I belong to the culture of Polish immigrants living here in America. Most Polish immigrants of my generation or older feel that since there is a higher level of democracy—or a lower level of unfreedom—in the U.S., they should simply embrace this country when they arrive, enjoy it uncritically, and rest. For me, a true artist cannot rest; criticism is attached to thinking and to making responsible art. I belong to those "artists-in-transit" who are critical and while crossing boundaries, change themselves, their art, and contribute to changing others' perceptions, imagination, and vision of the world. This is my culture: critical and mobile.

Much of my work consists of images which I project in light onto public monuments. By projecting the present onto structures from the past I rescue these monuments from simply being heritage, or remnants of former times. I force these monuments to become works of "critical history" and make visible ideas which otherwise would not be visible.

I did a projection in Madrid during the Persian Gulf War that was quite effective because it was adopted by antiwar demonstrations, which were massive in Spain. It was a set of icons that I adopted, transformed, and projected onto a fascist monument, a monument to Franco's army, at the moment of the outbreak of the war.

The civil war in Spain was one of the most tragic wars. So the Franco monument means a lot to people. It is a war that they understand, for all of its horrors. This monument to Franco is being rejected, no one wants to see it. But it is one of the biggest structures in Madrid and it is the entrance to the city, seen by hundreds of thousands of people a day. I illuminated this monument with a gun, an M-16 typical of those used during the Persian Gulf War, with a gas station nozzle, and with the word "¿Cuántos?" (How much? or How many?). These images were projected symmetrically onto the arch. So onto this past, which is a horrifying past that no one wants to remember, I projected the present to highlight the involvement of the Spanish navy in the Gulf crisis and the fear of further and further involvement. This projection was shown on the national and even the international news.

In talking about the public success of this artwork maybe we should think about how unsuccessful we are, and the world is, if all of our efforts did not prevent the United States, Europe, or Iraq from engaging in this war. I am not so naive to say that an artwork can change the world. But I would say that if I didn't do all of those projections and these other public interventions, or if other people didn't do their own critical art against the war and other such problems, the situation would definitely be much worse. Artists can help to connect global issues with the experience of those who have lived through them, making history emotionally and politically comprehensible. If we didn't do it, maybe the Persian Gulf War would have been ten times longer or it would most likely happen again. So if I see artists who really are trying, I think they are really the most successful, even if we don't see a so-called "result" immediately. One should hope that such a contribution to the change of perception, imagination, vision of the world and our own place and role in it, will become a critical heritage for the future generations.

David Wojnarowicz

Born: Redbank, New Jersey, 1954
Died in 1992

Your family is spread out, it couldn't hold?

My father was a sailor and was away for long periods of time. He would be home for two weeks every four months. At some point when I was little and my parents were separated, I was kidnapped from my mother, who had custody, by my father. I was taken to some place outside of Detroit, where there was a chicken farm and some distant relatives. He remarried. We moved almost once a year to keep ahead of the law and my mother.

What did you think of all this?

I thought it was fairly normal until I left, and once I was outside I realized how crazy it was. My father was extremely violent. It was a relief to get away from him. I stayed with my brother and sister and then I started running away from them entirely and living on the streets in New York.

You slept in doorways?

I slept in doorways in Times Square. I managed to find my way—a place to sleep, something to eat. I was taken care of by different people. I found a job at this halfway house and met people coming out of prison—people who went around passing bad checks, stealing left and right . . . But once in, I had a certain amount of structure where I could kind of repair the damage and get off the streets, find work, live a regulated lifestyle for a couple of years . . .

So it was never your idea to come off the street to become a famous painter?

Well, I wanted very much to do things and be supported in doing them or at least engage people in a dialogue of some sort. When I was living on the streets as a petty criminal and I was coming out of the halfway house and into daily society I was speechless for years. I didn't talk to anybody. I carried this stuff on my shoulders for years. I was at a party with some people involved in the arts or whatever, and I sat there and was silent the entire time because I never found a method of communication that could begin to touch on the experiences I'd had. Most people were living fairly normal lives. I'd seen

things that were so horrifying. . . . I was almost killed two or three times living on the street. And coming out of these experiences you need to find an entry point into a dialogue with people, and there isn't. You can't just say, "Hi." So I started writing.

What did you write?

Bad poems, stories, very direct explicit things about the experiences I gained on the street. That's what I try to do with the painting but using more imagination.

Was art the way out?

It was the only thing that continually made sense. The reason I couldn't talk about being a child prostitute or a thief or a runaway was because there was never anything or anyone in that environment—a contact point—that would help me step out of it. I wrote a piece on image, real and psychic violence in *The East Village Eye* (now defunct) a couple of years ago, and I went into my adolescence on the streets.

Who taught you how to paint?

Nobody, just myself. And I'm still learning.[4]

My paintings are my own written versions of history, which I don't look at as being linear. I don't obey the time elements of history or space and distance of whatever: I fuse them all together. For me, it gives me strength to make things, it gives me strength to offer proof of my existence in this form. I think anybody who is impoverished in any way, either psychically or physically, tends to want to build rather than destroy. Given what my childhood was, given the erratic structure I grew up in, I'll always need to build sense into things . . . I had violent episodes throughout my teens where I wouldn't think twice about banging somebody on the head if they gave me the wrong look or something. I responded to the world with the violence I'd learned as a kid, but at the same time I had an outlet, because I had a creative impulse that I enacted on the streets. I'd do drawings with ballpoint pen on paper and it made me happy to do that—somehow it gave me some comfort.[5]

Founded in New Orleans, Louisiana, 1988
Work in New Orleans, Louisiana

YA/YA, Inc.
(Young Aspirations/Young Artists)

Super colorful Young Aspirations/Young Artists (YA/YA, Inc.) is a collective of individual youth artists who are creating a new picture of the world. YA/YA design studio and gallery was founded in 1988 to offer young people professional opportunities in the arts. Located in New Orleans' central business district, YA/YA is the creative center for a core group of thirty high school and college students. Internationally renowned from Tokyo to Amsterdam and Paris to Los Angeles for their hip hand-painted furniture, fabric and other items, YA/YA represents the future for young people in America.

Who am I? I am one of many self-employed artists at YA/YA, Inc ... I am a young individual from "The Crescent" ... I came from my Momma, in N'Orleans, in a very down-to-earth family created by two special people ... My culture is African American, Hip-Hop Tribesters ... I'm the Man, Black, Dark Brown ... I am an Indian from the crazy 8th ward ... Art! That's who I am ... I'm a little girl who loves to dream ... I'm American, but I would love to grow in my African self ... I'm very friendly. Sometimes I feel sorry for people and take their side when I shouldn't ... I am human, my culture is mixed with everything ... I am a natural person ... somewhat gifted, and multicultural. I live in a global village; life is my culture.

Why do I make art? I make art because it is a way of expressing myself; it's enjoyable, important, exciting ... It liberates my mind. It's an outlet for me as an individual, another door between the soul and the heart ... I make art for people who wish to buy my chairs and like my style of painting ... I love doing things with my hands and working with different types of textured surfaces ... my work is a threat to society because it's honest and true—no bull.

Being a YA/YA makes me special ... I'm original, unique and I make YA/YA special ... Experiences from my past form my future desires just like new styles are created from everything around us ... My feelings and tensions are put in my work, all my fear, joy, and emotions become colorful and realistic for all the world to see ... It relates to my life because the stories I tell bring hope to despair ... It makes the world beautiful. That is what the YA/YA program is all about.

We work in a group because more things can be accomplished when you can get a helping hand to finish your piece ... Large commissions take lots of energy and many hands ... Projects like murals involve blending each others' art ideas together ... It builds trust ... You can borrow their things or have someone to talk to if you have a problem ... We also learn from each other's mistakes ... Trouble with behavior or attitudes bring the others down ... They can get you upset. That's the disadvantage, but misunderstandings are talked out and then someone "hits a big one," sells something, and everyone is enthusiastic again ... We all work as a rhythm, like a rap group in colorful, different, talking ideas.

My artist truth is a mixture of soulish laughter, cartoonism, and the opposite, realism ... I'm a graphical, cartoonist, realistical kind of guy. Word! I'm out, Peace!

Notes

1. This text is an excerpt from "David Hammons," an interview with David Hammons by Kellie Jones which first appeared in *Real Life* no. 16 (Autumn 1986). Reprinted in Russell Ferguson, William Olander, Marcia Tucker and Karen Fiss, eds., *Discourses: Conversations in Postmodern Art and Culture* (New York: The New Museum of Contemporary Art, and Cambridge, Massachusetts: The MIT Press, 1990), pp. 209–210.

2. Adapted from an interview by David Sheff published in *Rolling Stone,* August 10, 1989.

3. Excerpt from "Serrano Shoots the Klan," an interview with Coco Fusco. *High Performance,* Fall 1991.

4. Rose, Matthew, "David Wojnarowicz: An Interview," *Arts,* May 1988 pp. 62–63 and 64–65.

5. *Tongues of Flame,* Catalogue for Major Retrospective at University of Illinois, IL, 1990, p. 62.

John Ahearn
Nació: Binghamton, Nueva York, 1951
Vive en el Bronx, Nueva York

Rigoberto Torres
Nació: Aguadilla, Puerto Rico, 1960
Vive en el Bronx, Nueva York

John Ahearn: Vengo de una familia de clase media católica irlandesa del norte del estado de Nueva York. Yo soy de la tercera generación nacida aquí. Algo importante en mi vida fue el hecho de tener un hermano gemelo idéntico, Charlie. Durante la infancia, siempre fui uno de un par: "los gemelos". Así que tengo una constante necesidad de colaborar con otros. Mi padre era médico obstetra. Casi todos los materiales que utilizamos en nuestro arte son médicos. Pienso que la situación en que se hace un molde se parece a una mesa de operaciones y el proceso también es muy similar al proceso de dar a luz. Robert y yo somos como los médicos que ayudan a dar a luz una nueva creación.

Rigoberto Torres: Digan lo que digan, uno siempre está aprendiendo a lo largo de la vida. Nuestros padres nos ponen en la escuela para aprender, para despertar conciencia, para usar la mente, para abrir la mente. Pero más tarde, uno quiere hacer cosas que nunca antes había hecho y que nadie le ha enseñado. Ahí me encuentro yo en este momento.

Hace poco pasé seis meses en Puerto Rico buscando dentro de mí mismo si en realidad soy artista. Fui a Puerto Rico a trabajar en cosas creativas a mi propio ritmo y a mi propio nivel. Me fui a las montañas, compré un poco de equipo e hice cosas que me hicieron sentir de maravilla. Nada de televisión, nada de radio. Si en serio se dedica tiempo a pensar quién es uno en realidad, se puede averiguar.

Pues sí, me di cuenta de que en realidad soy artista y esta respuesta la encontré dentro de mí mismo. Cuando estoy creando arte, ése soy yo. Mi interior se siente feliz. Siento que tengo el mundo en mis manos. Siento fortaleza. Me siento feliz y saludable. La idea es llegar a que uno mismo lo haga, crear a partir de la energía interior. Mucha gente dice: "No, no sé hacer esto" o "no entiendo aquello". Ese negativismo es la parte que nos detiene. Ser positivo es lo que realmente ayuda.

Existe una especie de energía loca que hace crear y hacer cosas. Ésa es la parte que hay que aprender a controlar y a dejar salir cuando se necesita. Aun cuando no se está de buen ánimo, hay que seguir esforzándose. Como artista, hay que seguir adelante, porque uno sabe que más adelante obtendrá resultados que lo harán sentir muy bien.

John y yo empezamos a trabajar juntos en 1979. Nos conocimos en Fashion Moda, un "museo/tienda" del South Bronx. John vivía en el sur y yo en el norte.

JA: Un amigo mío acababa de abrir Fashion Moda. El lugar me llamó la atención porque era muy distinto a la onda artística del centro. Yo acababa de empezar un proyecto de una serie de rostros en yeso y decidí hacerlo en Uptown. A mitad de camino conocí a Robert. Al principio fue mi asistente, ayudándome pacientemente con todo lo que se necesitaba. Después me pidió materiales para llevarlos a su barrio. Le gustaba lucirse. ¿No hacías moldes en la acera?

RT: Sí, trabajaba en la acera. El primer proyecto que hicimos juntos en la calle sólo hicimos cabezas. Montamos un estudio en la calle. Éramos como un equipo; John conoció a mi familia, mi gente, mis amigos y nos dedicamos a trabajar juntos. Después de un tiempo, nos decían: "¿Cuándo nos van a hacer un molde a nosotros?". Uno le hace un molde a una persona y esa persona se lo dice a otra; cuando menos te lo imaginas, el vecindario entero está enterado.

Nuestro trabajo gusta, es algo que todo el mundo puede comprender, algo que algún día les gustaría hacer. Hay algo en este arte que les gusta.

JA: Nuestra colaboración funciona porque estamos firmemente de acuerdo sobre lo que es justo, lo que no es justo, lo que está bien, lo que es malo y lo que es bueno. Tenemos un terreno común en muchos aspectos. Tengo una confianza profunda en la intuición básica de Robert con la gente; pienso que ésa es la razón más importante por la cual trabajo con él.

Melissa Antonow

Nació: Queens, Nueva York, 1978
Vive en Queens, Nueva York

Nací el 12 de febrero de 1978 en St. John's Hospital en Queens, Nueva York. He vivido en el mismo domicilio toda mi vida. Mi padre es supervisor de los pintores de mantenimiento de la Health and Hospital Corporation. Mi madre trabaja en la industria alimenticia. Estudio en la escuela Our Lady of Hope en Middle Village.

El afiche *Venga a donde está el cáncer* fue una tarea que me pusieron en la escuela. El tema lo saqué de un anuncio comercial para los cigarrillos Marlboro que apareció en la *TV Guide.* El anuncio tenía el refrán "venga a donde está el sabor", de modo que yo simplemente lo cambié para que dijera "venga a donde está el cáncer".

Me entusiasmó mucho ver mi afiche en el metro; también me sorprendió. No se me ocurrió que pudiera tener tanta aceptación. Me sentí como envuelta en una gran oleada de popularidad. Fue algo agradable y al mismo tiempo un poco incómodo porque era muy joven y no estaba preparada para todo eso. Sin embargo, la prensa y los periodistas eran muy amables y profesionales en su conducta y sus palabras. Soy un poco tímida y reacia a ser el foco de atención, pero creo que la campaña contra el cigarrillo es un asunto muy importante.

Cuando prohibieron el afiche en el metro debido a las objeciones de una compañía de cigarrillos, me pareció que me habían negado el derecho de informar al público sobre el peligro de fumar. Al principio, el afiche fue simplemente una tarea más. Después, el señor Joseph Cherner, Presidente de Smokefree Educational Services, me hizo ver que mi afiche decía la verdad y que los afiches comerciales para vender cigarrillos decían mentiras.

Me interesan las matemáticas y la música *rock.* Me gusta estar con mis primos y amistades. También me gusta coleccionar minerales y fósiles. En la escuela, mis cursos favoritos son las matemáticas y el francés. También me gusta ir al campo, con sus árboles y lagos, aire fresco y animales. Además, me gusta contemplar el cielo de noche, lleno de estrellas.

Seguiré pintando como pasatiempo y para divertirme. Mi padre influye mucho en mí en cuanto al arte. Me gustaría ser contadora ya que me gustan las matemáticas y el dinero.

Nació: Chicago, Illinois, 1960
Vive en Cheverly, Maryland

Me llamo Kristine Yuki Aono. Nací en Chicago, Illinois, el 31 de diciembre de 1960. Soy *Sansei*; pertenezco a la tercera generación de japoneses-americanos. Mis abuelos son *Issei*; pertenecían a la primera generación que emigró de Japón a los Estados Unidos. Mis padres son *Nisei*; son de la segunda generación.

Desde niña, el arte ha desempeñado un papel importante en mi vida. Mis padres me alentaron a dibujar y a ser inventiva. Mi abuelo se interesó mucho en las artes tradicionales de Japón, como la pintura a pincel fino, el ikebana (arreglo de flores) y la fabricación y adorno de cometas, y eso me impresionó fuertemente. Crear una obra de arte es un acto individual. Para mí, constituye tanto un vehículo para la autoexpresión como una posibilidad de cumplir ciertas metas personales.

Mi escultura es de naturaleza narrativa. Cuento con una vasta gama de fuentes de información e inspiración. He leído muchos libros sobre la cultura e historia de los japoneses-americanos. Yo también me he interesado, desde hace mucho tiempo, en las artes tradicionales de Japón y las de la civilización del Occidente. Todas estas influencias confluyen en mi obra.

En los últimos años, mi arte ha sido fuertemente autobiográfico. La escultura me ofrece un método para examinar y expresar los conflictos que encierra mi identidad como japonesa-americana. A través del arte he podido expresar mi perspectiva personal sobre temas como la internación de los japoneses-americanos durante la Segunda Guerra Mundial, la aculturación, los estereotipos raciales y sexuales, y la historia de mi familia.

Creo que es importante que la fuerza de mis obras consista en algo más que el mensaje. La obra en sí debe ser interesante visualmente, para atraer al espectador y hacer que se acerque a ella. Sólo entonces se puede experimentar el impacto del contenido. A menudo utilizo materiales no convencionales: tierra, clavos oxidados, concreto. A mí me importa que la obra sea hermosa, pero la belleza es un valor subjetivo.

Deru kugi utareru. Traducido literalmente, este proverbio japonés que encontré en un libro que estaba leyendo, quiere decir, "el clavo que sobresale más, recibe más golpes". De ese dicho evolucionó una obra de arte que consiste en una bandera estadounidense formada por más de mil clavos oxidados para indicar los años, el tiempo que pasa y el dolor. El proverbio ilustra las presiones que existen en la cultura japonesa para imponer la conformidad social, según la cual se desprecia al individuo que llama la atención. Esta obra contestó las preguntas que tenía sobre cómo los *Issei*, y sobre todo los *Nisei* nacidos en Estados Unidos y ciudadanos de este país, pudieron haber entrado tan calladamente a los campos de concentración. Sé que mi generación hubiera protestado a gritos.

Mis obras las creo inicialmente para mí misma. Es de veras emocionante cuando otros asiáticos-americanos me dicen que también ven en ellas su historia. Encuentro que la mayor parte de los estadounidenses están interesados en aprender más sobre su propia sociedad políglota. El arte es el vehículo perfecto para comunicar estos mensajes.

Eduardo Aparicio

Nació: Guanabacoa, Cuba, 1956
Vive en Miami, Florida

Mis fotografías forman parte de un proyecto en curso de documentación de las comunidades latinas de los Estados Unidos. El proyecto se inició con la serie titulada *Estados Unidos,* que se concentra en las comunidades hispanoparlantes de Chicago, especialmente las comunidades mexicana y puertorriqueña. Hace un año, más o menos, comencé a expandir el proyecto para abarcar las comunidades latinas de San Francisco, Nueva York y Miami. Pienso que será un proyecto de toda la vida y que en el futuro abarcará también las comunidades latinas de Los Ángeles y las zonas rurales del Sudoeste.

El objetivo principal de esta documentación es representar las comunidades latinas de los Estados Unidos como parte integral y vital de la sociedad estadounidense. La selección que aparece en este libro documenta tiendas de propietarios latinos en Chicago. Los locales fueron deliberadamente escogidos por toda la ciudad, no solamente en los barrios considerados típicamente "hispanos". Los distintos grados de asimilación a las corrientes principales de la sociedad estadounidense se manifiestan en la mezcla de español e inglés y en el predominio de uno u otro idioma, según el lugar. En algunos casos, la presencia o ausencia de los colores nacionales (el rojo, blanco y verde de la bandera mexicana o el rojo, blanco y azul de la bandera puertorriqueña) indica el grado de asimilación.

La documentación de las vidrieras de estas tiendas ofrece un registro de arte vernáculo. Con frecuencia, se sobreponen representaciones de paisajes rurales, reales o míticos, al ambiente urbano. Esos paisajes sugieren la idea de vivir en dos lugares al mismo tiempo: la tierra natal de uno y la tierra adoptada. ¿Qué significan todas esas imágenes? ¿Son recuerdos de un pasado perdido o del deseo de regresar? ¿Reafirman la vieja identidad o son una manera de domar el medio ambiente nuevo, desconocido y a veces hostil?

El español no es un idioma extranjero en los Estados Unidos. Para cuando se llevó a cabo el censo oficial de 1990, la población total de "personas de origen hispano" en los Estados Unidos sumaba más de 22 millones. Los nombres de muchos de nuestros estados (California, Nevada, Texas, Colorado, Nuevo México, Montana, Florida) son un recordatorio constante de que la experiencia latina es una parte familiar de la vida en los Estados Unidos.

Nací en 1929 en el Bronx, Nueva York, en una familia de inmigrantes judíos.

Me dedico al arte porque no tengo realmente otra alternativa que hacer arte. Ser artista es un componente principal de mi identidad: es lo que soy. Por lo tanto, las obras de arte las creo básicamente para mí misma. Mi arte representa quién soy, cómo veo el mundo y cómo, entonces, reacciono. En ese sentido, mi arte está muy relacionado con mi vida.

Siempre me he identificado con los que no tienen poder en esta sociedad. Ya que me crié en una familia muy rígida, descubrí desde muy temprana edad cómo funciona el poder (y la falta de poder): el poder que tienen los padres sobre los hijos, los hombres sobre las mujeres, los médicos sobre los pacientes, los miembros de un grupo étnico sobre otro, el gobierno sobre los ciudadanos. Como mujer, mi arte refleja mucho las injusticias cometidas contra las mujeres en el pasado y el presente. Me preocupan especialmente los asuntos familiares, particularmente el abuso de los niños dentro de la familia. El abuso de los niños se manifiesta de muchas maneras: no sólo el abuso físico y sexual de los que estamos todos cada vez más conscientes, sino también el abuso psicológico que es más sutil, pero muchas veces igualmente perjudicial. Los niños son los que menos poder tienen en este mundo y son, la mayoría de las veces, víctimas, pero también son nuestro futuro. Por eso, mi arte representa un microcosmo del mundo en que vivimos y de la manera en que se abusa del poder en él.

Mi arte expresa cómo veo nuestra sociedad en el momento en que me toca vivir. Miro esta realidad, la despedazo, despliego todos los pedazos y frecuentemente termino con lo que parecen ser fragmentos desconectados y desprovistos de sentido. Para ello me valgo de repeticiones, imágenes irreales y dislocaciones violentas e imprevistas. Sin embargo, los paisajes y figuras de mi obra pertenecen y se refieren al mundo cotidiano, a la vida real, en la que muchas veces no se sabe realmente qué es lo que está pasando y en la que tanto parece ser algo al azar.

Entre los individuos que me han influenciado se encuentra el escritor moderno Samuel Beckett, quien utiliza frases cortas típicas y clichés para expresar los miedos y ansiedades que nos afectan a todos. Entre los demás artistas que me han influenciado, puedo mencionar a Francisco Goya, Käthe Kollwitz y John Heartfield, quienes se propusieron representar los horrores y las injusticias de su época. Finalmente, debo mencionar las estrellas de cine, de carácter fuerte, de los años 40 y 50: mujeres como Barbara Stanwyck, Joan Crawford e Ida Lupino.

Aunque soy una mujer y una artista de marcadas preocupaciones feministas, los temas de mis obras son universales. Así, mis fuentes surgen de todas partes. En realidad, rescato imágenes de entre los desechos; utilizo imágenes e ideas de la televisión, el cine, las revistas y el *National Inquirer:* cualquier cosa que tenga a mano. Luego reciclo y vuelvo a empaquetar las imágenes y, si todo funciona bien, la pintura se hace sola. También quisiera indicar que no soy exclusivamente pintora; además hago libros, esculturas, videos y películas. Básicamente hago arte.

Tomie Arai

Nació: Nueva York, 1949
Vive en Nueva York

Soy una artista visual japonesa-americana. Nací y me crié en Nueva York. He vivido en distintos barrios de la ciudad: en el Bronx y Harlem, donde pasé la niñez, en el Lower East Side, Chinatown y el Upper West Side de Manhattan. Mi esposo de 19 años, un chino-americano, se crió en la trastienda de una lavandería en la sección de Brooklyn que se llama Bedford Stuyvesant. Aunque soy, por definición, japonesa, y él, chino, nuestra experiencia ha sido singularmente estadounidense; una experiencia inevitablemente entremezclada con la vida de los negros, blancos y latinos que encontramos todos los días.

El autor Salman Rushdie caracteriza esta condición como un proceso de hibridación, de conciliar lo viejo y lo nuevo: "La visión del mundo del emigrante; el desarraigo, la desarticulación y la metamorfosis que son la condición del emigrante". Como bisnieta de agricultores japoneses que se establecieron en este país a principios del siglo, varias generaciones me separan de la experiencia del inmigrante. Sin embargo, como muchos asiáticos-americanos, mi vida sigue siendo definida como una vida eternamente extranjera, desarraigada y marginal.

Mi obra aborda esta experiencia, y los problemas de la identidad cultural, desde la perspectiva de una mujer asiática. Me interesa particularmente explorar la relación entre el arte y la historia y examinar el papel que desempeña la memoria al relatar el pasado colectivo. Mediante autobiografía, historias y fotografías de familia, material histórico e historia oral, creo páginas de historia "viva" que afirman la sensación de pertenencia y continuidad de la comunidad asiática-americana.

En toda mi obra hago referencias visuales a los biombos, los rollos de pergamino y los motivos que se encuentran en las artes tradicionales asiáticas. En mis obras, la tradición y la familia constituyen el vínculo principal entre el pasado y el presente, entre el "aquí" y el "allá", lo que vincula la vida que se dejó atrás y las infinitas posibilidades de la vida que tenemos por delante.

Tengo dos hijos y, como madre, siempre he trabajado con una corriente constante de interrupciones, las interrupciones de la vida cotidiana. Las exigencias de la familia y el choque de culturas en las calles donde he vivido me han obligado a reexaminar la forma en que creo mi arte y para quién, a quién va dirigido. Creo que es un proceso constante de exploración. A través de los años, he cultivado un proceso de creación con muchos participantes y puntos de vista. En los años 70 me involucré en el movimiento de arte de la comunidad en el Lower East Side de Nueva York. Eso me sirvió como agente catalizador para ampliar mi público y me insertó en el proceso de colaboración. Desde entonces he trabajado en colaboración con otros artistas en una variedad de medios, en proyectos de murales, de grabados y afiches, proyectos de pancartas y libros, y exposiciones organizadas por los mismos artistas en el contexto de la comunidad.

Mi obra se renueva con la energía que surge de estos proyectos y del diálogo entre artistas y no artistas, entre lo extraño y lo conocido, entre hombres y mujeres, entre niños y adultos, entre el pasado y el presente.

Nació: La Habana, Cuba, 1942
Vive en Nueva Orleans, Luisiana

Luis Cruz Azaceta

Soy un cubano del exilio y llevo 30 años viviendo en este país. Me metí a artista porque tenía una gran necesidad de decir algo y de forjar una identidad para mí mismo en la gran ciudad llamada Nueva York. El arte lo creo para mí mismo con la esperanza de que llegue a un gran público.

Creo que soy de los pocos artistas que creemos que el arte tiene el poder de cambiar el mundo para bien. A veces los libros, las películas, el arte, la filosofía, la religión, etcétera, pueden cambiarle a uno la vida, la visión del mundo, las opiniones que tiene sobre sí mismo y sobre la sociedad en su totalidad. Mejor dicho, creo que el arte es una manera de transmitir el amor, la compasión y el autoconocimiento.

La realidad alimenta mi obra. Por ejemplo, leer el periódico, mirar las noticias por televisión, viajar en el metro, caminar por la ciudad son experiencias cotidianas que me afectan personalmente o que nos afectan colectivamente. Me atraen los males de la sociedad como fuente de inspiración —el crimen urbano, el racismo, los desamparados, la epidemia del SIDA—, las cosas que intentamos pasar por alto o tapar.

En cuanto a la selección de materiales, prefiero la pintura sobre el lienzo o el papel. Me da placer y satisfacción aplicar y manipular la pintura sobre esas superficies. También me gusta que mi obra refleje la mano del artista.

En cuanto a la supervivencia económica, siempre he trabajado de tiempo completo como artista, con trabajitos de tiempo parcial para ayudar a pagar las cuentas. Más adelante en mi carrera, solicité y gané varias becas locales y nacionales para mantenerme. Además, he dado conferencias en escuelas de arte y universidades. Desde 1983 he podido mantenerme modestamente como artista con la venta de mis obras.

Border Art Workshop/
Taller de Arte Fronterizo

Fundado en San Diego, California, 1984
Trabaja en Tijuana, Baja California/
San Diego, California

El Border Art Workshop/Taller de Arte Fronterizo es un grupo binacional de colaboración, compuesto de hombres y mujeres de México y los Estados Unidos, que crean un arte basado en la historia y los acontecimientos de actualidad de la frontera que separa a los Estados Unidos y México. Nuestros objetivos son: 1) establecer nuevos frentes de comunicación entre los dos países; 2) ver ésta y todas las fronteras entre los pueblos como un concepto arbitrario y heredado; 3) descubrir métodos de colaboración que permitan la divulgación de puntos de vista y perspectivas distintos a los nuestros; 4) ir más allá de los límites impuestos por las prácticas tradicionales de la creación artística.

Los miembros de BAW/TAF son artistas profesionales, profesores y gente de una variedad de disciplinas relacionadas con la educación, el arte y las actividades de la comunidad; estudiantes de distintas formaciones; escritores; y personas comprometidas con el activismo social y político. En un momento dado u otro, hemos sido una mezcla de chicanos, mexicanos, angloamericanos, japoneses-americanos, una variedad de todos esos grupos y otros más.

Nuestra cultura es la cultura del internacionalismo, teniendo en cuenta la realidad de que nosotros caminamos por la línea divisoria entre Latinoamérica y los Estados Unidos. Lo que nos interesa es explorar la dinámica de la frontera, tanto de manera crítica como creadora.

Utilizamos el arte como catalizador para cualquier actividad o intervención que sea necesaria. Producimos arte para estimular la participación de un público más amplio en los hechos de actualidad que afectan el desarrollo de nuestra comunidad. A veces utilizamos el arte para buscar ciertos cambios relacionados con el racismo y el sexismo dentro del mundo del arte; a veces nuestro arte busca entablar un diálogo con perspectivas distintas a la nuestra; a veces lo utilizamos para poner de manifiesto las relaciones de poder que existen entre los medios de comunicación, el gobierno y la industria.

El arte es importante en el sentido de que puede entenderse como parte de la estructura social dentro de la cual se toman decisiones colectivas e individuales. Es un sistema en el cual lo cotidiano puede verse desde diversos puntos de vista. Es especialmente importante en el proceso de pensar cómo se debe presentar la historia, y en la documentación institucional y comunitaria. El arte es un dispositivo para volcar imágenes convencionales, textos y hechos a fin de examinar la historia y la cultura popular desde perspectivas diferentes.

Las colaboraciones iniciales de BAW/TAF fueron producto de cierta coyuntura, de haber estado en un lugar determinado en un momento dado. Había mucha gente que estaba trabajando en cosas afines, pero como individuos. Adquirimos experiencia, conocimientos y poder al asociarnos. El proceso no ha sido, bajo ningún concepto, idílico, pero hemos creado procesos efectivos trabajando en conjunto. Esto presenta enormes dificultades. Hay ideas compartidas, responsabilidades compartidas, errores compartidos y alegrías compartidas. En la historia de BAW/TAF ha habido quizás una lucha adicional a causa de la variedad de orígenes culturales y niveles de experiencia. No constituimos un modelo, sólo un proceso en curso que sigue y que ha tenido ciertos éxitos. Al finalizar lo que ha sido el siglo más totalitario en la historia del mundo, enfocarnos en la "realidad de la colaboración" en lugar del ego artístico individual es tal vez un fin oportuno y un comienzo apropiado para el próximo siglo.

La fragmentación social y cultural de nuestra época actual debe obligarnos a echar una mirada retrospectiva sobre modelos más antiguos, no para volver a vivir experiencias pasadas o ver, desde alguna nube romántica, "los buenos tiempos pasados", sino para encontrar métodos de

aprendizaje y adaptación que puedan conducir
a nuevas soluciones. La mayoría de los colectivos
se forman por intereses especiales o semejanzas
estilísticas y filosóficas. Así fue el caso en la etapa
formativa de BAW/TAF también. Los problemas de la
dinámica de grupo, el estrellato y las estructuras
jerárquicas han sido una amenaza para los artistas
que trabajan en colaboración desde hace décadas.
No hay soluciones inmediatas. Los períodos de
inestabilidad siempre amenazarán el trabajo en
colaboración, pero, por otra parte, la fricción puede
ser algo positivo.

Coqui Calderon

Nació: Ciudad de Panamá, Panamá, 1937
Vive en Coconut Grove, Florida

Me crié en Panamá y en la actualidad vivo en los Estados Unidos. Me considero muy afortunada de haber conocido diferentes culturas. Mi padre es panameño y se educó en el Instituto Tecnológico de Massachusetts. Mi madre nació en el estado de Georgia. Cursé mis primeros estudios en Panamá. Los años universitarios los pasé en los Estados Unidos y en Francia. Me identifico fuertemente con la cultura latinoamericana, pero soy bilingüe debido a mi madre y no me siento ajena a la cultura estadounidense. En la universidad me interesaban la historia y la historia del arte y ésta me llevó por primera vez a un estudio de artes plásticas, donde para siempre quedé fascinada con la aventura de crear arte.

Desde 1983 vivo y exhibo mi obra en Miami. También exhibo periódicamente en Panamá. En los últimos 10 años mi obra se ha concentrado en el estudio del paisaje y el cuerpo humano. La luz y el color del paisaje tropical me fascinan y son fuentes de inspiración sin fin. El estilo semiabstracto de mis pinturas ha recibido la influencia del movimiento abstracto expresionista estadounidense, aunque también reconozco que el manejo del color de los expresionistas alemanes y del fauvismo han tenido gran influencia en mí. La figura femenina me interesa enormemente: su fertilidad y sexualidad, su papel en la naturaleza, como parte del paisaje y de la misma madre Tierra.

Mis lazos emocionales con Panamá y los explosivos acontecimientos políticos que mi país ha sufrido en los últimos años cambiaron radicalmente las imágenes de mis lienzos. Durante el gobierno de Manuel Noriega, el país sufrió años de corrupción que lo dejó prácticamente violado y arruinado. Como protesta, el pueblo panameño se volcó a la calle con pañuelos blancos como símbolo de su cólera. Los cuadros de mi serie *Winds of Rage* son un homenaje a la lucha contra la opresión. En ellos alabo la tenacidad del espíritu humano y su sed, a lo largo de la historia, de libertad. En esos cuadros rindo homenaje a los miles de personas que, armadas solamente con un pañuelo blanco, se arriesgaron a salir a la calle a manifestar su disgusto, aun cuando se enfrentaban a pelotones de soldados armados que podían golpearlos y herirlos, como sucedió en muchos casos. Esas manifestaciones de masas eran espectáculos de gran belleza y esperanza, donde la energía reprimida del pueblo se liberaba con la confianza de que la inteligencia triunfara sobre la corrupción.

Ahora que Panamá tiene un gobierno democrático, pienso volver y he vuelto a mis temas e imágenes anteriores: paisajes y retratos en paisajes.

Considero que no existe mejor manera de expresar mis experiencias personales que a través de la manipulación del color, las líneas, la forma y la figura de una imagen. Me encanta la aventura de transferir mis sentimientos al lienzo. Es un proceso que requiere disciplina, paciencia y dedicación. Este proceso subjetivo no es totalmente satisfactorio hasta el momento en que se comparte con otros. Exhibir lo que uno ha creado es parte esencial del proceso creativo. Ya que el arte es, y siempre ha sido, un medio de comunicación del pensamiento humano, exhibirlo es una parte integral del proceso.

Soy estadounidense. Hablo y pienso en inglés. Tengo pasaporte de los Estados Unidos. No obstante haber nacido en Hong Kong y haberme criado en varios países asiáticos, crecí y me formé con una identidad estadounidense que defendía obstinadamente. En mi apariencia física, yo no correspondía a la imagen del estadounidense difundida por los medios masivos y para compensar, me hiperamericanicé. Rechacé las culturas asiáticas que estaban a mi alrededor y que percibía como una amenaza a mi ser estadounidense. Cuando regresé a los Estados Unidos, pensé que había terminado la batalla. Estaba, por fin, en mi tierra, donde no tenía necesidad de sacar a relucir mi ciudadanía.

Por fin, experimentaría directamente los Estados Unidos de Hawthorne, Thurber, Anderson, Twain y Faulkner. Podría adentrarme en las visiones de Wyeth, Dixon, Hopper, Wood y Sheeler.

—*Qué bien hablas el inglés.*

—*¿Por qué no? Soy estadounidense, igual que tú.*

Sería como el muchacho que vive al lado, el amigo de la familia, en las peripecias y tribulaciones televisadas semanales de *Ozzie & Harriet, Father Knows Best, Bachelor Father, Beaver* y *Lucy y Ricky.*

—*Eres muy alto para ser oriental.*

—*Mido seis pies y cuatro pulgadas, casi dos metros. Soy alto para ser estadounidense, punto. Y el término es asiático, no oriental.*

Podría viajar a dedo por el paisaje intranquilo de las películas *Rebel Without a Cause, Beach Blanket Bingo, Easy Rider, Woodstock* y *American Graffiti.*

—*¡Oye, japonés! Lárgate.*

—*¿Qué? No pueden estar gritándome a mí. No ven que no soy japonés, soy chino. Y además estoy en mi tierra.*

Elvis, Gary Lewis & the Playboys, Dylan, Simon & Garfunkel y los Beach Boys.

—*¡Oye, gook!*

No soy *gook,* hombre, soy estadounidense. ¿Cuántas veces te lo tengo que decir? Me tragué mi cuota de hamburguesas McDonald's, por poco me ahogo en la Generación de la Pepsi-Cola, aspiré nicotina en la tierra del Marlboro, Walter Cronkite fue mi Profeta y el *Reader's Digest* mi Biblia.

—*¡Tú, chino! ¡Mataste a mi padre!*

—*No me digas que tú también estás en eso. Tranquilo, compadre. Yo no maté a tu viejo. El gobierno federal declaró las guerras; ellos mataron a tu padre. Yo soy el que caminaba al lado tuyo y de tus padres en las manifestaciones del movimiento de derechos civiles, ¿no te acuerdas? Las voces que se escuchaban eran nuestras voces unidas.*

¿Pero cómo puedo esperar yo que entiendas tú? Yo hasta ahora me estoy despertando. Al cabo de años y años de afirmar mi identidad, pasiva y agresivamente, todavía no me consideran estadounidense.

Mi obra explora los temas de la aculturación. Busca reclamar una historia y crear modelos de comportamiento; volver al comienzo y cambiar la agenda heterosexista del hombre blanco que a todos se nos ha impuesto a través de nuestro sistema educacional prejuiciado; explorar la americanización de los *asiáticos* y el proceso de la toma de conciencia de todos los grupos marginados, ya que la sociedad no nos permite ser simplemente 'americanos'.

El multiculturalismo no es una tendencia de moda. Los Estados Unidos se construyó sobre una fundación de racismo. En ese sentido chueco, siempre hemos sido una nación multicultural. Se nos acerca el fin del siglo 20; ¿no es hora de que todos despierten y comprendan?

Houston Conwill, Joseph DePace, Estella Conwill Majozo

Fundado en Nueva York, 1985
Trabaja en Nueva York

Somos un equipo interdisciplinario de artistas interesados en la función del arte como medio para darle significado a nuestra vida y como agente catalizador para el cambio social. Houston Conwill es escultor, Joseph DePace es arquitecto y artista gráfico, y Estella Conwill Majozo es poeta. Creamos instalaciones de arte público para sitios específicos que plantean una nueva coreografía de su historia, con un impulso hacia la liberación. Nuestras obras tienen muchas capas y buscan abrir el exclusivo cánon histórico a múltiples perspectivas. Nos interesa preservar y comunicar la sabiduría y los conocimientos de múltiples generaciones y culturas, y es nuestra intención que nuestras obras sean vehículos para educar, cambiar estereotipos y presentar modelos de conducta positivos.

Nuestras obras encarnan una síntesis de fuentes multiculturales, entre ellas: el arte mundial, la música, la danza, la arquitectura, la poesía, el cine, la cultura popular, el arte popular y las artes de los festivales. Utilizamos lenguajes, luz, elementos naturales, vidrio, espejos y agua, además del video, la fotografía y el *performance*.

Creamos mapas de lenguaje que presentan viajes simbólicos de transformación, fomentando conciencia cultural, armonía racial y comprensión. Están compuestos de letras editadas y contrapuestas de música del mundo, como espirituales, *blues, gospel, soul, jazz, funk,* samba, merengue, *reggae,* calipso, *rock and roll, rap,* cantos de libertad y citas multilingües de discursos de modelos heroicos.

Sus palabras humanistas abordan los temas de la paz mundial, la justicia social, los derechos humanos y la ecología. Se enfrentan también a los enemigos universales: la opresión, el racismo, la violencia y la pobreza. Nos inspiran a franquear las barreras que separan a los grupos de ascendencia diversa y a construir puentes de compasión, abriendo un campo común de encuentro para toda la humanidad.

Nació: Arkansas, 1940
Vive en Bruselas, Bélgica

De acuerdo con los documentos oficiales nací en Arkansas en 1940, pero ese estado es un invento reciente. Todos los "estados unidos" fueron inventados en contra de los amerindios y yo, como cheroquí, nací en territorio cheroquí bajo el agresivo acto político llamado "Arkansas".

En una larga guerra que continúa aún, centenares de miles de valientes cheroquíes defendieron a nuestro pueblo y murieron para que mi generación pudiera vivir y seguir defendiéndose.

¿Sería, entonces, "patriótico" de mi parte decir que soy "americano", de la "minoría" llamada "americanos nativos"? No, soy cheroquí, y no puedo ser otra cosa.

Eso no quiere decir, sin embargo, que tenga que seguir una definición hecha por otros de lo que soy o lo que hago. He vivido en Europa, Nueva York y México, además de haber vivido en reservas. Es una especie de deber ser libres, intelectualmente y en todo otro sentido, salirnos totalmente del aislamiento en que nos mantienen.

Probablemente esa idea es la que me motiva a crear el tipo de arte al cual me dedico. De niño, hacía juguetes y objetos para mí mismo, para crear mi propio mundo de fantasía ya que el mundo en que vivía no siempre era bueno. Como demostré cierto talento al hacer esas cosas, luego me enseñaron a hacer objetos que se usaban en las ceremonias y otros para vender a los turistas. De modo que, por una parte, participaba en partes importantes de nuestra cultura, y por otra, participaba en nuestra degradación. Pero, en ambos casos, aprendí que es necesario relacionar el mundo personal de uno con el mundo público. Hay un concepto en el idioma cheroquí que podría traducirse de la siguiente manera: "Es necesario hablar bien y escuchar bien en el Consejo del mundo".

No puedo sentarme en mi taller, en mi propio mundo privado, y cultivar buenas ideas artísticas, ejecutarlas y abrirles un lugar en el mundo a empujones. Tengo que crear mi arte socialmente, para el uso común y el bien de todos. Pero si no hablo bien, si no me tomo a mí mismo en serio, no puedo crear nada que sea de utilidad para la sociedad.

También me parece necesario, por las mismas razones, integrar el mundo del arte —las galerías, los museos y las revistas de arte— al resto del mundo. El arte tiene funciones importantes en la vida humana. Aprendemos ciertas cosas a través del arte de una manera particular que no es posible a través de lo que llamamos lenguaje. Si pudiéramos decir el arte o escribir el arte, no haríamos arte.

Por razones complejas, los sistemas políticos modernos nos han dicho o que el arte no tiene función alguna o que su función es la de apoyar al sistema político. Para mí el arte es una combinación de investigaciones sensuales e intelectuales de la realidad. El hecho de que los gobiernos quieran controlar el arte es indudablemente parte de la realidad que el arte debe investigar. El hecho de que un gobierno extranjero (los Estados Unidos) quiera controlarme a mí como cheroquí es parte de la realidad que mi arte tiene que investigar.

Sin embargo, no quisiera ser como esos gobiernos. Quiero que mi obra dé energía y aliento a todo ser humano que entre en contacto con ella.

El "público" tiene también sus propias responsabilidades. Normalmente uno no lee una novela seria de la misma manera en que leería un libro de historietas; lo hacemos con calma y cuidado, y realizamos nuestras propias investigaciones. ¿Por qué acercarse de manera distinta al arte?

El lenguaje es una serie de destrezas que sabemos que tenemos que seguir desarrollando simplemente porque es un placer hablar con más gente. Los vocabularios del arte nos permiten el mismo placer.

Epoxy Art Group

Fundado en Nueva York, 1982
Trabaja en Nueva York

El Epoxy Art Group nació cuando se reunieron seis artistas de Hong Kong y China en Nueva York en 1982. Como pintores y escultores de varias nacionalidades asiáticas, nos aliamos en el ambiente de diversas culturas de Nueva York para trabajar en colaboración, con el fin de crear nuevas oportunidades artísticas. Escogimos el nombre "Epoxy" para sugerir la poderosa fuerza química de cohesión que tiene la adhesión entre culturas que se entrelazan.

Los proyectos del Epoxy Art Group son trabajos de colaboración realizados por un grupo variable de artistas, que va de dos a nueve personas. Las ideas para los proyectos surgen de la discusión entre los miembros; las discusiones siguen hasta que determinado concepto se defina en términos de una actividad específica. Al trabajar como grupo, la energía creadora personal se canaliza en un esfuerzo colectivo para discutir temas de interés común. Actualmente, los miembros del grupo prefieren ser anónimos de modo que la obra de cada miembro individual pierda su identidad propia para formar parte de la obra colectiva de Epoxy.

El resultado final, positivo, del proceso de colaboración es la sensación de camaradería y el intercambio de ideas y energía entre todos. La desventaja de trabajar como grupo es lo difícil que es lograr un equilibrio razonable de tiempo, espacio y energía, y coordinarlo a largo plazo. Con el paso del tiempo, cambian las prioridades e intereses de los distintos miembros del grupo y eso produce cambios en la química de la cohesión que afectan, a su vez, el resultado de la colaboración. Mantener el equilibrio y coordinar los elementos cambiantes que integran un grupo puede ser una experiencia agotadora.

Nació: Ciudad de México, México, 1955
Vive en Nueva York

Nací en septiembre de 1955 en el Hospital Español, ubicado en una colonia judía de ciudad de México, la metrópolis más densamente poblada del mundo. Fui el más prieto u "oscuro" de tres hijos, tanto en cuanto a color de piel como en cuanto a personalidad. Mi padre era más prieto que yo, un caballero deportivo de aspecto mestizo por excelencia. Mi madre era tan blanca como el papel. Parecía una "doña" española, pero tenía una ternura netamente mexicana. Siempre me sentí un poco fuera de lugar entre mi hermana pelirroja y mi hermano güero, ya que para verme "decente" siempre debía estar más limpio y mejor vestido que ellos.

Estudié en escuelas jesuitas. Allí me di cuenta de los privilegios del color de la piel. Los "niños bien" eran de piel blanca y facciones europeas. Los "nacos" eran prietos y bajitos. Por ser mestizo, yo era de los dos bandos, digamos un poco café con leche. El racismo del México moderno no es como el racismo militante de los Estados Unidos o de Sudáfrica. Es más bien un producto de la inflexible estructura social del país. De todos modos, ya de adolescente sabía que mi físico no era del todo aceptable. La madre de mi novia Adriana dijo una vez: "Guillermo no es feíto, pero desgraciadamente es prieto". Todavía llevo esa espina en el corazón, y vivir en los Estados Unidos lo que hace es infectar esa herida.

Hoy, me despierto a diario como un mexicano que vive en territorio estadounidense. Con mi psique mexicana, mi corazón mexicano y mi cuerpo mexicano tengo que crear un arte para un público estadounidense que conoce muy poco sobre mi cultura. Éste es mi dilema diario. Tengo que obligarme a cruzar una frontera, para darme de bruces siempre con la falta de reciprocidad del otro lado. Vivo físicamente entre dos culturas y dos épocas. Tengo una casita en ciudad de México y otra en Nueva York, separadas por mil años luz de distancia en cuestión de cultura. También paso parte de mi tiempo en California. Como resultado, soy mexicano parte del año y chicano el resto del año.

Cruzo la frontera a pie, en carro y en avión. Mi viaje no sólo me lleva del sur al norte, sino también del pasado al futuro, del español al inglés y de un extremo de mi persona al otro.

Esta experiencia de ningún modo es exclusiva. Miles de artistas de color en los Estados Unidos, Canadá y Europa cruzan constantemente diferentes fronteras y, al hacerlo, crean un arte nuevo, un arte de fusión y desplazamiento.

En México, donde a los escritores se les respeta y escucha, soy escritor; en los Estados Unidos, donde se margina a los escritores, soy *performance artist*. Tanto en mi obra escrita como en mis *performances* escojo un tono épico ya que creo que la experiencia latinoamericana contemporánea, marcada por la diáspora, el desaliento económico, el hostigamiento policíaco y la exclusión cultural, es de dimensiones épicas. Zigzagueo del pasado al presente, del inglés al español, de lo ficticio a lo biográfico. Fusiono poesía, sonido y texto, arte y literatura, activismo político y experimentación. Mis obras son, al mismo tiempo, ensayo y manifiesto; *performance* y crónica social; poemas bilingües y programas de radio. En ellas trato de ejercer toda la libertad que mis dos países me han negado.

Carlos Fuentes ha dicho que la esperanza política de nuestro continente radica precisamente en los modelos culturales que han creado sus artistas y escritores de gran imaginación. ¿Pero cómo transferir esos modelos al campo político? Si queremos ser creadores de la cultura de esta década en un país que nos margina constantemente, tenemos que luchar sin descanso por el derecho a tener una voz pública.

También tenemos que desafiar el mito anacrónico de que como "artistas de color" sólo podemos trabajar dentro de los límites de nuestra "comunidad" étnica. Nuestro lugar es el mundo y nuestra "comunidad" se ha multiplicado con creces. En esta década del 90, me siento conectado con todos aquéllos que en éste y otros continentes buscan nuevas formas de interpretar los peligros y los cambios de la época.

Gran Fury

Fundado en Nueva York, 1988
Trabaja en Nueva York

Gran Fury es un colectivo de activistas del SIDA. Juntos creamos obras de arte que examinan los fundamentos políticos y sociales de la crisis del SIDA. Buscamos concientizar sobre los prejuicios, las desigualdades de clase y raza, y la política económica y del poder que contribuyen y definen la naturaleza de la situación crítica por la que pasan actualmente los servicios de salud. Al identificar los problemas y poner al descubierto esos factores, aportamos información al debate público sobre el SIDA. Mediante presiones del público, se puede persuadir a los gobiernos a que tomen ciertas medidas.

Muchos de los miembros de Gran Fury son gay, muchos somos hombres y muchos somos blancos. No todos somos artistas. La vida de todos nosotros ha sido afectada por la epidemia del SIDA y eso nos ha llevado al activismo.

Gran Fury utiliza el espacio y el dinero proporcionados por el mundo del arte para montar campañas de información pública. Nuestros trabajos a menudo se ven en los autobuses y en el metro, en carteleras y afiches, en etiquetas engomadas y paradas de autobús. Muchas veces los disfrazamos para que se parezcan a los anuncios comerciales que la gente está acostumbrada a ver en esos lugares.

Todos recibimos la influencia de lo que vemos. Las imágenes públicas, las palabras públicas, desde la publicidad comercial hasta las bellas artes, son agrupaciones de ideas culturales. El diseño de cada paquete, cada anuncio que aparece en algún edificio expuesto a nuestra mirada es, hasta cierto punto, propaganda.

Se supone que debemos creer todo lo que se nos dice; como, por ejemplo, que el gobierno está haciendo todo lo posible por combatir el SIDA. Puesto que Gran Fury cuestiona eso, lo remplazamos con guerrilla de información, información que toma por asalto la voz de la autoridad. Insertamos nuestro mensaje en los espacios públicos porque es una de las formas que tenemos de influenciar el debate público en este país. Por eso "anunciamos" nuestras ideas políticas; por eso optamos por proyectarlas en los espacios públicos. Para nosotros el arte sólo tiene importancia en la medida en que sus técnicas ayuden a captar la atención del espectador. La atracción seductiva de una frase elocuente o un buen diseño gráfico comunica una idea al adoptar cierto "aire" de autoridad. El mensaje, que es el verdadero contenido de la obra, es lo más importante para nosotros.

Los momentos de crisis estimulan una reacción colectiva. Ya que el proceso colectivo en la toma de decisiones conduce con más facilidad a la acción colectiva, y hace falta acción colectiva para ponerle fin a la crisis del SIDA, Gran Fury trabaja colectivamente.

Hay tantos asuntos relacionados con el SIDA y tantos grupos afectados que las voces individuales son inadecuadas para trazar el cuadro completo. El desafío que presenta esa multitud de voces nos obliga a analizar nuestra propia comprensión del significado político y cultural del SIDA. Mientras más voces se sumen a la creación del producto final, más probabilidad hay de que tenga significado para el público amplio.

El proceso de colaboración nuestro empieza con conversaciones largas y detalladas sobre qué estrategia o problema queremos abordar. Una vez que lleguemos a un acuerdo en cuanto al tema o el público en cuestión, ponemos sobre el tapete el lenguaje y las imágenes de la pieza, y discutimos la política y/o tácticas que de ahí se desprenden. Esas discusiones pueden durar semanas y a veces meses. Después de que se tome una decisión en cuanto al contenido, empezamos la fase de la producción. Generalmente, unos cuantos miembros dirigen la producción, pero en principio pueden participar todos

los miembros de la colectividad. Las tareas se
reparten de acuerdo con los recursos y experiencia
de los participantes.

El proceso de colaboración es arduo, exige mucho
tiempo y resulta, de vez en cuando, doloroso. La
desventaja de nuestro colectivo en particular es que
no tenemos representación del espectro completo de
comunidades afectadas por el SIDA. Pasamos mucho
tiempo comentando y analizando esta realidad. Las
mujeres y la gente de color que forman parte de
nuestro grupo se ven repetidamente en la posición
de tener que hablar por la comunidad entera a la
que representan. Para que nuestra voz tenga mayor
alcance hemos colaborado en varias ocasiones con
grupos que trabajan en otras comunidades afectadas
por el SIDA.

Group Material

Fundado en Nueva York, 1979
Trabaja en Nueva York

Group Material está compuesto por un núcleo de individuos, entre quienes han figurado Doug Ashford, Julie Ault, Félix González-Torres, Karen Ramspacher y Tim Rollins. Colaboramos para organizar exposiciones y proyectos de arte relacionados con temas sociales. Group Material se fundó en el año 1979 y desde entonces ha estado organizando exposiciones en Nueva York, la sede del grupo, así como en otros lugares dentro y, a veces, fuera del país.

Group Material rechaza la noción tradicional de que el artista es un ser solitario y alejado del resto del mundo. Como artistas, nos vemos como participantes vitales de la sociedad. Queremos jugar un papel activo, no de consumidores, en el desarrollo de nuestra cultura. Nos interesa utilizar una cultura estética y visual para comunicar un significado y sugerir formas alternativas de imaginar la sociedad.

Group Material produce exhibiciones y proyectos temporales, en lugar de objetos de arte. Nuestras exposiciones cuestionan las nociones aceptadas de lo que es el arte, a quién está dirigido y dónde debe ser visto. Al combinar las bellas artes con objetos de producción en masa, televisión y diversos artefactos, estamos extendiendo la definición del arte para incluir una gama más amplia de producción cultural. Esos diversos materiales se instalan en un diseño específico de manera que permita trazar conexiones entre los elementos. Las exposiciones sirven de foro para alentar y expresar distintos enfoques y puntos de vista artísticos. Las representaciones aguadas y blanqueadas que pintan la cultura dominante y sus instituciones fomentan determinadas agendas sociales y políticas, y excluyen otras. Group Material presenta un cuadro más amplio e inclusivo de la sociedad mediante la representación de diversidad cultural y la investigación manifiesta de la problemática política y social. Por encima de todo, nuestro trabajo muestra una fuerte influencia del proceso de colaboración, entre nosotros y con la

sociedad en general. En una de nuestras primeras colaboraciones públicas, *The People's Choice*, pedimos a nuestros vecinos que contribuyeran algún "objeto valioso" que tuvieran en su casa. El resultado final fue un retrato colectivo de nuestra manzana con recuerdos personales, símbolos religiosos, arte popular, reproducciones y obras de arte originales.

Comenzamos a trabajar en grupo para ampliar la sensación de comunidad que experimentamos cuando éramos estudiantes. Cuando salimos de la escuela, no quisimos permitir que la competencia y la economía determinaran nuestra motivación y nuestras creaciones artísticas. Idealmente, la colaboración puede ser una forma de aprender los unos de los otros, de escuchar y compartir ideas y perspectivas. Una ventaja de trabajar en grupo es tener la oportunidad de poner a prueba las ideas a través de la conversación y de (frecuentes) discusiones. Durante el proceso de colaboración, una idea se desarrolla y se transforma, dando paso a una creación nueva, que no puede ser concebida por un solo individuo. La discusión como proceso toma tiempo y es difícil porque es necesario poner a un lado nuestros egos en favor de la identidad y el propósito del grupo. En esas situaciones uno aprende a escuchar atentamente y a respetar las ideas, opiniones y agendas de otras personas.

Nuestros proyectos están dirigidos a una gran variedad de públicos. Algunos proyectos como *Inserts*, un folleto de 10 páginas de artistas, se insertó en 85.000 periódicos de la edición dominical del *New York Times* el 22 de mayo de 1988 y llegó al azar a un público muy variado. Las exposiciones que se llevan a cabo en espacios específicos como, por ejemplo, *AIDS Timeline* (una instalación con objetos de la cultura popular e información acerca de la epidemia del SIDA en su contexto político y económico), están dirigidas a los visitantes de

un museo. El público de un museo es una población muy variada, con una extensa gama de intereses y de capacidad de interpretación. Al crear nuestros proyectos, tenemos una idea del público, pero la experiencia nos ha enseñado a no estereotipar a los espectadores.

Como artistas, valoramos nuestro trabajo como una recompensa personal. Nuestro trabajo nos ofrece procesos de estudio e investigación, de aprendizaje, creatividad y crecimiento. También valoramos nuestra práctica artística porque nos da la oportunidad de intercambiar ideas y de hacer oír nuestra voz en el dominio público. Es nuestra esperanza alentar cambios sociales a través de nuestro trabajo.

Me llamo Dolores Guerrero-cruz. Soy pintora. Nací en Rocky Ford, Colorado, y soy chicana. Mi madre murió cuando yo tenía tres años. Después de la muerte de mi madre, mi hermana mayor, mi hermano menor y yo nos trasladamos a casa de nuestra abuela paterna que vivía cerca. En 1954 la familia se fue de Colorado a Los Ángeles. He conservado el apellido Guerrero, el de mi abuela, quien me crió, me enseñó a ser independiente y autosuficiente, y estimuló mi espíritu creador. En casa de mi abuela, vivía sumergida en la cultura mexicana. Mi abuela era de Guanajuato, sólo hablaba español, y servía frijoles y tortillas todos los días. Los santos católicos formaban parte del ambiente de mi casa.

Mi arte se inspira casi exclusivamente en mi crianza como chicana, en la vida de mi familia, los niños, otras madres, amantes y el simbolismo chicano. También he recibido la influencia de la pintura de Paul Gauguin y los temas elaborados en ella. Me gusta la soltura de las líneas y la claridad de los cuadros de Matisse, y me encantan el estilo y los colores de la obra de Diego Rivera.

Creo mi obra artística como medio de auto-expresión y supervivencia. Desde niña, me di cuenta de que no tenía otra alternativa; necesito crear arte como parte de la vida diaria. Aunque ha habido etapas de mi vida en que las circunstancias no me dejaban pintar, siempre he logrado volver a lo que ahora reconozco como mi vocación y mi don. Mi público es a la vez personal y universal. Mi arte se dirige a la comunidad chicana como una forma de identidad propia positiva y de autoimagen, pero tiene algo que decir, además, a la comunidad en general para que pueda aprender algo de mi cultura; se dirige a las mujeres de mi grupo étnico, así como a las mujeres en general. Mi visión y mis deseos para el futuro son utilizar mi arte para explorar y confirmar tanto la experiencia chicana como la de ser mujer en las Américas del siglo 20.

Busco imágenes que tengan la capacidad de hacer que la gente esté más consciente de su propio comportamiento. Rechazo la forma en que la sociedad limita a la mujer mediante un hostigamiento que restringe nuestras posibilidades de escoger distintos estilos de vida. La serie *Mujeres y Perros* explora el tema del hostigamiento de la mujer por el hombre. Los hombres aparecen como perros rojos. Las mujeres aparecen representadas de distintas maneras. Cada cuadro narra su propia historia sobre la mujer y su relación con el "perro". Aunque no todos los hombres son "perros", pienso que hay muchos, demasiados, que sí lo son. La sociedad tiene que aprender una actitud distinta con respecto a la mujer. Los hombres tienen que dejar de contemplar a la mujer como si fuera un objeto y nada más.

Desde la niñez, el ambiente de la casa siempre ha sido importante para mí. La *Serie Sarape* consta de cuadros que representan escenas caseras, de interiores, que tienen como foco los sarapes mexicanos de colores vivos que adornan los muebles. Estos "paisajes culturales" evocan recuerdos del pasado y reafirman nuestros vínculos con la tradición.

El arte es un elemento esencial en la vida cotidiana de todos. Resulta imposible pensar en cualquier faceta de la sociedad contemporánea sin reconocer la presencia del arte. El arte es la sustancia de mi existencia, el vehículo principal a través del cual expreso mis valores emocionales, espirituales e intelectuales. El arte es lo que hago, cómo me siento, quién soy, lo que pienso, cómo vivo mi vida. A través de mi arte, le pido a la sociedad que se comprenda a sí misma, que corra el riesgo de examinarse a sí misma, que se enfrente a problemas, actitudes y formas de conducta, y finalmente, que acepte el desafío de transformarse. Veo la galería y el museo como medios para presentar mi arte a un público mayor, pero considero que sólo el público y mis compañeros pueden ofrecer una valoración crítica válida de mi obra. Rechazo la noción de que las galerías y los museos determinen la importancia del arte. Al contrario, el arte le da la oportunidad a las galerías y los museos de informar e instruir, en asociación con el artista.

Fundado en Nueva York, 1985
Trabaja en Nueva York

Somos un grupo de mujeres artistas anónimas de Nueva York y nos asociamos en la primavera de 1985 para combatir el racismo y el sexismo en el mundo del arte utilizando los medios de comunicación y la calle.

Llenamos las calles de afiches con estadísticas sobre la desigual presencia (o ausencia) de mujeres y minorías en las galerías y museos. Atacamos también a los críticos y coleccionistas por no escribir sobre el arte hecho por mujeres y artistas de color ni comprar sus obras en suficiente cantidad.

Ya que somos mujeres artistas, todas hemos experimentado la discriminación en el mundo del arte y nos damos cuenta de que el hecho de no haber tenido buena acogida no se debe necesariamente a la calidad de la obra en sí sino que refleja más bien un dilema cultural. El mundo del arte, compuesto de dueños de galerías, críticos, artistas y coleccionistas, está controlado principalmente por hombres blancos y sólo expone, desafortunadamente, una esfera muy limitada del arte.

Sabemos que el arte es esencial para la vida, y que como los seres humanos son distintos uno del otro y cada uno tiene sensibilidades y experiencias únicas, esto se refleja en sus obras. Por lo tanto, es esencial que se muestre una vasta gama de obras y que la gente pueda ver más que un solo tipo de arte.

Trabajamos en grupo porque se requiere más de una persona para hacer todo lo que hacemos. Entre nosotras no hay una "encargada". Todas tenemos el mismo poder. Nuestras ideas son el resultado del trabajo de muchas mentes. Cuando surge algún asunto que nos parece que merece atención, nos reunimos para lanzar e intercambiar opiniones. Esas ideas se van refinando hasta que llegamos a una decisión del grupo.

La ventaja de trabajar en grupo es que hay más información y una variedad de puntos de vista. Como nos damos apoyo unas a otras al trabajar en conjunto, podemos encauzar los sentimientos de impotencia y rabia hacia acciones constructivas.

La desventaja de trabajar en grupo es que hacer cualquier cosa se demora más ya que cada quien tiene ideas propias y fuertes.

Una de nuestras metas, como grupo, es crear un ambiente en que cada artista individual tenga la misma oportunidad de darse a conocer, independientemente de su sexo o raza. O sea, valoramos mucho el compromiso que tiene cada artista con su propia obra.

Marina Gutierrez

Nació: Nueva York, 1954
Vive en Brooklyn, Nueva York

Nací en Nueva York y pertenezco a la segunda generación de mi familia que ha nacido y crecido aquí. Cuando en otros países me preguntan cuál es mi nacionalidad, siempre contesto que soy nuyorquina con pasaporte estadounidense. Mi cultura es híbrida, una mezcla de las culturas puertorriqueña, europea y estadounidense, desarrollada bajo una fuerte influencia de la cultura africana y enriquecida por el constante contacto con las comunidades china, italiana, india, judía, griega, árabe, coreana y antillana que cohabitan en mi ciudad.

De niña, empecé a dibujar y a hacer cosas y no he parado desde entonces, pero me tomó cierto tiempo darme cuenta de que sí es posible sobrevivir como artista (¡lo es!). También me ha tomado tiempo desarrollarme al punto en que puedo "hablar visualmente", con mis propias palabras, con una voz propia.

Recuerdo mis dibujos cuando pequeña: caras, ojos (azules con demasiada frecuencia). Recuerdo cómo hacía casas de arena y hojas, y cómo transformaba bolsas de papel en marionetas. Recuerdo los juguetes: juguetes viejos de metal esmaltado impresos con el registro corrido (lo cual creaba arco iris en los contornos), el olor a plástico de muñecos nuevos y rosados. Recuerdo los broches, hilos y retazos sobre el suelo de madera… e historias, dibujaba historias interminables, que se derramaban por los bordes de la hoja de papel.

Esas historias siguen evolucionando, infinitas y complejas. Son las imágenes de mi propia visión en momentos que han quedado helados, estáticos. Son cuadros habitados por gente conocida, en lugares y espacios en donde el contenido determina la perspectiva y representación del tiempo. Son narrativas de recuerdos, comentarios, conexiones, explicaciones, investigaciones, revelaciones y destilaciones analíticas.

Me enseñaron una versión limitada y unilateral de la historia, un mito aburrido y erróneo que excluía a mis antepasados. He decidido reclamar el pasado, explorar la "historia" como "nuestra" historia y trabajar en narrativas visuales, recordando e interpretando nuevamente el pasado y el presente.

Me preocupa la cultura consumista en que vivimos y la conformidad irreflexiva que promueve. Mi respuesta a esta situación es ser artista, pensar y crear, comunicarme. Exhibo en museos y galerías, y algunas veces vendo mis obras. También he creado afiches para trenes, letreros para exhibirse en las calles y animación para llegar a distintos públicos, por varios medios y formas. Las formas cambian, pero el contenido y la intención son constantes en mi trabajo.

En una sociedad en la cual el arte es una inversión para la élite rica, con frecuencia existe la tendencia a restringir los límites de los temas artísticos "apropiados".

El tema de mi trabajo surge de situaciones que me conmueven: la lucha en contra del racismo (tanto aquí como en Sudáfrica), la guerra, la explotación y la ecología, pero también las alegrías que la vida presenta, y la riqueza de la historia y la herencia cultural del pueblo.

También trabajo con gente joven. En mi enseñanza, presento distintas opciones y apoyo a mis estudiantes en la búsqueda de sí mismos, de una carrera, de un lugar propio en el mundo. Aun los que no lleguen a ser artistas se fortalecerán durante el proceso creativo.

En realidad, detesto el arte... nunca, nunca me ha gustado el arte. En la escuela nunca tomé clases de arte.

Nació conmigo. Por eso no lo estudié, porque nació conmigo. A mí me echaron de muchas escuelas de artes liberales, me dijeron que me metiera a una escuela vocacional. Un día me dije: "Bueno, ya estoy muy viejo para seguir huyendo de este don", así que decidí agarrar el toro por los cuernos. Pero siempre me ha enfurecido el arte porque nunca fue muy importante para mí. Cuando estaba en California, los artistas trabajaban años y jamás hacían una exposición. Así que las exposiciones nunca han sido muy importantes para mí. Maldecíamos a la gente que nos compraba obras, a los vendedores, porque esa parte de ser artista era un chiste para nosotros.

Algo que me influenció, de cierta manera, fue la obra de Mel Edwards. En 1970 hizo una exhibición en el Museo Whitney con una cantidad de cadenas y alambres. Ésa fue la primera obra de arte abstracto que vi que tenía valor cultural para los negros. Me dejó boquiabierto porque hasta ese momento yo pensaba que no se podía crear arte abstracto con mensaje. Yo capté los símbolos de la obra de Mel. Después conocí a su hermano y hablamos todo el día de símbolos, de Egipto y de mil cosas. De que un símbolo, una forma, tiene significado. Después de eso, comencé a usar el símbolo de la espada; eso fue antes de las bolsas de grasa. Estaba tratando de entender por qué a los negros nos llaman, despecti-vamente, *spades* y no porras. Porque me acuerdo que una vez me llamaron *spade* y no sabía qué significaba; *nigger* sí entiendo, pero *spade* no. Así que empecé a pintar la forma de la espada. Empecé a trabajar con la espada más o menos como Jim Dine estaba trabajando con la forma del corazón. Vendí algunas; Stevie Wonder me compró una. Después comencé a trabajar con palas (espadas); hacía máscaras con ellas. Fue como una reacción en cadena. En el arte suceden muchas cosas mágicas. Suceden cosas increíblemente mágicas cuando uno

se mete con un símbolo. Les pasaba el carro por encima a unas palas y las fotografiaba. Las colgaba de árboles. Unas eran de cuero (eran piel). Cogía ese símbolo y hacía montones de cosas tontas, ignorantes, cursis con él. Pero uno lo hace, y después de hacer todas esas cosas ignorantes, todas esas cosas cursis, de repente comienza a aparecer algo brillante. Hay que pasar por un proceso para llegar a lo brillante; hay que hacer cosas cursis, hay que poner a prueba quizás 500 ideas. Hay que hacer un bosquejo de cualquier ridiculez que se le ocurra a uno. Es como sacarse del cerebro todas las ideas ignorantes, bobas y ridículas que uno tiene adentro, hasta que no queda nada más que las ideas brillantes. Así se incuban las ideas brillantes. Con el tiempo, a uno se le ocurren ideas en que nadie más hubiera podido pensar porque uno no las pensó, porque pasó por ese proceso para llegar a ellas. Esas ideas son las que valen, las últimas de las 100 o de las 500, cuantas sean necesarias. Esas ideas son las que sirven para hacer la imagen y las demás se descartan. A lo mejor, uno echa el vuelo con esa última buena idea y comienza a pensar así, de modo que no tiene que hacer otra vez todas esas cosas tontas.[1]

Keith Haring

Nació: Reading, Pensilvania, 1958
Murió: 1990

¿Qué te llevó a ser artista?

Mi papá dibujaba monitos. Desde niño, yo dibujaba monitos, creaba personajes y cuentos. Pero para mis adentros, veía una separación entre dibujar monitos y ser "artista". Cuando tomé la decisión de ser artista, empecé a hacer cosas completamente abstractas, que eran lo más que uno se podía alejar de los monitos.

¿Cuándo decidiste entrar en una escuela de arte?

Mis padres y el consejero de la escuela me convencieron; decían que si iba a dedicarme en serio a ser artista, debía tener buenas bases de arte comercial. Entré en una escuela de arte comercial, donde en un dos por tres me di cuenta de que no quería ser ilustrador ni diseñador gráfico. Me salí. Fui a ver una gran retrospectiva de Pierre Alechinsky en el Museo de Arte Carnegie. Por primera vez, vi a un artista mayor y establecido hacer algo vagamente similar a mis dibujos abstractos. Eso me dio empuje y confianza. Por esa época, andaba pensando si efectivamente sería artista, por qué y qué quería decir eso. Me inspiraron los escritos de Jean Dubuffet y me acuerdo que oí una charla de Christo y vi la película *Running Fence*.

¿Cómo te inspiraron esos artistas?

Lo que más me impactó fue su certeza de que el arte puede tocar a gente de toda clase, en contraposición a la postura tradicional, de que el arte es algo elitista.

¿Cómo empezaste a dibujar en el metro?

Cuando tenía 20 años me vine para Nueva York. Un día que iba en el metro vi un panel negro vacío, donde ponen anuncios. Inmediatamente me di cuenta de que era el sitio perfecto para dibujar. Salí ahí mismo a la calle a una papelería a comprar tiza, volví al metro e hice un dibujo. Era perfecto: un papel negro suave donde la tiza se resbalaba suave. Seguí viendo esos espacies negros y seguí dibujando en

ellos. Como eran tan frágiles, nadie se metía con ellos; los respetaban y no los borraban ni dañaban.

Las imágenes del metro llegaron a los medios de comunicación y empezaron a salir al mundo en revistas y en la televisión. Se me asoció con Nueva York y con la onda *hip hop,* con su *graffiti, rap* y *break dancing.* Llevaba unos cinco o más años haciendo mis dibujos, pero no habían llegado a la población general. Para mí fue increíblemente interesante ver cómo tocaban a gente de diferentes niveles y capas. Luego, en 1982, hice mi primera exposición individual en una galería grande de Nueva York.

¿Tus padres supieron desde el comienzo que eras gay?

Mis padres han sido increíbles al respecto, pero a su manera: saber y no decir nada. Yo nunca lo escondí y ellos nunca me preguntaron. Por mi trabajo, sabían que estaba haciendo algo bueno con mi vida y eso es lo que les importaba.

¿Estás convencido de que todos deben ser abiertos acerca de su homosexualidad?

Ser normales al respecto. Para mí no es nada especial. Pero creo que una de las cosas más difíciles con el SIDA es lo que le ha hecho a los muchachos que están creciendo, que están tratando de elucidar su sexualidad de una forma imparcial, porque se ha equiparado a la homosexualidad con la muerte. Por eso es tan importante saber qué es el SIDA, sus alcances reales. Son tan pocos los buenos modelos abiertamente gays o simplemente la gente decente que sea abierta acerca de su sexualidad. Ahora *tiene* que haber más amplitud sobre todo esto. Los muchachos de todos modos van a tener relaciones sexuales, así que más vale ayudar a que lo hagan sin peligro.

¿Cómo ha cambiado tu vida el SIDA?

Lo más difícil es saber que hay tanto por hacer.

Yo soy un obsesivo con el trabajo y me aterra pensar
que un día no podré trabajar. En todos los proyectos
que estoy haciendo ahora —un mural en un hospital
o nuevos cuadros— estoy haciendo como una
especie de balance. Cuando uno está escribiendo una
historia, puede irse por aquí y por allá, divagar en
un montón de direcciones, pero cuando va llegando
al final tiene que empezar a atar todos los cabos. Yo
estoy en ese punto ahora, sin saber dónde termina,
pero consciente de que es importante hacerlo ahora.[2]

Richard Hill

Nació: Buffalo, Nueva York, 1950
Vive en la Reserva Tuscarora,
Sanborn, Nueva York

Tengo la buena suerte de haber nacido tuscarora y miembro del Clan de los Castores. Mi identidad la heredé de mi madre y sus antepasados femeninos. Mi padre es mohawk, del Clan de las Tortugas, y después de una carrera de 30 años como herrero, ahora se desempeña como artista de tiempo completo. De joven, todos mis héroes eran herreros. Mi padre y hermano siguieron la tradición de los iroqueses, quienes durante el siglo pasado se ganaron la vida y la fama en la construcción de este país. Ser indígena significaba ser herrero. Y también vivir en la ciudad. Nací en una familia de indígenas más o menos urbanos; viví en Buffalo, Nueva York, hasta cumplir los cinco años.

Luego nos mudamos a la isla más grande de los Grandes Lagos, entre Buffalo y Canadá, y me volví "suburbano". Ése era un buen lugar para un muchacho, aunque nosotros éramos los únicos indígenas en esa comunidad. En realidad, fue una experiencia que me ayudó a tener más conciencia de mi identidad propia y singular o, mejor dicho, de estar más consciente de lo que no era. Podíamos andar por los bosques, pescar y nadar en agua menos contaminada de la que tenemos hoy, y nuestro destino era el de ser herreros.

Me inicié en el oficio a los 16 años, trabajando con mi padre, Stan Hill. Mi primera experiencia fue en un pequeño puente ferroviario en Rochester. Al llegar, nos esperaban dos herreros mohawk y trabajamos duro el día entero para terminar aquel pequeño puente. Llevé mi cámara y tomé fotos de los herreros. En cierto sentido, eso también constituía una tradición familiar. Mi papá sacaba fotografías de las obras en las que trabajaba. Mi crié con un álbum viejo que hojeaba constantemente de fotografías en blanco y negro de herreros encaramados, jugando delante de la cámara. Ellos eran mis héroes culturales. Eran los amerindios que conocía.

A los 16 años se me despertó el interés en la fotografía como forma artística. Siempre había sido artista, desde los primeros días en la escuela, y en la escuela secundaria escogí el arte como concentración. Con la fotografía podía captar el mundo desde mi perspectiva, la de un individuo indígena. Durante los veranos seguí trabajando como herrero e hice un gran esfuerzo por complacer a mi padre, pero después de que se cayó mi hermano el oficio me pareció menos heroico. Cada vez que moría un hombre en la obra, mi papá pasaba varias semanas muy triste. El oficio de herrero comenzó a parecerme más bien un castigo por haber nacido amerindio que una necesidad económica.

Después de la secundaria, decidí matricularme en la escuela de arte. Como me daba un poco de miedo decírselo a mi padre, le pedí al profesor de arte que le hiciera la visita y se lo explicara. Mi padre, en uno de sus muchos gestos inesperados, dijo: "ve y sé el mejor artista que puedas".

Me dedico a la creación artística porque es algo que puedo darle al mundo para que los amerindios sean considerados y comprendidos como gente contemporánea. Los prejuicios y el racismo que confronté de niño me hicieron crecer resuelto a dejar saber que soy amerindio y me dieron la motivación de lograr cosas en este mundo. Las influencias principales para mi arte son mis experiencias reales, mi extensa familia y la perspectiva que tengo sobre lo que significa ser amerindio en el mundo moderno.

Los materiales para mis obras provienen de lo que he podido reunir a través de los años, y muchas veces me siento y los estudio muy detalladamente antes de comenzar una obra. Colecciono obras de otros artistas como fuente de información e inspiración. Me dedico alternativamente a la artesanía tradicional, la fotografía, la pintura y la escritura. Me gusta en especial reciclar los objetos que nos rodean y colocarlos en un contexto nuevo. Me interesa saber cómo se hizo determinado objeto antes de pintarlo o fotografiarlo. Así resulta más real para mí.

He recibido la influencia de Ernest Smith, pintor séneca, quien me enseñó que la pintura tiene un papel en la educación de los amerindios del futuro;

Jesse Cornplanter, artista séneca, cuyo trabajo me enseñó que tenemos una gran tradición como narradores y que el artista visual se ha vuelto el narrador de esta generación; Huron Miller, tradicionalista onondaga, quien me educó sobre las ceremonias y la forma de pensar iroquesas; Handsome Lake, profeta séneca del siglo pasado, quien me enseñó que las actividades cotidianas son nuestra cultura; Walker Evans y Robert Frank, quienes me alentaron a fotografiar a mi propia gente; y Edward Hopper, cuyas visiones tristes y solitarias de la vida estadounidense me motivaron a buscar con más empeño formas indígenas de vivir.

¿Cómo se relaciona mi arte con la sociedad? Trato de provocar el pensamiento, de poner los estereotipos en tela de juicio y de mostrar a los amerindios como existen actualmente, no congelados en el tiempo. Los estadounidenses reciben una educación que les inculca nociones muy extrañas sobre los amerindios. Tienen poca o ninguna información salvo lo que han aprendido en las historietas cómicas, las películas de Hollywood, los libros de texto y otras fuentes de información errónea.

El contexto es esencial para el arte amerindio, pero los amerindios mismos tienen que definir y explicar ese contexto, no los antropólogos e historiadores del arte. La filosofía implícita no es la tierra ni los búfalos, las águilas o el círculo. Los principios fundamentales en los cuales tenemos que basarnos para acercarnos al arte amerindio son: que los amerindios existen en el mundo moderno, mantienen una cultura viable y han podido adaptarse a los cambios que ocurren. La facultad creadora es parte integral de nuestra tradición; si no fuera así, hubiéramos desaparecido hace tiempo ya.

No soy troglodita. No vivo en una vivienda comunal iroquesa hecha de corteza. Me educó el hombre blanco. No soy cristiano. No soy tradicionalista. Junto con muchas generaciones de amerindios, soy el producto de un experimento social que se ha estado llevando a cabo con los amerindios desde 1492. A pesar de las muchas mutaciones, sigo siendo indígena. Seguimos siendo indígenas. Hemos sobrevivido y creamos evidencia y testimonio de nuestra existencia. Creamos arte.

Jean LaMarr

Nació: Susanville, California, 1945
Vive en Susanville, California

Mi experiencia personal es directamente responsable de las declaraciones de mis obras. La supervivencia cultural de mi comunidad es el tema de mi arte. La mayor parte de mi trabajo se dirige a un público que no es indígena, ya que mi propósito es generar conciencia e interés por la supervivencia de la Tierra y nuestras futuras generaciones. También abordo los derechos de los indígenas y la experiencia de la mujer amerindia, lo que lleva de nuevo el arte a lo personal.

Mis intereses se desarrollaron cuando estudiaba en la escuela pública. Me preguntaba por qué en las clases de historia apenas mencionaban a los primeros habitantes de Norteamérica. En esa época sentí mucho racismo. El querer saber más sobre la historia del pueblo indígena fue un catalizador de mi obra artística. Tener la posibilidad de elaborar material impreso me permitió satisfacer la necesidad de informar a mi propia comunidad y al mundo no indígena. Mi primer trabajo público como adolescente consistió en diseñar volantes y afiches que anunciaban a la comunidad el Baile Primaveral del Oso. Desde entonces considero que el arte es un medio de difusión de información y un instrumento educativo. Los murales que hago en la actualidad versan sobre la supervivencia cultural de mi pueblo.

Los temas de mi obra están interrelacionados. Los sitios sagrados del pueblo indígena están siendo destruidos por la industrialización, por la expansión de parques y por el gobierno. Construyen depósitos de desechos nucleares con fines de desarrollo económico. Mi arte hace posible una experiencia visual que sirve de puente de comunicación entre el mundo indígena y el mundo que no lo es. Esa comunicación visual combina filosofía, concepción del mundo y estereotipos de indígenas, presentados como contraste a las imágenes preconcebidas que existen de mi comunidad.

Nació: Wellsville, Kansas, 1909
Murió: 1993

Cuando tomé mi primera clase de dibujo de contorno, a los 68 años, el maestro me preguntó cómo quería que me llamara. Respondí: "Mi nombre es Elizabeth Layton, pero todos los de tu edad me dicen Abuela". Todavía firmo mis obras Abuela Layton.

He vivido la mayor parte de mis 83 años en Wellsville, un pequeño pueblo agrícola de Kansas, casi en el centro de los Estados Unidos.

Los que viven aquí vienen de familias que emigraron a los Estados Unidos hace tres o cuatro generaciones, principalmente del norte de Europa. Siempre sentí que me hacía falta algo porque teníamos pocas oportunidades para conocer y hacernos amigos de gente de otras culturas. Generalmente había una familia mexicana en el pueblo, pero ningún afroamericano, asiático, amerindio ni otros grupos minoritarios.

Crear una obra de arte da una sensación maravillosa. Me encanta hacerlo. Me dedico a la creación artística para mi propia satisfacción, pero resulta que muchas veces a los demás también les gusta lo que hago. Ése es otro factor positivo.

El arte es muy importante para mí. Le da equilibrio a mi vida.

Mi arte no es tradicional a causa del método, el del contorno, que empleo. Con este método miras a la persona o el objeto que dibujas, pero nunca miras el papel mientras estás dibujando. El resultado es una caricatura, como las figuras de las historietas.

Mi arte es mi vida tal como la veo yo y así la trazo en líneas sobre el papel. Todo lo que dibujo es muy personal. En el arte, hay que partir de lo personal para llegar a lo universal. Dibujo lo que siento, que es lo mismo que sientes tú. Es también lo que siente un desconocido que está a muchas millas de aquí. Los sentimientos comunes nos unen a todos.

Se dice muchas veces: "Escribe sobre lo que conoces", como buena regla general para un escritor. La misma regla podría aplicarse al artista. Si el artista ofrece una versión de su propio mundo, así enriquece el mundo de su público.

Soy una vieja y eso es lo que dibujo porque es lo que mejor conozco, además de mi familia y lo que me rodea.

Dinh Le

Nació: Vietnam, 1968
Vive en Brooklyn, Nueva York

Nací en Vietnam y allí viví hasta cumplir los 11 años. En Vietnam me enseñaron la historia oriental, los valores de Confucio y la religión budista. La otra mitad de mi vida la he pasado en los Estados Unidos, donde estudié en instituciones occidentales. Aquí, estudié la historia, la filosofía, la religión y las artes occidentales. Asimilé la cultura popular a través de la televisión. Entonces, ¿quién soy? Soy producto del Oriente y del Occidente. Mi cultura es híbrida, una mezcla de ambas culturas.

Uno de los aspectos más interesantes de mi obra es la técnica de tejer que empleo. Mi tía, que hacía hermosos petates de hierbas tejidas, me enseñó a tejer. Aunque sí es una práctica tradicional, difícilmente puede considerarse una tradición singularmente vietnamita. El tejido —de canastas a alfombras— existe en todas las culturas. Cuando decidí incorporar el tejido en mi obra, no fue apenas un reflejo de mi patrimonio cultural. La técnica de tejido que uso se desprende de la idea de revelar el entrelazamiento y la conjunción final de dos culturas diferentes.

La primera vez que creé algo lo hice porque era divertido. A medida que me he metido más en el arte, se ha vuelto cada vez más una forma de conceptualizar, visualizar, de comunicar lo que siento y lo que me parece importante. Los temas de mi obra provienen de muchos aspectos de mi vida. A veces los temas que exploro son sumamente personales; otras veces, abordo grandes problemas de la sociedad que me preocupan, confunden o interesan. La creación artística me da el tiempo y los medios de buscarles soluciones.

Nació: Athens, Ohio, 1959
Vive en Nueva York

Nací en 1959 y me crié en Athens, Ohio, un pequeño pueblo rural. Mis padres eran profesores de la Universidad de Ohio. Tengo un hermano mayor que es poeta.

Mis padres son de Pekín y Shangai. Soy china-americana de primera generación. Culturalmente, soy de los pocos asiáticos-americanos que se criaron en un pueblo blanco de los estados centrales del país.

Soy artista/arquitecta. El arte y la arquitectura son mi manera de comunicarme; me comunico a través de la forma, no las palabras. La obra se siente/se experimenta mediante la manipulación del espacio y de la superficie.

Mi obra abarca de lo público a lo privado. La arquitectura, en vista de la relación de colaboración entre arquitecto/a y cliente, es pública. Las esculturas que hago en mi taller son privadas; son para mi propia exploración personal.

Todas mis obras están hechas para un sitio específico. Me interesa no sólo la naturaleza física del sitio sino también las indicaciones psicológicas. Uno de los elementos comunes de mi obra es mi deseo de provocar una reacción de empatía en el espectador.

Mi acercamiento es intuitivo y experimental, no teórico. La arquitectura es una manipulación del ser humano por medio del espacio. Mediante cambios de luz, materiales, escala y textura, creo una serie de experiencias que se viven a nivel inconsciente.

Las obras en tierra, hechas por artistas como Robert Smithson, Michael Heizer y Richard Serra, han influido en mi propia obra. En el esfuerzo por llegar a comprender mejor la relación entre la tierra y las formas construidas, la arquitectura de Louis Barragon, Louis Kahn y los jardines de Kyoto, en Japón, han sido muy importantes.

En mi arte y arquitectura utilizo materiales naturales inorgánicos, como piedra y cera. El color y la textura de la obra derivan del mismo material, no son aplicados. Mediante el uso del espacio, la luz y la superficie, entro en un diálogo con el espectador y ofrezco una perspectiva nueva o distinta.

Yolanda M. López

Nació: San Diego, California, 1942
Vive en San Francisco, California

Soy Yolanda M. López. Nací en San Diego, California, durante la Segunda Guerra Mundial. Me crié en Logan Heights, "el lado mexicano de la ciudad". Mi madre se casó a los 22 años, tuvo tres hijas de su primer matrimonio y antes de dar a luz a la tercera de las niñas se divorció. Yo soy la mayor. Vivimos con mis abuelos maternos y varios tíos hasta que cumplí los 11 años y mi mamá se casó por segunda vez.

Mi madre trabajó por un tiempo de planchadora en varias tintorerías y lavanderías. Por fin consiguió trabajo en el Centro de Entrenamiento Naval en San Diego, donde pasó 26 años en la sastrería haciéndoles arreglos a los uniformes de los nuevos reclutas.

Mis dos abuelos nacieron en centros urbanos de México; mi abuelo (Senobio Franco) nació en Guadalajara, de una familia emprendedora de tenderos; mi abuela (Victoria Fuentes) nació en ciudad de México, de una familia de vendedores de flores en un suburbio llamado Santa Anita, que tenía jardines flotantes como los de Xochimilco.

Mi abuelo trabajaba como sastre y mi abuela era ama de casa. Como muchos de mi generación, recuerdo haberme criado con una jerarquía sobreentendida de papeles masculinos y femeninos, y del lugar que ocupaban los blancos y los mexicanos en la sociedad. El ambiente de San Diego, que dependía económicamente de la industria militar, era muy opresivo.

Mis abuelos me hablaban en español y yo contestaba en inglés. Mi madre me hablaba sólo en inglés. Ya que Tijuana, en Baja California (México), y San Diego tienen una frontera común, son ciudades que se han influenciado fuertemente cultural y económicamente, y yo obviamente recibí la influencia de las dos.

¿Por qué me dedico a la creación artística y para quién creo mi obra? Creo que decidí conscientemente ser artista dos veces en mi vida. La primera fue en mi adolescencia cuando los adultos me preguntaban hasta fastidiarme qué iba a ser cuando fuera grande. En aquel entonces, decía que quería trabajar con Walt Disney —la magia y la opulencia de los dibujos animados me había seducido— o que quería ser escenógrafa o diseñadora de vestuario para el cine. La segunda y última vez fue en la escuela secundaria, cuando estaba a punto de graduarme. En esa época lo que quería era ser profesora de historia en una de las universidades exclusivas de la "Ivy League" o asesora histórica para el cine en Hollywood. Pero como mi lectura y redacción no eran muy buenas, decidí dedicarme a lo que mejor hacía: dibujar. No tenía idea de cómo estudiar para una carrera artística. En mi último año traté de matricularme en un curso de dibujo mecánico o lineal pero no me dejaron porque no aceptaban muchachas. No sabía por dónde ni cómo empezar, aunque sí sabía que dictaban clases de arte en la universidad. Con la ayuda de un profesor, me matriculé en un *junior college*.

También debo mencionar que no tenía el menor deseo de casarme acabadita de graduarme de la secundaria, y aunque me había enamorado muchas veces y tenía amistad con varios muchachos, no andaba de novia. Tenía un grupo multiétnico (en el que también había blancos) de amigos y amigas, que hoy serían considerados "muy fresas". Por doloroso que fuera para mí en esa época no ser una de las "muchachas bonitas" de la escuela, creo que mis amigos y yo nos divertimos más y la pasamos mejor que el grupo "popular" al salir todos juntos y compartir nuestros diversos intereses. Sé que muchas de las cosas que empezaron a interesarme en la escuela secundaria influyen en mi obra artística hoy.

Me parece que todavía no he explicado por qué me dedico a la creación artística. No hay razón o explicación racional. Por una parte, es algo que

necesito hacer; por otra, me gusta. Crear una obra es mi manera de ser buena ciudadana.

¿Para quién creo mi obra? Bueno, cada una de las piezas que hago, la hago para mí misma, por supuesto, porque me interesa. Además de eso, creo arte para otros chicanos, especialmente los que conozco, los chicanos de California. Comparto con ellos los chistes implícitos en mi obra, nuestra cólera y nuestra rabia, nuestra apreciación común de lo bueno y lo humano en un mundo tan lleno de ironía e injusticia.

El arte es importante. El artista es, en la sociedad, el individuo que sueña en voz alta.

James Luna

Nació: Orange, California, 1950
Vive en la Reserva La Jolla,
North County de San Diego, California

Cuando me preguntan: "¿quién eres?", "¿de dónde vienes?", la respuesta indica lo que separa a las culturas tribales de los Estados Unidos de las demás. Soy de aquí. Soy payoukeyum (indio luiseno) de la Reserva La Jolla en el North County de San Diego, California. La historia de nuestra creación comienza y termina aquí en esta tierra; no soy de ninguna otra parte.

Indio americano no es un término que me guste. Es incorrecto, ya que no somos de la India, así que yo utilizo el término pueblos y culturas de las Tribus Nativas. Mi cultura está ligada al ambiente en el cual sobrevivió y progresó mi pueblo. Mi tribu es similar a las muchas tribus que poblaban esta tierra de múltiples culturas y ambientes, pero también distinta de ellas.

Una de las razones principales por las cuales creo obras de arte es para informar sobre los pueblos nativos desde nuestro punto de vista: un punto de vista que por su historia tiene una tradición cultural nativa muy rica, que ha recibido la influencia de la sociedad estadounidense contemporánea y ha influido en ella. Creo firmemente que los pueblos de las Tribus Nativas son los menos conocidos y los más erróneamente representados en la historia, los medios de comunicación y las artes. Quiero cambiar esas percepciones.

Inventé el término "Artista Contemporáneo Tribal Tradicionalista" para describirme, ya que el logro de mis principales obras es que han incorporado tradiciones culturales de las sociedades nativa y contemporánea en las que vivo, aquí en el sur de California. No hay una sola tribu en Norteamérica que no haya entrado en contacto con la sociedad occidental. Somos hoy producto de ambas culturas y no tenemos necesidad de ser exclusivamente de una o la otra. Soy un educador profesional, graduado de la universidad, pero también hago un esfuerzo por estudiar y practicar las tradiciones y la cultura de las Tribus Nativas en la vida cotidiana, y por transmitir esos conocimientos a mis hijos.

En mis instalaciones de multimedia y en mis *performances* creo que he encontrado los medios que me permiten expresar mejor mis inquietudes culturales y personales. Empleo sonidos e imágenes de mi casa en la reserva rural; incorporo música e historias indígenas; y utilizo la fotografía y el video para enriquecer y documentar la obra. Si he roto con las formas tradicionales nativas es sólo para presentarlas de una manera más contemporánea.

Nació: San Jose, California, 1943
Vive en San Francisco, California

Soy Amalia Mesa-Bains. Soy de la primera generación de mi familia que nació en los Estados Unidos. Mis padres nacieron en México pero vinieron a este país muy jóvenes. He pasado toda la vida en California y me describo a mí misma como chicana: una estadounidense de ascendencia mexicana cuya identidad se formó en el movimiento chicano de los años 60 y 70. Sabía que quería ser artista desde los cinco años y mis padres me ayudaron mucho al proporcionarme materiales artísticos. Mi educación como artista siguió durante la escuela secundaria y en la universidad me gradué en pintura. Lo más importante para mi desarrollo como artista fue el haberme unido con otros artistas chicanos. Nos asociamos para formar nuestras propias galerías y crear arte para nuestras comunidades chicanas.

Mi decisión de dedicarme como artista a las instalaciones surge de mis experiencias de niña, de ver cómo mantenía mi abuela el altar de su casa, y mi madrina, el altar del patio. Además de eso, el rescate de las prácticas culturales y espirituales del Día de los Muertos, la celebración conmemorativa de los antepasados, ha tenido una influencia importante en mi obra. Los primeros altares que hice eran celebraciones comunitarias para servir a mi pueblo y he seguido usando elementos del altar en mis instalaciones actuales. Trabajo en locales específicos con creaciones efímeras o temporales que muchas veces relatan una historia de mi vida personal y cultural. Creo que el arte puede darnos una visión más aguda del mundo social que nos rodea y hay ocasiones en que incluso puede curar el espíritu. El Sudoeste de este país antes formaba parte de México y del vasto mundo de las Américas y a causa de esta historia (muchas veces pasada por alto) nosotros, como artistas chicanos, procuramos rescatar nuestra herencia cultural. Mi propia obra artística sigue dedicada a la historia y la vida de mi comunidad cultural. Como chicana, mi obra está relacionada con la defensa de la comunidad. Mi obra artística es sólo una de las maneras en que trabajo para la comunidad y es la parte más importante de mi vida, la que más satisfacción me da. Creo que los artistas constituyen un grupo especial en cualquier sociedad y que los artistas que buscan mejorar la condición humana para sus comunidades tienen un propósito que los motiva y llena su arte de significado.

Kay Miller

Nació: Houston, Texas, 1946
Vive en Boulder, Colorado

Muchos artistas crean "arte" a partir de la "vida". Para mí, el arte ha creado mi vida. Mi arte me permite ver más claramente quién soy, cómo actúo, qué siento, así como lo que valoro y deseo en la vida.

Los símbolos que más uso los ha inspirado la naturaleza. Aunque me crié en el ambiente urbano de Houston, Texas, mi familia tenía mucha conexión con la naturaleza. Mis padres se criaron en el campo de Texas y querían preservar su conexión con la tierra. Vivíamos cerca del puerto de Houston, donde vi barcos y conocí gente de todas partes del mundo. Teníamos unas huertas diminutas que eran como joyas urbanas, y a veces pescábamos o cazábamos para comer. Las verduras y frutas nos las vendía un señor de una carreta tirada por un burro.

En mis obras por lo general empleo dos formas (por ejemplo, una cruz y una mazorca). A veces la relación entre esas imágenes es armoniosa; otras veces es de conflicto o confrontación. Las pinturas tienen mucha pintura y son pesadas (pueden pesar hasta 150 libras). El espesor de la pintura hace que la obra parezca fija, pero la riqueza de la textura comunica movimiento y energía. Esos contrastes sugieren la gama de posibilidades de la vida misma. Hago esas pinturas para que el observador (y yo) pueda aprender de los diferentes significados que damos a las relaciones entre formas.

Por lo general trabajo unos tres años en cada pintura; de ese modo, el arte es un medio de meditación que me permite reflexionar sobre mí misma y sobre el mundo. Por medio del arte puedo examinar mi existencia a diario, imaginar mi futuro y decidir conscientemente qué traer a mi vida (a la vez que me mantengo alerta a lo inesperado). Reconocer mi voz interior me permite encontrar una armonía y equilibrio con la energía espiritual que es parte de todos los seres vivos.

Me llamo Yong Soon Min. Otros coreanos, cuando se refieren a mí, me clasifican como de la 1.5 generación de coreanos-americanos. Eso quiere decir que me encajan en algún punto intermedio entre la primera generación de coreanos inmigrantes y la segunda generación de coreanos que nacieron aquí. Aunque nací en Corea, el hecho de haber inmigrado de niña y vivido la mayor parte de mi vida aquí me ha "americanizado" demasiado como para considerarme una verdadera inmigrante. Voy descubriendo que, a medida que pasan los años, se desarrolla una relación más compleja y delicada entre las formas de ser coreana y estadounidense, una relación que cambia constantemente. La identidad cultural que nace de esta situación es necesariamente híbrida, una mezcla fluida de influencias y perspectivas múltiples.

La creación artística es para mí un proceso de descubrimiento, de aprender más sobre mí misma y mi relación con el mundo. Entraña además mi deseo de comunicar y de compartir esa exploración y conocimiento con otros para así completar la dinámica. Creo obras de arte para un público que me incluye a mí también. Ese público, idealmente, comprende a todos y a cualquiera. Ciertas obras tendrán una pertinencia particular para ciertos públicos porque contienen información o utilizan un lenguaje cultural específico. Pero eso no debe excluir a los que no tienen los mismos conocimientos de apreciar la obra a su manera o de hacer un esfuerzo por aprender. Una obra tiene éxito, en mi opinión, si logra estimular una respuesta en el público, que puede ir de la mera curiosidad al profundo interés que conduce al deseo de aprender más.

En mi caso, el proceso de la creación artística ha evolucionado con el tiempo; lo que fue inicialmente un pasatiempo que me encantaba se convirtió en carrera y constituye ahora una herramienta esencial para procesar conocimientos y experiencias. Es una parte tan vital e integral de mi vida como cualquiera de las otras actividades que sostienen la vida. Lo que hago como artista abarca no sólo la producción creadora, sino también otras actividades relacionadas, como organizar, crear redes de comunicación y escribir; en otras palabras, una vida cultural más totalizadora, que espero pueda producir algún cambio en el statu quo.

Lo que impulsa mi obra es principalmente el contenido. Me interesa e inspira el arte que hace un comentario sobre la condición humana, en el que participan y se desafían el intelecto y el corazón al mismo tiempo, a la manera brechtiana. En mis años formativos en la universidad, me influenciaron especialmente cineastas como Jean-Luc Godard, que exploraban y estiraban al máximo las relaciones posibles entre lo didáctico y lo metafórico, lo poético y lo político.

El tema de mi obra surge principalmente de la historia: la historia oficial, documentada, y la mía, en una yuxtaposición que a menudo implica una crítica o controversia de las relaciones de poder existentes.

Mis materiales están al servicio de la idea o el contenido de la obra. No soy partidaria de ningún medio en particular. Debido a la falta total o al bajo nivel de subvención que generalmente recibo, la mayoría de las veces selecciono los medios más módicos para realizar una obra, lo cual puede significar, por ejemplo, usar fotocopias en lugar de fotografías. No me interesan la preciosidad ni la viabilidad comercial de la obra. Más bien, quisiera que transmitiera cierta integridad humilde y un vigor ingenioso y experimental.

Hay muchos tipos de belleza. El concepto de la belleza es altamente subjetivo y en muchos casos determinado o formado culturalmente. Considero la verdad y la integridad como equivalentes precisos de la belleza. Toda obra que refleje un empeño honesto y que comunique efectivamente las sinceras aspiraciones y experiencias del artista es significativa,

y hace que la preocupación con su originalidad
pierda sentido. La originalidad pesa mucho en la
transformación del arte en mercancía de consumo,
no en su creación, apreciación o respeto. La noción
de la originalidad, como la obsesión euroamericana
con la individualidad, con la que está estrechamente
relacionada, es el dogma que predomina en la
cultura contemporánea establecida aquí, y debe ser
cuestionada y confrontada.

Nació: Boston, Massachusetts, 1942
Vive en Nueva York

Mis padres llegaron cada uno por separado de Jamaica, allá por los años 20. Se conocieron en Boston, a la hora del té, durante un encuentro de criquet en el que uno de mis tíos participaba. Aunque durante la posguerra hubo una gran corriente migratoria de las Antillas occidentales, la mayoría de los antillanos se establecían en Brooklyn. La comunidad antillana de Boston apenas alcanzaba para llenar la iglesia episcopal de San Cipriano.

En cierta forma, desde un comienzo entendí que, por ser parte de la primera generación de antillanos negros nacidos en los Estados Unidos, yo era lo que podría llamarse "una mezcla cultural". Pero no tenía palabras para describir y analizar mi experiencia: no hasta que años más tarde palabras como "diáspora" e "hibridismo" ganaron fuerza gracias a los movimientos migratorios y a la mezcla de dos o más culturas.

Cuando era adolescente tenía pocos puntos de referencia y modelos en qué basarme. Así, tuve que negociar entre las siguientes alternativas: 1) los valores tropicales de mi familia, propios de las clases medias y altas de la colonia británica; 2) el estilo más relajado, al cual aspiraban vanamente los intelectuales negros de Boston, algunos de cuyos ancestros se remontaban a épocas anteriores a la Revolución; 3) el maridaje entre la ética yanqui e irlandesa que se enseñaba en la escuela preparatoria para señoritas donde, después de seis agotadores años que me marcaron para siempre, llegué a ser la alumna más aventajada en historia antigua y latín; 4) la urgencia vital de la cultura de la clase negra trabajadora que me rodeaba y que constantemente irrumpía en mi vida fuera del aula, a pesar de todos los esfuerzos de mis padres por mantenerme al margen.

Me rebelé contra los valores en conflicto que había en mí. Al recordar los esfuerzos que hice entonces y después por reconciliarlos, reconozco que mi experiencia, lejos de ser singular (a pesar de lo ardua que pudo haber sido), es cada vez más típica. Muy pronto todos llegaremos a ser biculturales o incluso triculturales.

Mi trabajo se ha visto menos afectado por los detalles de mi trasfondo cultural que por el proceso de tratar de entenderlo. El arte para mí es parte de un proyecto de por vida en busca del equilibrio, en busca de la integridad. He tenido que aprender a simplificar para darle cabida a la complejidad. Al igual que muchos artistas biculturales o triculturales, he sido arrastrada a la díptica o imágenes múltiples, en donde gran parte de la información importante ocurre *en el espacio intermedio.* Y como muchos, he realizado y he instalado trabajos de *performance* e instalación en los que partes del proceso quedan fuera. En mi trabajo "mestizaje", esa palabra peyorativa que se refiere a la mezcla de razas, funciona como una metáfora tanto para el medio artístico mixto que empleo como para las dificultades y potenciales de la reconciliación cultural.

Pienso que cada cultura es compleja y que se diferencia por su historia. Los artistas alcanzan lo universal sólo al prestar atención a lo específico, lo que inevitablemente resulta ambiguo. Por tal razón, me niego a aceptar conceptos tales como "la auténtica experiencia negra" y "voceros de la cultura". Quiero que mi trabajo sea un ejemplo de las diferencias, no de las diferencias *entre* culturas —un teorema que ya debería ser evidente—sino de las diferencias *dentro* de las culturas. Esta idea permanece innecesariamente batallada con respecto a la cultura negra, vista con frecuencia como un todo monolítico. Pero la complejidad es inherente a la realidad, así como no hay conflicto inherente entre lo bello y lo político.

Los artistas y escritores de los que más he aprendido son Jean Rhys, Flannery O'Connor, Toni Morrison, Man Ray, Adrian Piper, Rene Magritte y John Heartfield. También estoy agradecida a críticos de los mecanismos neocoloniales y de la diáspora como Stuart Hall, Kobena Mercer, Coco Fusco, Homi Bhabha, Trinh Minh-ha y Paul Gilroy. Ellos me han ayudado a reclamar la subjetividad de la mujer negra y me han dado modelos para vivir en el siglo 21.

Barbara Jo Revelle

Nació: Nueva York, 1946
Vive en Boulder, Colorado

Soy una mujer, madre, feminista y artista de 49 años y he trabajado en fotografía, cine y otros medios relacionados, y arte público. Me crié en los bosques al norte del estado de Nueva York a las orillas de un pequeño lago con padres que eran muy amantes de la soledad. El letrero que indicaba el camino, sin pavimentar, que conducía a la casa decía: "Camino privado. No entren. Ni siquiera usted". Abajo llevaba la imagen de la calavera y los dos huesos cruzados. ¿Mi cultura? Bueno, soy caucásica y algunos de los antepasados de mis padres eran hugonotes, pero diría que la cultura de influencia más marcada en mi temprana juventud fue algo así como la "Escuela Norteamericana del Individualismo Vigoroso".

Me dedico al arte porque es una manera de comunicarme con otros seres humanos. Para mí, la creación artística es la mejor manera de expresar las ideas que se forman en mi cerebro. Me gusta lo que dijo el arquitecto e inventor Buckminster Fuller: *"You either make money or you make sense"* (que quiere decir algo como "o tienes dinero o tienes sentido"). Creo que dedicarse al arte es una buena manera de tener sentido.

Para mí, el arte es crear significado y creo que el significado radica en la relación entre una cosa y otra. A mi modo de ver, las imágenes solitarias, como la vida vista fugazmente desde un tren elevado, son conmovedoras pero ayudan poco a comprender lo que pasa. Hace mucho tiempo comencé a construir significados con combinaciones de fotos. Después, me dio por combinar las fotos con palabras, con historias grabadas, con ruidos de animales, con lápidas, cáscaras de huevos, tortas nupciales. Film con comida. La experiencia de uno siempre sobrepasa los límites de su vocabulario. Por eso, la creación artística es una manera de ponerle nombre a lo que no tiene nombre y de hacer visible lo que no lo era antes.

Mi obra ofrece perspectivas alternativas sobre la historia. La mayoría de los libros de historia hablan de presidentes y gobernadores, leyes y guerras, de las aventuras de figuras que son generalmente hombres blancos y famosos. Con el mural público *Colorado Panorama* (una historia de Colorado desde el punto de vista del pueblo), yo trato de hacer otra cosa. En mi mural está representado Kit Carson, pero también su sirviente cautivo amerindio, Juan Carson, y hay mineros y sindicalistas, agricultores y maestros, sufragistas e inmigrantes, enfermeras y veteranos de Vietnam, Panteras Negras y activistas chicanos, y los que murieron del SIDA. Y hay tantas mujeres como hombres que es, desde luego, la situación real aunque uno no lo podría deducir al leer la historia oficial de ninguna parte del mundo.

La imagen es poderosa y tener imágenes de nosotros mismos nos da poder. Por eso la censura me resulta tan odiosa. Le permite a un grupo dictar lo que puede ser representado por todos los demás.

Nació: Occidente del estado de
Nueva York (Tuscarora), 1956
Vive en Sanborn, Nueva York

Me llamo Jolene Rickard y pertenezco al Clan de las Tortugas de Tuscarora. Tuscarora está localizado en la parte occidental de Nueva York. Originalmente los tuscarora eran de "la tierra del pino flotante", también conocida como Carolina del Norte. En el siglo 18 tuvimos que emigrar por nuestra propia supervivencia. Los iroqueses nos adoptaron en su confederación y actualmente somos un "hermano menor".

Para mí es muy importante identificar a mi clan. Así es como nos organizamos. Debido a nuestra tradición matriarcal, soy del Clan de las Tortugas por el lado materno. Para nosotros, la tierra y las posesiones materiales se heredan a través de las mujeres del clan. El hecho de que la identidad propia de cada persona y los derechos de propiedad vengan por vía materna ha asegurado la posición de las mujeres en nuestras comunidades. A pesar del deterioro que actualmente existe, la voz popular, la madre del clan y el consejo llevan a cabo sus negociaciones en un lento proceso de consenso. Mis fotografías son, en parte, una declaración para asegurar la posición de las mujeres en nuestras comunidades como una fuente de fortaleza para el futuro.

Me gusta presentar imágenes fotográficas porque eso me ayuda a recordar y a dar forma a nuestra identidad indígena. En los últimos 300 años, mi pueblo ha pasado por una especie de reconstrucción cultural que ha supuesto la adopción de la cosmo-logía de nuestros hermanos y hermanas iroqueses. Mi obra fotográfica es una avenida para atar los cabos de lo que una vez fue tuscarora. Esas conexiones permanecen en los matices de nuestra vida cotidiana, esperando reconocimiento. Mi noción del pasado no es un recuerdo romántico sino el reconocimiento de que mi pueblo, al igual que otros grupos indígenas, tiene la cultura más antigua y continua.

El concepto del arte, según la definición de la sociedad europea occidental, es una expresión relati-vamente reciente en las comunidades indígenas. Trazo una clara distinción entre las creaciones de mi pueblo antes y después de entrar en contacto con los colonizadores, cuando los europeos invadieron, colonizaron y se dedicaron al comercio en nuestros territorios. Antes del contacto, no teníamos una palabra o categoría específica "arte". Sin embargo, el proceso de "hacer pensamientos" era integral para todos los indígenas. La función del "objeto creado" era importante tanto en el ámbito político como en el espiritual. Si fuésemos a hacer una comparación entre las culturas, sería correcto decir que el "arte" era un aspecto integral al bienestar y continuidad del marco cultural en nuestra vida.

Pienso que es necesario imaginarse el futuro para alcanzarlo. No puedo sentarme a lamentar lo que mi pueblo hubiese sido sin la invasión de las culturas imperialistas, pero sí puedo imaginar cómo promulgar el hecho de que existen diferencias que deben ser aceptadas. Puedo ayudar a mi pueblo a identificar y rechazar los valores que sostienen que Europa es el "centro". Mi arte puede ayudar a formular preguntas y buscar respuestas. Creo mis imágenes con un público indígena en mente, pero también pienso que atraen a los que tienen interés en el pensamiento de los indígenas.

Mi trabajo actúa como una primera señal de alerta: despierta y observa intensamente, ¿qué ves? ¿En realidad es mejor tu vida gracias a los aparatos de la vida moderna? Por contraste, a veces me concentro en resaltar vistazos de nuestras valiosas verdades. Todas mis imágenes son puntos de resistencia y continuidad simultáneos. El estrecho desfiladero por el que mi pueblo escapó del genocidio merece atención. El lente dirige mi atención a la esperanza y los desalientos de nuestro porvenir. Recuerdo algo que el hermano de mi padre, mi tío William, dijo una vez: "Los indios son los canarios de la humanidad; cuando nos morimos, es demasiado tarde".

Jolene Rickard

El significado de mi trabajo cambia de acuerdo
a la perspectiva desde la que se percibe lo que
conocemos como "sociedad". En el contexto de las
comunidades indias o indígenas, mi trabajo es un
reflejo de la continuidad cultural tuscarora y de las
interrupciones que ha experimentado. Si mi arte se
mira con ojos "eurocéntricos" podría parecer
distante, pero pienso que a un nivel humano, mi arte
llega a quienes tienen una mentalidad de justicia:
a la gente que busca nuevos "caminos" para vivir
una vida más sana y saludable, una vida más
honesta, la gente que ha saltado de la pirámide de
la sociedad para formar parte del círculo de la vida.

Las sociedades que se organizan en forma de
pirámide, como la mayoría de los estados nacionales,
se basan en la premisa de que es lícito que unos
vivan en la abundancia y otros mueran de hambre.
Las sociedades basadas en una organización circular
se concentran en proveer de morada, alimentos y
cuidados a toda la gente de la comunidad. Si pierdes
el trabajo, no puedes encontrar trabajo durante un
año, tienes hijos que alimentar y te echan a la calle,
¿a qué sociedad querrías pertenecer? Yo me dedico
al arte para hacer que la gente piense en las
opciones que tenemos.

Me llamo Faith Ringgold y soy una artista afroamericana. Me identifico así porque el arte es una disciplina que se comunica a través de la experiencia y que utiliza visiones o visualizaciones. Es muy importante que los artistas sepan ver. De hecho, los artistas son los que ven, como los músicos son los que oyen.

Existen características o atributos culturales específicos que afectan la obra de todo artista visual. Creo que, como artista y mujer afroamericana, las formas clásicas del arte para mí no son las griegas sino las africanas. Creamos un arte basado en nuestras propias experiencias, un arte que se parece a nosotros. Por eso, como afroamericana, creo un arte basado en mi propia experiencia. Mi experiencia es la de ser negra y mujer en los Estados Unidos. Regreso, además, a las raíces africanas que forman la base de mis influencias artísticas. Recibo la influencia de la máscara, del diseño africano, de la forma en que las mujeres creaban *appliqués* y piezas con telas, que constituirían la base del arte de hacer edredones en los Estados Unidos. Empecé a estudiar lo que hacen las mujeres africanas y encontré toda una increíble obra con telas. Claro está que las mujeres africanas no son las únicas que trabajan con tela, pero indiscutiblemente son las líderes en ese campo. Todo eso me fascina. Me enorgullece utilizar formas artísticas africanas en mi trabajo.

He creado arte toda la vida, desde que era niña. Siempre soñaba que podía cambiarlo todo. De niña me parecía siempre que tenía el poder de rectificar cualquier situación. Hoy creo que defender ideas puede mejorar la vida y es una forma de traer el cambio. Hablar en defensa del cambio social es vital, necesario, importante; hay que hacerlo. En mi carrera como artista, me he dedicado a eso. Sin embargo, no creo que todo el mundo tenga que hacerlo. No quisiera ser dogmática en ese sentido y decir que algo no es una obra de arte si no hace eso.

Supongo que todavía me gustaría cambiar el mundo. No creo que el arte sea capaz de lograrlo, pero sigo haciendo el esfuerzo. Me consuela saber que al menos he dicho algo, intentado algo. No creo que el arte inicie revoluciones. Los que quieran una revolución social deberían usar otros medios. Pero el artista tiene cierto poder en tanto que el público contempla su obra, la comprende y la puede ver por un largo tiempo. En otras palabras, el artista puede documentar un período de la historia; por ejemplo, se produjeron muchas obras de arte sobre la guerra del Golfo, y eso es importante. Si los artistas pasaran por alto la historia de su tiempo, no tendríamos a nadie que provoque en nosotros los sentimientos que hacen falta. Éste es uno de los verdaderos propósitos del arte, creo yo.

Es muy difícil ser artista por muchas razones, aunque ser artista es como cualquier otro oficio. Uno encuentra los mismos problemas que encuentran los demás en el resto del mundo. Hay estructuras en el mundo del arte que son muy difíciles de penetrar si eres mujer, una persona de color o pobre. Esas clasificaciones te colocan fuera del mundo oficial y del arte institucional. Para crear un arte que goce de un público apreciativo y de un mercado, hay que trabajar muy duro. Hay que inspirar a muchos para que se les despierte interés en tu obra. Es un negocio muy complejo, muy difícil y, me atrevería a decir, muy racista y sexista. Pienso que los estudiantes necesitan saberlo porque la mayoría de la gente no cree que sea así. Quizás porque el arte no es una cosa popular.

Es muy importante que los estudiantes que tengan la pasión y energía necesarias para ser artistas visuales lo hagan. Pero tienen que saber que hay obstáculos. Esto puede ser una fuente de inspiración. Me inspiró a mí, creo. Si a mí me dicen que hay algo que no puedo hacer, eso es precisamente lo que quiero hacer. A lo mejor si fuera demasiado fácil, no hubiera sido artista. Si los estudiantes deciden ser artistas sin darse cuenta del enorme reto implícito, sin estar preparados para asumirlo, creo que se pueden desilusionar y darse

por vencidos. Pero si están preparados y dispuestos, creo que todo eso puede ser una gran inspiración.

Mi consejo a los estudiantes es el siguiente: trabajen dura e intensamente, véanlo todo, vayan a todos los museos, mírenlo todo, miren todo el arte y después estudien todo lo que está a su alrededor porque lo que deben hacer es crear un arte basado en la vida, no en el arte de otros. Pero hay que conocer el arte de otros para examinar las distintas maneras en que han creado arte basado en la vida. Miren todas las obras hechas por todos los artistas y no permitan que les digan que sólo los hombres blancos hacen obras de arte. No es cierto. En todas partes del mundo se crean obras de arte. Todos los pueblos, en todas las épocas, han creado obras importantes y duraderas que merecen conocerse, contemplarse y estudiarse. Después, pueden empezar a crear su propia obra porque tienen todas las obras de los demás creadores metidas en la cabeza. En realidad, el mundo entero del arte nos pertenece a todos nosotros en nuestras manos y nuestra cabeza. Lo podemos usar. En el proceso de crear un arte basado en la vida, puede servirnos de inspiración todo lo que han hecho los demás.

Pertenezco a la segunda generación de puerto-
rriqueños de mi familia nacidos y criados en
Brooklyn, Nueva York. Mis padres emigraron de
Puerto Rico a Nueva York a principios de los años
50 y se establecieron en Brooklyn. Siempre hemos
vivido en comunidades predominantemente afro-
americanas y puertorriqueñas. El español es mi
primer idioma y empecé a aprender inglés cuando
entré a la escuela primaria. En la comunidad donde
vivo la lengua, la comida, las costumbres religiosas,
la música y las actitudes tienen raíces puerto-
rriqueñas. Es una comunidad donde la gente de
Puerto Rico, Santo Domingo (República Dominicana)
y otras partes de Latinoamérica puede vivir hablando
sólo español, sin necesidad de aprender inglés.

La gente ha transformado esas comunidades en
pequeños países hispanoparlantes, con todas las
comodidades, los problemas y las contradicciones de
esa situación. Mi arte ha recibido la influencia de
todo eso y más. Creo obras de arte porque me da
autoestima al definir quién soy. Es mi manera de
expresar y compartir mis pensamientos, alma y
corazón con un público amplio.

Las fuentes que moldean mi arte son la historia,
la política y la cultura de Puerto Rico, Latinoamérica
y África. Los temas que me atraen son las cosas que
experimento todos los días. Selecciono materiales
que puedo manipular con facilidad. Estoy muy
versado en el proceso fotográfico, además de la
pintura y el dibujo. El texto, ya sea poesía, literatura,
historia o testimonio personal, también me fascina
y me brinda muchas posibilidades.

El papel del artista en la sociedad es muy
complicado, pero creo que el artista debe explorar
y acercarse lo más posible a la verdad, de una forma
u otra. La humanidad no puede sobrevivir sin la
expresión artística, creadora. La sociedad aún no ha
podido aceptar al artista como miembro productivo,
responsable e importante. Se teme, a veces, al artista
ya que ella o él insiste en expresar inquietudes a las
que la sociedad no quiere enfrentarse.

Las relaciones que se establecen entre el arte
y la política, el arte y la religión, el arte y la cultura,
el arte y la educación, son integrales. Se influencian
y alimentan mutuamente. El gobierno no debe
imponerle condiciones al arte ni censurarlo; el
gobierno nunca ha sido la verdadera voz del pueblo
de los Estados Unidos.

Mi público ideal lo forman los que están
dispuestos a ver, sentir y pensar. La gente dispuesta
a enfrentarse a cosas, incluso cosas que resulten
dolorosas, si eso permite mayor conciencia
y crecimiento.

Mi obra alternativamente abraza las tradiciones
y rompe con ellas. Creo que mi arte le ha gustado a
mucha gente joven porque en él hablo de cosas
y experiencias de mi propia juventud. Las
inquietudes que se expresan en mi obra están vincu-
ladas con la realidad que vive la gente joven ahora,
y también con sus raíces históricas y culturales. Mi
gente, los puertorriqueños, son posiblemente el
público que más aprecio porque me han dado
muchas respuestas que me llenan de satisfacción.

Mi arte no se concibe con los museos o galerías
en mente. Creo un arte que puede colocarse en un
ambiente fuera de los círculos artísticos del mundo
del arte institucional, ya que la mayor parte de mi
gente no va a museos y galerías de arte. Las
inquietudes formales y estéticas de mis cuadros
reflejan el ambiente y las experiencias de mi gente.

Ser artista es una experiencia maravillosa y muy
noble. Uno puede expresar lo que tiene en la mente
y en el alma, y ser un "reflector" de la sociedad.
El artista puede tener un gran impacto sobre la
sociedad. Se necesita mucho valor y honestidad para
ser artista; también se requiere disciplina y un
compromiso firme. Como artista, hay que cultivar una
mente abierta. Hay que familiarizarse con una
variedad de asuntos humanos y globales,
y descifrar cómo nos afectan personalmente. Hay
que ser un individuo supremamente sensible,
que se preocupa por los demás, cuya preocupación
principal es dar y compartir.

Andres Serrano

Nació: Nueva York, 1950
Vive en Brooklyn, Nueva York

El simple hecho de ser una persona de color es político. Todo lo que esa persona hace es político, sin tener que decirlo. Mi obra tiene implicaciones sociales; funciona en la arena social. Pero creo que la politizaron fuerzas externas y, como resultado, el espectador observa mi obra con la expectativa de ver algo "político".

Cuando era niño, nos llamaban *Spanish*. A medida que crecí, los adjetivos cambiaron y ahora somos *Hispanic*. Siempre he considerado que soy la suma total de mis partes. Por eso me alegra mucho que, como artista, no se me considere un artista hispano. Soy única y exclusivamente un artista, que es como debe ser. Mi obra es intensamente personal. Trabajo como me parece, desde un punto de partida personal con mayores implicaciones. No opino que sólo por ser hispano uno deba sentirse obligado a crear arte hispano. ¿Es hispano fotografiar al Klan? La gente siempre trata de explicar y categorizar mi obra.

Siempre he creído que mi obra es religiosa, no sacrílega. En ella exploro mis obsesiones católicas. Los artistas no somos nada sin nuestras obsesiones. Me saca de quicio que los fundamentalistas clasifiquen mi obra de "intolerancia anticristiana". Como persona que una vez fue católica y que no tiene inconveniente en que la llamen cristiana, me molesta que me digan que no puedo utilizar los símbolos de la iglesia y siento que tengo el derecho de hacerlo. Cristo me atrae, pero la iglesia católica me perturba. A menudo amamos las cosas que odiamos y viceversa. Desafortunadamente, la actitud de la iglesia ante los problemas contemporáneos del mundo dificulta que la tomemos en serio. Mis problemas con el catolicismo comenzaron cuando era adolescente. A mi obra le han colgado las etiquetas de sagrada y profana. Mi opinión es que una cosa no puede existir sin la otra. Ambas son necesarias. He pasado por épocas antisociales en mi vida. Nunca he sido parte del sistema. Nunca he votado. Siempre que es posible, funciono fuera del sistema. Ahora me doy cuenta de que no puedo seguir funcionando como ser humano en un vacío.

Soy artista primero y fotógrafo después. El medio que utilizo es el mundo de las ideas que presento visualmente de manera coherente. Me considero un conceptualista con cámara en mano. En otras palabras, me gusta tomar fotos de las imágenes que veo en mi mente, que a veces no tienen nada que ver con la fotografía.[3]

Me llamo Helen Zughaib Shoreman. Nací en Beirut, Líbano, en 1959. He vivido en Beirut, Kuwait, Irak, Grecia y París. Aunque soy estadounidense, me identifico mucho con el Oriente Medio. Mi padre es libanés, y ahora es ciudadano naturalizado de los Estados Unidos. Como me crié en el extranjero, absorbí la cultura, la historia y el arte árabes. Creo que eso ha influenciado profundamente mi obra artística. La cultura árabe es muy rica en su arte, lengua y religión. Uno no puede dejar de recordar eso al caminar por las partes viejas de una ciudad, los *souks* (mercados) o visitar las ruinas antiguas.

Me considero afortunada por haber vivido en el mundo árabe cuando todo estaba relativamente tranquilo, salvo las veces en que nos evacuaron durante dos guerras y un golpe de estado. El golpe sucedió en Bagdad; las dos guerras, en Líbano, una en 1967 y la otra en 1975. Desde entonces, la situación se ha deteriorado pero la gente sigue asombrosamente optimista. Vi muchas tragedias y mucha tristeza, en mi propia familia y en las de parientes y vecinos.

No puedo imaginarme la vida sin el arte. Me parece que es el único aspecto de mi vida sobre el que tengo dominio total. Creo arte principalmente para mí misma. Ya sea un cuadro profundamente personal o de un mercado lleno de gente en un día de calor, siempre me resulta algo difícil dejar que otros lo vean. Por otra parte, me doy cuenta de la importancia de las exposiciones, la visibilidad y el reconocimiento. Por eso, hago todo lo posible para que el público vea mi obra. Aprovecho la oportunidad también para ayudar a entender la cultura árabe y aclarar ciertos malentendidos.

Las mayores influencias en mi obra provienen de mi contacto con el Oriente Medio. Los detalles, los patrones y la intensidad de los colores evocan el mundo árabe. La perspectiva no tradicional que creo en mi obra puede encontrarse en el arte árabe antiguo. Básicamente, transformo el contenido o tema de la obra en una serie de patrones y colores, y así se produce una ilusión óptica que hace que el espectador se adentre en el cuadro como en una especie de rompecabezas. También me inspiro en los lugares donde vivo y los que visito. Por ejemplo, para una exposición reciente escogí tres monumentos de Washington, D.C.: el monumento a Lincoln, el monumento a George Washington y el Capitolio. Utilizo principalmente aguadas, aunque a veces utilizo acrílicos, sobre lienzo, cartulina, lino natural y madera. Me gusta pintar a la aguada por los colores puros e intensos que produce.

El arte es muy importante, ya sea que el artista quiera hacer una afirmación con su obra para despertar la conciencia del público o que quiera crear por amor a la belleza. Creo que los artistas tenemos dos papeles importantes hoy: primero, tenemos la responsabilidad de examinar y representar asuntos de actualidad y problemas de la sociedad, y segundo, de levantar los ánimos. Hay tanto dolor y tristeza en el mundo que si la gente se alivia aunque sea por un momento, quizás en un museo, una galería o la sala de la casa, eso puede aportar al desarrollo de una actitud más positiva.

Coreen Simpson

Nació: Nueva York, 1942
Vive en Nueva York

¿QUIÉN ERES?

Soy artista. Es a la vez una bendición y una responsabilidad. El Artista Supremo es el Creador. El artista debe tener una relación espiritual con ese Ser. Si esos lazos son personales y familiares, el arte que uno crea tendrá fuerza y espíritu.

¿DE DÓNDE ERES?

Nací en Nueva York. Me crié en Bedford-Stuyvesant, un barrio de BROOKLYN.

Padre: Músico

Madre: Maestra DIVORCIADA/ ... Hija Adoptiva.

¿CUÁL ES TU CULTURA?

Afroamericana

¿POR QUÉ TE DEDICAS A LA CREACIÓN ARTÍSTICA?

Porque así me siento más cerca del Gran Artista.

¿PARA QUIÉN CREAS TU OBRA?

Para Él, para mí misma ... y otros que consideren que mi arte es válido.

¿ES IMPORTANTE EL ARTE?

Si uno tiene hambre, la comida es importante. La tarea del artista es la de destapar el hambre de arte oculta.

¿CÓMO SE RELACIONA TU ARTE CON LA VIDA/LA SOCIEDAD?

Mi arte se inspira en la vida que me rodea. Se conecta con las avanzadas culturales, y es un reflejo y un registro de ellas.

¿TU OBRA TIENE INTERÉS PARA LA GENTE JOVEN?

Sí.

Gran parte de mi obra fotográfica tiene como tema la juventud. Encuentro en la gente joven una tremenda fuente de inspiración para llevar la cultura al próximo siglo.

¿QUÉ CONSEJO LE DARÍAS A LOS ESTUDIANTES QUE QUIEREN SER ARTISTAS?

Piensa en lo que puedes dar, brindar y decir a los demás. Ya sea en lo visual, lo literario o el espectáculo, como dijo James Baldwin, "sigue el latido de tu corazón". Encuentra tu voz ... tu propio camino. Pide orientación/consejo.

¿QUÉ SE NECESITA?

Visión

¿Podrían comentar algo sobre el proceso de colaboración?

Somos miembros activos de la comunidad artística de San Diego y hemos tenido muchas oportunidades de ver y comentar nuestras respectivas obras. A través de los años, hemos establecido vías para la comunicación que siguen vigentes hasta hoy. Nuestra colaboración empieza a partir del momento en que uno trata de despertar el interés de los demás para trabajar en conjunto sobre un asunto de interés público inmediato. Entonces, se forma un grupo *ad hoc*. El grupo decide cómo se van a compartir las responsabilidades: las tareas de llamarse unos a otros por teléfono para organizar las reuniones, redactar las propuestas, crear y producir las obras de arte, formular estrategias para acercarse a los distintos sectores del público (las fuentes de becas y subvenciones, los grupos comunitarios, las organizaciones artísticas y los medios masivos de comunicación), y, por último, la documentación del proyecto. Como artistas públicos, nuestra razón de ser no es crear arte para el público, sino expresarnos *como* público. Creemos que el acto creador comprende no sólo la iniciativa del artista, sino la respuesta de la comunidad. Nuestro aporte sobre temas públicos actuales a nivel local es insistir en que la identidad de la comunidad sea una creación constante en la que participa una multiplicidad de voces. Buscamos desempeñar una función artística en ese proceso de autodefinición de la comunidad, para forjar una visión verdaderamente pública de nuestra ciudad.

¿Qué importancia le dan Uds. al artista como individuo?

Trabajamos juntos porque nos vemos, unos a otros, como artistas individuales que han sabido crear, cada uno por su cuenta, una obra de firmeza y fortaleza. Paradójicamente, la colaboración funciona mejor cuando individuos de fuertes opiniones y creencias entran en un debate apasionado sobre la mejor manera de lograr los objetivos que tienen en común. Los debates nos estimulan, como individuos, a utilizar nuestros talentos individuales para el bien común. Así, la obra se presenta siempre como un esfuerzo de grupo, reconociendo a los participantes individuales.

¿Por qué prefieren trabajar en colaboración? ¿Cuáles son las ventajas y desventajas de trabajar en grupo?

La mayor ventaja de trabajar en colaboración es la de multiplicar nuestro poder en tanto artistas al compartir recursos. Esos recursos son nuestros distintos puntos de vista basados en raza, edad y sexo; nuestras distintas actitudes acerca de la creación artística; y nuestras distintas ideas sobre la mejor manera de solucionar los problemas que nosotros mismos creamos. Nuestro grupo tiene artistas con experiencia en varios medios: fotografía, video, artes gráficas, muralismo e instalaciones. En conjunto, contamos con más destrezas y conocimientos que cualquiera de nosotros individualmente. Además, cada miembro del grupo aporta su red de partidarios, periodistas, activistas y organizaciones de la comunidad, agencias que otorgan becas, artistas, conservadores y otros. Como grupo, realizamos proyectos de mayor envergadura y podemos desafiar a los políticos y burócratas porque contamos con la solidaridad y cohesión del grupo ante cualquier confrontación.

La otra ventaja de la colaboración es de tipo social. Es muy divertido trabajar con otros, contar chistes cuando las cosas se ponen tensas y agobiantes, salir a comer juntos, y ayudarnos mutuamente a resolver los problemas artísticos y cotidianos.

Nuestro arte se concentra en la participación democrática en la esfera pública (en otras palabras, un arte que concibe la sociedad como una colaboración gigantesca). Debido al tipo de proyectos que realizamos, es importante que el proceso tenga como

esencia la participación, no la habilidad o "genio" de un individuo aislado.

La mayor desventaja es trabajar en proyectos públicos como grupo mientras el mundo artístico todavía prefiere relacionarse con los artistas como individuos que trabajan en museos o galerías de arte. Aunque explicamos que nuestro trabajo es colectivo, muchos todavía preguntan a quién, específicamente, de nosotros se le ocurrió tal o cual idea y quién estaba a cargo del proyecto. Así que constantemente tenemos que reiterar que nuestro trabajo es colectivo. Otra desventaja es que la educación que se recibe en las escuelas de arte no prepara a los artistas para trabajar en grupo. Nos toca aprender constantemente los métodos y procedimientos que han utilizado, desde hace mucho tiempo ya, los artistas de teatro y los organizadores de la comunidad para aplicarlos al arte visual.

¿Cómo se vincula la obra de Uds. con la historia de los artistas que han trabajado en colaboración?

Nos consideramos miembros de una sociedad de ideales democráticos. Como tales, tomamos en cuenta los ideales y la práctica de los movimientos sociales para entender la colaboración: el movimiento de derechos civiles, los movimientos chicano, antibélico, feminista y sindicalista. También vemos intenciones sociales paralelas en la historia del movimiento del arte constructivista de la Unión Soviética en los años 20, el movimiento situacionista de Francia durante los 50 y los 60, y los movimientos del arte chicano en los Estados Unidos.

Nació: Greenbelt, Maryland, 1954
Vive en San Diego, California

Elizabeth Sisco

Soy artista, fotógrafa y profesora. Nací y me crié en Greenbelt, un pequeño pueblo de Maryland, no muy lejos de Washington, D.C. Vivo en San Diego, California, desde que tengo 18 años. Pertenezco a la segunda generación de ciudadanos americanos de una familia judía de ascendencia europea, eslava. Como todo ciudadano de este país, mi cultura es una mezcla de gentes e ideas. Enseño en una universidad cerca de la frontera de México, en un ambiente en el que la mayoría de los estudiantes están tan versados en español como en inglés. En mi barrio hay chinos, mexicanos, afroamericanos, vietnamitas y anglos. En oposición al mito popular que concibe a los Estados Unidos como un enorme crisol en que gente de diversos orígenes y culturas se funde en una sola identidad homogénea, mi experiencia me ha enseñado que nuestra cultura está compuesta de identidades, creencias y costumbres distintas, además de las compartidas.

El crear arte es mi manera tanto de explorar el mundo como de explicarlo. El proceso de la creación artística es a veces una experiencia muy social, y otras veces, una actividad muy solitaria. Generalmente, al iniciar un proyecto, hago un esfuerzo por aprender lo más que pueda sobre el tema y le saco fotografías. En el proceso de conversar y de sacar retratos, las ideas que tengo se expanden y cambian continuamente. En el trabajo documental, si quieres retratar a una persona o representar a un grupo o actividad lo más honestamente posible, hay que mantener la mente muy abierta para que el trabajo no sea simplemente una ilustración de un punto de vista preconcebido. Los proyectos más interesantes, los de mayor fuerza, son los que he ejecutado después de haber pasado mucho tiempo observando y estudiando a mis sujetos y leyendo sobre ellos.

Mi obra explora principalmente los temas sociales: el racismo, la xenofobia y la lucha constante en nuestra sociedad por la justicia social y económica. Procuro crear un arte que incite al espectador a examinar su propia relación con la desigualdad que existe en la sociedad estadounidense y sus percepciones sobre ella.

Louis Hock

Nació: Nogales, Arizona, 1948
Vive en San Diego, California

En 1915 mi bisabuelo inició un servicio de transporte de mercancías, con mulas, en Nogales, Arizona, en la frontera entre los Estados Unidos y México. Cuando entré a la escuela, me mudé a Tucson, a 60 millas al norte, con mi madre y mi abuela. Me crié, como emparedado, entre la cultura de los vaqueros y la mexicana. Viviendo en mi pequeña ciudad del Sudoeste, un poco apartada, me imaginé siempre que la "cultura" auténtica se encontraba en otra parte, en la biblioteca o el cine, pero no a mi alrededor. Más adelante, cuando comencé a crear obras de arte, me di cuenta de que mi fascinación juvenil con las ceremonias amerindias, la construcción de corrales y los juguetes mexicanos de madera constituía una influencia cultural tan poderosa como cualquiera de las obras de Shakespeare o el cine francés.

Después de haber pasado toda la secundaria y la mayor parte del tiempo en la universidad luchando por expresar mis ideas claramente por escrito, y sin poder lograrlo, comencé a hacer películas, como pasatiempo, a los 20 años. Quedé contentísimo con mis primeras producciones. Era como si pudiera hablar con los ojos. Después de haber pasado casi 10 años haciendo películas, me preocupó la exclusividad de los museos y los cines de arte donde se pasaban mis películas, y salí en busca de un público más amplio. No bastaba que las ideas fueran visibles en las películas; las películas también tenían que verse. Hice un gran mural fílmico que se exhibía en las calles; la pantalla era el lado de un remolque blanco que cambiaba de lugar cada dos o tres días. Quería que la película tuviera la misma relación con el público que un mural pintado en una comunidad.

A la vez que pasaba el mural fílmico en varias ciudades, comencé a documentar mi propia colonia en video. En el transcurso de siete años terminé una serie de cuatro horas de duración acerca de la vida y las experiencias de mis vecinos mexicanos indocumentados. Las imágenes de los mexicanos indocumentados que veía en los periódicos y la televisión nunca correspondían a la experiencia mía de vivir en una comunidad de trabajadores indocumentados. La imagen difundida por los medios masivos había sido creada por senadores, profesores y policías. Mi objetivo principal al hacer los videos era invitar a mis vecinos a que ellos mismos hablaran, creando así su propia visibilidad.

En 1988 comencé a colaborar con otros artistas para hacer arte público y extender más los deseos que habían inspirado mi trabajo anterior: salir en busca de un público más amplio, participar en la producción de imágenes de la comunidad y utilizar los medios de comunicación populares. La meta de este trabajo es iniciar un diálogo mediante afiches, vallas, *performances* y anuncios en los bancos de las paradas de autobús. La controversia que genera la obra sirve para llamar la atención de la prensa y así poner los temas explorados en los proyectos a la vista del público.

Con el transcurso de los años, aunque el contenido de mi obra se ha ampliado, todavía considero que el poder del arte es hacer visible lo invisible.

Nació: San Diego, California, 1947
Vive en National City, California

¿Quién eres?

Soy un chicano que hace su interpretación de un artista.

¿De dónde vienes?

Mi madre se llama María Torres Ávalos. Nació cerca de Guadalajara, México. Mi padre se llama Santos Urquizo Ávalos. Nació en Durango, México. Yo soy de una colonia que se llama Old Town National City en el sur de California, al sur de San Diego y al norte de Tijuana. Actualmente vivo en otra parte de la National City con Verónica Enrique y nuestros hijos: Xima, que tiene once años, Tona, que tiene nueve, y Graciano, que tiene seis.

¿Cuál es tu cultura?

Soy chicano: una persona de ascendencia mexicana que está creando el futuro dentro de la sociedad estadounidense. Soy mestizo: una persona de ascendencia mixta, principalmente una mezcla de indígena y europeo. Mucha gente de ascendencia mixta conoce exactamente en qué consiste la mezcla que tiene, pero en México se han estado mezclando desde hace unos 500 años, de modo que a veces pierden la cuenta. Mi tía Maura dice que uno de mis bisabuelos era tarahumara y su esposa era italiana. Estoy seguro de que hay otros ingredientes más. Ahora, cuando se reúne la familia en casa de mi madre, es evidente que todavía nos estamos mezclando. Sus nietos y bisnietos son todos hermosos y distintos uno del otro: de pelo rubio y ojos azules, de pelo crespo y ojos castaños, de pelo negro y sin dientes. Son niños de ascendencia indígena, europea y africana.

Mi cultura es una historia viva. Todos los días nos despertamos y creamos capítulos nuevos. Durante 500 años hemos aguantado la colonización, el racismo y la brutalidad, y no hemos dejado que eso nos estropee el espíritu. Durante 500 años hemos confrontado el poder y abrazado los terrores y los éxtasis del mundo con nuestra mente y nuestro corazón. Durante 500 años hemos celebrado nuestra capacidad para sobrevivir y prosperar con sentido del humor y de la dignidad.

Mi cultura es una cultura de la liberación. La comparto con todos los del pasado y el presente que se han negado a ser o amo o esclavo. La comparto con todos los que entienden que "tú eres mi otro yo".

¿Por qué te dedicas al arte?

Porque me permite participar en el mundo con mis propias condiciones.

¿Es importante el arte? ¿Por qué sí o por qué no?

El arte es una de las cosas que define y hace la sociedad. El arte tiene algo que ver con nuestra creencia en la posibilidad de que todas las cosas estén de alguna manera vinculadas. Quizás nos ayuda a conservar la lucidez cuando estamos asustados o desconcertados. Quizás nos ayuda a no perder la esperanza a pesar de nuestras dudas. Quizás nos ayuda a abrir el corazón a la dulzura y conservar el sentido del humor ante las amarguras.

Si algo de esto es verdad, el arte se inspira en la creatividad de la vida cotidiana, no en las galerías y los museos. Como un chicano que a veces crea obras de arte, trato siempre de ser lo más creativo posible, ya sea al preparar un sándwich o hacer el amor. El arte puede ser importante si nos permite llegar a conocer el poder creador de los demás y bailar con él.

Nació: Washington, D.C., 1939
Vive en Nueva York

Soy una mujer afroamericana. También soy artista visual, conferenciante, escritora y maestra. Además, soy cofundadora y Coordinadora Nacional del Coast to Coast National Women of Color Artists' Projects (Proyecto Nacional de Costa a Costa de Mujeres Artistas de Color), un grupo organizado para darle visibilidad, apoyo y atención nacional a las artistas de color.

Vengo de Arlington, Virginia.

Mi cultura es afroamericana de la clase trabajadora. Me crié en un pueblo pequeño dentro de la tradición bautista de los negros del Sur en los años 40 y 50. Participé en el movimiento de derechos civiles de los 60, fui madre, trabajé en distintos cargos profesionales a través de los programas de Equal Employment Opportunity, viví en muchas partes de África, y actualmente vivo y trabajo en el campo de las artes visuales en Soho, en Nueva York.

Hago arte para mi ser, para ser. Cuando otra gente saca provecho de mi arte me siento bien al poder contribuir con algo a su vida.

El arte es muy importante para mí. Por medio de imágenes conecto el pasado con el presente. Se ha vuelto una forma de aprender lo que sé, de descubrir cómo y por qué lo aprendí, y de desaprenderlo. Lucho por liberarme de inhibiciones y liberar el espíritu.

Mi arte es mi vida; comunico las conexiones de mi propia existencia y el universo a través del arte.

Me gusta cuando alguna persona me dice que gracias a alguna de mis obras ya no se siente extraña o avergonzada de sí misma. También me han dicho que mi trabajo les ha servido de inspiración para confrontar mitos y tabúes sociales.

Mi trabajo se identifica con la gente joven. Cosas que me sucedieron cuando era joven todavía forman parte de mi vida como persona adulta.

Lo que le diría al estudiante que está pensando en ser artista es lo siguiente: "Tu vida es importante; tienes algo que decir y es importante que lo digas".

Algunas de las cosas necesarias para ser artista son:
1) apoyo
2) enfoque
3) compromiso
4) estar dispuesta a confiar en sí misma y
5) crítica constructiva.

En mi idioma soy *anishinabeykwa*: una mujer indígena. Crecí en Rhode Island, en las comunidades indígenas de Providence y Charlestown. Mi padre es un choctaw de Misisipí, pero he vivido muy poco tiempo en Misisipí. Me siento más allegada a los algonquinos del sur de Nueva Inglaterra. Las tradiciones culturales de mi casa cuando era niña, eran muchas: comíamos sopa de maíz, pan frito y venado fresco; ensartábamos cuentas, curtíamos cueros y hacíamos prendas de vestir; preparábamos materiales naturales para tejer y recogíamos plantas medicinales.

La cultura de los indígenas norteamericanos los ha preparado para sobrevivir. Cuando digo supervivencia no me refiero solamente a las necesidades básicas. Aunque éstas sean de suma importancia para cualquier persona, existen muchas otras cosas que los indígenas norteamericanos consideran más importantes. Me refiero a todo lo relacionado con lo espiritual. Si los espíritus internos y externos no se nutren, la persona morirá; no podrá sobrevivir aun cuando el cuerpo parezca vivo.

Ustedes se preguntarán: ¿qué tienen los indígenas que los prepara para la supervivencia personal? Todos tenemos una visión, a veces múltiples visiones, que se originan en nuestro centro. A veces tienen que ver con nuestra vida actual; otras veces con vidas pasadas, en este cuerpo o en otro; otras veces son cosas tan antiguas que ni siquiera podemos describir la edad. Esas visiones nos dan respuestas y nos ayudan a resolver problemas. Nos dan comprensión, paciencia y aceptación de la realidad que nos rodea.

Los indígenas han articulado esas visiones durante siglos. Las pinturas de los tipis, los escudos, las alforjas de cuero, las bolsas bordadas con cuentas, la capa ceremonial, las rocas pintadas y talladas son unos pocos ejemplos. Con frecuencia se le llama artesanía a las obras de arte tradicionales más bellas de los indígenas, tales como los vestidos, mocasines y bolsas de cuero bordados con cuentas.

Pero cualquier objeto que posea una estética limpia, que requiera destreza en su diseño y ejecución, y que sea algo bello es una obra de arte.

A través de mi arte investigo la historia indígena norteamericana y busco mi lugar en esa historia. Mi proceso artístico y creativo es una continuación de las tradiciones indígenas combinadas con los numerosos aspectos personales que hacen de mí lo que soy. Soy mujer, madre y abuela. Los hijos que he parido y los que he enterrado han cambiado mi vida de una manera tan poderosa que no me queda otra alternativa que sucumbir a esa fuerza. Y al entregarme, me recupero y me permite dar con meta, intención, dedicación y con una plegaria constante de que todo lo que considero importante en este mundo siempre exista. Mi obsesión es que siempre exista un mundo con aire, agua, árboles, aves y el águila mensajera del Creador. Que este mundo exista para los nietos de mis tataranietos es mi gran obsesión.

Sólo me queda la esperanza de que al mirar mis visiones, al mirar el dolor y el sufrimiento continuo de la humanidad, al mirar la felicidad y lo maravilloso, las cosas bellas que el Creador nos ha dado, al cantar las canciones y bailar las danzas, pueda, a través de mi obra, mostrarle al mundo su belleza única. Ésa es la meta de mi arte, la esperanza de hacerle llegar a otros mis obsesiones y obsesionarlos a ellos también.

Masami Teraoka

Nació: Japón, 1936
Vive en Waimanalo, Hawai

Soy japonesa pero he pasado 34 de mis 59 años en los Estados Unidos. O sea, he tenido la ventaja de vivir en dos culturas sumamente distintas.

Me dedico al arte porque me gusta pintar. Me dedico al arte, en primer lugar, para comprenderme a mí misma. El arte es importante porque es un método que me permite aprender acerca de la vida, del mundo y de mí misma. La pintura refleja mis pensamientos; cuando dejo de pintar, me siento enferma. También expreso mis experiencias a través del arte para comunicarme. Uso la estética y el sentido del humor para hacer que mi visión sea más accesible al espectador. Utilizo contracorrientes sociales y políticas que de alguna forma van cambiando el sistema de valores como temas primarios en mis obras. Cuestiones como la contaminación, la crisis del SIDA y la agresiva conquista cultural del globo terráqueo por el Occidente son fuentes de inspiración para mi trabajo. Considero que es muy importante abocar las coyunturas históricas en que vivimos. Me obsesiona la dirección que está tomando el mundo y lo que vamos a ganar o perder en el proceso.

El contraste entre el pasado y el presente en las culturas de Japón y de los Estados Unidos es el punto focal de mi trabajo. Utilizo dos fuentes principales para expresar este tema: el arte pop norteamericano y el *ukiyo-e* japonés, o grabado al boj. Estos dos campos, que en principio parecen divergentes, en realidad son expresiones parecidas del mismo concepto, en dos mundos distintos. El tema de ambos es la cultura popular.

Los grabados al boj *ukiyo-e* son equivalentes a los carteles publicitarios u otras formas de producción artística en masa. El *ukiyo-e* fue una técnica dominante durante el período Edo en Japón, aproximadamente de los siglos 17 a 19. El *ukiyo-e* refleja la opulencia de la sociedad japonesa a finales del período Edo, con el predominio de la clase mercantilista y un estilo de vida decadente. El arte pop de los años 60 es una de las formas de arte especialmente estadounidenses. Representa la orientación consumista de esta sociedad. En cuanto a la extensión del consumismo, no existe ningún otro país como éste. La unión de estas dos formas artísticas es una manera obvia de combinar las influencias culturales que he experimentado a lo largo de mi vida, que me permite hablar acerca de ambas culturas.

Mis nuevas obras miden un promedio de seis por nueve pies y están pintadas con acuarelas sobre lienzo aprestado con cola de piel de conejo. Uso la acuarela como medio primario porque me permite reconstruir la sensación y el efecto de la textura de los impresos al boj tradicionales. Sería imposible hacer grabados de este tamaño con la técnica original.

En una buena pintura el mensaje y la visión estética van de la mano. Ninguno de los dos se puede abandonar. El objetivo final de la pintura es lograr el balance entre los dos para así crear la manifestación poética de una idea. La inspiración artística proviene de muchas fuentes; la originalidad estriba en seguir los sentimientos, pensamientos y filosofía propios, y en interpretar de las influencias que se presentan en la coyuntura histórica del momento.

Me llamo Danny Tisdale. Nací en Compton, California. Soy afroamericano. Me dedico a crear arte porque siento una gran necesidad de llevar distintas imágenes y perspectivas a la atención del público y del mundo del arte. Eso lo puedo hacer con el poder del arte.

El arte es algo importante; es como un indicador de la sociedad y la cultura en la que se vive. Si el arte muestra una perspectiva de apertura, la sociedad es abierta; si es un arte cerrado, la sociedad es cerrada. Cuando una sociedad no censura su arte y lo digiere sin prejuicios, esa sociedad va por buen camino.

El arte es mi vida; no existe separación entre los dos. Mi trabajo artístico surge de mi vida, de mi experiencia, de mis posturas políticas y de gente que he conocido y que ha tenido una influencia en mi vida, gente que quiero.

El arte es mi terapia, mi liberación, mi compromiso y participación en el mundo. A través del arte, he tenido la oportunidad de comunicarme con grupos y personas con los que de otra manera no me hubiese sido posible.

Mi trabajo tiene que ver con la realidad de los jóvenes porque presenta la misma enajenación y falta de comprensión que existe en la vida de mucha gente joven, la búsqueda de sus propias voces, la búsqueda de que se les escuche.

Mi trabajo tiene interés para con los jóvenes porque postula que todos somos parte del mundo en que vivimos y que todos los problemas nos afectan directamente, ya sea cuando ocurren en algún lugar del mundo o en la casa de al lado. No podemos seguir dándonos el lujo de pasar por encima de alguien o de cerrar los ojos cuando vemos a alguien que necesita nuestra ayuda porque, algún día, puede ser que nosotros seamos los que necesitemos ayuda. Somos parte del problema o parte de la solución.

En una sociedad que predica la democracia, es importante tener un arte que exprese e ilustre distintas perspectivas, aun cuando eso signifique que se creen imágenes que no les gustarán a algunos. En una verdadera democracia, el arte habla en todos los idiomas, a todas las edades, todos los sexos y razas.

El arte representa esperanza en la vida, esperanza de ver realizados objetivos y deseos, de ser partícipes. El arte permite recobrar la confianza en nosotros mismos, permite experimentar deseos, convierte fantasías en realidades.

¿Qué se necesita para ser artista? Bueno, yo pienso que para ser artista hacen falta las mismas cosas que para ser médico o abogado: tiempo, compromiso, talento y amor.

Mi consejo a la gente joven (y la mayor también) que quiere ser artista es ¡lanzarse! Es necesario seguir el corazón, comprometerse a aquello en lo que uno cree y hacerlo realidad. NADIE puede entorpecer la tarea de hacer lo que uno quiere, excepto UNO MISMO. Nosotros controlamos nuestro destino; no podemos permitirnos el lujo de dejar que nuestro destino nos controle a nosotros. Tampoco podemos esperar que algo que realmente merece la pena ocurra de la noche a la mañana; lo que vale siempre toma tiempo. Si quieres ser artista, haz un compromiso personal y lánzate a la lucha.

Richard Ray Whitman

Nació: Claremore, Oklahoma, 1949
Vive en Norman, Oklahoma

Como una cohesión científica, yo soy los átomos
y las moléculas, la sangre y el polvo de mis ante-
pasados, no como fragmento de su historia sino
como su continuación. Nuestra cultura la describimos
como un círculo, lo que quiere decir que es un todo
integrado, un círculo de muchos círculos. Mi
expresión artística se deriva de esa herencia. Ese
círculo de tradiciones y experiencias culturales es lo
que me permite ser un ser humano. Para nosotros y
para mí, la única forma de ser humano, no sólo hacia
otros seres humanos, sino hacia cualquier otro ser
vivo, es ser yuchi. A los yuchi no nos interesa
convertir a otras personas a nuestras costumbres
y creencias, sino contribuir a la humanidad según
nuestras filosofías, ideas y valores. Es algo que
compartimos y ofrecemos de corazón. Pero
nuestras ceremonias y creencias espirituales son
únicamente nuestras, pertenecen a nuestras
comunidades, tribus y naciones. Es cosa nuestra.
En la lucha constante por proteger lo que somos,
nuestra relación con la naturaleza y por recuperar
nuestra posición en el universo, cuanto más
luchamos más aprendemos de ese mismo universo.
Con ese espíritu de lucha.

Pat Ward Williams

Me llamo Pat Ward Williams. Soy una mujer afroamericana, nacida en Filadelfia, Pensilvania, en 1950. Pertenezco a la cuarta generación de mi familia que ha nacido en este país. Mis padres nacieron en el Sur: mi madre es de Virginia y mi padre de Carolina del Norte. En las tres generaciones previas a la mía hubo inventores, artistas, médicos, trabajadores de fábricas y amas de casa. No existen datos anteriores a estas generaciones pero mi espejo me dice que soy africana y alguien de mi familia sobrevivió la travesía en un barco negrero. Yo siento un profundo respeto por esa persona desconocida. Las luchas y triunfos de mi familia son una fuente de inspiración; reivindico cualquier cultura africana (kongo, yoruba, ashanti) como propia.

Todas las personas tienen pasiones, ideales políticos, esperanzas y sueños. El arte es lo que organiza las ideas y le da una voz propia al individuo. El arte puede expresar una identidad propia y/o la posición única de ese individuo dentro de un grupo cultural. Me dedico al arte porque vivo en este mundo y quiero comprenderlo. Veo el racismo, el egoísmo y la manipulación política que existe, y tengo algo que decir acerca de lo que veo y lo que siento. Lo visual es mi idioma, el arte es mi voz. En mi fotografía y en mis instalaciones, trato de hacer que la gente piense acerca de lo que está viendo. Pido a mi público que piense en los distintos significados de una fotografía; le pido que contemple el mensaje intrínseco de la imagen.

No tengo un público específico en mente cuando trabajo. Pienso que si uno tiene un público en mente, se crea una tendencia de autolimitación que no permite que el arte llegue a distintos grupos que podrían tener distintas percepciones y puntos de vista. Tampoco pienso que deba haber categorías para observar y evaluar el arte. A pesar de que existe una estética característica de la cultura negra, no creo que en realidad exista un estilo característico de arte negro. A artistas negros como yo nos inspiran ciertos patrones, texturas o estilos de respuesta, pero son escogidos, no obligatorios. Las obras de arte creadas por artistas negros reflejan el amplio marco de experiencias e intereses de los negros. Es importante que toda la gente conozca las raíces de las imágenes visuales creadas por los artistas negros. Eso es darle reconocimiento a una comunidad creativa y vibrante de artistas, a su arte.

Krzysztof Wodiczko

Nació: Varsovia, Polonia, 1943
Vive en Nueva York;
Cambridge, Massachusetts;
París, Francia

La pregunta "¿Cuál es mi cultura?" es algo que debo examinar desde el principio. Mi experiencia como inmigrante, con todas las dificultades que he tenido que sobrepasar, y con las ventajas que también he experimentado como extranjero, constituyen mi cultura. Yo emigré de Polonia a Canadá y de Canadá a los Estados Unidos, y no importa cuán americano o canadiense sea, yo soy polaco. La parte polaca es la que todos reconocen inmediatamente. Pero no puedo decir que pertenezco a la cultura de los inmigrantes polacos que viven aquí. La mayoría de los inmigrantes polacos de mi generación o mayores piensan que como aquí encuentran un nivel más alto de democracia —o un nivel menor de falta de libertad— simplemente deben abrazar este país, disfrutarlo sin crítica y descansar. Para mí, un verdadero artista no puede descansar; la crítica va unida al pensamiento y a la creación de arte responsable. Yo pertenezco a los "artistas en tránsito", que son críticos y, mientras cruzan fronteras, cambian y cambian su propio arte, y contribuyen a cambiar las percepciones, imaginación y visión del mundo de los demás. Ésa es mi cultura: crítica y móvil.

Una gran parte de mi trabajo consiste de imágenes que, con técnicas de iluminación, proyecto sobre distintos monumentos públicos. Proyectando el presente sobre una estructura del pasado logro rescatar esos monumentos de su existencia como simples imágenes de patrimonio nacional o como objetos del pasado. Hago que sean obras de "historia crítica" y hago visibles ciertas ideas que de otra manera permanecerían ocultas.

Durante la guerra del golfo Pérsico hice una proyección en Madrid que resultó muy efectiva porque la adoptaron las manifestaciones en contra de la guerra, que en España fueron enormes. Fue una proyección de una serie de íconos que adopté, transformé y proyecté sobre un monumento fascista, un monumento al ejército de Franco.

La guerra civil española fue una de las guerras más trágicas y el monumento a Franco representa muchas cosas para los españoles. Es una guerra que entienden, por todos sus horrores. Ese monumento a Franco ha sido rechazado, nadie quiere verlo. Sin embargo, es una de las estructuras más grandes de Madrid y está localizado a la entrada de la ciudad, donde cientos de miles de personas lo ven a diario. Yo iluminé el arco de esa estructura con imágenes simétricas de un M-16 (un fusil típico de la guerra), la boquilla de una manguera de gasolina y la palabra "¿Cuántos?". Así que, a ese pasado, ese pasado horrorizante, en el que nadie quiere pensar, proyecté el presente para destacar la participación de la marina española en la crisis del Golfo y el temor de una ingerencia más y más profunda. La prensa nacional e internacional mostró fotografías de esa proyección.

Al hablar acerca del éxito público de esa obra de arte es necesario pensar en nuestros fracasos, y los del mundo en que vivimos, si todo nuestro trabajo no pudo evitar que los Estados Unidos, Europa o Irak se lanzaran a esa guerra. No soy tan ingenuo como para decir que una obra de arte puede cambiar el mundo, pero sí puedo decir que si no hiciera ese tipo de proyecciones, si otra gente no se dedicase a hacer críticas en contra de la guerra a través de su arte, la situación sería mucho peor. Los artistas podemos conectar situaciones globales con las experiencias de los que han vivido esas situaciones, haciendo que la historia pueda percibirse tanto en el terreno emocional como en el político. Si no lo hiciéramos, quizás la guerra hubiese sido 10 veces más larga o podría repetirse. Así que creo que los artistas que realmente están tratando de mejorar la situación son los más exitosos, aun cuando los "resultados" no sean tan aparentes. Uno esperaría que tal contribución a un cambio de percepción, imaginación, visión del mundo y de nuestro lugar y papel en él sea un legado crítico para las próximas generaciones.

Tu familia está dispersa, ¿no?

Mi papá era marinero y se iba mucho tiempo. Iba a la casa unas dos semanas cada cuatro meses. Cuando era chiquito, mis padres se separaron y mi papá me robó de mi mamá. Me llevó a una finca en las afueras de Detroit, con unos familiares. Él se volvió a casar. Casi todos los años nos mudábamos, para que no nos fuera a encontrar la policía ni mi mamá.

¿Qué pensabas tú de todo eso?

Me parecía medio normal hasta que me fui; después me di cuenta de que era una locura. Mi papá era sumamente violento. Fue un alivio irme. Viví un tiempo con mi hermano y mi hermana, pero después me alejé completamente de todos ellos y me fui a Nueva York a vivir en la calle.

¿Dormías en portones?

Dormía en portones en Times Square. Me las arreglaba; encontraba dónde dormir, qué comer. Varias personas me cuidaron. Conseguí un trabajo en un hotel de paso, donde conocí gente recién salida de la cárcel, gente que hacía trampas con cheques, robaba.... Pero ahí tenía cierta estructura y pude reparar un poco los daños, dejar de vivir en la calle, trabajar, vivir una vida más o menos regulada un par de años....

¿O sea que nunca se te ocurrió ser un pintor famoso?

Bueno, quería hacer cosas que contaran con apoyo o que por lo menos abrieran alguna especie de diálogo. Cuando vivía en la calle como ratero y tal, y cuando salí del hotel de paso y entré a la sociedad diaria, no pude decir palabra durante varios años. No hablaba con nadie. Cargué ese peso durante años. Una vez estaba en una fiesta con gente del mundo del arte y me senté todo el tiempo sin decir palabra porque no encontraba un método de comunicación que pudiera tocar las experiencias que

había vivido. La mayoría de la gente vivía una vida relativamente normal. Yo había visto cosas horripilantes.... Casi me matan dos o tres veces en la calle. Con esas experiencias a cuestas, uno necesita encontrar un punto de entrada al diálogo con otros, y no lo hay. No se puede no más decir "hola", así que comencé a escribir.

¿Qué escribías?

Poemas malos, cuentos, cosas muy explícitas sobre las experiencias que tuve cuando vivía en la calle. Eso es lo que trato de hacer con la pintura, pero con más imaginación.

¿Te abrió una salida el arte?

Era lo único que siempre tenía sentido. Yo no podía hablar de mi prostitución cuando era niño, de haber sido ratero o de que me escapé de la casa, porque jamás encontré nada ni nadie —un punto de contacto— que me ayudara a salir de ahí. Hace un par de años escribí un artículo sobre la violencia imaginaria, real y psíquica en *The East Village Eye* (que ya no se publica), donde hablé de cómo fue mi adolescencia en la calle.

¿Quién te enseñó a pintar?

Nadie, yo solo y sigo aprendiendo.[4]

Mis cuadros son mis propias versiones escritas de la historia, que no considero lineal. No obedezco los elementos cronológicos de la historia, ni el espacio ni la distancia: lo fusiono todo. A mí me fortalece hacer cosas, me fortalece dar prueba de mi existencia de este modo. Creo que todo el que sea pobre, ya sea psicológica o físicamente, prefiere construir a destruir. Teniendo en cuenta mi niñez, el errático medio en que crecí, siempre siento la necesidad de dar sentido.... De adolescente pasé por épocas violentas en que no

dudaba en romperle la cabeza a alguno por nada.
Respondía al mundo con la violencia que aprendí
de niño, pero por otra parte tenía una salida porque
tenía un impulso creativo que expresaba en la
calle. Hacía dibujos con un bolígrafo y eso me
gustaba, me daba cierto consuelo.[5]

Fundado en Nueva Orleans, Luisiana, 1988
Trabaja en Nueva Orleans, Luisiana

El supercolorido Young Aspirations/Young Artists (YA/YA, Inc.) es un colectivo de artistas jóvenes individuales que están creando una nueva imagen del mundo. El estudio de diseño y galería YA/YA se fundó en 1988 para ofrecer oportunidades profesionales a los jóvenes en las artes. Localizado en el distrito comercial central de Nueva Orleans, YA/YA es el centro creativo para un núcleo de 30 estudiantes de secundaria/preparatoria y de universidad. Reconocido internacionalmente de Tokio a Amsterdam, de París a Los Ángeles, por sus vitales muebles pintados a mano, telas y otros objetos, YA/YA representa el futuro para los jóvenes en los Estados Unidos.

¿Quién soy? Soy uno de muchos artistas que trabajan por su cuenta en YA/YA, Inc. . . . Soy una persona joven de "The Crescent". . . . Nací de mi Mamá en Nueva Orleans y crecí dentro de una familia que tenía los pies bien plantados en la tierra, formada por dos personas muy especiales. . . . Mi cultura es afroamericana, "Hip-Hop Tribesters". . . . Soy el Hombre, Negro, Marrón Oscuro. . . . Soy un indio del loco Distrito No. 8. . . . ¡Arte! Eso es quien soy. . . . Soy una pequeña niña a quien le encanta soñar. . . . Soy estadounidense, pero me gustaría crecer dentro de mis raíces africanas. . . . Soy una persona muy amigable. Algunas veces, cuando siento pena por alguien, me pongo de su lado, aunque no debiera. . . . Soy humana, mi cultura está mezcla con todo lo demás. . . . Soy natural . . . con un cierto grado de talento y una visión multicultural. Vivo en una aldea global; la vida es mi cultura.

¿Por qué me dedico al arte? Me dedico al arte porque es una forma de expresarme; es algo que disfruto, algo importante, apasionante. . . . Me libera la mente. Para mí, es un escape como individuo, otra puerta entre el alma y el corazón. . . . Hago arte para la gente que desea comprar mis sillas, que gusta del estilo de mis pinturas. . . . Me fascina hacer cosas con las manos y trabajar con distintas superficies y texturas. . . . mi trabajo es una amenaza a la sociedad porque es honesto y certero, sin carreta.

Ser parte de YA/YA me hace una persona especial. . . . Soy original, una persona única y hago de YA/YA algo también especial. . . . Las experiencias de mi pasado forman mis futuros deseos, de la misma manera que creamos estilos nuevos a partir de lo que nos rodea. . . . Mis tensiones y sentimientos se vuelcan en mi trabajo artístico; mis miedos, alegrías y emociones se convierten en imágenes coloridas y realistas para que todo el mundo pueda verlas. . . . Se relacionan con mi vida, porque cuento historias que traen esperanza a la desesperación. . . . Esto hace hermoso al mundo. Esa es la onda de YA/YA.

Trabajamos en grupo porque se pueden lograr más cosas cuando se tiene ayuda para terminar una pieza. . . . Los encargos grandes requieren una gran cantidad de energía y muchas manos. . . . Para crear proyectos como murales, es necesario que unamos las ideas artísticas de cada cual . . . esto crea confianza. . . . Podemos prestarnos nuestras cosas o tener alguien con quien hablar cuando tenemos algún problema. . . . También aprendemos de los errores de los demás. . . . Los problemas de actitud o comportamiento afectan a los demás. . . . Pueden hacer que los demás se sientan mal. Ésa es una desventaja del trabajo en grupo, pero los malentendidos siempre se discuten. Después alguien vende una pieza y nuevamente el entusiasmo regresa al grupo. . . . Trabajamos en ritmo, como un grupo de *rap*, expresando ideas distintas y coloridas.

Mi realidad artística es una mezcla de risas del alma, caricaturas y de lo opuesto, el realismo. . . . Así soy: gráfica, caricaturista, realista. ¡Chale! Me fui, ¡paz!

Notas

1. Pasajes de "David Hammons", una entrevista a David Hammons hecha por Kellie Jones que se publicó por primera vez en *Real Life,* número 16, otoño de 1986, y se reimprimió en *Discourses: Conversations in Postmodern Art and Culture,* editado por Russell Ferguson, William Olander, Marcia Tucker y Karen Fiss (New York: The New Museum of Contemporary Art y Cambridge, Massachusetts: The MIT Press, 1990), pp. 209-210.

2. Adaptado de una entrevista realizada por David Sheff y publicada en *Rolling Stone,* agosto 10, 1989.

3. Fragmentos de la entrevista "Serrano Shoots the Klan", hecha por Coco Fusco y publicada en *High Performance*, número de otoño, 1991.

4. Rose, Matthew, "David Wojnarowicz: An Interview", *Arts,* mayo, 1988, pp. 62-63 y 64–65.

5. *Tongues of Flame,* catálogo de una exhibición retrospectiva en la Universidad de Ilinois, 1990, p. 62.

Part 4:

Integrating Curriculum and Experience: Lesson Plans

American Identity

Carmen Bardeguez and Zoya Kocur

This material aims to sensitize students to issues of cultural identity and to enhance their knowledge of the historical and political circumstances underlying differing attitudes about ethnicity, heritage, and identity in the United States. Through studying the art of contemporary U.S. born and immigrant artists, students will examine their own cultural identities while exploring multicultural perspectives on "American" identity. Students will examine three different historical conditions in the United States, that of Native peoples, immigrants (voluntary and involuntary), and those who experience circular migration, specifically, Puerto Ricans. In addition, the lessons address the intersection of African, European, and indigenous ancestries among people of the United States, including Puerto Rico.

The teaching strategy is to draw on students' experiences to develop language and writing skills, and to integrate contemporary art and culture with personal experience through a creative project.

If you question whether or not this material is relevant in your particular locale because your student population is primarily of European descent, consider how racism and discrimination, which often results from ignorance of particular groups, are destructive and demeaning to everyone. Also consider both the diversity of European backgrounds and the reality that fewer and fewer communities are comprised of homogenous populations. In Minneapolis, for example, more than forty languages are spoken in the school district, and Native American, Hmong, African American, and Latino children represent 60% of the total enrollment in Minneapolis public schools.[1] Exploring ethnicity is not about studying something "other" than oneself, but about studying our particular and collective complex cultural affiliations.

Subject Areas: *Art, Language Arts, Social Studies, History, Media Studies*
8 Lessons (11–16 classes)

Objectives:

a. Students will explore their families' cultural backgrounds and histories through interviewing one another.

b. Students will articulate their images and perceptions of the United States, and discuss how contemporary artists portray the social conditions and history of this country.

c. Students will examine contemporary art that expresses the experience of multiple, sometimes conflicting, cultural identities.

d. Students will create individual and collaborative art projects.

e. Students will critically examine representations of Native Americans.

f. Students will learn different viewpoints of the history of Native peoples in the United States and examine how the U.S. educational system presents Native history.

g. Students will see how contemporary artists address Native histories in creative and visual form.

h. Students will discuss Puerto Rico's history and commonwealth status. The lesson will explore the experience and history of Puerto Rico's colonial relationship to the United States through art and literature.

i. Students will be introduced to the concept of transnational identity.

Through interviewing one another, students will explore their families' cultural heritages and histories.

Resources:
A world map, preferably Peters Projection.
Order from Friendship Press, P.O. Box 37844, Cincinnati, Ohio 45222-0844.
Telephone: (513) 948-8733.

Artists' statements:
David Avalos, Yolanda M. López, Juan Sánchez.

Slides:
David Hammons: *Spade with Chains* (p. 128)
Jean LaMarr: *They're Going To Dump It Where?!?* (p. 76)
Yolanda M. López: *Things I Never Told My Son About Being a Mexican* (p. 235), *Portrait of the Artist as the Virgin of Guadalupe* (p. 80)
Juan Sánchez: *NeoRican Convictions* (p. 90), *The Bandera Series: La Danza Guerrera; The Old Building; The World Belongs to The People; Willie Escapes!* (p. 248)
Richard Ray Whitman: *Dancing Back Strong* (p. 99)

Lesson 1: **Immigration and the United States: Who are We?**

Suggested Procedures:

1. Divide the class into pairs (with the teacher included as part of a pair if needed).

2. Have the students take turns conducting interviews with each other working from the following list of questions or similar questions they develop through class discussion:

a. What is your name? Do you know the meaning of your name?
b. Where are your parents from?
c. Where are you from?
d. Do you know or use any languages besides English?
e. Do you have relatives in other countries?
f. How long has your family lived in the United States?
g. Why did your family originally come to the United States?
h. What did they encounter once they arrived?

3. Have the students write the answers to these questions for presentation to the rest of the class. As each one presents the "cultural portrait" of his or her partner, ask the students to identify and point out the countries or states mentioned in the interviews on a map. (If you are using the Peters Projection map, you may wish to have a separate class period to explain what makes it different from the Mercator map. "A New View of the World," a handbook on the Peters Projection map, also available through Friendship Press, is a valuable tool.)

4. After these presentations, use the following questions to focus a discussion with the whole class:

a. What are the most important or surprising things you have learned about your partner? Your classmates?
b. How does this knowledge help you to better understand your classmates?
c. Are you curious to know more about your own origins? Why or why not?
d. What do you think you might learn by interviewing your parents or a close relative?
e. Describe any unexpected *similarities* between classmates of different backgrounds.

Yolanda M. López
Things I Never Told My Son About Being a Mexican, 1984
Mixed media installation
96″ × 144″

5. In a brainstorming session, have the class build a list of all the reasons their families came to the United States, voluntarily or not, no matter how long ago.

6. Ask students to consider all the information presented in their interviews to answer the following questions:

a. How have the reasons for emigrating to the U.S. changed over time?

b. What are some of the specific circumstances that led to immigration in students' ethnic or national groups?

c. What similarities in circumstances exist, no matter what the country or geographic area of origin? What important differences?

d. How have the economic and historical circumstances of different countries made the experiences of immigration unique for different peoples?

e. Were early migrations of Europeans to the U.S. motivated by different sets of circumstances than those existing for immigrants of today?

7. Anthropologist John Ogbu distinguishes between what he calls castelike minorities, and immigrant and other types of minorities.[2] (Characteristics of castelike minorities include involuntary and permanent incorporation into society, experience of job and status ceilings, and a tendency to formulate economic and social problems in terms of collective institutional discrimination.) Present students with the statements and works of artists who address the conditions they face and ask them to identify these conditions. Use for example the statements by **David Avalos, Juan Sánchez, Yolanda M. López,** and the works listed at the beginning of this lesson.

8. At this point you may wish to introduce the distinction between voluntary immigrants and those groups who historically were

subjected to forced migration. Discuss the desire for acculturation/ assimilation among newer, voluntary immigrants versus the resistance to assimilating European American culture by some descendants of involuntary immigrants and Native peoples.

9. Ask students: Are most people in the United States aware of the range of social, political, and economic factors responsible for present migration to the U.S.? Why or why not?

10. Ask students: How does mainstream U.S. society respond to _____ immigrants? (Fill in the blank with groups identified by students, such as Salvadoran, Hmong, Italian, Ukrainian, and Chaldean.) How are the experiences of highly educated and upper-class immigrants from each group different from that of less educated or working-class immigrants? How might social and economic conditions affect different immigrants' attitudes toward the U.S.?

Assignment:

Have each student use the information obtained from the interview to write a biography of his or her classmate. An additional interview to gather information may be needed.

Evaluation:

Use the students' participation in class discussion and their biographies to assess their increased knowledge about their own cultural heritage and that of their classmates. Assess their understanding of the social and economic factors affecting immigration to the U.S. historically and today.

Lesson 2: **Images of America**

🕐 **Time:** 2 class periods

❓ **Objective:**
Students will articulate their images and perceptions of the United States, and discuss how contemporary artists portray the social conditions and history of this country.

✔ **Resources:**
Book:
A People's History of the United States, by Howard Zinn (New York: Harper Perennial, 1990).

Slides:
Kristine Yuki Aono: *Issei, Nisei, Sansei, ...* (p. 53–55)
Eduardo Aparicio: *Rinconcito Sudamericano, 2529 North Milwaukee Ave, Chicago; Paletería Lulu, 1249 West 18th Street, Chicago; La Hacienda, 911 North Ashland Ave, Chicago* (p. 56)
Tomie Arai: *Chinatown* (p. 58), *Angel Island Poem*
Luis Cruz Azaceta: *Lotto: The American Dream* (p. 59)
Houston Conwill, Joseph DePace, Estella Conwill Majozo: *The New Ring Shout* (p. 63)
Gran Fury: *Welcome to America* (p. 67)
Dolores Guerrero-cruz: *Clarence Thomas and Members of Senate* (p. 69)
Guerrilla Girls: *Pop Quiz* (p. 70)
David Hammons: *Spade with Chains* (p. 128), *How Ya Like Me Now?, Higher Goals* (p. 72)

Suggested Procedures:

1. The *day before* class, give students the following homework assignment:

Select an image you feel is representative of the United States and bring it in for the next class. This could be a personal photo, a print advertisement, a product wrapper, a postcard, an original drawing, or any image that sums up or illustrates what the USA stands for.

Tell students that the image can be positive, critical, ambiguous, or with multiple meanings, as long as it represents some aspect of "America" they feel is important. Encourage imaginative use of materials; emphasize that you are not looking for any particular kind of image.

At the next class, have each student present his or her image or object to the rest of the class and explain why he or she believes it represents the United States. Students who bring foreign language materials should explain their content. As students present their images, keep a running list of major themes.

2. Once the presentations are completed have the students review the list of themes and identify dominant issues and points of contrast. Has a consistent image of the U.S. emerged from the group, or a mixture of diverse impressions? Were the images predominantly positive or critical? What does this assignment reveal about the definition of "America"?

3. Use all the materials gathered to create a large group portrait of the United States. This can be done as a collage on large paper or foam-core, or on a large piece of fabric which could be hung on the wall.

4. Show the following slides and ask students what historical events or conditions are being referred to in each. Have students describe what kind of "America" is portrayed:

Kristine Yuki Aono: *Issei, Nisei, Sansei, ...*
Eduardo Aparicio: *Rinconcito Sudamericano, 2529 North Milwaukee Ave, Chicago; Paletería Lulu, 1249 West 18th Street, Chicago; La Hacienda, 911 North Ashland Ave, Chicago*
Tomie Arai: *Chinatown, Angel Island Poem*
Luis Cruz Azaceta: *Lotto: The American Dream*

Jean LaMarr: *Some Kind of Buckaroo* (p. 43), *They're Going to Dump it Where?!?* (p. 76)

Maya Lin: *Civil Rights Memorial* (p. 324), *Vietnam Veterans Memorial* (pp. 79, 345–346)

Yolanda M. López: *Who's the Illegal Alien, Pilgrim?* (p. 244); *Things I Never Told My Son About Being a Mexican* (p. 235)

James Luna: *Take a Picture With an Indian* (p. 42); *Artifact Piece* (p. 81)

Kay Miller: *Seeds* (p. 84)

Barbara Jo Revelle: *Colorado Panorama: A People's History of Colorado* (pp. 87, 348–349)

Juan Sánchez: *The Bandera Series: La Danza Guerrera; The Old Building; The World Belongs To The People; Willie Escapes!* (p. 248)

Andres Serrano: *Klansman (Imperial Wizard)* (p. 91)

Elizabeth Sisco, Louis Hock, David Avalos: *Welcome to America's Finest Tourist Plantation* (p. 94)

Danny Tisdale: *The Black Power Glove, The Black Museum* (p. 98); *Five Afro Combs, The Black Museum* (p. 327); *Dashiki, Album Covers, Black Panther (Leather) Jacket, Afro Hair, The Black Museum*

Richard Ray Whitman: *Dancing Back Strong* (p. 99)

Materials:
Newspapers and magazines, photos, personal objects.

Houston Conwill, Joseph DePace, Estella Conwill Majozo: *The New Ring Shout*

Gran Fury: *Welcome to America*

Dolores Guerrero-cruz: *Clarence Thomas and Members of Senate*

Guerrilla Girls: *Pop Quiz*

David Hammons: *Spade with Chains, Higher Goals, How Ya Like Me Now?*

Jean LaMarr: *Some Kind of Buckaroo, They're Going to Dump it Where?!?*

Maya Lin: *Civil Rights Memorial, Vietnam Veterans Memorial*

Yolanda M. López: *Who's the Illegal Alien, Pilgrim?; Things I Never Told My Son About Being a Mexican*

Barbara Jo Revelle: *Colorado Panorama: A People's History of Colorado*

Juan Sánchez: *The Bandera Series: La Danza Guerrera; The Old Building; The World Belongs To The People; Willie Escapes!*

Andres Serrano: *Klansman (Imperial Wizard)*

Elizabeth Sisco, Louis Hock, David Avalos: *Welcome to America's Finest Tourist Plantation*

Danny Tisdale: *The Black Power Glove, The Black Museum; Five Afro Combs, The Black Museum; Dashiki, Album Covers, Black Panther (Leather) Jacket, Afro Hair, The Black Museum*

Richard Ray Whitman: *Dancing Back Strong*

Pat Ward Williams: *Accused/Blowtorch/Padlock*

6. Select excerpts or chapters from the book *A People's History of the United States* by Howard Zinn. This U.S. history incorporates viewpoints of those who have been left out of most official histories. Chapters to consider are "The Intimately Oppressed" (Chapter 5) on women; Chapter 6 on Native American history; and Chapter 16, "Surprises," covering topics such as the Attica prison uprising and the American Indian Movement (AIM).

7. After completing the reading in Zinn, repeat the collage assignment, creating a second group collage of images of the United States. Ask students to compare the two finished collages and discuss how

they differ. For extra credit, ask students to create their own accounts of the ethnic groups that have been left out of history books. The students should do photo and image research, as well as gather written materials and oral histories from their interview subjects.

Evaluation:

Assess how well students were able to use images, objects, and words effectively as symbols to represent the idea of "America" and verbally articulate the concepts behind the images. Were they able to connect the visual art works shown in class with specific historical viewpoints? Did you observe a marked difference in sophistication of ideas and presentation from the first collage to the second?

Lesson 3: **Contemporary Art from Bicultural Perspectives**

Suggested Procedures:

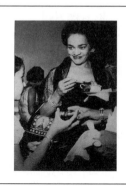

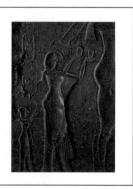

< Kristine Yuki Aono
Hashi/Fork, 1984
Wood, Paper
44″ × 7″ × 4″

^ Lorraine O'Grady
Ceremonial Occasion, 1980/88
from Miscegenated Family Album
Left: Devonia O'Grady Allen attending a wedding
Right: Queen Nefertiti performing an Aten ritual
Cibachrome, 28″ × 39″

1. Show slides of works by **Kristine Yuki Aono, Dinh Le, James Luna, Yolanda López, Lorraine O'Grady,** and **Helen Zughaib Shoreman.** One at a time, discuss how these artists combine elements of two or more cultures in their artwork.

2. Ask how each of the artists appear to feel about each culture and about the mixing of two cultures. Is this presented as a positive or negative phenomenon? Does the work suggest pressure to adapt to Anglo-American culture? Is it possible, or desirable, to keep cultures separate? Is the artist making a clear statement, taking a neutral stance, or asking a question in the artwork? Do the cultural attributes/identities portrayed in the artworks seem willingly taken on, or imposed by others?

3. Ask students to read the statements by the artists after seeing the slides. Does this change their interpretation of the artworks?

4. Continue the exercise for the remaining artists and works listed. (You may wish to focus on a certain ethnic group or theme.)

Artists' statements:
**Kristine Yuki Aono, Ken Chu,
Jimmie Durham, Dinh Le,
Yolanda M. López,
Lorraine O'Grady,
Helen Zughaib Shoreman.**

Assignment:

Make a self-portrait or portrait of a family member or friend emphasizing the relationship between two cultures. If a student feels that he or she has only one culture to draw on, pair the student up with a classmate from a different background to complete the assignment together.

This assignment is an opportunity for students to respond to the material they have just studied by incorporating their own experiences. The portraits can take many different forms depending on your content area and objectives. Students can create written portraits; produce written or taped oral histories with family, friends, or community members; do a photo essay, taking their own photographs or using existing family photographs; cut out newspaper or magazine pictures; make drawings; make multi-media collages; bring in objects (found or ones they own) which embody their culture; or a combination of all these in scrapbook or album form.

Additional Project Ideas:

1. Use the photography of **Eduardo Aparicio** as a model for a photo project documenting your neighborhood and its cultural landscape. (Suitable for media, photography, social studies, and art classes.)

2. Use Yolanda M. López's collage *Things I Never Told My Son About Being a Mexican* as a model for a project on ethnic stereotypes in the mass media or how ethnic groups are used to sell products. (Suitable for art, media, and social studies classes.)

3. After reading selected statements ask students to write responses to some of the questions asked of the artists for their statements: Who are you? Where do you come from? What is your culture? (Suitable for English, bilingual language, ESL, art, and social studies classes.)

Evaluation:

Were students able to identify various cultural elements and how these were represented in the visual art? Were they able to suggest interpretations of the artists' intent and possible motivations in making the art?

American Identity

Time: 1–2 class periods

Objective:
Students will present and analyze their cultural portraits, which will then be used as a basis for a collaborative project.

Resources:
Completed portraits assigned in Lesson 3; various slides.

Suggested Procedures:

1. Have each student present her or his portrait to the class, answering any questions about it classmates may have. The class should identify and record in writing the central themes of each portrait.

2. List the themes identified by the students on the blackboard. From this list, have the students choose one or more themes around which to focus a collaborative project. It is important that the topic is decided upon by consensus so that all students have the opportunity to participate in the decision-making process and feel invested in the project. If there are several themes, students should be made aware that they will have to find a way to integrate all these topics into a cohesive whole. Though it may take more than one class period, it is essential to have consensus before moving on.

3. Once the themes or content of the project have been negotiated, the next step is to decide on form. It is helpful at this juncture to bring in a variety of examples to give students some visual ideas to respond to. You may wish to review the slide set, selecting artworks with physical forms that can be adapted easily to your classroom environment.

Project Suggestions:

A. If you are teaching media or video production, the class may produce a video. Possible formats include videotaped oral histories, an experimental art video documentary, and fictional narrative such as soap opera or sit com. Students decide on the content and themes.

B. If you are teaching language or literature, you may want to incorporate writing. Show students examples of book art, illustrated books, comic books, or artworks that combine images and text. See, for example, **Clarissa Sligh**'s artist book *What's Happenin' With Momma?*, **Richard Hill**'s black and white photo and text series, and **Yolanda M. López**'s *Things I Never Told My Son About Being a Mexican*.

C. Another project suitable for language arts classes is to divide students into groups, assigning one student to begin writing an autobiographical story from the perspective of a newcomer to this country. The story is then passed on to the next group member, who continues it, in the same autobiographical fashion. The completed

stories of each group could be combined into a book of short stories illustrated with drawings, and/or incorporating materials such as photos, collages, and fabric. The project might also take the form of a long illustrated narrative scroll.

D. Students might be asked to use forms of expression common in their own cultures or forms of cultural expression they may take for granted and would not think to utilize outside of their usual context. Look at the work of **Amalia Mesa-Bains**, who uses the tradition and form of the Mexican altar. **Faith Ringgold**, who draws upon the African American quilting tradition; **Dinh Le**, who combines modern color photography with a traditional Vietnamese weaving technique; and **Gran Fury** who uses sophisticated advertising techniques to generate discussion about urgent social problems.

E. If any of the sample projects listed at the end of Lesson 3 address topics chosen by the students, these can be suggested, adapted or expanded. Themes developed by students in The New Museum's High School Art Program have included: immigration; "the American Dream"; adapting to a new culture; racism in the United States; freedom in the U.S. compared to other countries; social and economic mobility in the U.S. as compared to other countries; language; family pressures to maintain cultural traditions; relationships; and friendship.

Enough time should be allotted for presentations at the culmination of major projects. It is rewarding for the entire group to have a celebration or "opening," where the entire school, parents, and friends are invited to share in what the students have accomplished.

Evaluation:

Assess how well students were able to pick out themes of one another's portraits. Once themes were identified, were students able to reach a consensus among themselves on their group project's form, content, and objectives? Ask students to reflect upon and articulate what they have accomplished. Also ask them to evaluate the process and make suggestions for how it might be done better the next time.

Time: 1–2 class periods

Objectives:
Students will identify stereotypes and critically examine representations of Native Americans.

Resources:
Slides and statements:
Jimmie Durham: *Self-Portrait* (p. 64)
Richard Hill: *Urbanized (Dave Elliot)* (p. 75), *My Father, My Friend* (p. 74)
Yolanda M. López: *Who's the Illegal Alien, Pilgrim?* (p. 244)
Selected others
(see Procedure 4)

Suggested Procedures:

1. Ask the students to do freewriting for about 5 minutes on their ideas and images of Native Americans.

2. Read the statements and show the above slides of **Durham, Hill,** and **López.**

3. Ask students to compare their freewriting responses to the images of Native Americans in the works of Durham, Hill and López. Is there any difference between students' portrayals and those of the artists? If so, what do the students think accounts for the discrepancy?

4. Ask students to read statements of some of the other artists who discuss Indian or Native American ancestry, such as **David Avalos, Guillermo Gómez-Peña, Dolores Guerrero-cruz, Jean LaMarr, James Luna, Jolene Rickard, Diosa Summers, Richard Ray Whitman.** Show slides of the work of each artist whose statement students have read. Ask students to identify how these artists' indigenous ancestry might be reflected in their art.

5. Discuss how Latino—particularly Chicano—identity intersects with indigenous ancestry, as addressed in the statements of Gómez-Peña, Guerrero-cruz, López and Avalos.

6. Have students watch any cartoon, TV show, or movie, in class or as a homework assignment, and analyze the way the Native Americans are depicted. Ask students to pay attention to physical and mental characteristics (in female and male characters), and their role in the story. (Are they portrayed as intelligent? Savages? Servants? Heroes? Villains?) Ask students to compare these mass media portrayals of Native Americans to the statements and art works produced by Native Americans themselves. How are they different? What accounts for this?

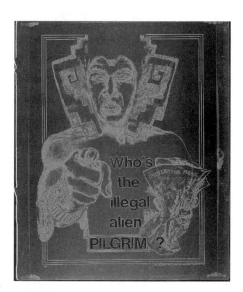

Yolanda M. López
Who's the Illegal Alien, Pilgrim?, 1978
Ink on paper
28″ × 32″

American Identity

Evaluation:

Through class discussion, assess how well students were able to identify common stereotypes of Native Americans. Were they able to distinguish between stereotypes and some of the more varied and realistic images created by Native American artists? Do students have a grasp of the problems inherent in assigning fixed meanings to terms such as "Native American," or "Chicano," or "Latino"?

a. Students will learn different viewpoints of the history of Native peoples in the United States and examine how the U.S. educational system deals with Native history.

b. Students will see how contemporary artists address these histories in creative and visual form.

✓ **Resources:**

Books:

Rethinking Columbus, a special issue of *Rethinking Schools.* Write to: *Rethinking Schools,* 1001 E. Keefe Ave., Milwaukee, WI 53212. Telephone: (414) 964-9646. (Price based on order size.)

A People's History of the United States, by Howard Zinn (New York: Harper Perennial, 1990).

We the People, exhibition catalog from a 1987 exhibition of the same name at Artists Space in New York City. To purchase, contact Artists Space: 38 Greene Street, 3 Fl.; New York, New York 10012. Telephone: (212) 966-1434.

Slides:

Jimmie Durham: *Self-Portrait (p. 64)*

Richard Hill: *Urbanized (Dave Elliot)* (p. 75)

Jean LaMarr: *Some Kind of Buckaroo* (p. 43), *They're Going to Dump it Where?!?* (p. 76), *Cover Girl Series*

Lesson 6: **The Legacy of the Conquest**

Suggested Procedures:

1. For general background on some of the issues and struggles of Native Americans, have students read the following two articles from *Rethinking Columbus:*

"The Iroquois Contribution to the Constitution," page 44. Ask whether or not students had been made aware of these facts in any of their school history books. If not, why is this key information omitted?

"Struggles Unite Native Peoples," an interview with Chief Tayac, pages 56–58. Ask students to summarize the main points made by Chief Tayac before continuing the lesson.

Also assign, in part or in full:

"As Long as Grass Grows or Water Runs," Chapter 6, in Zinn.

2. Ask students to read **Jimmie Durham**'s poem "Columbus Day" (in *Rethinking Columbus,* p. 59). Optional reading: "Savage Attacks on White Women, as Usual" by Jimmie Durham, in *We the People,* pp. 14–19. Ask students if they believe schools have the responsibility to teach history from all sides of a conflict, including the viewpoint of the historical "losers" of a battle? Why or why not? Should each group involved have the right to record history as their own people believe it happened?

3. Present the following slides: **Richard Hill**'s *Urbanized,* **Richard Ray Whitman**'s *Dancing Back Strong,* **James Luna**'s *Artifact Piece* and **Jean LaMarr**'s *Cover Girl,* and *Some Kind of Buckaroo.* Ask students how these art works comment on the history of Native American peoples.

4. View the following slides: *Self-Portrait* by Jimmie Durham; *Take A Picture With An Indian* and *War-Dance Technology* by James Luna. Ask students how these Native American artists use humor and satire to comment on the treatment of Native American people.

5. Have students read the poem "Halfbreed Girl in the City School" by Jo Whitehorse Cochran in *Rethinking Columbus,* p. 48, and consider the following questions:

a. Can you relate to the experiences of the girl in the poem?

b. How do the experiences of this "halfbreed" girl reflect and comment on the legacy of Columbus and conquest?

c. How might this legacy, as expressed in the poem, relate to experiences of those who are U.S. citizens not of European descent–African Americans, for example?

Note: For more information on resources contact the American Indian Community House and other organizations in the Resources section.

Evaluation:

Can students demonstrate a more thorough understanding of the history of Native American people and nations? Are they able to articulate how contemporary Native American artists express their unique histories?

James Luna: *Artifact Piece* (p. 81), *Take a Picture With an Indian* (p. 42)
Richard Ray Whitman: *Dancing Back Strong* (p. 99), *Man Form-Indian Self*

Films:
Optional:

Geronimo Jones: A young boy (Apache/Papago) living on a reservation experiences the conflicts between his Indian heritage and the pressures of the dominant culture. 1970. 21 minutes, Rental $75, purchase $250, VHS. Order from Coronet/MTI Film and Video. Telephone: (800) 621-2131.

More Than Bows and Arrows: A classic film to increase understanding of Native Americans for elementary through adult audiences. $15 Rental, Honor Organization Inc. 2647 N. Stowell Avenue, Milwaukee, WI 53211. Telephone: (414) 963-1324.

Powwow Highway: An independent film about the different journeys undertaken by two friends discovering what it means "to be Cheyenne," based on the novel by David Seals. Released in 1989 by Cannon Home Video, 90 minutes. Check your local video store.

American Identity

Objective:

a. Students will learn about Puerto Rico's history and commonwealth status.

b. Students will explore the experience and history of Puerto Rico's colonial relationship to the United States through art and literature.

Resources:

Artists' statements: **Marina Gutierrez** and **Juan Sánchez.**

Slides:

Marina Gutierrez: *Get Back, Isla del Encanto (p. 71)*

Juan Sánchez: *NeoRican Convictions (p. 90), The Bandera Series: La Danza Guerrera; The Old Building; The World Belongs To The People; Willie Escapes!* (p. 248), *Plebiscite*

Books:

A Puerto Rican in New York and Other Sketches by Jesus Colon (New York: International Publishers, 1991).

Down These Mean Streets by Piri Thomas (New York: Vintage Books, 1991).

Lesson 7: **Puerto Rico and the United States**

Suggested Procedures:

1. Present background information about Puerto Rico and its colonial status in relation to the United States. A good background text for students is *Puerto Rico: Culture and History* created in the Rochester, New York school district.

2. Present the artworks *NeoRican Convictions* and *Plebiscite* by **Juan Sánchez** and ask the students to identify some of the symbols Sánchez uses, and what they think the symbols mean. (Sánchez uses images from the art of the indigenous Taino Indians of Puerto Rico, as well as flags, newspaper headlines, and photos.)

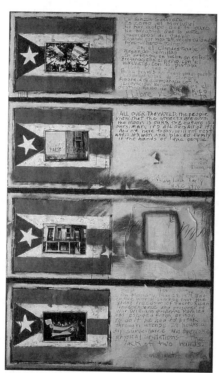

Juan Sánchez
The Bandera Series (The Flag Series), 1982
Danza Guerrera (War Dance); The Old Building;
The World Belongs to the People; Willie Escapes!
Oil, mixed media on canvas
4 panels, 28″ × 66″ each

3. Read Sánchez's statement and discuss *The Bandera Series: La Danza Guerrera; The Old Building; The World Belongs To The People; Willie Escapes!* and *Plebiscite.* Ask students how these works address the issues and history of independence for Puerto Rico. Ask students whether or not they believe Puerto Rico should remain a commonwealth. Should it become the fifty-first state? An independent country? What are the pros and cons of each option?

4. View slides *Isla del Encanto* and *Get Back* by **Marina Gutierrez.** Read her statement. How do her artworks address different visions of Puerto Rico and of Puerto Ricans?

5. Many Puerto Ricans engage in a process of circular migra-

American Identity

tion, moving back and forth between the island and mainland. An individual may migrate back and forth several times during his or her lifetime. This two-way migration is driven both by economic need, and by the desire to return "home" to Puerto Rico, perhaps to retire in one's family's hometown after a lifetime spent in New York City. Inform students that in interviews conducted with twenty students (ten in New York and ten in Puerto Rico) the theme arising most often was bicultural identity, according to research on circular migration among Puerto Ricans.[3] Ask students to discuss how the migration situation of Puerto Ricans is unique. How does this situation affect the cultural identity of Puerto Ricans in both places?

6. Select a few chapters from one or both books listed above. Jesus Colon's stories tell about the experiences of working class Puerto Ricans in the 1940s and '50s. The introduction by Juan Flores is also relevant for teachers and students. In *Down These Mean Streets* by Piri Thomas, have students read the particular chapters about moving from El Barrio in New York City to Long Island and his trip to the South to come to terms with his black identity. Please note that this book contains strong language; please preview whatever you ask students to read to decide if they are mature enough to read the material critically.

7. From the readings, what differences in racial attitudes and categories did students observe between island-born and mainland-born Puerto Ricans? Did the writers discover different types of racial discrimination in Puerto Rico versus in the United States society? Do these attitudes exist today? Is there racial discrimination in Puerto Rico?

8. Ask students if their perceptions of Puerto Ricans have changed after reading the writings of and seeing art made by Puerto Ricans. How so? Have any students had experiences similar to those they read about?

9. Can students identify similarities and differences in the history and circumstances of Puerto Ricans and that of African Americans? Between the history of Puerto Ricans and Native Americans? Puerto Ricans and Chicanos?

Puerto Rico: History and Culture (Maywood, NJ: People's Publishing Group, 1993). To order call (800) 822-1080 or write People's Publishing Group, 230 West Passaic Street, Maywood, New Jersey, 07607.

Film: *La Operación* (40 min.) by Ana Maria Garcia, in Spanish with English subtitles. Distributed by Cinema Guild: 1697 Broadway, Suite 812, New York, NY, 10019. Telephone: (212) 246-5522.

American Identity

10. Optional: Present the short film *La Operación* by Ana Maria Garcia, about the aggressive family planning practices of the U.S. and Puerto Rico that led to the sterilization of one-third of all Puerto Rican women. (Note: The information in this film is somewhat dated; you may want to do additional research on the topic or ask students to do research after seeing it.)

For more information about Puerto Rican studies contact the Centro de Estudios Puertorriqueños at City University of New York.

Evaluation:

Are students more aware of cultural, political and historical issues surrounding Puerto Rico's relationship to the United States? Are they able to identify differences and similarities between Puerto Ricans and other immigrants? Between Puerto Ricans and other "castelike" minorities in the U.S.?

Lesson 8: **Transnational Identities**

🕐 **Time:** 1 class period

❓ **Objective:**
Students will be introduced to the concept of transnational identity and will examine artists' connections to countries and cultures outside the U.S.

✓ **Resources:**
Slides:
Kristine Yuki Aono: *Hashi/Fork* (p. 240); *Deru Kugi Utareru* (p. 258); *Issei, Nisei, Sansei,...* (pp. 53–55)
Houston Conwill, Joseph DePace, and Estella Conwill Majozo: The *New Ring Shout* (p. 63)
Epoxy Art Group: *Guest Becomes Host* (p. 65)
Faith Ringgold: *Dancing on the George Washington Bridge* (p. 89), *Street Story Part III: The Homecoming* (p. 329)
Pat Ward Williams: *Accused/Blowtorch/Padlock* (p. 100), *Sibling Rivalry* (p. 261)

Artists' statements:
Tomie Arai, Houston Conwill, Joseph DePace and Estella Conwill Majozo, Jimmie Durham, Faith Ringgold, Pat Ward Williams, Krzysztof Wodiczko.

Suggested Procedures:

1. Read the statements of **Faith Ringgold** and **Pat Ward Williams.** Both mention being influenced by African art and culture in their own work. How does this influence appear in their artwork?

2. Read the statement of **Jimmie Durham.** In calling the United States an "invention" and rejecting identification as a U.S. citizen, what is Durham expressing? Is he opposed to all kinds of national identity or specifically a United States identity?

3. Read the statement and look at the work of **Houston Conwill, Joseph DePace** and **Estella Conwill Majozo.** How do these artists approach and define the idea of African American identity? From the statement and art, what is the artists' culture; what does it embrace? How does their statement relate to the concept of nation and national identity?

4. Read the statement of **Krzysztof Wodiczko.** In it, he acknowledges being Canadian and American, but "definitely Polish." Why might someone emigrate to and live in the U.S. for many years, yet declare they are Polish first, while someone else may live in the U.S. one year and declare "I am American!" What does Wodiczko mean when he says he is Polish? What does a new immigrant mean when he or she says, "I am American"? Is it possible to be Polish one day, and "American" the next? Can one be both? Is this a contradiction?

5. Read the statement and look at the art of **Kristine Yuki Aono.** She identifies herself as "Sansei." Does this identification place more emphasis on Japanese or American heritage, or does it refer to a unique Japanese American identity? Is the relationship of Japanese Americans to Japan unique among immigrants? Do you imagine that Aono can say, if she desires, that she is Japanese at some times, and American at others? If she went to Japan, would she be considered Japanese? American? Sansei?

6. Read the statement of **Tomie Arai.** How does she define her identity? How does it differ from the ideas expressed by the other artists considered here?

American Identity

7. Show the slide of **Epoxy Art Group**'s *Guest Becomes Host*. What does this work suggest about economic relationships between Japan and the U.S.? How do increasingly interdependent global economic relationships affect concepts of national identity?

8. Discuss the concepts of identity and nationality expressed by all the artists above. Do they express stable, clearly defined notions of nationality and cultural identity? Fluid, changeable ideas of national identity? Conflictual or contradictory ideas? Can you draw any conclusions about the concept of national identity?

Evaluation:

Assess students' understanding of the concept of transnational identity through class discussion.

Note: These lessons are not intended as a comprehensive curriculum in ethnic studies. Consult *Teaching Strategies for Ethnic Studies,* edited by Banks and Banks, listed in the bibliography. Also look through the arts and media organizations list for curriculum packets offered through various organizations.

Notes

1. William Celis, 3rd. "Schools in Minneapolis Try a Corporate Approach" *The New York Times,* December 1, 1993, B11

2. John Ogbu, "Cultural Discontinuities and Schooling," *Anthropology and Education Quarterly,* V. XIII, No. 4, p. 299.

3. Dennis Sayers. Source: conference presentation by Sayers at National Association for Bilingual Education, Houston, Feb. 1993.

Recasting the Family

Zoya Kocur

Recasting the Family

In this section, we will explore some myths and facts about the family. We will talk about the invisibility (or alternately, scrutiny and criticism) of families that don't conform to dominant ideas. Approximately 5% of U.S. families fit the structure of working father and mother at home with two kids—thereby leaving the vast majority of families outside the "ideal."

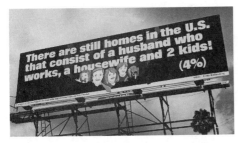

Erika Rothenberg
There Are Still Traditional Families, 1990
Billboard
14′ × 48′

The central question examined will be: How can we account for the vast difference between the dominant societal images of the "normal" family and how most families actually configure themselves? Among the specific issues examined will be:

a. Who defines family norms, and how;

b. The impact of not living in a "normal" family structure;

c. The purpose(s) of norms regarding the family, and examination of the kinds of values embodied or expressed in each norm, particularly as they are expressed through gender and class;

d. Differences in cultural beliefs and values regarding family.

Many of these ideas will be examined through a critique of mass media representations of family, as well as students' own experiences of family. Students will work toward a creative project in which they create realistic representations of family, and alternatives to those representations offered by the mass media. Project discussion should begin at whatever point during this series of lessons you feel students need to begin hands-on work to demonstrate comprehension and creatively interpret the concepts they are exploring.

Subject Areas: *Studio Art, Photography, Social Studies, Language Arts, Media Studies*
Time: 9 Lessons (16–20 classes)

Objectives:

a. Students and teachers will analyze their own and societal beliefs and opinions about family.

b. Students will engage in cross-cultural and intergenerational analyses of the importance of family.

c. Students will critically examine representations of families, including their own families.

d. Students will critically examine norms and ideals in family structure.

e. Students will understand the family as a social structure and economic institution, as well as a biological unit.

f. Students will examine diverse attitudes toward marriage, children, and family size.

g. Students will examine changing legal definitions of family.

h. Students will analyze representations of families in the mass media and create alternative representations that reflect their own experiences.

i. Students will learn how the roles of different family members reflect societal beliefs.

? **Objectives:**

a. Students will examine their own attitudes about family.

b. Students will examine and appreciate differences in family structures.

c. Students will appreciate the roles of older people within family and society.

✔ **Resources:**

Slides:

John Ahearn: *Maria's Mother* (p. 256)

Ida Applebroog: *Riverdale Home for the Aged* (p. 257)

Richard Hill: *My Grandmother (Charlotte Hill)* (p. 74)

Elizabeth Layton: *Thanksgiving, Buttons* (p. 77)

Equipment:

Slide projector and screen.

Lesson 9: **Cultural and Intergenerational Perspectives on Family**

Suggested Procedures:

1. Ask students to discuss the importance of family in their lives and to describe their own families:

a. How important is your family to you? How important compared to friends?

b. Do you consider yourself "close" to your mother and/or father? Grandparents? Siblings? Extended family, such as aunts, uncles, cousins?

c. Do you live within a nuclear family household? With extended family?

d. Has your living situation ever changed (i.e., have you lived with different family members or relatives at different times)? Is this typical among your friends and relatives?

e. Is your family defined by who is living with you in your house or apartment at any given time, or in some other way?

f. Do you value closeness to your parents, or do you feel indifferent or antagonistic toward your parents? Is your attitude typical among your friends?

Do students' responses reveal any cultural differences? What other factors might account for differing responses?

2. Show and discuss slides of the following works, using the questions below to initiate students' responses:

Maria's Mother by **John Ahearn**

a. What is being portrayed?

b. Does this scene seem typical or familiar to anyone?

c. Are you expected to show respect to parents and other older relatives in your families? How are grandparents treated in your family? Are older family members valued, seen as a burden, or both?

d. What are specific reasons for having extended family living together? Are they economic? Do they reflect social or cultural values? If so, what values?

Ask students who do not have extended family living at home whether they view this positively or negatively and why.

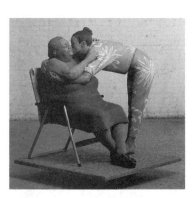

John Ahearn
Maria's Mother, 1987
Oil on fiberglass
51″ × 52″ × 48″

Recasting the Family

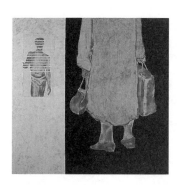

Ida Applebroog
*Riverdale Home for the
Aged,* 1984
Oil on 2 canvases
100″ × 100″

Riverdale Home for the Aged by **Ida Applebroog**

a. From whose perspective is the scene painted?

b. What might Applebroog be saying about sexual desire among
 the aged and society's assumptions about it?

c. Should grandparents be at home with you, especially if they
 need care, or should they be in a nursing home if the family can
 afford it? Why or why not?

Thanksgiving and *Buttons* by **Elizabeth Layton**

a. Do these portrayals differ from the typical ways in which older
 people, particularly women, are represented? How?

Have students consider what their responses to these artworks,
and the responses of others, reveal about attitudes toward the elderly
and the roles they play in the family and in society.

Assignment:

Have the students interview an elderly relative or neighbor. Help
the class design the interview questions. Questions might include
the following:

a. How do you think older people are typically perceived by
 younger people?

b. What misconceptions do younger people hold about older
 people?

c. How do you feel the elderly are treated in society?

Have students read their interviews to each other and discuss ways
in which the interview may have challenged their assumptions about
the elderly.

Evaluation:

Assess whether students grasp the broad variety of family
configurations and some of the reasons that might account for this
variety. Assess whether students are more aware of the concerns and
social roles of senior citizens.

Recasting the Family

Lesson 9: **Cultural and Intergenerational Perspectives**

Objectives:

a. Students will examine cultural differences within families.

b. Students will identify tensions between the need and desire to assimilate to a mainstream culture and resistance to assimilation.

Resources:

Slides:

Kristine Yuki Aono: *Deru Kugi Utareru* (p. 258); *Issei, Nisei, Sansei,...* (pp. 53–55); *Hashi/Fork* (p. 240)

Ken Chu: *I Need Some More Hair Products* (p. 62)

Yong Soon Min: *Make Me* (p. 85)

Artists' statements:

Kristine Yuki Aono, Ken Chu, and **Yong Soon Min**

Equipment:

Slide projector and screen.

Suggested Procedures:

1. Ask students to describe their family structures and to explain whether they think their family is representative of society's definition of "normal." Ask students who were born or have lived outside the U.S. to describe families in these other countries, and to compare them to U.S. families. Ask other students to talk about what they know (or imagine) of family life in other cultures or countries and how this compares with their own experiences.

2. Pose the question of the American Dream: What type of family does the American Dream prescribe? If you have students who are immigrants or first-generation born in the United States, ask them how this "ideal" compares with the family "ideal" in their native cultures.

3. Ask students who are being raised in a culture new or different from that of their parents:

a. Are there tensions in the family due to differing expectations of children in your two cultures? If so, what is the nature of these conflicts?

b. Do you feel that your parents' expectations of you are different from the expectations U.S.-born parents have of their children? How do you expect your parents to adjust to the different social values in the United States?

4. Show slide of **Kristine Yuki Aono**'s *Deru Kugi Utareru* and read the artist's statement, particularly the section that focuses on this work. Have students identify some of the intergenerational differences Aono describes between herself and her parents. Show the slide *Make Me* by **Yong Soon Min** and read the artist's statement. Discuss the meaning of the term "1.5 generation."

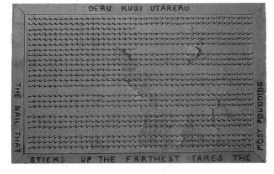

Kristine Yuki Aono
Deru Kugi Utareru, 1984
Mixed media
37″ × 24″ × 3″

5. Show slides of Kristine Yuki Aono's *Issei, Nisei, Sansei, ...;* and *Hashi/Fork* and read the artist's descrip-

tion of these works. Have students examine each piece and discuss how Aono represents various generations.

6. Ask students to read **Ken Chu**'s statement. Next, view Chu's *I Need Some More Hair Products*. Ask students to discuss the idea of assimilation and the pressure to conform. Have they experienced this pressure in any way? How?

Assignment:

Have students bring to class and share with each other two or three objects that represent two or three generations within their own families. In class, have students discuss what these objects reveal about their family's history, including geographical relocation, acculturation, class mobility, and other factors.

Provide students with additional material to read or view about families in a variety of cultures both within and outside the U.S., such as films or contemporary fiction. Have students compare their own beliefs and attitudes with those they read about or see. Focus on materials that emphasize interaction between two cultures, particularly conflicting values families must negotiate. Examples might include novels such as Amy Tan's *Joy Luck Club* (New York: Ballantine, 1989) and Cristina Garcia's *Dreaming In Cuban* (New York: Ballantine, 1992), both about intergenerational and cultural conflicts among the women of a Chinese family and a Cuban family, respectively.

Evaluation:

Assess students' understanding of cultural differences within families through their selection and discussion of objects.

Time: 2–3 classes, plus 2–3 weeks for two assignments.

Objectives:

a. Students will examine what kinds of stories, values, and myths we communicate to ourselves and others through family albums and snapshots.

b. Students will examine the functions albums play within and outside the family.

c. Students will understand relationships between real and symbolic representations.

Resources:

Slides:

Richard Hill: *My Grandmother (Charlotte Hill); My Father, My Friend; Urbanized (Dave Elliot); My Son Randy* (pp. 74–75)

Clarissa Sligh: *Bee Bee Gun, Wonderful Uncle* (p. 261)

Pat Ward Williams: *Sibling Rivalry* (p. 261)

David Wojnarowicz: *Untitled* (p. 272)

Equipment:

Slide projector and screen; camera.

Materials:

Family photographs; film; empty photo albums or scrapbooks.

Lesson 11: **Picturing the Family: Snapshots, Albums, and Home Videos**

Suggested Procedures:

1. Ask students if their families have family photographs or videotapes. Inform the students that a study of 82 families in Chicago found that family photographs were ranked as the family's third most important possession after furniture and visual art.[1]

2. Do the following exercise with your own family photos in mind. Ask students:

a. What types of events are considered important enough to preserve and why?

b. Who is taking the photo or video? (Consider this in terms of both gender and generation, i.e., is it typically the parents, particularly the father if there is one at home, who take the pictures or video?) Do children or grandparents tend to take pictures?

c. Where are photos taken? (Almost all family snapshots are taken in the living room or family room or outdoors, almost none in bedrooms, kitchens, or bathrooms.)

d. What kinds of family events are omitted from family photos?

e. Why are certain pictures put in the family album and others left out?

f. Who in the family puts together the photo album or organizes family pictures? Who is the "keeper" of the family's history?

g. Can you tell from looking at these images who are the more powerful and less powerful family members? Who poses or arranges the people being photographed?

3. Did you notice cultural differences among students in their responses? Ask students to elaborate on why certain things are important for them or their family to record and preserve.

4. Ask students how family snapshots, albums, and home videos reinforce societal norms about the family. Encourage students to consider how these forms of self-representation mirror social relations in the world at large. Pose this in terms of relative status of various family members, such as mothers and fathers, men and women, parents and children, the old and young.

Recasting the Family

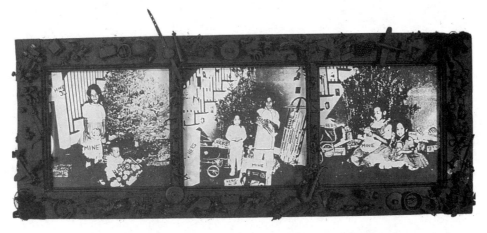

Pat Ward Williams
Sibling Rivalry, 1987
Cyanotype, mixed
media
9″ × 23″

5. Ask students to consider the purposes of family photos and
videos, both private and public:

a. Under what circumstances are family photos brought out? To
whom are they shown? (Relatives? Friends? Strangers?)

b. In showing others these personal images, what are we saying
about ourselves?

6. Show students a selection of works in which artists have used
photographs of their own families, including the artworks listed at the
beginning of this lesson.

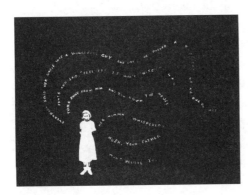

Clarissa Sligh
Wonderful Uncle, 1988
Van Dyke Brown print
11″ × 14″

Briefly survey all the images, then go
back and have students look closely at
each one. Have students identify the
subject matter and discuss how the
incorporation of written texts affects
the meaning of each. (If you choose to
show *Wonderful Uncle* by **Clarissa Sligh**
and *Untitled* by **David Wojnarowicz,**
you may want to invite appropriate
school staff members to answer ques-
tions or address concerns about incest
and homosexuality, topics that are
dealt with in these works.) Ask students
how these photos compare with the
kind of snapshots they have taken of their own families. Discuss
ways in which these photos publicly address issues that are often
considered private. Ask students what value there is in making such
"private" matters public.

Assignment:

Divide the class into two groups. Over a one-week period, have
one group keep a written journal of family events. Have the second

Recasting the Family

Lesson 11: **Picturing the Family**

group photograph family events. Compare the two groups' work the following week. Have students consider how the written and photographic records revealed different kinds of information about the families. (For example, ask students which form lent itself better to recording intimate information, or conflicts.)

Project:

Have students use their written journals and photographs as the basis for real-life or "alternative" family albums. The objective is to create a representation of family life that includes experiences and normal daily events that are typically omitted from family albums.

Suggest that the camera be put in the hands of family members who are not normally asked or allowed to take the family snapshots (a younger sibling, or a grandmother, for example), in order to include perspectives of people who may not ordinarily be heard from. Students might photograph cooking, cleaning, arguing, studying or illness, or take pictures in places in which the family spends time but are not usually seen in the family album. Give students the option of combining written stories or short captions with photographic images. The albums might be serious or humorous. If students do not have access to cameras the lesson may be adapted by modifying xerox copies of existing family photos by the inclusion of written texts. Review *What's Happenin' with Momma?* by Clarissa Sligh as a possible model.

Have students share their albums with the class, bringing in their family's own albums, if possible, for comparison. Have students consider similarities and differences, which kind of album tells more about their families, and which album they prefer.

Evaluation:

Assess whether students understand the public and social role of "private" family images. Were students able to "read" different types of information in their family photographs, such as hierarchy within the family? Were they able to pick up on the highly standardized content of family photos and hypothesize some of the underlying sociological reasons for this?

Lesson 12: Norms and Family Structure: Defining the Ideal Family

Time: 2 classes

Objectives:
a. Students will critically examine norms and ideals in family structure, including analysis of where these ideas come from.
b. Students will create a definition of family.

Suggested Procedures:

1. Present students with the following statements:

A normal family owns a home.
A normal family lives in an apartment.
A normal family is homeless.

Ask students if they think any of these statements seem more true than the others.

Continue by discussing the following sets of statements:

A perfect family is rich.
A perfect family is middle class.
A perfect family is poor.

A normal family is rich.
A normal family is middle class.
A normal family is poor.

A perfect family is Asian.
A perfect family is black.
A perfect family is white.
A perfect family is Native American.
A perfect family is Latin American.
A perfect family is ethnically mixed.

Ideally, a family consists of two parents and two children.
Ideally, a family consists of one parent and two children.
Ideally, a family consists of two parents and five children.
Ideally, in a two-parent family, the father goes to work and the mother stays home with the children.
Ideally, in a two-parent family, the mother goes to work and the father stays home with the children.

It is normal for a woman who is also a mother to work outside the home.
Ideally, a woman who is a mother stays home to raise her children.

Have students explain why they find some of these statements more accurate than others.

Ask students:

a. What is a "normal" family?

b. What is an "ideal" family?

c. Do people of different economic backgrounds have different family ideals?

d. How does your own family compare to your definition of a perfect family? A normal family?

Ask students where their idea of what is normal comes from, for example, parents, teacher/school, television and movies, church, books, or friends.

2. Make a list of characteristics which define a "family." Encourage students to consider a wide range of living arrangements such as a single person living alone, an unmarried couple (heterosexual or homosexual), the presence or absence of children or "extended family" members such as grandparents, aunts, uncles and cousins, living with foster parents or adoptive parents, or with other people who are not related by blood. Was there a consensus among students in defining "family"? Were several definitions of family structure considered valid, or was there one preferred definition?

3. Point out that there can be conflicts between people living in certain kinds of families and the court system, schools, churches, or other social institutions. Discuss who ultimately decides what a family is or is not. (These questions are examined again in lesson 16 on legal definitions of family.)

4. Inform students that according to the 1990 census, 74% of U.S. families do not live in a "nuclear" family household, defined as married-couple families with children under 18 years of age. Only 4% to 7% of U.S. families fit the idealized family structure of "father working, mother at home with two children," thereby leaving 93% to 96% of U.S. families outside the "ideal." Even in 1955 only 23% of all households conformed with this structure.[2] Ask students:

a. Do you think people who do not live in traditional "nuclear" family structures are criticized, made to feel abnormal, different, or deprived? If so, how and by whom?

b. Why do some people defend the nuclear family as the preferred family form?

c. What impact do imposed unrealistic family ideals have on us?

5. For homework, have students find headlines in magazines and newspapers that refer to the family and identify what norms and ideals these headlines imply. For example, a *Newsweek* magazine cover from August 30, 1993, reads: "A World Without Fathers: The Struggle to Save the Black Family." This headline implies that a household without a father is not a family. The use of the words "struggle" and "save" convey a negative image of fatherless households, while reinforcing negative stereotypes of African Americans.

6. Have students share their findings with each other in class and discuss the impact of the mass media's language on how they view themselves and the groups to which the headlines refer.

Note: Teachers may wish to read the chapter entitled "The Aberrant Fifties" in Sylvia Ann Hewlett's *A Lesser Life, The Myth of Women's Liberation in America* (New York: William Morrow, 1986) for background information. Also see a report available through the Population Reference Bureau called "New Realities of the American Family" by Dennis Ahlburg and Carol DeVita. Write to the PRB at 1875 Connecticut Avenue NW, Suite 520, Washington, D.C. 20009. This is particularly useful for discussing population statistics and questions of government policy.

Evaluation:

Through students' contributions to class discussion, assess their understanding of the diversity of family structures. Are students able to distinguish between the ideal and reality? Do they understand why certain kinds of families are accepted by society and others are not? Were students able to identify and analyze biased language in mass media in their class presentations of newspaper and magazine selections?

❓ **Objectives:**

a. Students will discuss norms and values relating to childbearing.

b. Students will discuss attitudes of young females and males about childbearing and childrearing responsibilities of each parent.

c. Students will analyze to what extent ideas about having children and family size are determined by "outside" forces or societal expectations.

☑ **Resources:**

The Birth of a Candy Bar, 1988 (28 minutes), produced by the I-Eye-I Video Workshop at the Henry Street Settlement with Branda Miller. Available through Video Data Bank (see Part 5) or Electronic Arts Intermix, 536 Broadway, New York, NY 10012. Telephone: (212) 966-4605.

Suggested Procedures:

1. Ask students:

a. What does a norm of two children (if indeed students accept this as the norm) imply about families with four or seven or twelve children?

b. Is there a belief in the United States that people shouldn't have several children? How many children is it acceptable to have? How did you arrive at this number?

c. Where does the two-children ideal come from? Is this ideal operative across ethnic and racial and geographic differences?

2. Note any variation in students' responses based on cultural differences or geography. Are different values expressed about family size in a rural community versus a large city? Review answers and ideas offered by students, and if clear norms or biases emerge, help the students determine what the deviations from the norm might signify. (For example, if the majority of students believe it is unacceptable to have ten children, ask where this value comes from and what it means.)

3. Ask students:

a. Should all married couples have children if they are physically able? Why or why not?

b. Should all women have children sometime in their life? Why or why not?

c. Should all women want or try to get married? Should all men want or try to get married?

d. Are women who have no desire to get married and/or have children abnormal? Unfeminine?

e. Are men who don't want to marry or become fathers abnormal? Unmasculine? Is it acceptable for women to have children without being married? How about fatherhood without marriage? Are standards and expectations regarding marriage and children for men and women the same or different? Why?

4. Ask students how many of them want to get married? Have children? How many? Are there divergent opinions? Are there differences in student responses to the above questions about women and men? If so, are they based on students' gender? Cultural background?

Other factors? To what extent do students feel they have a choice in these decisions? If almost all respond the same way, yet all feel they have total control over marriage and childbearing decisions, ask them to reconsider whether their choices are really free. If students cite a traditional family structure as the ideal, ask them to define what is preferable about this structure. Are students' definitions of ideal family different in this lesson than in earlier lessons where the questions was asked in a different context?

5. Inform students that 1 in 4 babies in the U.S. today is born to an unmarried mother (compared to 1 in 10 in 1970). The number of unmarried American women with at least one child is 24% according to a Census Bureau study in 1993.[3] Ask students what social or economic forces they think are responsible for the rise in single motherhood, which, still rising among black women, is increasing most rapidly among highly educated and white women.

6. View *The Birth of a Candy Bar,* a videotape about teen pregnancy produced by artist Branda Miller in collaboration with teens from New York City's Henry Street Settlement, in order to stimulate discussion about teen pregnancy. What were the main messages in this video?

7. Ask students:

a. How do you feel about teen pregnancy? Do you approve or disapprove?

b. Is teen pregnancy primarily the female's responsibility? What is the role of the teenage father?

c. How are pregnant teens and teenage parents viewed by adults? By society at large?

d. Why are there more pregnant teens today than 20 or 30 years ago?

e. How are pregnant teens represented in the media, including newspapers, television, and movies? For teens who are parents, do they feel these portrayals are accurate?

f. How would teen mothers represent themselves to the world through the mass media if given the opportunity?

8. Ask:

a. What kinds of adaptations in families have been made necessary by the increased number of teenage mothers? Are these changes positive, negative, or neutral?

b. What kinds of families do you think will be prevalent in the future?

Evaluation:

Do students have a better understanding of the origins of and variations in societal beliefs about family size, children, and childbearing decisions? Are students able to distinguish between their personal beliefs and societal expectations regarding these issues?

Lesson 14: **Reproductive Rights**

Time: 2–3 classes

Objective:
Students will explore ethical issues and conflicts emerging out of the development of new reproductive technologies.

Resources:
(Optional) *Born to be Sold: Martha Rosler Reads the Strange Case of Baby M,* 1988 (35 minutes), co-produced by Martha Rosler and Paper Tiger TV. Available through Video Data Bank (see Part 5) and Electronic Arts Intermix, 536 Broadway, New York, NY 10012. Telephone: (212) 966-4605.

Equipment:
Video monitor or TV and VCR.

Suggested Procedures:

1. Ask students whether or not they would like to have children. Discuss how many children each student would like to have and at what age they would ideally like to have them.

2. Ask students how they might feel and what they would do if they or their girlfriend had an unplanned pregnancy. For students who answer they would keep the baby, ask them to respond to the concerns raised in *The Birth of a Candy Bar.* For those who would opt not to continue the pregnancy, ask why. Ask students:

 a. Should abortion be legally available to all women, regardless of age or economic background?

 b. Should parental notification or permission be required if the patient is a minor?

 c. Should the government pay for abortions for anyone who cannot afford it?

 d. Is abortion a government issue? A religious issue? A personal issue? A family issue?

3. Ask, conversely, what would they do if they wanted children, but could not conceive. Explain the concept of surrogate pregnancy. Ask students if women or couples who cannot conceive should be able to legally contract with a surrogate mother to bear a child for them in exchange for money.

 a. Should surrogate motherhood be allowed, even if babies are available for adoption?

 b. Should surrogate mothers be paid for carrying the child above the medical costs of carrying and delivering the child?

 c. What rights should the biological mother have over her child after she has given custody to the couple she contracted with?

 d. If a man donates sperm or physically impregnates someone as a surrogate father, should his rights, if any, be similar to those of a surrogate mother? Does the fact that she carries the child for nine months make any difference?

4. (Optional) Show students the videotape by Martha Rosler and Paper Tiger TV entitled *Born to Be Sold: Martha Rosler Reads the*

Strange Case of Baby M and discuss the issues of race, class, and gender that Rosler raises about surrogacy.

Assignment:

Do a research project on the case of Baby M in New Jersey, or on any other cases about surrogate parenting; or research the history of surrogacy law in your state. As you do your research, focus on learning about the perspective of one of the following:

- women who have been surrogate mothers
- parents who have hired surrogate mothers
- scientists (they can be either in favor of or against surrogate parenting)
- children who are born to surrogate mothers

Have the students choose and debate any question covered in this lesson, from the perspective of the group they represented in their research and then from their own perspective.

Project:

Have students create visual representations of the issues, in the form of graphically designed posters presenting their political and ethical viewpoints. To give students some visual ideas, look at the work of the **Guerrilla Girls, Gran Fury, Melissa Antonow,** and **Keith Haring**'s mural "Crack is Wack."

Evaluation:

Do students have a thorough understanding of the ethical, personal and legal considerations of surrogacy? Do they understand the abortion debate from these positions as well? Were they able to effectively and persuasively articulate their opinions in a graphic or visual form?

Lesson 15: Family as a Social Institution

Time: 2 classes

Objectives:
a. Students will examine different functions of the family and different members' roles within the family.
b. Students will discuss the role of government and schools in promoting certain family structures and values.

Resources:
Slides:
Gran Fury: *Welcome to America* (p. 67)
Richard Hill: *My Grandmother (Charlotte Hill), My Son Randy* (pp. 74, 75)
David Wojnarowicz: *Untitled* (p. 272)

Book:
Optional background reading for teachers: Sylvia Ann Hewlett, *A Lesser Life, The Myth of Women's Liberation in America* (New York: William Morrow, 1986), chapters 4 and 10.

Suggested Procedures:

1. Ask students what they think is the role of the family in society. Do we typically view the family as an economic unit? A religious unit? A stable environment for reproducing the species (i.e. a biological function)? A means for the wealthy to preserve and protect their wealth (i.e. a socioeconomic or political function)? A structure which fulfills basic human emotional needs (i.e. a psychological function)?

If students arrive at answers indicating that families serve several functions, ask them to try to prioritize these based on which they feel is the most important.

2. Ask the students to describe the roles of individual family members within this scheme. For example, what are the responsibilities of the mother? Should fathers stay home and raise children? Why or why not? Should children work and bring money home to help support the family if it's needed? If so, at what age should they begin working?

3. Show slides of **Richard Hill**'s *My Grandmother (Charlotte Hill)* and *My Son Randy*. Do Hill's narratives about his father represent an idealized family or real families? Ask students:

a. What kinds of social values are implied in the "working father, housewife, two kids" ideal?
What does this tell us about the role of women, and mothers, in society? What is the role of men, and fathers, according to this ideal structure?

b. Does the "breadwinner" of the family have more decision-making power than the other family members? If both parents or partners work, do they tend to have equal power or influence in the family? Should they? Does it depend on who earns the most? If children work to support the family, do they gain in power to make family decisions? Should they?

For background related to the following, read Hewlett's Chapter 4, "The Wage Gap" and Chapter 10, "Ultradomesticity: The Return to Hearth and Home."

4. Ask students to describe their ideal family, and their own role within it. What factors in society, and what circumstances in their real family lives, make this ideal family improbable?

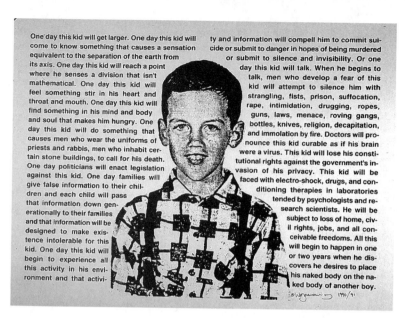

One day this kid will get larger. One day this kid will come to know something that causes a sensation equivalent to the separation of the earth from its axis. One day this kid will reach a point where he senses a division that isn't mathematical. One day this kid will feel something stir in his heart and throat and mouth. One day this kid will find something in his mind and body and soul that makes him hungry. One day this kid will do something that causes men who wear the uniforms of priests and rabbis, men who inhabit certain stone buildings, to call for his death. One day politicians will enact legislation against this kid. One day families will give false information to their children and each child will pass that information down generationally to their families and that information will be designed to make existence intolerable for this kid. One day this kid will begin to experience all this activity in his environment and that activity and information will compel him to commit suicide or submit to danger in hopes of being murdered or submit to silence and invisibility. Or one day this kid will talk. When he begins to talk, men who develop a fear of this kid will attempt to silence him with strangling, fists, prison, suffocation, rape, intimidation, drugging, ropes, guns, laws, menace, roving gangs, bottles, knives, religion, decapitation, and immolation by fire. Doctors will pronounce this kid curable as if his brain were a virus. This kid will lose his constitutional rights against the government's invasion of his privacy. This kid will be faced with electro-shock, drugs, and conditioning therapies in laboratories tended by psychologists and research scientists. He will be subject to loss of home, civil rights, jobs, and all conceivable freedoms. All this will begin to happen in one or two years when he discovers he desires to place his naked body on the naked body of another boy.

David Wojnarowicz
Untitled, 1990
photo stat
30" × 40"

5. Have students consider the interrelationship between families and other social institutions and the roles of these institutions in shaping family life. Ask students if they think the government favors one kind of family over another. Do political parties have viewpoints on family structure? (For example, do conservative politicians favor a particular family formation? If so, what kind and why? Do liberal or progressive politicians favor a particular family formation? If not, why?)

6. Show the slide of *Welcome to America* by Gran Fury. Inform students that about 34 million Americans are not covered by health insurance, including 10.6 million women and 11 million children.[4] Ask students how the lack of available health care might weaken family ties. How about the lack of adequate daycare? Inform students that less than 2% of private companies and 9% of government agencies offer employer-sponsored daycare.[5]

Teachers, for additional background information read anthropologist Carol Stack's study "All Our Kin" for an analysis of how government welfare policies have affected black families.

7. Have students discuss the role of family in relation to the functions of schools. Ask students:
 a. What are some of the overlapping responsibilities of families and schools?
 b. What conflicts might there be between these two institutions?

8. Show Wojnarowicz's *Untitled* self-portrait and have students read the text. Discuss the role of the educational system in promoting or discouraging different family structures. Ask students:

 a. Should teachers be prohibited from discussing the existence of diverse family structures, including homosexual ones, in the classroom? Why or why not?

 b. Should religious views of the family be discussed in school? Why or why not?

 c. Who should decide what is taught about family and how? Parents? Students? School administrators?

9. Ask students to summarize the different interests in, and pressures on, the family from government and other societal institutions. Do students perceive any conflicts between what they desire and what their families and the government or other institutions want them to be?

Assignment:

Ask students to formulate their own definition of "family values." Have them specify what kind of family or families they prefer, the roles of the various family members, and what they expect their family to provide. They might also include what role government should play in the family (regulating or helping) and what role churches, schools, businesses, or other organizations should play.

Evaluation:

Were students able to identify multiple functions of and in the family? Were they able to identify ways in which institutions such as government directly affect family structures and family life?

Time: 1 class

Objective:
Students will examine how
the definition of the family is
shaped and regulated by gov-
ernmental institutions.

Resources:
Dictionaries

Lesson 16: **Changing Legal Definitions
of the Family**

Suggested Procedures:

1. Ask students to bring to class a dictionary definition of family.
Encourage students to try to draw from as wide a variety of dictionar-
ies as possible. For example, a definition of the family from an early
twentieth-century dictionary might have included servants. If students
have non-English dictionaries at home, ask them to look up "family"
and bring in the definitions; can any cultural differences be discerned?
You may wish to supplement definitions gathered by students with
ones you gather from a wide historical or geographical range of
sources.

2. Read students the following excerpt from an article printed in
The New York Times on November 9, 1989, on changes in the legal
definition of "family" designed to protect unrelated household
members from housing evictions in the event of death of the lease-
holder or separation:

> "New York Housing Officials
> Redefine Family to Block Evictions"

> ... The new law essentially gives tenants living in certain
> types of nontraditional families the same rights as tradi-
> tional family members. New York's Housing Commissioner
> was quoted as saying, "We must assure that nontraditional
> family members of tenants, especially those most vulnera-
> ble such as the elderly, disabled and persons infected with
> the AIDS virus, are not unfairly subject to eviction."

> A broad range of people would be affected by the new
> rules, including many poor and elderly people who often
> form nontraditional households out of economic and
> social need.

The "nonfamily" households in question constitute 29% of all U.S.
households.[6]

Landlords opposed the new rules. One lobbyist for landlords was
quoted in the *New York Times* article as saying, "The government is
basically saying that property owners must bear the brunt of the

societal question of what is family." In this instance, the conflicting interests of tenants and property owners were legally framed as an issue of defining family. Ask students if they would typically expect that a battle to define "family" would be fought between property owners and tenants? Why or why not?

3. Inform students of another governmental decision in which New York City adopted a more flexible definition of family by changing its bereavement policy to give unmarried employees the same right as married employees to paid leave after the death of a partner. Ask students what role cities or officials play in deciding what a family is.

4. Inform students that some states permit same-sex marriage or legal domestic partnership for gay couples, while others do not. As of 1993, forty-eight states allow adoptions by partners of the same sex, pointing to the fact that different types of family arrangements are legal in different states and cities. Ask students:
 a. Should it be up to the state or any government body to decide who can or cannot be married?
 b. Should homosexual couples be able to legally get married if they wish?
 c. Should they be able to adopt children, or have children?
 d. Do homosexual couples who would like to marry constitute a real family? If they have children (either with the participation of friends, artificial insemination, or from previous heterosexual relationships) or adopt, does this make a difference whether they are a family or not?

5. Ask students:
 • Do courts or other government agencies' rules affect what kinds of families are acceptable in society?
 • Are they responding to changing family structures, or shaping them?
 • Do family laws always lag behind social realities?
 • Why are there different laws about family in different states?

Recasting the Family

Lesson 16: **Changing Legal Definitions of the Family**

Assignment:

Ask students to research laws pertaining to family. Assign each student a different state to research. Share findings and discuss possible reasons for differences in state laws on the same family-related issue. Do the differences mean that people living in different parts of the United States have different beliefs about the family?

Evaluation:

Assess whether students understand that the definition of family is not fixed. Assess students' comprehension of the ways in which government and the legal system affect the way real families live.

Lesson 17: **Images of the Family in TV and Print Media**

Time: 3 classes plus project (additional 3–6 weeks)

Objectives:
a. Students will examine the roles of television and advertising in sustaining the myth of the traditional family.
b. Students will learn how the media have responded to changes in actual family structures.
c. Students will examine race, class, and gender representation on television.
d. Students will produce their own video/TV program which accurately portrays their idea and experiences of family.
e. Students will work cooperatively.

Resources:
Film:
Color Adjustment, 1986 (86 minutes), produced by Vivien Kleinman and Marlon Riggs. Directed by Marlon Riggs. Distributed by California Newsreel.

Equipment:
Video camera (optional); video monitor and deck.

Materials:
Sketch pads; colored markers or pencils; blank videotape.

Suggested Procedures:

1. Ask students to name all the television programs they can think of that portray families. Ask students which of these portray "ideal" families and which portray "alternative" families.

2. For homework, have students watch television, looking closely at a variety of programs and commercials for patterns that can be discerned in the ways in which families are portrayed.* Have them consider the following questions:

a. What are the characteristics of the types of families seen most frequently? Consider such factors as economic and social class, racial and ethnic identity, age, gender, and sexual orientation.

b. What stereotypes can be observed? For example, female characters as docile (subservient, sexy, and silly) or manipulative (selfish, materialistic, and sexually voracious).

c. Are male and female characters stereotyped equally frequently?

d. In cases where the old stereotypes have been broken, have new ones replaced them? What kinds?

3. Have the students report on their findings. Compare students' findings with the statistic that only about 5% of all families consist of working husband, housewife, and schoolage kids. Have students discuss the media's responsibility to reflect the broad spectrum of people who comprise the U.S. population and the impact of limiting or stereotyping identities.

4. Show the documentary, or excerpts from, *Color Adjustment* (86 minutes) by Marlon Riggs for a history of the portrayal of African Americans on television, including a critique of both "negative" and "positive" images.

Assignment:

Have students choose and watch one category of the following types of TV programs: sitcoms, dramas, cartoons, news programs,

Note: At the time of this writing there are no Latino or Native American families portrayed on network prime time "family" programs. The first program featuring an Asian family, "All American Girl," debuted in 1994.

commercials. Identify and write down family structures and portraits of main characters. Identify for each character gender, age, economic and social class, physical and intellectual characteristics, racial or ethnic background, jobs or responsibilities, how and where the character lives. Design a large grid containing all the variables. Have each student plug in his or her own data and determine as a class if any particular kind of family portrait emerges. This activity can also be done with comic strips.

Class Project: Video Production

1. Divide the class into groups of 4 to 7 each. Have each group select a television format (e.g., soap opera, documentary, situation comedy, news program).

2. Have each student create a basic story idea, including plot, characters, location, time period (historical or contemporary), keeping in mind that the objective is to portray families in an accurate and if necessary, different, way than mainstream TV or movies.

3. Have each student present his or her idea to the whole class, then to his or her group. Each group will choose which story idea they will produce, adopting one student's idea or combining elements of several students' ideas. Depending on the availability of video equipment and the desired scale of the project, have each group produce a video based on their favorite idea or have the whole class work on a single idea, in which case the class should decide by consensus which idea to develop and produce.

4. If the whole class is working together on one tape, decide which students will handle each of the following responsibilities. If each of the small groups is producing its own tape, the responsibilities can be handled by individual students. In either case, students should choose which tasks they will work on:
 a. Writing the script and creating storyboards (visual sketches, scene by scene);
 b. Choosing the locations where videotaping will be done (including obtaining permission to shoot wherever necessary, whether inside or outside the school);

c. Deciding what kind of props and costumes are needed;

d. Creating or finding costumes and props;

e. Casting the actors for each role (if possible, involve family or community members suitable for the roles. For example, if you have scripted a role for a grandmother, an older person might be invited to play the part);

f. Doing the camera work and taking charge of the shooting;

g. Coordinating the production logistics (including location, props, actors, script, and make-up).

5. After completing videotaping, groups should work together to view and review footage and make editing decisions. Editing can be done by designated students or by the group as a whole.

6. Plan a schoolwide screening, perhaps as an evening event, inviting students, teachers, families, and friends.

Evaluation:

Compare students' work to actual TV and comic strip representation of families and evaluate students' ability to create or identify representations that successfully critique standardized, stereotyped representations.

Note: Resources are available for teachers who would like to learn video editing skills. (In New York City, for example, Educational Video Center, listed in Part 5.) Community-based film and video organizations often provide free or low-cost training and provide access to editing facilities at a low hourly cost

Recasting the Family

Note

1. In: Richard Chalfen, *Snapshot Versions of Life,* Bowling Green, OH: Bowling Green State University Press, 1987, p.15.
2. *Washington Post,* July 26, 1987, B5.
3. Statistics from U.S. Census Bureau report released in July 1993 quoted in "Husbands No, Babies Yes" by Jean Seligman with Kendall Hamilton, *Newsweek,* July 26, 1993, p. 53.
4. Karen DeWitt, "Bigger Business Role Urged in Prenatal and Maternal Care" in *The New York Times,* May 1, 1992.
5. Paula Ries and Anne J. Stone, eds. *The American Woman 1992–93,* (New York: W.W. Norton & Co., 1992).
6. *Monthly News from the U.S. Bureau of the Census,* vol. 26, no. 2, February 1991, p.3.

AIDS and Its Representation

Simon Leung

The primary purpose of these lessons is to provide a context for the discussion of AIDS and its related social issues. This discussion is meant to allow you to introduce facts about AIDS, correct misconceptions about AIDS and the people afflicted by it, and to communicate to students how one's attitudes toward AIDS are bound up in its representations and are thus largely shaped by them. These lessons are not meant to be a substitute for a course on safer-sex practices. However, it is very important that you yourself become very familiar with the most up-to-date guidelines for safer sex and the basic medical facts about AIDS before teaching this course, as many questions about safer-sex will arise during the course of these lessons. An excellent information source is the paperback *What You Can Do To Avoid AIDS* by Earvin "Magic" Johnson (New York: Random House, 1992), written in a clear prose style partially targeted toward teens. Another good source is "Medical Answers about AIDS" published by Gay Men's Health Crisis (GMHC) in New York. An excellent information resource for teens is the video tape *It Is What It Is,* also available through GMHC, which addresses teen sexual identity and AIDS prevention. Medical information on AIDS and HIV is continually being updated. Please request the most recent information before sharing it with your class.

Subject Areas: *Art, Language Arts, Social Studies, Health, Media Studies*

9 Lessons (21–24 classes)

Objectives:

a. Students will learn to distinguish between myths and facts about AIDS.

b. Students will explore how attitudes toward AIDS are bound up in its representations.

c. Students will see how artists and filmmakers have approached the subject of AIDS.

d. Students will understand how institutionalized sexism, racism, and language biases affect access to information on AIDS prevention and health care.

e. Students will see how people with AIDS have chosen to represent themselves as people "thriving with AIDS" rather than "dying from AIDS."

f. Students will recognize the need for equal access to healthcare and AIDS prevention information.

g. Students will appreciate their own potential to participate in AIDS education.

Objectives:

a. Students will explore their attitudes toward AIDS and People with AIDS.

b. Students will learn to distinguish between myths and facts about the disease.

Lesson 18: **Myths and Facts about AIDS**

Suggested Procedures:

1. Ask students to describe their attitudes toward AIDS and People with AIDS:

 a. When you think of someone with AIDS, what is the face you see?

 b. Do you remember how you felt when you first learned about AIDS?

 c. Have your attitudes towards AIDS changed since you first heard of the disease?

2. Ask students to explain the difference between being HIV-positive and having AIDS. Make sure they understand that being HIV-positive and having AIDS are not the same thing. Being HIV-positive means that one shows antibodies to the human immunodeficiency virus (HIV) in a blood test. HIV is believed to cause AIDS, although some members of the medical community believe HIV to be a factor, and not the cause. "Having" AIDS, as defined by the current medical establishment, means being HIV-positive and having a breakdown of the body's immune system due to an opportunistic infection associated with AIDS. Not everyone who tests positive for HIV develops AIDS. Although AIDS is generally viewed as a "life-threatening" disease, some people have been living with AIDS for more than ten years.

3. Make a clear distinction between "high-risk behavior," which is conducive to HIV infection, and "high-risk group," which is a myth because no group is immune from getting AIDS. Ask students what it means to be "at risk." Make a list of "at-risk" practices, such as being sexually active without barrier methods, sharing needles, or coming into contact with another person's bodily fluids which contain blood.* Should students offer incorrect responses, start a second list of practices that do not put one at risk and explain why they do not. For example, kissing does not put one at risk since it does not entail the exchange of body fluids containing blood. Use these lists to dispel myths that AIDS is something which happens only to certain "others" such as gay men, drug users, or the poor.

*Note: There are "body fluids" that are not "transmission fluids," such as saliva.

AIDS and Its Representation

4. Have students discuss how they reacted when Magic Johnson revealed that he was HIV-positive. Ask students if they think it was important for him to make this revelation. If so, important for whom? Do they think revealing oneself to be HIV-positive or to have AIDS is now less of a stigma due to his revelation?

5. Ask students to consider whether or not discussing and learning about AIDS can help prevent one from getting the disease. Have them consider what some of the barriers are to such discussions.

6. For the remaining ten minutes of the class, ask each student to make a list of five myths about AIDS and five facts about AIDS. The list can be based on what was discussed in class or what they know personally about the disease, such as personal experience or information not covered in class. Collect for evaluation.

Evaluation:

Assess students' knowledge about AIDS based on the discussion. Assess students' attitudes towards AIDS and AIDS education.

Objectives:

a. Students will analyze artistic strategies used to disseminate information about AIDS.

b. Students will learn how institutionalized sexism, racism, and language biases affect access to AIDS information and healthcare.

c. Students will understand and discuss how different AIDS communities have different needs.

d. Students will appreciate their own potential to participate in AIDS education.

Resources:

Artists' statement:
Gran Fury

Slides:
Gran Fury: *Women Don't Get AIDS* (p. 284)

Books:
Earvin "Magic" Johnson, *What You Can Do To Avoid AIDS.* (New York: Random House, 1992).
ACT UP New York Women and AIDS Book Group, *Women, AIDS & Activism.* (Boston: South End Press, 1990).

Lesson 19: **Targeting Communities with AIDS Education**

Suggested Procedures:

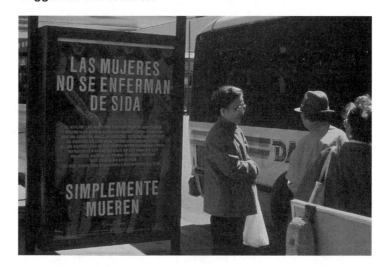

Gran Fury
Women Don't Get AIDS, They Just Die From It,
January 1991
Offset lithography
Busboard ad and poster

1. Have students read the artist's statement by **Gran Fury** and show the slide of *Women Don't Get AIDS.* Ask students to discuss preconceptions about women and AIDS:

a. Do you usually associate AIDS with women? Why? Who do you usually associate AIDS with? Why? Are these associations accurate?

b. Women obviously "get AIDS." Why did the artists phrase this poster in this way?

c. Since people with AIDS suffer a great deal of discrimination, why does Gran Fury want to expand the definition of AIDS?

2. Discuss with students how AIDS is manifested in men, women, and children differently. Inform students that many of the illnesses women suffer associated with AIDS, such as cervical cancer, were not defined as such by the Centers for Disease Control (CDC) until recently due to lack of research statistics. Consequently women were generally diagnosed with AIDS at a more advanced stage and thus lived significantly shorter periods after being diagnosed and had a slimmer chance for survival. Many women were diagnosed with AIDS only after they had died.

3. Explain to students that the Centers for Disease Control and Prevention (CDC) is a division of the Department of Health and Human Services and is the main governmental agency which collects data on disease in the United States. A large part of its function is the study of epidemics using information local health departments have reported. The CDC uses this information to generate statistics and preventive measures to contain the spread of diseases. Ask students to consider gender and cultural biases in efforts to study, treat, and prevent AIDS:

a. What do you think it took for the CDC to expand the definition of AIDS for women?

b. Why did Gran Fury make the same poster in two languages?

c. Do you think health care information should be disseminated in as many languages as possible? What are some of the barriers to such an approach?

d. Do you think art in public spaces should address its audience in as many languages as possible? Why or why not?

4. Review the following portion of Gran Fury's statement and ask students to consider why a mostly gay, white, and male art group would make a poster about women and AIDS in Spanish:

> Many of Gran Fury's members are gay, many of us are male, many of us are white. Not all of us are artists. All of us have felt our lives affected by the AIDS epidemic, which has led to our activism.

5. Discuss with the class all the various groups which are affected differently by AIDS, such as women, drug users, teenagers, children, and different ethnic and language groups. Include groups in which the students feel they themselves belong based on their age groups, neighborhoods, cultural backgrounds and so forth. You may wish to screen *Think About It ... It's Up to You* by Louis E. Perego. A portion of this videotape features portraits of two young adults who have been diagnosed as being HIV-positive.

Film and Video:
Absolutely Positive, (27 minutes, 1990). Directed by Peter Adair.

Think About It ... It's Up to You (26 minutes, 1994). Produced by Louis E. Perego, Skyline Community. Available through: Skyline Community, P.O. Box 1203, Old Chelsea Station, New York, NY 10113-1203. Telephone: (212) 686-7030.

Equipment:
Slide projector and screen; poster size paper, paint or marker.

After naming each group, together as a class also discuss:

a. What are the special needs of each of these groups in regards to AIDS education?

b. What are the obstacles to AIDS education particular to each community?

c. What styles of language and/or images would each group be most responsive to in AIDS education?

6. Ask each student to choose one category which had been named and discussed and make an AIDS-awareness poster for that group by representing information about how AIDS affects this particular community. This assignment can function as a homework assignment or a follow-up class. For further research on specific communities affected by AIDS, see *What You Can Do To Avoid AIDS* and *Women, AIDS & Activism*.

7. Have class discuss the finished projects.

Evaluation:

Assess students' understanding of how AIDS affects different communities. Assess students' attitudes towards AIDS education in communities with which they are not familiar. Assess students' posters to determine how much they understand the purposes and goals of public posters on AIDS. Assess the accuracy of students' information on their posters.

Lesson 20: **Terminologies and the Power of Naming**

⏱ **Time:** 1–2 classes

❓ **Objectives:**
a. Students will understand how language has been used to manipulate public perceptions of the AIDS pandemic.
b. Students will explore terminology of empowerment rather than victimization.

✔ **Resources:**
Book:
George M. Carter, "ACT UP, The AIDS War and Activism." (*Open Magazine,* Pamphlet Series).

Videotape:
Absolutely Positive (27 min., 1990). Produced and directed by Peter Adair. Distributed by Select Media.

Equipment:
Video monitor and deck.

Suggested Procedures:

1. One AIDS-awareness poster made by **Gran Fury** presents the statements: "All people with AIDS are innocent" and "A virus has no morals." Ask students to discuss the meanings of these phrases and whether or not they agree with them.

2. Some people have used the word "plague" when speaking of AIDS, while other people reject this term because it connotes judgment and retribution of a god. Have students discuss whether or not they think the word "plague" should be used in regards to AIDS. Why or why not?

3. Have the class read and discuss this statement by George M. Carter about the relationship between People with AIDS and their doctors:

> People with AIDS (PWAs) continue to fight the perception, often spread by the media, of being AIDS "victims." This stems in part from the doctor-patient relationship which tacitly presumes that the patient is the victim of a disorder and the doctor is the savior. PWAs more and more act as partners with their health care providers.

4. Ask students if they think the word "victim" emphasizes hope or helplessness? Which feeling do they think would better help a PWA in his or her fight against the disease?

5. Have students discuss how what they are called influences the way they think about themselves or a condition they may be in?

6. Inform students that Gran Fury took its name from the type of car driven by undercover police. Ask students why a group of artists dedicated to stopping AIDS would call themselves "Gran Fury?"

7. Screen *Absolutely Positive* (27 minutes) by Peter Adair, a film in which eleven men and women from diverse racial and cultural backgrounds speak about being HIV-positive and how they are living positively with this condition. While watching, have students jot down statements made by people in the film.

8. Share and discuss these statements after viewing. Ask students what their expectations were of people who were HIV-positive, and how they were similar or different from the way people in the film portrayed themselves. What were the most surprising statements? What is the difference between being HIV-positive and having AIDS? Do the people in this film consider themselves victims? Do they have differing attitudes about their common condition?

9. Ask students to imagine that they are related to or friends with one of the people in the film. Instruct each student to write a letter to this person telling how hearing his or her testimony has affected the student's attitudes toward him or her and the disease. Ask each student to read the letter aloud.

Evaluation:

Assess students' understanding of the importance of different uses of language in representing AIDS. Assess students' understanding of the value of first-person testimony and representation in discussing AIDS. Use students' letters to evaluate their understanding of different ways of acquiring AIDS, and the different kinds of people who are living with HIV and AIDS.

Lesson 21: **Public Dimensions of AIDS**

Suggested Procedures:

1. Show *Women Don't Get AIDS* and *Welcome to America* by **Gran Fury.** Focus a discussion on Gran Fury's work in art/education projects that exist only in a public forum. Tell students that Gran Fury's posters and other works are made only for billboards, bus stops, and other public places. Ask students why they think an artists' group would choose to work in this way.

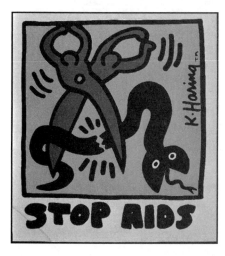

Keith Haring
Stop AIDS, 1989
Sticker

2. Show *Untitled* (subway drawing), *Crack is Wack*, and *Stop AIDS* by **Keith Haring**. These three public works, done in the early, mid and late 1980s, reflect Haring's concerns during different stages in his life. Why do you think Haring—who began his art career by doing drawings in the New York City subways, but then became a very successful gallery artist—would continue to make public art pieces for free? How is his style suited to a street audience?

3. Ask students if they think information about AIDS should be available to the public? If so, who should pay for the dispersal of this information? Who should carry it out? Should this be a combination of public (governmental) and community effort? Why?

4. Inform students that President Reagan who was elected in 1980 did not mention the word "AIDS" in public until 1987, many years into the epidemic. Ask students:

a. Why do you think he waited so long?

b. Do you think President Reagan could have made a difference in preventing more people from contracting AIDS had he addressed this issue earlier?

c. What role should the government play in informing the public about AIDS?

? **Objectives:**

a. Students will examine how AIDS exists in the public discourse.

b. Students will explore how artists use public forums for AIDS activist work.

c. Students will conduct research projects.

d. Students will examine the relationship between AIDS and governmental policies.

✓ **Resources:**

Slides:
Luis Cruz Azaceta: *Babies with AIDS* (p. 290)
Gran Fury: *Women Don't Get AIDS* (p. 284), *Welcome to America* (p. 67)
Keith Haring: *Untitled* (p. 129); *Crack Is Wack* (p. 73); *Stop AIDS* (p. 289)

Films:
Voices from the Front (90 minutes, 1991). Produced by Testing the Limits Collective. Distributed by Frameline.

RSVP (23 minutes, 1991). Directed by Laurie Lynd. Distributed by Frameline.

Equipment:
Slide projector and screen; poster size paper, paint; video monitor and deck (optional); 16mm film projector (optional).

Luis Cruz Azaceta
Babies with AIDS, 1989
Acrylic on canvas
10′ × 10′

5. Show the slide of *Babies with AIDS* by **Luis Cruz Azaceta** and ask students:

a. What does the flag of the United States represent? Why?

b. Who do you think should be responsible for preventing the spread of AIDS? For finding a cure or a vaccine?

6. Inform students that during the early years of the AIDS epidemic, most people afflicted with AIDS in the United States were gay men and intravenous drug users. Today it is a "pandemic," an epidemic which occurs over a wide geographic area and affects everyone. Ask students:

a. Had the disease initially affected people considered to be more in the "mainstream," would public response to AIDS have been different? How so and why?

7. Begin two-part project which will span about one week.

Part one

Have each student write a short research paper (3–5 paragraphs) about what he or she feels is the most important public issue in AIDS, and what he or she feels is the most important personal issue in AIDS. Show students the source books you have used in conducting this course, as well as recent magazine articles which deal with the subject of AIDS. These texts will serve as examples of information sources for research. Since newspaper and magazine articles on AIDS are abundant, there should be an adequate amount of information in the library.

Guide the students' research in the following manner:

a. Help students select an area of concentration (for the "public issue" portion of the essay, this could be medical research, education for children or young adults, immigration policy, or national healthcare).

b. Help students locate books and periodicals which provide information for their research.

c. Help students organize their papers so that they discuss the public dimension first, then the private.

d. (Optional) Show a film related to the assignment during the course of the week. Recommended are: *RSVP* (23 minutes, 1991) by Laurie Lynd, a lyrical film which explores the emotions felt by friends, family and lover of a man who has recently died of AIDS; and *Voices from the Front* (90 minutes, 1991) produced by Testing the Limits Collective, a documentary on AIDS activism in the United States using voices of those directly engaged and affected. (Due to the length and occasionally adult language in this film, it is recommended for older students already experienced in dealing with the theme of AIDS.)

Part two

Have students who have chosen the same or similar topics for the most important public issue in AIDS form small groups. Based on their common focus, ask the students in each group to design a public poster which would communicate these public concerns. Each group will consider the following:

a. What community will this poster address?

b. If there are discrepancies between individual students' information, how will they be reconciled?

c. Where will the poster be displayed?

d. What are the most appropriate languages and images for this poster? (for example, *Crack is Wack* by **Keith Haring** addresses a youth audience both graphically and in its use of slang)

e. How can the students incorporate what they feel to be the most important "personal concerns" in AIDS into this poster? Or should the poster only address public issues? Which focus would make the poster more effective?

After the posters are completed, display the project and discuss the differences between working individually on a research paper and using the information learned to build a collaborative project intended for the public.

AIDS and Its Representation

Lesson 21: **Public Dimensions of AIDS**

Evaluation:

Assess students' understanding of the interconnection between AIDS and governmental policies and actions. Assess students' process of translating research material into collaboration. Assess students' collection and organization of materials. Assess students' ability to connect (or disassociate) public and private issues of AIDS in two different modes of presentation.

Lesson 22: **AIDS and the Art of Memory**

Suggested Procedures:

1. Show students the slides of *Tale of a Thousand Condoms/Mates* and *Vaccine Day Celebration*, a painting in which a couple celebrate the discovery of an AIDS vaccine done in the manner of a nineteenth-century Japanese woodblock print. Point out that Teraoka's paintings look like traditional Japanese woodblock prints which could have been made a hundred years ago, but are actually recent watercolors. Ask students to identify the clues which indicate that these are contemporary paintings (e.g. condoms in *Tale of a Thousand Condoms/Mates*, the blond woman with a modern hair style in *Vaccine Day Celebration*). Also, ask students what they imagine the Japanese characters to say. (They refer to AIDS and condoms as a means to protect themselves.)

Masami Teraoka
Tale of a Thousand Condoms/Mates, 1989
Watercolor on canvas
81 1/2″ × 136″

2. Have students read the artist's statement by **Masami Teraoka** and discuss:

a. In what ways does Teraoka's work "mirror" society?

b. In what ways is AIDS part of the "social and political issues that are undercurrents of changing values?"

c. What responses do you suppose these paintings get from people who are familiar with Ukiyo-e prints? Do you think they would agree that AIDS is an appropriate issue to be dealt with using Ukiyo-e print imagery? Why or why not?

d. What are the connections between how tradition is carried on (as in using traditional Ukiyo-e print forms in contemporary paintings) and how the past is remembered?

e. Do you think Teraoka's paintings suggestion that AIDS is a global phenomenon? Why?

3. Ask students to read **Keith Haring**'s statement and show the slides of Haring's *Untitled* (subway drawing), and *Stop AIDS*, keeping in mind that *Stop AIDS* is produced as a sticker. Discuss:

a. In what ways can *Stop AIDS* be considered another form of graffiti?

Time: 2 classes

Objectives:
a. Students will explore the fact that AIDS is a multi-cultural phenomenon.
b. Students will explore the possibility of using traditional forms when dealing with contemporary issues such as AIDS.
c. Students will learn about the uses and values of memorials

Resources:
Slides:
Keith Haring: *Stop AIDS* (p. 289), *Untitled* (p. 129)
Masami Teraoka: *Tale of a Thousand Condoms/Mates* (p. 293), *Vaccine Day Celebration* (p. 97)

Films:
Common Threads, 79 minutes, by Bill Conturie, Robert Epstein, and Jeffrey Friedman. Telling Pictures Production, 1989. (Winner of the 1989 Academy Awards for Best Documentary)

We Bring a Quilt 30 minutes, by David Thompson. NAMES Project Foundation. Both films available through: NAMES Project Foundation, 310 Townsend Street Suite 310, San Francisco, CA. 94107. Telephone: 1(800) USA-NAME

Books:

The NAMES Project Book of Letters, by Joe Brown, Avon Books, 1992.

The Quilt: Stories from the NAMES Project, by Cindy Ruskin, Pocket Books, 1988.

Equipment:
Slide projector and screen.

b. In what ways are the messages in *Stop AIDS* similar to the message in Teraoka's painting? In what ways are they different?

c. Do you think Haring regards graffiti as a tradition just as Teraoka regards Ukiyo-e prints?

4. Ask students how they think we should memorialize the discovery of an AIDS vaccine, if one is found in the future? Are public memorials inherently different from personal memorials? In what ways are memorials for people who have died of AIDS (e.g., *The NAMES Project Quilt,* candlelight marches) different from the imaginary celebration Teraoka paints in *Vaccine Day Celebration*?

5. Begin the following take-home art project:

Have students portray a *Vaccine Day Celebration* using elements, motifs, and forms from a particular culture, especially encouraging students to consider using images and words from their own culture if the class is culturally or linguistically diverse. Encourage students to use collage and other "found materials" from home, as well as more common art media such as paintings and sketches. While working on this project, ask students to consider the following:

a. How will this memorial explain to the next generation the experience of AIDS in our time?

b. What hero or heroes would you choose to portray the struggle against AIDS?

c. Would this portrayal of celebration be comprised of people in the particular culture from which you've taken the inspiration? Or would people of different races or backgrounds be included in the portrayal (as in Teraoka's painting)?

Students should finish the project at home, bringing it to class for the next discussion.

Note: An appropriate work to look at and discuss is the *Vietnam Veterans Memorial* by **Maya Lin**. Use this work to discuss the following issues concerning the memorial object:

a. What is the relationship between the physical form of the memorial and the ideas the memorial is trying to express?

AIDS and Its Representation

Lesson 22: **AIDS and the Art of Memory**

b. Memorials are usually celebratory and heroic depictions of collective, traumatic, difficult events (such as wars, civil rights struggles, or the death of an important person). The *Vietnam Veterans Memorial* is neither heroic nor celebratory, but is instead a wall which reflects both personal and national mourning. Do you think a similar type of memorial would be appropriate for an AIDS memorial? Why or why not?

6. Discuss students' projects in the following class.

7. (Optional) After the class discussion show *Common Threads,* a film about the *NAMES Project Quilt.* The *NAMES Project Quilt,* inaugurated at the Mall in Washington, D.C., in 1987, has been one of the most visible and powerful memorials to people who have died of AIDS. The quilt is comprised of 3′ × 6′ panels of fabric made by friends, family, and admirers of those who have died.

In addition to discussing the content of the film, you may wish to further explore the following ideas with your class:
 a. Much of the power of the *NAMES Project Quilt* lies in the fact that it is both a personal and collective way to remember loved ones. Is this different from most memorials you can think of?
 b. Is there another memorial you can think of that's similar to the *NAMES Project Quilt?* (e.g., the *Vietnam Veterans Memorial*)
 c. What statement does the *NAMES Project Quilt* make about AIDS? How does the way the quilt is made convey that message?
 d. How does the material used to make the quilt (fabric, clothing, stuffed animals) help convey that message?
 e. What message does the quilt send out to the government about the AIDS crisis? Does it call for change? How so?
 f. What have you learned personally about AIDS through seeing this film?

Evaluation:

Assess students' ability to integrate specific cultural elements with AIDS issues. Assess students' comprehension of the use of monuments of a people's or a community's suffering.

Time: 2 classes

? Objectives:

a. Students will examine the interconnection between institutional discrimination and the politics around AIDS.

b. Students will develop a project which uses the codes of advertising to speak about AIDS.

✓ Resources:

Slides:

Gran Fury:
Kissing Doesn't Kill (p. 296)
Keith Haring: *Ignorance = Fear/ Silence = Death* (p. 297)

Equipment:
Slide projector and screen.

Lesson 23: **Discrimination, Racism, Homophobia, and the Language of Mass Media**

Suggested Procedures:

Introductory note: The work presented in this lesson can effectively introduce the interrelationship between AIDS and discrimination. Your students' initial reactions may be embarrassment or disparagement, and some of their attitudes may not change after one or two classes. However, in frankly and seriously discussing the issues brought up, you will help students question their attitudes toward discrimination and the people depicted in this work.

1. Show the slide of *Kissing Doesn't Kill* by **Gran Fury.** Ask students what is meant by the statement "Kissing doesn't kill: Greed and indifference do"? Ask students:

 a. How are the images of these couples related to AIDS?

 b. Is there a relationship between the fear of homosexuals and the fear of AIDS? Is this fear justified when AIDS is a disease which afflicts all people?

 c. What do the couples depicted have in common? Is this a controversial image? Why or why not?

 d. Why is AIDS a "political crisis" and not just a "medical crisis?"

 e. What are the "political" issues surrounding AIDS?

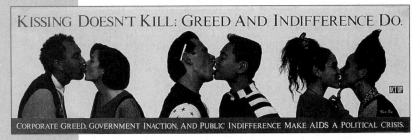

Gran Fury
Kissing Doesn't Kill: Greed and Indifference Do, 1989 Busboard advertisement and poster, offset lithography

2. Point out that *Kissing Doesn't Kill* is a public poster modeled after a Benetton clothing ad. Ask students why they think the artists chose this medium and this "look."

3. Show *Ignorance = Fear/Silence = Death* by **Keith Haring.** Discuss the meaning of the text in the work. Inform the students that this poster was created by Haring for ACT UP, an activist group whose acronym stands for AIDS Coalition to Unleash Power, which since its

AIDS and Its Representation

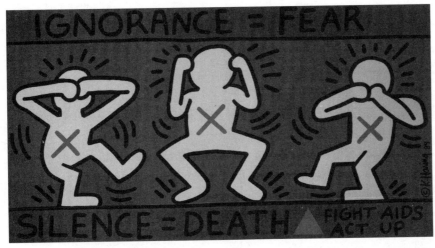

Keith Haring
Ignorance = Fear / Silence = Death,
1989
Poster for ACT UP
20" × 38"

inception in 1987 has been instrumental in increasing governmental attention to and spending on AIDS. The pink triangle along with the words "silence = death" is ACT UP's symbol. The pink triangle was appropriated by ACT UP and other gay and lesbian organizations as a means to reclaim and transform a symbol which was once used by the Nazis in World War II to designate homosexuals in concentration camps. Discuss:

a. What are the connections between the images and the text?

b. What do the pink "x"s represent?

c. Ask students if they know of other groups that were persecuted by the Nazi's during World War II and what symbols were used to mark these other groups.

d. Why would a contemporary activist group like ACT UP want to use the pink triangle as its symbol since it recalls a painful period in history? Do you feel that people who are different (gays/lesbians, People with AIDS, other minorities) are still being persecuted? In what ways?

e. What are the connections between how the pink triangle marks a population which would otherwise be invisible, and how it is difficult to tell if someone has HIV unless they develop visible symptoms of AIDS?

4. Ask students the following questions or use them as the basis for a writing assignment:

AIDS and Its Representation

Lesson 23: **Discrimination, Racism, Homophobia**

a. In what ways do you think society's attitude toward people are shaped by the media? By advertising? How has the media influenced your attitudes toward AIDS?

b. Should free health care be provided to all people regardless of ability to pay? Why or why not?

c. Give specific examples of how your views about mixed-race couples and same-sex couples have been influenced by their representation in movies, television, or advertising? Do you agree with these representations? Why?

d. Explicate the meaning of Haring's piece by writing five sentences each on the phrases "Ignorance = Fear" and "Silence = Death."

5. Have students choose an advertisement from TV or a magazine, take notes on the visuals, timing, and language of the advertisement. Transform the ad into an AIDS education poster like *Kissing Doesn't Kill* or *Ignorance = Fear/Silence = Death*. If students choose examples from TV, have them rewrite the ads in the form of storyboards. If they choose examples from magazines, have them insert the appropriate educational information via collage. Instruct students to reuse the tone of voice of the ads so as to better imitate the codes of advertising.

6. Discuss projects with class upon completion. Consider the following questions:

a. Would these transformed ads be as effective as advertising if they were distributed in the same way?

b. Why aren't there more AIDS education ads on TV even though AIDS is a tremendous problem?

Evaluation:

Assess students' ability to see the connection between different forms of discrimination and AIDS discrimination. Use students' projects to assess their ability to express their own concerns through exploring the language of the media and advertising. Assess students' understanding of the political dimensions of AIDS.

AIDS and Its Representation

Lesson 23: **Discrimination, Racism, Homophobia**

Lesson 24: Homophobia, Healthcare, and Civil Rights

Suggested Procedures:

1. Show slide of *Untitled* by **David Wojnarowicz**. Ask three or four students to read sections of the text aloud so that the text will be occupied by various students voices.

2. Ask students who the child is. Suggest various possibilities such as the artist, someone the artist knows, someone who stands in for gay people, someone who stands in for persecuted people, or "ourselves."

3. Have the students discuss the text by considering these questions:
 a. In what ways can you identify with this boy?
 b. What are the legislations "politicians will enact against this kid?"
 c. What is the "false information" which is "passed down from generation to generation designed to make existence intolerable for this kid?"
 d. Should the violence and oppression described happen to this kid when he grows up just because he will discover that he is gay?
 e. Historically, what groups other than gays suffer the same oppressive consequences for simply being who they are? Have these people also been the object of "false information?" How?

4. Inform students that until the civil rights movement brought changes to American legislation in the 1960s, segregation was legal and miscegenation illegal in some states. Ask students if they see any parallels between the condition of African Americans and other people of color, and the condition of gay and lesbian people? How so? If not, why not?

5. Have students discuss whether they think there should be a political movement like the civil rights movement for gay and lesbian people? For all people?

6. Tell students that the word for hatred and fear of homosexuals is "homophobia." Ask students:
 a. Is homophobia equivalent to other forms of discrimination? If so, what other forms and how?
 b. Has homophobia contributed to ignorance about AIDS? How?

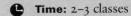 **Time:** 2–3 classes

Objectives:
a. Students will explore and discuss the connection between civil rights and the struggles against homophobia.
b. Students will examine their own attitudes towards gays and lesbians.
c. Students will discuss the government's responsibility towards its citizens' health care.

Resources:
Slides:
Gran Fury: *Welcome to America* (p. 67)
David Wojnarowicz: *Untitled* (p. 272)

Film:
Homoteens
(56 minutes, 1993).
Directed by Joan Jubela.
Distributed by Joan Jubela,
P.O. Box 1966,
New York, NY 10013.
Telephone: (212) 226-2462.

Books:
Sasha Alyson, Editor,
Young, Gay & Proud
(Boston: Alyson Publications, Inc., 1985).

Ann Heron,
One Teenager in 10: Writings by Gay and Lesbian Youth
(Boston: Alyson Publications, Inc., 1985).

Aaron Friche,
*Reflections of a
Rock Lobster.*
(Boston: Alyson Publications,
Inc., 1981).

Audre Lorde,
*Zami: A New Spelling
of My Name.* (Freedom, CA:
Crossing Press, 1982).

Equipment:
Slide projector and screen;
film projector (optional).

7. Show slide of *Welcome to America* by **Gran Fury**, and inform students that the work was created before the end of South African apartheid. Read the text aloud and introduce to the class the concept of national health care. Discuss:
 a. In addition to the absence of national health care, what are other similarities between U.S. and South Africa before the end of apartheid? How are these similarities related to free national health care for "everyone?"
 b. Should health care be a basic human right or a privilege only for those who can pay?
 c. How is AIDS a health care issue?
 d. Is anyone profiting from the lack of national health care? Is anyone suffering?
 e. If so, is there a relationship between this suffering and racism? Discrimination in general?
 f. Why did the artist choose to make a poster intended for the streets when asked to contribute to an art show?
 g. What can the average person do to make health care a basic right?

8. The Clinton administration has vowed to make national health care a priority. Do you feel this is a good idea? If so, why? Is there an area of government spending you think can be reduced to provide funds for national health care? Many have suggested that the end of the cold war will mean more federal funds for domestic programs like health care. Do you believe this is true? What are the obstacles to this becoming a reality?

9. Have students discuss the ways in which the issues of AIDS, homelessness, and abortion are related.

10. Have students choose from the following 3 topics for an essay:
 a. Should society alter its attitudes towards gay and lesbian people? Why? How?
 b. How has your attitude towards gay and lesbian people changed or developed in the recent past? What brought about this change? If your attitudes haven't changed, why not?

AIDS and Its Representation

Lesson 24: **Homophobia, Healthcare, and Civil Rights**

c. Make a report on one openly gay or lesbian person in the public eye whom you consider to be a good role model. Is there a lack of openly gay or lesbian role models for teenagers? Why or why not?

11. (Optional) Screen *Homoteens* (56 minutes, 1993) by Joan Jubela, five first-person stories from teenagers speaking out about their (homo)sexuality. Discuss the film after screening.

12. Additional resource materials for students:
- *Reflections of a Rock Lobster* by Aaron Fricke.
- *Zami: A New Spelling of My Name* by Audre Lorde.
- *Young, Gay & Proud* by Sasha Alyson
- *One Teenager in 10: Writings by Gay and Lesbian Youth* by Ann Heron.

Evaluation:

Assess students' understanding of the pervasive ramifications of homophobia in this society. Assess students' understanding of the struggle against homophobia as a civil rights issue. Determine from students' essays whether they have developed an accepting attitude towards gay and lesbian people. Assess students' understanding of civil rights as a multifaceted historical continuum which is a living, evolving movement.

Lesson 25: **AIDS Timeline**

Objectives:

a. Students will use different primary and secondary sources to collect information.

b. Students will work cooperatively.

c. Students will identify ways in which representations of the AIDS pandemic have changed over the past 15 years.

d. Students will appreciate that major sources of information often reflect opinions and ideas of the dominant group.

e. Students will create an AIDS timeline which can be used to educate other students.

Resources:

Slide:

Group Material: *AIDS Timeline* (pp. 68, 302)

Equipment:

Slide projector and screen.

Suggested Procedures:

Group Material
AIDS Timeline, 1989
Mixed media installation

1. Show students the slide of **Group Material**'s *AIDS Timeline* installed at the University Art Museum at the University of California, Berkeley, in 1990.

2. Divide the class into small research teams (2–3 students per team) and ask each team to research one year between 1980 and the present regarding information about AIDS.

3. Ask each team to identify three events and choose three images which relates to AIDS during that year. Moments to look for: Rock Hudson's death; the founding of ACT UP (AIDS Coalition to Unleash Power); Magic Johnson's disclosure. A good method to pursue this project would be to use library references for periodicals, so that significant news stories about AIDS as they appeared in periodicals could be photocopied and appropriated.

4. After each team has gathered the information and images, have each team present its findings to the class in a chronological fashion. Since some of the materials may not be as compelling as others, have students select from the materials gathered based on their historical significance and news currency at the time. After all materials have been selected, discuss and identify themes for the timeline (e.g., finding a cure, the initial portrayal of AIDS as a "gay disease") and/or

AIDS and Its Representation

look for changes in the ways in which people with AIDS have been portrayed since the early '80s.

After isolating these bits of information, make a caption for every image and write a short narrative (1–3 sentences) for all themes which have been isolated.

5. Make a timeline which wraps around the interior of the classroom, punctuating each year with the information and illustrations the students have acquired during their research. If the students wish, they may also make their own illustrations or write texts for the timeline.

Evaluation:

Assess students' historical understanding of AIDS based on the timeline, and their understanding of the impact of AIDS on society. Assess students' ability to discern crucial movements in the representation of AIDS.

Objectives:

a. Students will examine the impact of AIDS on individual lives.

b. Students will examine their personal feelings towards AIDS through a letter-writing exercise.

✓ **Resources:**

Slides:

Keith Haring:
Ignorance=Fear/Silence=Death (p. 297), *Stop AIDS* (p. 289)

David Wojnarowicz: *Crash: The Birth of Language/The Invention of Lies, Where I'll Go If After I'm Gone* (p. 102), *Untitled* (p. 272)

Book:
Close to the Knives by David Wojnarowicz (New York: Vintage Press, 1991).

Videotapes:
PWA POWER: Life After Diagnosis (28 minutes, 1989). Directed by Jean Carlo Musto and Gregg Bordowitz. Available through Gay Men's Health Crisis.

Absolutely Positive (27 minutes,1990). Produced and directed by Peter Adair. Distributed by Select Media.

Equipment:
Video monitor and deck; drawing paper and color pencils, pastels (optional).

Lesson 26: **People Living with AIDS**

Suggested Procedures:

1. Ask students to read the artist's statement by **David Wojnarowicz,** an artist who died of AIDS in 1992. Before viewing his work, discuss with the class the content of his statement. A good source book for teachers (but probably too controversial for the class) is the collection of Wojnarowicz's writing *Close to the Knives.* Ask students:

a. In what ways do you identify with the artist's statement? In what ways do you find it alien?

b. Had you met David Wojnarowicz when he was a teenager, what would be your attitude toward him?

2. Show slides of *Crash: The Birth of Language/The Invention of Lies, Where I'll Go If After I'm Gone,* and *Untitled* in that order. Ask students:

a. Does the fact that the artist knew he had AIDS when he made the paintings affect the way you view them? How?

b. Do you agree with the title *Crash: The Birth of Language/The Invention of Lies*? Given what you know about the artist from his statement, what were the "lies" he was trying to portray in this painting?

c. What kind of place is depicted in *Where I'll Go If After I'm Gone*?

d. Although these paintings were made by a person who had AIDS, are they necessarily about AIDS? If so, in what ways?

e. How are the first three works different from *Untitled*?

3. Show the slides of *Ignorance = Fear/Silence = Death* and *Stop AIDS* by **Keith Haring.** Both of these works were made especially for AIDS organizations soon after Haring discovered that he had AIDS. Discuss:

a. Given that Haring was already ill when he made these works and that he probably knew he would not have long to live, why did he engage in activist art making?

b. Can you create a definition of "activist art?" Who benefits from this kind of art? (Consider **Gran Fury**'s work as another example.) Why do artists make this kind of work?

AIDS and Its Representation

4. Ask students to imagine that they or someone close to them is HIV-positive or has AIDS. In some cases, students will really know someone who is HIV-positive or has AIDS. Ask each student to write a first-person narrative about this imagined experience in the form of a letter. Issues to think about include racism, healthcare, the reaction of family and friends, the reaction of the community and the government. Will this be entirely negative like Wojnarowicz's statement? Or do you see hope and changing attitudes about this issue? Use this opportunity to express what is difficult for students to discuss aloud.

5. (Optional) Transform this letter-writing exercise into an art project by choosing a central motif from the letter ("a hand" for "letting go" or "loss"; "water" for "time passing"). Ask students to make a color drawing of this symbol as a background. Rewrite the letter over the drawing (or combine the text of the letter with the drawing in another way) to complete the project. Discuss with the class how personal feelings towards AIDS can be expressed in words and images.

6. Ask the class to summarize the feeling of each work by David Wojnarowicz in one word. Discuss how each word is related to the experience of someone who was living with AIDS.

7. View and discuss the videotape *PWA POWER: Life After Diagnosis,* and/or *Absolutely Positive,* which address AIDS through first-person accounts of those living with the disease.

Evaluation:

Assess students' ability and willingness to sympathize with a person with AIDS, and to understand such a person's attitudes and feelings about his or her illness. Assess students' ability to articulate what firsthand knowledge of AIDS can be.

Conclusion:

These lessons have focused on the politics of representing AIDS and its related issues. You may want to follow up with your own lessons on safer-sex practices for teenagers and other ethical issues such as condom distribution in schools. In addition to *What You Can Do to Avoid AIDS* by Magic Johnson, there are many video titles available through Select Media (see Part 5) which are excellent tools through which you may introduce and discuss these topics with your class. A few of these tapes are: *Sex, Drugs, and HIV* (18 minutes, 1991, Directed by Franklin Getchel, Distributed by Select Media) which presents HIV prevention information and strategies; *Word on the Street* (18 minutes, 1991, Directed by Jaimal Joseph, Distributed by Select Media), aimed at youth such as homeless or run-away kids; *Face to Face with AIDS* (31 minutes, 1988, Directed by Peter Rabinowitz, Distributed by Select Media), aimed at male teenagers; and *Are You with Me?* (18 minutes, 1989, Produced by AIDSFilms, Distributed by Select Media) which deals with a teenager's negotiations with safer sex.

Additional Resources:

Books:

Medical Answers about AIDS. (New York: Gay Men's Health Crisis [GMHC], 1989).

Douglas Crimp and Adam Rolston, *AIDS Demo-Graphics.* (Seattle: Bay Press, 1990).

Videotapes:

It Is What It Is (58 minutes, 1993). Directed by Gregg Bordowitz. Distributed by Gay Men's Health Crisis (GMHC).

Seriously Fresh (30 minutes, 1989). Produced by AIDSfilms. Distributed by Select Media.

The War in Vietnam/ The War at Home

Pam Sporn

In this series of lessons, we will look at the theme of war. Through viewing and discussing pieces of art that use the Vietnam and Persian Gulf Wars, and the antiracist movements as points of departure, students will explore how those particular wars impacted on, and are remembered by diverse communities. The individual perspectives of the artists' works offer students the opportunity to examine different points of view about war.

Students will be asked to examine several specific issues. One is "How do communities collectively remember a war?" To answer this question, students are asked to use their communities as terrains of study. Another issue examined is "How does the government mobilize public support for a war?" Several of the art works suggest that the notion of a mythic "American" (i.e. person of European descent) faced with the threat of the "other" ("non-American") is one of the main cultural devices used to win the population's support for a war. The works of **Faith Ringgold, Danny Tisdale,** and **David Hammons** take students right into the hearts and minds of the Black community in the late 1960s. By exploring these pieces, students may gain insight into the acute awareness of many African Americans of the contradiction between being expected to fight in, or support, a war abroad while the war against racism and social inequality had not yet been won at home.

Students will conclude this sequence of lessons by creating a comic strip in which they interpret the issues and attitudes they explored related to the Vietnam War, civil rights, and Gulf War eras.

Subject Areas: *Art, Language Arts, Social Studies*
13 Lessons (15–20 classes)

Objectives:

a. Students will explore their own attitudes toward war.

b. Students will learn how different communities remember a war.

c. Students will see how artists and filmmakers have approached the theme of war.

d. Students will develop a greater understanding of the impact of war on people who fought.

e. Students will become sensitized to differences in the social roles of men and women in relation to the Vietnam War.

f. Students will consider the purposes of war memorials.

g. Students will learn to recognize how racism was used to mobilize support for the Vietnam and Persian Gulf Wars.

h. Students will learn about the relationship between the civil rights movements in the U.S. during the 1960s and the Vietnam War.

i. Students will see how contemporary artists have reflected upon the civil rights movement of the 1960s in works of art from the 1980s and '90s.

Objectives:

a. Students will explore their attitudes toward war.

b. Students will interpret their own and others' drawings.

c. Students will appreciate how individuals imagine war differently.

Materials:

Newsprint paper; pencils or markers.

Lesson 27: **Imagining War**

Suggested Procedures:

1. Ask students to close their eyes and visualize the strongest image that comes to mind when they hear the word "war." Give each student a large sheet of newsprint and have them draw their images of war (even if they can draw only stick figures or symbols).

2. Have everyone present their drawings to the whole class to initiate a discussion of students' impressions of what war is like, their personal contact with war, and themes related to war. This can be done in several ways:

a. Each student can hold up and explain his or her drawing to the class.

b. Students can pair up, exchange drawings, and then write captions for their partner's drawing. The student/artist can tell his or her partner if the caption accurately captures the meaning of the drawing. If time permits, several pairs can share their drawings with the whole class and report on what they "read" in each other's drawings.

c. Have the students tape their finished drawings to the classroom wall. When everyone's drawing is up, have the students walk around the room, carefully viewing all of the drawings. Ask each student to tell the rest of the group which drawing was most powerful to him or her and why.

However the sharing is done, the teacher or a designated student should keep a running list of the emotions, experiences, and themes that are brought up in the students' drawings and discussion. The list can be referred to later, or can be used to choose themes or topics to explore further.

Evaluation:

Assess students' ability to express concepts in visual form. Assess students' ability to interpret visual information. Assess students' appreciation and respect for similarities and differences amongst students in the class. Assess students' ability to empathize with people who have experienced war.

Lesson 28: **How Communities Remember a War**

🕐 **Time:** 2 classes

❓ **Objectives:**
 a. Students will learn how communities remember war.
 b. Students will learn interview techniques.
 c. Students will appreciate how a war impacts on groups and individuals differently.
 d. Students will recognize members of their communities as valuable historical witnesses.

Suggested Procedures:

1. Have students interview a parent or grandparent (or someone in their community of roughly the same age as their parent or grandparent). Help the class design interview questions. Questions might include the following:

 a. What is your most vivid memory from the years of the Vietnam War?
 b. How was your community affected by the Vietnam War?
 c. How did people in your community feel about the Vietnam War when it was going on?

For a class with many immigrant students modify the questions:

 d. What significant events were happening in your country during the 1960s and 1970s?
 e. What impact did the U.S. war in Vietnam have on your community?
 f. What experiences did your generation have with war in your country?

Advise students to take mental notes when conducting their interviews. Instruct them to write a summary of the person's response to each question when the interview is over. If students do not have to worry about taking notes while conversing, they will be able to listen more carefully and the conversation will flow more naturally.

2. Many students' families and communities were touched by the Persian Gulf War. The following questions can also be incorporated into the interviews:

 a. How was your family or community affected by the Persian Gulf War?
 b. What was your strongest emotion during the months of the Gulf Crisis? What caused you to feel the way you did?
 c. What image (news photo, poster, or something else you saw) do you remember most strongly from the Gulf Crisis? Why did this image have such an impact on you?

3. Have students read their interviews to each other.

4. Conduct a discussion on the following aspects of the interviews:

Process:

a. Did the people interviewed speak freely or did they resist talking about the Vietnam War (or any other war)?
b. Did anyone refuse to be interviewed?
c. What might speaking freely or resisting speaking about the Vietnam War signify?

Content:

a. Did any of the responses remind you of the drawings we shared during the last session?
b. What themes from our list were brought up by community and family members who were interviewed?

Students' reactions:

a. What responses surprised you the most? Why?
b. What (Vietnam War related) theme brought up in any of the interviews are you most interested in finding out more about? Why?

Evaluation:

Assess students' appreciation of diverse perspectives on war.
Assess students' interview techniques.

Lesson 29: **The Impact of War on the People Who Fought**

⏱ **Time:** 2–3 classes

❓ **Objectives:**

a. Students will understand the impact of war on people who fought.
b. Students will appreciate the different needs of racially and ethnically diverse communities of veterans.
c. Students will do a close analysis of an individual artwork.
d. Students will apply written information to interpretation of a work of art.
e. Students will write about the responsibilities of the government to veterans.

Suggested Procedures:

1. Have the class read the statement by artist **Ida Applebroog.** Ask them to figure out how old the artist was in 1968, at the peak of the fighting in Vietnam.

2. Show the slide of *Thank You, Mr. President* by Ida Applebroog. Ask the students what point they think Ida Applebroog is making in this work and what they think the title of the piece means. Ask the students where they see evidence in *Thank You, Mr. President* of Ida Applebroog's personal philosophy toward art.

3. Have the students discuss their personal reactions to *Thank You, Mr. President.* Ask them to consider questions such as the following:

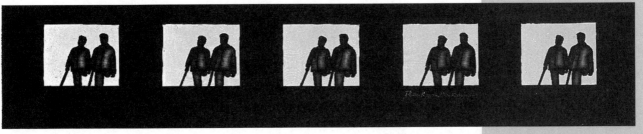

Ida Applebroog
Thank You,
Mr. President, 1983
Enamel and Rhoplex on canvas
12″ × 66″

a. What should be the government's responsibility to veterans?
b. From your personal experience or the experience of someone you know, do you think the government lives up to its responsibility to veterans of the Vietnam War?
c. Is it a citizen's civic duty to serve in war time, even though the consequences may be serious physical injury or death?
d. Is Ms. Applebroog's sarcastic title fair, or unfair, in your opinion?

4. Have students read excerpts from disabled Vietnam Veteran Ron Kovic's autobiographical book, *Born On The Fourth Of July.* On pages 127 through 33 (Pocket Books edition), Kovic describes the

Resources:
Artist's statement:
Ida Applebroog

Slide:
Ida Applebroog, *Thank You, Mr. President* (p. 311)

Book:
Ron Kovic, *Born on the Fourth of July* (New York: Pocket Books, 1977).

Equipment:
Slide projector and screen.

treatment he received while a patient in the Bronx Veteran's Administration Hospital. On pages 176 through 184 Kovic recounts how he made an antiwar speech from his wheelchair on the floor of the 1972 Republican National Convention during Richard Nixon's presidential nomination acceptance speech.

5. Continue the class discussion on the responsibilities of government to veterans using specific examples from Ron Kovic's experiences.

6. Have the students write an imaginary dialogue between the man portrayed in *Thank You, Mr. President* and former President Johnson or Nixon. Begin the dialogue with the words "Thank You, Mr. President."

Evaluation:

Assess students' dialogues to determine how well they understand the needs of diverse communities of veterans. Assess students' ability to interpret a work of art, including the ability to relate written information to visual art.

Lesson 30: **Women and War**

Time: 1–2 classes

Suggested Procedures:

1. Screen the documentary film *Regret To Inform* by Barbara Sonneborn and Kathy Brew which addresses the experiences of Vietnam War widows in both the U.S. and in Vietnam. While watching, have the students jot down statements made by women in the film that they find most powerful.

2. Share and discuss these statements after the viewing. Ask the students what surprised them most about the attitudes of some of the widows. Have the students consider and discuss why the points of view of women Vietnam veterans, and those of the wives and widows of Vietnam veterans, have not been given more attention in the past.

3. Have students review the interviews conducted in Lesson 28 and note any patterns of difference in the responses of men and women. Ask the students to consider why the responses of men and women might differ.

4. Ask students to imagine that they are the wife, mother, or sister of a soldier in Vietnam and that they have received an official notice from the government that their husband, son, or brother has been seriously wounded or killed in action. Instruct students to write a letter to President Kennedy, Johnson, Nixon, or Ford in which they express their feelings about their loved one's death, and the cause of his death. Tell them to begin their letter with the words, "Thank you, Mr. President."

Evaluation:

Use students' writing to evaluate their understanding of the positions of women in relation to the Vietnam War and their understanding of the concerns and feelings of those who have lost loved ones in war.

Objectives:

a. Students will become sensitized to differences in the social roles of men and women in the Vietnam War.

b. Students will appreciate the impact of the Vietnam War on women whose husbands were killed.

c. Students will try to empathize with those who lost a loved one in the war by writing from their point of view.

Resources:

Film:
Regret To Inform (1993). Documentary film produced and directed by Barbara Sonneborn and Kathy Brew. Distributed by Regret to Inform. Telephone: (510) 526-9106.

Equipment:
Video monitor and deck.

Objectives:

a. Students will consider the purposes of war memorials.

b. Students will appreciate the difficulties of memorializing a controversial war.

c. Students will learn that there may be contrasting ideas and opinions regarding war memorials.

Resources:

Slide:
Maya Lin: *Vietnam Veterans Memorial* (pp. 79, 345–346)

Artist's statement:
Maya Lin

Excerpts from articles published about the *Vietnam Veterans Memorial*.

Equipment:
Slide projector and screen.

Materials:
Paper and pencils.

Lesson 31: Memorializing Soldiers Killed in a Controversial War

Suggested Procedures:

1. Show students the slides of the *Vietnam Veterans Memorial* by **Maya Lin** in Washington, DC. Ask students:

a. What statement does the memorial make about the Vietnam War? About war in general?

b. How does the design of the memorial convey that message?

c. Is the memorial antiwar, prowar, or neutral? Does the memorial encourage the viewer to ask questions about the Vietnam War? Should it encourage the viewer to do so?

d. What, if anything would you add to, or change in the *Vietnam Veterans Memorial*?

e. How would you memorialize the dead soldiers of a controversial war? An unjust war?

f. What are the difficulties in remembering or memorializing soldiers who die in an unpopular war?

2. Have students read the statement by artist Maya Lin. Ask the students if they think the artist expresses a point of view about the Vietnam War in her statement. If so, what point of view does she express? If not, why not?

3. Have students read excerpts from articles that both supported and denounced the design of the *Vietnam Veterans Memorial*. Ask students which points of view they agree with, which they disagree with, and why.

4. Ask students what they think the U.S. troops who served in the Persian Gulf War came home to. Ask them to imagine how the homecoming for the Gulf War soldiers may have differed from that of soldiers who fought in Vietnam.

5. Have students work in groups of four to come up with a design for a memorial in which they "remember" the soldiers who were killed in Vietnam. Supply all of the students with paper and pencil so that they can illustrate their ideas to the rest of the group. Each group should come up with one agreed-upon design to share with the whole class.

6. Have students write about the process of coming up with a shared vision for a memorial with their group. Ask them to reflect on what might have accounted for unity or disagreement among the group members.

Evaluation:

Use the students' designs and writings to determine how well they grasped the varying points of view about a Vietnam War memorial.

Objectives:

a. Students will learn how racism is used to mobilize support for war.

b. Students will use primary source materials, including personal testimonies and works of art, to analyze the impact of racism on individuals and society at large.

c. Students will create mixed-media projects which challenge racist imagery in the mass media.

Resources:

Slides:
Ken Chu: *I Need Some More Hair Products* (p. 62)
Epoxy Art Group: *Guest Becomes Host* (p. 65)

Artists' statements:
Kristine Yuki Aono, Ken Chu, and **Epoxy Art Group**

Film:
Who Killed Vincent Chin? (82 minutes). Documentary film by Christine Choy and Renee Tajima. Distributed by Filmmakers Library.

Equipment:
Slide projector and screen; video monitor and deck.

Materials:
Paper; scissors; glue; markers.

Suggested Procedures:

Introductory note: Historically, the ability of the United States to mobilize its population to support a war has depended on the civilian and military population *perceiving* an identifiable "enemy." Racism has often been an underlying attitude because the "enemy" is usually identified as someone "other" than a "typical American." Asian Americans suffered from being targeted as "enemies" in both World War II and the Vietnam War.

1. Have the class read and discuss the testimony of a Japanese-American Vietnam veteran during the Winter Soldier Investigation:

> Congressional Record, April 6, 1971
>
> Before I went into the Marine Corps, I grew up (as a Japanese American) in an all-white and Chicano neighborhood and I encountered a moderate amount of racism; it didn't bother me much. When I went into the Marine Corps, I thought I was going to serve my country and be brave, a Marine and a good American. As I stepped off the bus at UCMD, San Diego, the first words that greeted me were when the DI (Drill Instructor) came up to me and said, "Oh, we have a gook here today in our platoon." This kind of blew my mind because I thought I was a pretty cool guy myself. But, ever since then, all during boot camp, I was used as an example of a gook. You go to a class, and they say you'll be fighting the VC or the NVA. But then the person who is giving the class will see me and he'll say, "He looks just like that, right there."

2. Ask students to discuss what impact they think the military officer's statements had on this Japanese American soldier and on the non-Asian soldiers in his platoon.

3. Ask two students to read **Ken Chu**'s statement aloud, alternating between the two "voices" in the text. Also read the statement by artist **Kristine Yuki Aono.** Ask students how these artists have personally experienced the attitude that Asian Americans are not "real" Americans.

4. View the slide of Chu's painting *I Need Some More Hair Products*. Have students discuss the internal conflict portrayed in the work and the social message the artist conveys about his experience of being both Asian and American in the United States. Have students describe how Chu responds to anti-Asian racism through his art.

5. View the slide of *Guest Becomes Host* by **Epoxy Art Group**. Have students discuss what point Epoxy Art Group is making about the targeting of the Japanese as "economic enemies" today.

6. Ask the class to look for, and bring to the next session, examples of anti-Asian attitudes or messages from newspaper articles and editorials, advertisements, or other media. Use these examples to stimulate a discussion about the ways in which anti-Asian (particularly anti-Japanese) attitudes are communicated, and the validity or nonvalidity of blaming Japan for economic problems in the U.S., and the possible consequences for Asian Americans.

7. Have students create mixed-media projects in which they change the meaning of the images they have brought to class through altering them or through captioning.

8. Have students view and discuss the documentary film, *Who Killed Vincent Chin?* about the beating death of a Chinese American in Detroit.

Evaluation:

Assess students' mixed-media projects to determine how well they were able to detect, analyze, and challenge racist imagery in mass media.

Objectives:

a. Students will learn how racism has been used to mobilize support for war with specific emphasis on anti-Arab prejudice and U.S. involvement in the Middle East.

b. Students will develop a project designed to counter anti-Arab prejudice.

Resources:

Film:

Muquadimma Lynihaiyat Jidaal: An Introduction to the End of an Argument (Intifada): Speaking for Oneself . . . /Speaking for Others. (60 minutes, 1990) By Elia Sulieman and Jayce Salloum. Distributed by Third World Newsreel.

Equipment:
Video monitor and deck.

Materials:
Variable, depending on nature of student project.

Lesson 33: **Mobilizing a Country for War**

Suggested Procedures:

1. Have students consider how racism has been used to mobilize support for U.S. military involvement in the Middle East. Inform students that during the Persian Gulf War, Arab Americans experienced a sharp increase in harassment by ordinary citizens and the FBI. Ask students to discuss any examples of anti-Arab messages or images they have heard or seen on TV, in movies, or in popular music. Discuss how these images may have affected popular support or lack of support for U.S. military action in the Persian Gulf.

2. Show the videotape *Muquadimma Lynihaiyat Jidaal: An Introduction to the End of an Argument (Intifada): Speaking for Oneself . . . /Speaking for Others,* by Elia Sulieman and Jayce Salloum, a critique of Western-biased representations of Arab culture combining news sound bites, movie clips, and documentary footage. Have students discuss how the editing technique used by the filmmakers highlights the prevalence of Arab stereotypes. Ask students whether or not they were previously aware of these stereotypes in the media. Discuss how the usual mode in which these images are presented on TV and in film makes them seem "natural."

3. Ask students what kinds of images they might produce to counter anti-Arab stereotypes in American culture. Ask students how they would go about educating other students about the connections between racism and war.

4. Use the ideas generated in the class discussion to develop a project for presentation to other classes.

Evaluation:

Assess students' understanding of racial and ethnic stereotypes in mass media through their discussion of the videotape. Use students' studio projects to assess their understanding of the connections between racism and war.

Lesson 34: **The Impact of War on Art/ The Impact of Art on War**

🕐 **Time:** 2 classes

❓ **Objectives:**
 a. Students will learn how artists can make public statements about contemporary social and political issues through their artwork.
 b. Students will analyze the impact of art on current events.
 c. Students will learn how economic factors affect the composition of the armed forces in the United States today.

☑ **Resources:**
Slide:
Krzysztof Wodiczko: *Arco de la Victoria, Madrid* (p. 101)

Artist's statement:
Krzysztof Wodiczko

Film:
Caught in the Middle of the Crisis (18 minutes, 1990). Videotape produced by Through Our Eyes Video and History Project. Available from Pam Sporn, c/o Educational Video Center.

Equipment:
Slide projector and screen; video monitor and deck.

Suggested Procedures:

1. Show students the slide of *Arco de la Victoria, Madrid* by **Krzysztof Wodiczko**. Explain that the projection was done in Madrid during the Gulf War. Ask students if they think there is a prowar or an antiwar message in the work. Have them explain the basis for their answers.

2. Have one student read Wodiczko's statement to the rest of the class. Ask students to discuss the following questions:
 a. After hearing Wodiczko's statement about his intentions as an artist, do you still agree with your answer to the previous question?
 b. What is the artist's point of view on the Persian Gulf War?
 c. What is *Arco de la Victoria, Madrid* saying about the causes of the Gulf War? Do you agree or disagree?

3. Provide students with background information on General Franco and the Spanish Civil War. Ask students:
 a. What is an "icon?" What is powerful about projecting the images of a gun and a gas nozzle onto a monument to Franco's army?
 b. If Wodiczko had done his projection in the United States, what monument might he have used and why?

4. Show the videotape *Caught: In the Middle of the Crisis*. While viewing the tape ask students to jot down a statement they agree or disagree with. After the tape is finished have the students "talk back" in writing to the person who made the statement in the tape. Have the students share their writing as a way to initiate a discussion of the issues raised in the video.

5. Ask students to identify the point of view of the videomakers. What kind of visual images, sounds, people, and events did the video producers capture on tape? How did the videomakers arrange these different elements in their video to express their point of view?

6. Refer students to these lines from Krzysztof Wodiczko's statement: "I did a recent projection in Madrid that was quite effective because it was adopted by antiwar demonstrations, which were

massive in Spain ... [Nonetheless,] in talking about the success of an artwork maybe we should think about how unsuccessful we are, and the world is, if all our work did not prevent the United States, or Europe, from engaging in this war." Remind students that at the end of *Caught: In the Middle of the Crisis* the videomakers said they hope their video will help prevent war. Have students discuss whether artists can have an impact on world events through their artwork.

7. Approximately 1/3 of the U.S. troops in the Persian Gulf were people of color, many were women. Some people felt this was a sign of advancement for disenfranchised groups, while others felt it was a sign of limited opportunities in our society. Ask students to discuss their opinions.

8. Over 2,500 U.S. soldiers filed for conscientious objector status during the Gulf Crisis. Many were held in military prisons before being court-martialed. Ask students why they think so many reservists and active-duty soldiers did not want to participate in the Persian Gulf War. Discuss whether or not soldiers should have the right to claim conscientious objector status. Conduct research on what has happened to soldiers who filed for conscientious objector status.

9. Ask students if they know anyone who is currently in the army or planning to join. Have students conduct interviews in which they investigate reasons why people enlist, or choose not to enlist, in the army today. Have students share their interviews with the rest of the class. Ask students to consider similarities and differences among those interviewed to identify any patterns in who joins the army and why. Interviews may be published in the school newspaper.

Evaluation:

Assess students' understanding of the impact of art on current events through class discussion. Use students' writing to assess their ability to identify and understand various forms of resistance to war.

Lesson 35: **National Liberation Movements**

⏰ **Time:** 1 class

❓ **Objectives:**
 a. Students will learn about the Puerto Rican Independence Movement.
 b. Students will compare the Vietnamese struggle against French colonialism with the Puerto Rican Independence Movement.
 c. Students will analyze how two Puerto Rican artists living on the U.S. mainland have dealt with the themes of colonialism and oppression in the U.S.
 d. Students will learn about the role of Latinos in the Vietnam War.

☑ **Resources:**
Slides:
Marina Gutierrez: *Isla del Encanto* (p. 71)
Juan Sánchez: *The Bandera Series: La Danza Guerrera, The World Belongs To The People* (p. 248)

Artists' statements:
Marina Gutierrez and **Juan Sánchez**

Equipment:
Slide projector and screen.

Suggested Procedures:

1. Show the slide of **Juan Sánchez**'s *La Danza Guerrera* (included in the *Bandera Series* slide). Ask the students what they think the painting means, whether or not they are able to read its Spanish text. If possible, have a Spanish-speaking student read out loud the Spanish text of the painting and translate it for the rest of the class. Or, if necessary, provide the class with the English translation.

2. Ask the class to identify the artist's point of view and the message being communicated through the work:
 a. What point of view or message is the artist communicating in his work? What is "guerrilla war?"
 b. Why would there be a guerrilla war in Puerto Rico? What is the Puerto Rican Independence Movement fighting for?
 c. What is colonialism?
 d. What is national liberation?

3. View the slide of *Isla del Encanto* by **Marina Gutierrez**. Ask students to discuss what statement Marina Gutierrez is making in her work about war and Puerto Rico:
 a. Why did the artist draw an outline of Puerto Rico with the scope of a rifle (or other weapon) superimposed on it?
 b. What do you suppose the artist is saying by aiming a weapon at Puerto Rico? Why?
 c. How does *Isla del Encanto* give fuller meaning to the points made by Juan Sánchez in *La Danza Guerrera*? Does *Isla del Encanto* provide any answers to the questions in Procedure #2?

4. Have students compare *La Danza Guerrera* to the following statement made by Vietnamese leader Ho Chi Minh in a 1946 appeal to the Vietnamese people:

> Whoever you may be, men, women, children, old or young, whatever your religion or whatever your nationality, if you are Vietnamese, rise up to fight the French colonialists, to save our country. He who has a gun, let him fight with a gun; he who has a sword, let him fight with

the sword; he who has neither gun nor sword let him fight with spades, with pickaxes, with sticks. Let no one stay behind or outside the patriotic struggle against the colonialists.

Ask students what are the similarities in language and tone between this statement and Juan Sánchez's statement in *La Danza Guerrera*? From reading Ho Chi Minh's statement, what can they tell about what the Vietnamese were fighting for in 1946 (and in the 1960s)? Were Ho Chi Minh's people fighting for national liberation? Why would Ho Chi Minh be considered an enemy by the U.S. government?

5. Tell students the following statistics:[1]

a. During the Vietnam War, men in the Latino community were drafted (many directly from Puerto Rico) at double and triple their proportion in the U.S. population.

b. One out of every two Latinos who went to Vietnam served in a combat unit.

c. One out of every five Latinos who went to Vietnam was killed in action.

d. One out of every three Latinos who went to Vietnam was wounded in action.

6. Show the slide of Juan Sánchez's *Bandera Series*; view the panel titled *The World Belongs To The People*. Draw the students' attention to the fact that the text is credited to the "Young Lords Party, 1970." After reading the text, ask the students what they think the Young Lords Party stood for and who might have belonged to the organization. Ask the students what they think the Young Lords Party's attitude might have been toward the war in Vietnam and Puerto Ricans' participation in that war.

7. Have students discuss the following questions:

a. Do you think Puerto Ricans (from the island or the mainland) and other Latino Americans had a reason to fight in Vietnam?

b. Should Puerto Ricans living in Puerto Rico, which is not a state, have been subject to the draft?

The War in Vietnam

Lesson 35: **National Liberation Movements**

8. Have students imagine they are Latino soldiers in Vietnam. Have them write letters home to their families in the U.S. (or Puerto Rico, the Dominican Republic, Mexico, and so on) about what they are experiencing in Vietnam. In the letter, ask them to express their feelings about being a Latino soldier fighting in Vietnam.

Evaluation:

Assess how well students use information on the Puerto Rican Independence Movement to understand the motivation for, and goals of, the Vietnamese Independence Movement.

? **Objective:**
Students will begin to explore relationships between the civil rights movement and anti-war sentiments in the United States.

☑ **Resources:**
Slides:
David Hammons: *Spade With Chains* (p. 128)
Maya Lin: *Civil Rights Memorial* (p. 324)

Book:
Student Nonviolent Coordinating Committee, "Statement on Vietnam, January 6, 1966," in Joanne Grant ed., *Black Protest: History, Documents, and Analyses, 1619 to the Present* (Fawcett Premier, 1986).

Equipment:
Slide projector and screen.

Lesson 36: **The War at Home**

Suggested Procedures:

1. Remind the class that the civil rights movement was going on intensely throughout the South (and later shifting to the North) at the same time that the U.S. was building its war efforts in Vietnam. Inform the students that one of the main civil rights organizations was the Student Nonviolent Coordinating Committee (SNCC), and that it was led by and consisted primarily of black college students.

2. Have the students read SNCC's, "Statement On Vietnam, January 6, 1966." Discuss the following questions:
 a. What was SNCC's opinion about the U.S. war in Vietnam?
 b. What reasons did SNCC give for their stance?
 c. What comparisons did SNCC make between black people in the U.S. and Vietnamese people in Vietnam?
 d. Do you think SNCC's statement represented the feelings of few, or many, black people in the U.S. in 1966? Why?

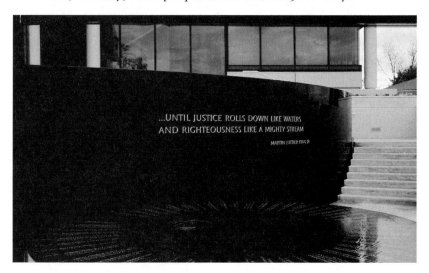

Maya Lin
Civil Rights Memorial, 1989–1990
Black granite, palladium leaf, water

3. Show the slide of **Maya Lin**'s *Civil Rights Memorial* in Montgomery, Alabama, and **David Hammon**'s *Spade With Chains*.

Discuss:

 a. In their art, how do Maya Lin and David Hammons deal with some of the themes expressed in the SNCC statement?

 b. Ask the class what the significance of the sundial-like design of Maya Lin's *Civil Rights Memorial* is.

 c. Ask the students why they would or would not consider the *Civil Rights Memorial* a "war" memorial.

 d. Tell the class that David Hammons did *Spade With Chains* in 1973. Ask them what they think Hammons is saying about the status of black people in America in that year.

 e. Ask the students why they might, or might not, consider *Spade With Chains* a suitable "civil rights memorial."

4. Ask students which, if any, of the interviews from Lesson 28 included sentiments about the attitudes, concerns or struggles in the black community during the Vietnam Era. Have students refer back to these interviews, reading pertinent sections aloud in class.

Evaluation:

Assess students' ability, in class discussion, to recognize common themes in the reading and art work. Assess students' understanding of the goals and impact of the civil rights movement by evaluating their ability to analyze previous interviews in an expanded historical context.

Time: 1 class

Objectives:
a. Students will learn how symbols can be created to represent political ideas.
b. Students will learn how contemporary African American artists have represented the civil rights struggles of the 1960s and '70s.

Resources:
Slides:
Faith Ringgold: *Street Story Part III: The Homecoming* (p. 329)
Danny Tisdale: *The Black Power Glove, The Black Museum* (p. 98), and *Five Afro Combs, The Black Museum* (p. 327)

Article:
"When Protest Made a Clean Sweep," *The New York Times,* by Charles Knorr, June 28, 1992.

Equipment:
Slide projector and screen.

Lesson 37: **Symbols of Resistance and Empowerment**

Suggested Procedures:

1. Divide the class into two groups. Have each group read one of the statements by **Faith Ringgold** or **Danny Tisdale** and share their reactions:
 a. What comments had the most meaning to you, as teenagers, in the 1990s?
 b. What did you agree or disagree with in the artist's statement?
 c. What would you like to ask the artist, if you could?

2. Show students slides of each artist's work having one student "reporter" from each group introduce the work by reading the artist's statement to the whole class.

3. Discuss several artworks that refer to struggle against racism during the 1960s and '70s. While showing the slides of *Street Story* by **Faith Ringgold** and *The Black Power Glove, The Black Museum,* and *Five Afro Combs, The Black Museum* by **Danny Tisdale,** ask students what they can tell about the concerns of the black community in the late 1960s and early 1970s.

4. Ask students what the slogans in the window in *Street Story* tell us about the attitude of some members of the black community toward the Vietnam War. What do they think accounted for those feelings?

5. While showing *The Black Power Glove, The Black Museum* by **Danny Tisdale** tell students that the photograph in the work portrays two black American Olympic medalists who raised their fists in the Black Power salute while the U.S. national anthem was playing at the 1968 Olympics in Mexico City. Ask students what they think the athletes might have been saying about U.S. involvement in Vietnam by making a symbolic statement at the Olympics in the presence of other countries.

6. Ask the students to read the newspaper article "When Protest Made a Clean Sweep." Ask students:
 a. Why is this photograph still in the public eye after 25 years?
 b. What does it symbolize today?

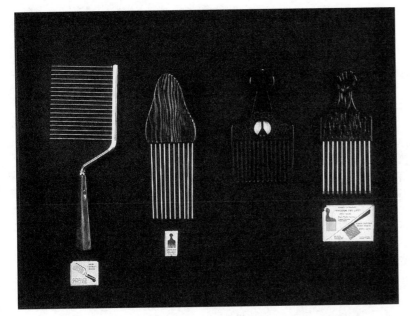

Danny Tisdale
Afro Combs, The Black Museum,
1990
Wood, plastic, steel and jade
30″ × 24″

7. While showing *Five Afro Combs, The Black Museum* by **Danny Tisdale** tell students that black gloves, afros, peace symbols, and fists were powerful and unifying symbols for black soldiers in Vietnam. Ask students what might be symbolized by an afro comb with a peace sign.

8. Ask students to discuss why an artist would create artworks in the 1990s referring to events that took place twenty or twenty-five years earlier.

Evaluation:

Assess students' ability to identify and analyze the meanings of symbols. Assess students' ability to articulate the political mood and attitudes of some African Americans during the Vietnam Era.

🕐 **Time:** 2 classes

Objectives:

Students will learn multiple perspectives on African American activism against the Vietnam War.

✓ **Resources:**

Videotapes:
Disobeying Orders: GI Resistance to the Vietnam War (29 minutes, 1989). Produced and directed by Pam Sporn. Distributed by Filmmakers Library.
The Bloods of Nam. Directed by Wallace Terry. Produced by WGBH's *Frontline.*

Film:
No Vietnamese Ever Called Me "Nigger" (1968). Directed by David Loeb Wiess. Distributed by Cinema Guild.

Slides:
Faith Ringgold: *Street Story Part III: The Homecoming* (p. 329)
Danny Tisdale: *Black Power Glove, The Black Museum* (p. 98); *Five Afro Combs, The Black Museum* (p. 327)

Equipment:
Video monitor and deck; slide projector and screen.

Suggested Procedures:

Project One:

1. Show the documentaries *Disobeying Orders: GI Resistance To The Vietnam War* or *The Bloods Of Nam. Disobeying Orders* deals with the antiwar movement within the armed forces, focusing on the impact of racial matters at home on black soldiers in Vietnam. *The Bloods of Nam* is about the experience of black soldiers in Vietnam.

2. After the students have viewed one of the documentaries, project the slides of **Danny Tisdale**'s *The Black Power Glove, The Black Museum* and *Five Afro Combs, The Black Museum.* Instruct the students to do a piece of writing in which one of the objects in the slide appears in Vietnam in the possession of one of the soldiers who speaks in either *Disobeying Orders* or *The Bloods of Nam.* Tell the students that the writing can be a story; a letter from the soldier to someone at home; a dialogue between the soldier and his or her officer; a conversation between several soldiers in the barracks about one of the objects; or any other situation the students can think of.

3. On day two of the lesson, have students form groups of two to four each. The students should share their writing within the group, then assign themselves roles of characters in the writings. After they have had time to practice their roles, have the groups "perform" each scene for the whole class.

Project Two:

1. Show *No Vietnamese Ever Called Me "Nigger,"* a documentary film that directly addresses black community response to the Vietnam War. The film documents an antiwar march in Harlem led by Stokely Carmichael.

2. After the students have viewed *No Vietnamese Ever Called Me "Nigger,"* project the slide of **Faith Ringgold**'s *Street Story, Part III: The Homecoming.* Ask the students to imagine that the antiwar march in the documentary passed in front of the building in *Street Story, Part III: The Homecoming.* Instruct the students to write a dialogue

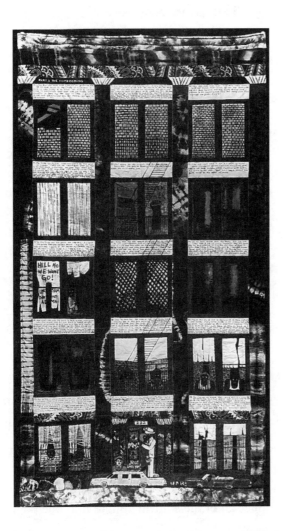

Faith Ringgold
Street Story Part III: The Homecoming, 1985
Acrylic on canvas, dyed and pieced fabric
90″ × 48″

between two of the people looking out of their windows as the antiwar march passed by the building. Encourage students to have the characters share their opinions about the march, the war, and racism while reminding them that these characters *do not* have to agree with each other.

3. On day two of this lesson have students work in pairs. Have them share their dialogues with each other. Each person should assume the role of one of the characters in each dialogue. After the students have had time to practice reading the dialogues out loud, have the pairs take turns "performing" them for the whole class.

Evaluation:

Use students' writing to assess their understanding of causes of antiwar activism among African Americans.

The War in Vietnam

Time: 1–2 weeks

Objectives:
Students will synthesize information they have learned about the Vietnam War by producing a large-scale studio art project.

Resources:
Materials:
Large sheets of paper; pencils and markers.

Equipment:
Audio tape recorder or video camera.

Lesson 39: **Representing War**

Suggested Procedures:

1. Once the students have some background on the Vietnam War and surrounding issues, assign them to video tape or audio tape a detailed oral history interview of an older family member or friend. Have the students spend time developing and revising questions about how the person to be interviewed felt and was affected by the Vietnam War and other events going on in his or her community at the time.

2. Have students transcribe their taped interviews.

3. Ask the students to read over their interviews and select the segments they think are most compelling and that would lend themselves for use as the basis for a drawing.

4. Have students block out nine frames on a piece of paper (similar to a storyboard). Instruct them to break up the action of the selected segment of their interview and spread it over the nine frames.

5. The complete comics can be shown in several ways:
a. Create a display for other students to see.
b. Submit for publication in the school newspaper.
c. Compile all of the student comics into one book that can be duplicated.

Evaluation:

Compare students' interviews from Lesson 27 with interview from this lesson to assess students' knowledge of the Vietnam War. Assess students ability to translate concepts into visual and written form.

These lessons are based on and adapted from an essay entitled "Teaching The Vietnam War At A South Bronx Alternative High School" *Radical Teacher,* #28, 1985; reprinted in O'Malley, Rosen, Vogt, eds., *Politics of Education: Essays from Radical Teacher* (Albany: SUNY Press, 1990).

Note

1. Ruben Treviso, "Hispanics and the Vietnam War," in *Vietnam Reconsidered: Lessons From a War,* edited by Harrison Salisbury (New York: Harper & Row, 1984).

Art in the Public Realm

Zoya Kocur

The aim of these materials is to examine artworks that were made to be seen outside of the context of art galleries and museums. The focus is on works that have been accessible to a broad public. Most of the works explored here have been viewed as controversial for a variety of reasons. The three central public artworks presented take as their subjects the Vietnam War, the history of the state of Colorado, and United States/Mexican border relations (specifically the role of undocumented workers in the California tourist economy). Additional public works are examined in the final section.

Subject Areas: *Art, Social Studies, Media Studies, Language Arts*
4 Lessons (8–10 classes)

Objectives:

a. Students will identify and discuss the roles of public art in our society.

b. Students will explore the public reaction to three controversial public artworks.

c Students will examine the responsibilities of government in funding public art.

d. Students will examine the history of the controversy over the *Vietnam Veterans Memorial*.

e. Students will explore how an artist interpreted Colorado's history through a large-scale public artwork.

f. Students will examine the process of deciding whose history gets recorded.

g. Students will survey a range of public artworks.

Art in the Public Realm

Lesson 40: **Welcome to America's Finest Tourist Plantation**

Background Information:
Created by the artists **Elizabeth Sisco, Louis Hock,** and **David Avalos,** the bus poster *Welcome to America's Finest Tourist Plantation* sparked active and some-times angry debate in San Diego and elsewhere. The poster, which appeared on the back of San Diego public buses during January of 1988, contains three images. The central image is a docu-mentary photograph of a Border Patrol Agent handcuff-ing two people being removed from a public bus in La Jolla, California. The other photographs depict a pair of hands washing dishes and a chambermaid's hand reaching toward a hotel room door.

The artists also compiled a book containing commen-tary on the poster, including local and national media coverage, grants and propos-als, art reviews, and project documentation.

The majority of the debate about the poster centered on applauding or denouncing the artists' point of view, and arguing the appropriateness of using public funds for art that questions the government and public attitudes. This lesson explores the central issues raised by the poster.

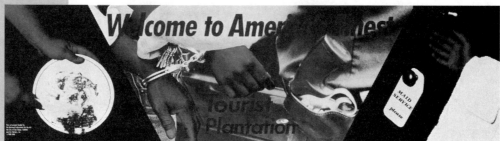

Elizabeth Sisco, Louis Hock, and David Avalos
Welcome to America's Finest Tourist Plantation, 1988
Commercial silkscreen
photo-montage with text
21″ × 72″
External Bus Poster

Suggested Procedures:

1. After showing the slide or reproduction of *Welcome to America's Finest Tourist Plantation* provide students with the following state-ments from the three artists:

Question to the Artists: Is placement on the back of buses which go throughout the city the appropriate medium for the display of this kind of artwork, or would it be better in an art museum?

Elizabeth Sisco: I think it's the perfect place for this artwork. We chose it very carefully. One, we are symbolically putting the people back on the bus that Immigration has taken off. Secondly, in San Diego there has been an endless dispute over what public art can be sanctioned and what public art can be prohibited.... Instead of ghet-toizing our art in the galleries and museums, if we truly want our art to be public art then we have to seek to create the space ourselves. We have been able to create an artwork that has no boundaries; it travels throughout the city. It travels through every neighborhood in the city and reaches a very diverse population.[1]

David Avalos: They [the Convention and Visitors Bureau] are work-ing constantly to reinforce the idea of San Diego as a tourist town. Those messages are designed to satisfy the fantasies and wishes of people who don't live in San Diego.... One of the things we are saying is that if you are asking public artists to contribute to the

establishment of a community identity it has to be done based on the needs of the people who live in that community ... and that one of the overlooked segments of San Diego society is the undocumented worker. That's what we are trying to get at with this piece.[2]

Louis Hock: We wanted to deal with a topic that's indigenous to our area. We wanted to make a statement that would relate to people taking the bus. We didn't want to make art for Hallmark cards. Art is not meant to be a cheerleader. It is the responsibility of the artists who receive public funds to show things the way they see them. This piece directly addresses an important element in the local situation. I'm interested in art that makes the invisible visible. That's one of the most powerful roles that art can play.[3]

2. Ask students:

a. What is the role of public art in society today? Does it have more than one role?

b. What are the different roles public art can play in a society?

3. Ask students to consider whether it is valid for artists to try to provoke public debate through their artwork. Does this take away from the work's validity as art? (To stimulate discussion, make a comparison to rap music or other popular musical expression. Does the fact that some rap music deals with serious social issues make it a less valid form of music?)

4. Explain that controversy arose over the fact that some of the funding for the bus poster came from public funds (federal and city money regranted through the Combined Art and Education Council of San Diego County). Some felt that it was inappropriate to use government funds to address the role of undocumented workers in the California tourist industry. Ask students:

a. When disbursing government money for the arts, is it government's responsibility to provide opportunities for expression of a diverse range of ideas, even those which may not coincide with some government policies?

b. Should every taxpayer have a chance for representation?

c. Who defines the "public" the government is supposed to serve?

Art in the Public Realm

Lesson 40: **Welcome to America's Finest Tourist Plantation**

335

? Objectives:

a. Students will identify and discuss the roles of public art in society.

b. Students will explore public reactions to a controversial public artwork and examine the role of government funding in public art projects.

c. Students will discuss the concept of borders.

✓ Resources:

Articles:
"The Politics of Nativism,"
Anthony Lewis,
The New York Times,
January 14, 1994, A29.

Artist Statement:
Jimmie Durham

Slides:
Melissa Antonow: *Come to Where the Cancer Is* (p. 52)
Border Art Workshop/Taller de Arte Fronterizo: *Whitewash(ed) Portable Exhibit* (p. 60)
Gran Fury: *Women Don't Get AIDS, They Just Die From It* (p. 284), *Welcome to America* (p. 67), *Kissing Doesn't Kill: Greed and Indifference Do* (p. 296)
Yolanda M. López: *Who's the Illegal Alien, Pilgrim?* (p. 246)
Jean LaMarr: *They're Going to Build It Where?!?* (p. 76) and *some Kind of Buckaroo* (p. 43)
Elizabeth Sisco, Louis Hock, and **David Avalos:** *Welcome to America's Finest Tourist Plantation* (pp. 94, 334)

Equipment:
Slide projector and screen.

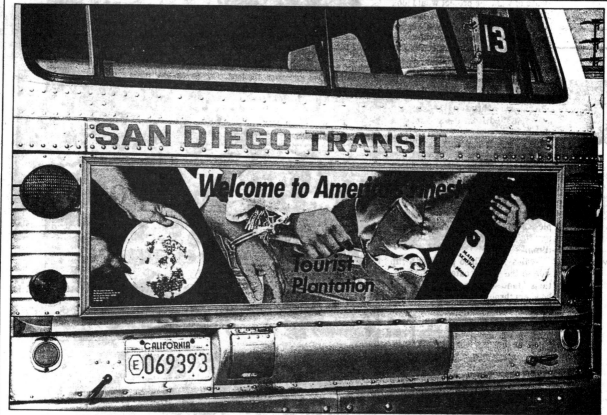

The San Diego Union

A Copley Newspaper

Thursday, January 7, 1988

The San Diego Union/Dennis Huls

The work of local artists on display on several transit buses have San Diego officials upset. The creation entitled "Welcome to America's Finest Tourist Plantation" deals with the plight of undocumented workers.

Bus art takes a controversial route

By Steve Schmidt, Staff Writer

One group's artistic statement has turned into another's public relations nightmare.

Over the weekend, the backs of 100 San Diego Transit buses were plastered with a striking poster that declares: "Welcome to America's Finest Tourist Plantation."

The horizontal poster shows what is supposed to be an undocumented worker toiling as a dishwasher, another alien working as a maid, and two people being handcuffed by a U.S. Border Patrol agent.

"We have to recognize that (undocumented workers) are a part of our society," said artist David Avalos, explaining one of the key messages of the mobile work he helped create.

"In one kind of way, it's celebratory (of undocumented workers). In another kind of way, it's not an easy piece," said Louis Hock, another of the artists involved.

"It's reality."

Tourism officials and Super Bowl organizers have taken a look at reality — and don't like what they see.

Phil Blair, a member of the Super Bowl Task Force, believes the display could not have come at a worse time — with thousands of tourists soon pouring into the city for the Jan. 31 football spectacle.

"I don't think it's proper," Blair said yester-

day. "You want to put your best foot forward when you have a house full of guests."

"I think it's done in poor taste," said Ted Kissane, president of the San Diego Hotel-Motel Association. "It's perplexing to me why anyone would want to tear down their city."

Fueling the controversy further is that part of the money used to pay for the $8,000 project came from the largely city-funded Combined Arts and Educational Council of San Diego (COMBO).

According to Hock, COMBO contributed $4,600 to the project, allocating money raised partly

See **Bus** on Page A-10

Art in the Public Realm

Lesson 40: **Welcome to America's Finest Tourist Plantation**

The San Diego Union

Col. Ira C. Copley, 1864-1947
James S. Copley, 1916-1973

Editorials/Opinion

Helen K. Copley, Publisher
Gerald L. Warren, Editor

Page B-6 *A Copley Newspaper* Tuesday, January 12, 1988

With freedom... responsibility

By Whitney Mandel, Ph.D.

Displayed on the back of 100 public-transit buses is a poster which carries the message "Welcome to America's Finest Tourist Plantation." The artwork depicts what the artists say are undocumented workers being handcuffed by a U.S. border patrol agent and two others working as a dish washer and a maid.

The poster has caused quite a commotion in America's finest city — mainly because of media attention drawn to it and because the controversial message was largely paid for with public funds.

The artists are the only ones who will assume responsibility for the work, although grant money was administered by the Combined Arts and Education Council of San Diego (COMBO) and approved by a City Council advisory peer panel. These groups say that the San Diego Transit should have intercepted the poster, but they do not explain how transit officials could have legally rejected the artwork.

The commissioned artists, David Avalos, Louis Hock, and Elizabeth Sisco, are widely known for provocative work. Earlier creations dealt with the plight of Mexicans along the border. They say their handiwork

Commentary

The Union welcomes commentaries from its readers. Submissions should be typed, double-spaced, and not more than 750 words. Information cannot be provided on individual commentaries because of their daily volume. Inquiries about them, therefore, should not be made. Manuscripts will not be returned.

should come as no surprise to anyone connected with the project.

The artists claim the poster was largely intended to recognize the role undocumented workers play in the local tourism industry. The tourist industry, however, is insulted by what it sees as a grossly inaccurate depiction. Many San Diegans are incensed that their money was dispensed, in such a bumbling manner, for an obviously controversial statement.

Avalos, Hock, and Sisco are pleased that their poster has caused such a stir. What they attempted to do, they say, is to create a dialogue on this issue. Well, the trio certainly did that. "Art," they maintain, "should make a difference to people ... Art has a role, along with medi-

cine, science, and government." No argument here. "If we can stretch the vision of art in San Diego, then we'll have done something."

The artwork was commissioned and displayed in such an egregious manner that it probably will stifle freedom of expression in the city rather than promote it.

It is also logical to assume that in the future, public agencies will be reluctant to consider art that even hints of controversy.

The art is insulting and embarrassing to the community, and some feel it is racist as well. But if the posters are removed from the buses now, the San Diego Transit risks the possibility of lawsuits. So the posters will stay put through Super Bowl weekend, when the national media will have their say.

In my opinion, this artwork should be displayed, but not on the back of a bus and not paid with public funds. Show it openly and honestly in the proper forum. For, along with First Amendment rights of freedom of expression, comes responsibility and the understanding of long-term consequences.

Dr. Mandel is a local media analyst and the head of the broadcast journalism division at SDSU.

Art in the Public Realm

EL SOL
de San Diego

January 28, 1988

OPINION

Confronting stereotypes

By Consuelo Puente de Miller

My husband and I are long-time residents of San Diego. As members of the business community, we contribute to the local economy, pay our fair share of taxes and accept all the responsibilities of citizenship.

For years, I have kept quiet about the ugly stereotypes that pass for an image of Mexican people in San Diego. I'd become somewhat inured to the violence directed against Hispanics by border bandits, racist thugs and even agents of law enforcement agencies. Like most of us, I had grown accustomed to, but never comfortable with, our people being described as "aliens" in the media. Is that term used because we are green and have antennae, or is the intent simply to dehumanize us?

Now, it's my turn to speak out.

I don't accept the distinction between Chicanos and our blood kin in Mexico. U.S. citizenship does not make one a human being, and the absence of U.S. citizenship does not make anyone a subhuman "alien."

I'm tired of the blatantly racist attitude displayed by many San Diegans toward my people. It's not often directed at me personally because I own my own business, so they don't see me as one of "those people." Mexicans are viewed by many as members of an inferior race, who are pouring, like so many cockroaches, over the border to take American jobs, steal American money and sell drugs to young Americans.

I find this kind of prejudice disgusting, and not very intelligent. Hispanics founded San Diego in 1769, over 75 years before the Anglos came and took the city by military force. The grandparents of the people who want to seal the border sailed through an open border themselves. They came to America to escape poverty and oppression. They came from England, Germany, Ireland, Poland, Italy and Russia in the millions, seeking only an opportunity to work hard and give their children a chance to succeed. These immigrants were willing to accept menial employment, washing dishes, gardening, sweeping streets, and cleaning up after others. Sound familiar?

In the past 15 years or so, Chicanos, Cubanos and Puertoriqueños and other Latinos have asserted their rights as Americans and challenged anti-Hispanic prejudice. While brown faces have begun to appear with more frequency on television, and the news media have "discovered" us, the undercurrent of racism runs deep in America, and in San Diego as much as anywhere.

Most of the time, that racism is kept under the surface. The discrimination is subtle. People who are hiring suddenly are "no longer taking applications" when someone with a Spanish accent inquires. Hispanic youngsters are harassed by sheriff's deputies, police and border patrol officers for "suspicious activity," i.e. being brown and out after dark. Hispanics are theoretically free to elect one of their own to represent them in local government, but in San Diego we are denied that right by a cynical, but effective, gerrymander. Social services for an entire community are given last priority, when that community is Hispanic. That's racism of the "closet" variety.

"Skinheads" and Nazis brag openly about beating Mexicans, and sing that "there's no place for them" in their fascist view of America. Perhaps more San Diegans should be as honest about the way they feel about us.

Prejudice is not restricted to hostile adolescent males. Letters to the *San Diego Union* on January 15, 1988, demonstrate that even "rational" Anglos have deep-seated racist sentiments. Responding to a controversial work of art, Anglos from the lily-white towns of Lakeside and Poway wrote poison-pen letters describing the "ingratitude" of Mexicans and suggesting that we go "back to Mexico." Few Anglos have any idea how painful that tired old phrase is to us.

Although insulted by this kind of invective, I realize that the authors of those letters were merely being honest. If, as I suspect, they are expressing the view of the majority in San Diego, then we are in for a confrontation such as hasn't been seen here since 1846.

We were here first. We belong here. And if others don't like our color, our language or our customs, then I feel sorry for them. We are nearly half a million strong in San Diego County. We're growing stronger every day, and we aren't going anywhere.

Consuelo Puente de Miller is a businesswoman and the outgoing President of the Chicano Democratic Association.

Art in the Public Realm

San Diego Business Journal

— EDITORIAL —

WEEK OF JANUARY 11, 1988

Public art not required to ape majority's views

We don't think the city of San Diego or Combined Arts and Educational Council members have to apologize for providing money to artists who created the controversial posters appearing on San Diego Transit buses.

The posters, by artists David Avalos, Louis Hock and Elizabeth Sisco, depict illegal aliens working as maids and kitchen helpers in two photographs, and being handcuffed in a third. The posters carry this message: "Welcome to America's finest tourist plantation."

The work has shocked tourist officials here, who strongly disagree with the artists' point of view.

The work will shock and startle others here in the coming weeks; it startled us. Many others will disagree with the artists' viewpoints; we also disagree.

But all of that is beside the point. It is not a requirement of public art that it support the popular point of view. Art that shocks people into thinking, that startles the imagination and that challenges preconceived notions is art serving an important purpose.

The artist must be true unto himself; his work must support his own views.

Having said that, we would note that the artist also has a responsibility to the public and to the rest of the arts community.

The posters have stirred up enough anger that city officials may feel pressured into initiating more control over the sort of artwork that is placed before the public. That would be an unfortunate overreaction.

It is essential that artists who produce public works be granted the freedom of expression. But the artists themselves bear a portion of the responsibility for making sure that freedom is retained.

Art in the Public Realm

Lesson 40: **Welcome to America's Finest Tourist Plantation**

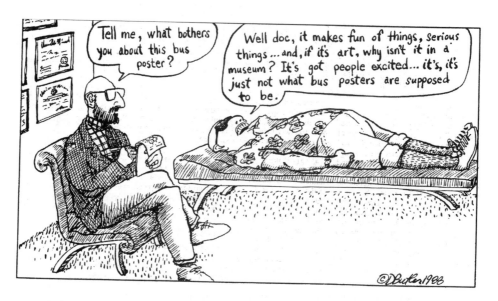

5. Ask students to create a bus poster. Instruct them that it is to be an artwork expressing a viewpoint about undocumented workers such as migrant agricultural laborers, restaurant and hotel workers, or sweatshop employees.

6. Invite students to present their finished posters. Conduct a discussion about opinions expressed in the posters. Were students able to use artistic techniques effectively to enhance their message?

7. View the following slides: *Come to Where the Cancer Is* by **Melissa Antonow**, and each of **Gran Fury**'s busboard ads and billboards. How do these artworks combine art and a public message? Do the artists get their message across effectively? Are these works successful from an aesthetic point of view?

The following questions focus on border and immigration issues:

8. Over the last 500 years, borders have been forcibly imposed by European outsiders on the indigenous peoples of the Americas. Assign students to read the statement by **Jimmie Durham** and discuss his perspective on borders. How might native peoples of the Americas view current geopolitical borders?

9. Look at the slide of **Yolanda M. López**'s *Who's the Illegal Alien, Pilgrim?* What position does the artist take on the issue of "illegal aliens"? Do students agree or disagree with López?

10. Ask students to respond to the following argument (which reflects some of the opinions published in response to Sisco, Hock and Avalos's poster): No one forces people to migrate to the U.S.; undocumented people are here because the U.S. is better than where they came from. Because they are here illegally, they do not deserve the same rights afforded to U.S. citizens and should be deported.

11. Discuss the argument that undocumented workers steal jobs from "Americans." Are the unemployed Americans who are complaining likely to take the kinds of jobs available to undocumented laborers, such as becoming day laborers in the fields, dishwashers, or garment workers? Is there a consensus among students? If not, what divides their opinions?

12. Have students research and discuss newspaper articles presenting various points of view about immigrants, "legal" and undocumented.

13. What should United States immigration policy be? Should anyone who wishes be able to live in the United States? Become a citizen? If not, on what basis should these decisions be made (i.e., who and how many can come)? What should the requirements of citizenship be?

14. What are the historical and economic reasons that account for the disparity in living standards between the U.S. and Mexico, or between the U.S. and any other country whose citizens migrate here for economic reasons? Are the inconsistencies in immigration quotas for different countries based on political or humanitarian factors? Compare and discuss the history of U.S. immigration policy toward Cubans and Haitians, for example. What are the differences in policy? What accounts for these differences?

15. Fifteen U.S. states border either Mexico or Canada: what kinds of activities take place at these borders every day? Who regulates these activities? Are the cultures on either side of these borders different or similar? How? Are the cultures of, for example, Texans and Mexicans

more similar or more different than the cultures of Texans and Vermonters? How so? What shapes the interactions of people living on either side of these borders more, the political boundaries separating them or shared cultural elements?

16. View slide of **Jean LaMarr**'s *They're Going to Dump It Where?!?* and *Some Kind of Buckaroo*. What comments do these artworks make about reservation borders, and in particular, use of Native American lands for nuclear waste dumping and missile siting and testing?

17. The concept of physical borders operates in many ways (for example, most towns have "good" and "bad" neighborhoods). Ask students to identify borders in their own community or city. Who creates these borders? Who decides if and when they may be crossed, and by whom? Are these borders old or new? Do they change? Should they exist? Are they a positive or negative factor in the community?

18. Ask each student to draw a map delineating the borders of their community, however they choose to define it. Have students compare maps covering the same geographic area. Did students learn anything new from one another about communities they are already familiar with?

19. Ask students to consider the idea of boundaries and then draw a second, imaginary map. (It might reposition or eliminate boundaries, or represent an ideal or utopian community or world, or even a map of oneself.)

20. Read the following description of the *Whitewash(ed) Portable Exhibition* initiated by the **Border Art Workshop/Taller de Arte Fronterizo,** and discuss the phenomenon of teenage border vigilantes in California:

> The idea for the exhibit *Whitewash(ed)* at the Centro Cultural de la Raza and the Portable Exhibit came from the actions of teenage border vigilantes playing war games and hunting undocumented persons in the Tijuana/San Diego border region. The idea that young people mimic their elders' actions to justify these games led us to examine the attitudes

underlying these incidents. The artwork addressed prevailing attitudes of racism, discrimination, and prejudice and aimed at creating understanding for the plight of those who are considered "different." We encouraged the viewers to identify their own prejudices and to realize the commonalities between other people who face discrimination and themselves.

There were two parts to this project: 1) *Whitewash(ed),* in which over twenty-five artists from Tijuana, Mexico; San Diego, U.S.A.; and London, England participated, and 2) the Portable Exhibition, an extension of *Whitewash(ed)* that toured four San Diego-area high schools. The main focus of this project was the Portable Exhibition for the high-school students.

The portable high-school exhibit was constructed of painted cardboard, paper, and light-weight wood held together with wire, nuts, and bolts. It consisted of different stations where the student viewers were asked to respond in writing to different questions. In a giant book with painted cardboard pages, for example, viewers were asked questions such as "Have you ever experienced discrimination?"; "Name three things that you value in life"; "I can ..."; "I wish ... "; "I feel ... " One page merely read: "You are important. Sign here." We wanted to show how people who are different share many of the same hopes and fears and encourage them to realize their similarities instead of fearing their differences.

In a few of the other stations the artists told of their personal experiences with prejudice and discrimination and then asked the students to write about their own experiences. The writing was done directly on the walls like graffiti. We hoped that the process of each school contributing to the exhibit as it traveled would connect different schools from across the county.

When visiting schools, the activities, possible motivations of the teenage vigilantes, and current events in relation to vigilantism were discussed at length. Important to each visit was the group discussion that followed the exhibition viewing. We also made a brochure to hand out to the students to promote discussion on the issues. Later, we decided to make a booklet documenting the students' writ-

ings, including photographs of our visits. The booklet was then sent to the high schools with an invitation to photocopy and use for their own classes.

Most exciting about this project was that we provided a means for students to express themselves. We, as artists, took one step back and became the channels for other peoples' expression. The most gratifying response to this project came from one of the high schools which chose to produce an art exhibit on racism themselves. They invited us back to view their work, and what we found was a wealth of creative response and energy. The students made books, collages, installations, art objects, and asked for written responses to questions they had developed. They installed their exhibit in the school library and had classes from the rest of the school visit. The audience for the issue of racism multiplied from the five classes we visited to the entire school. The student artists were proud of their work. Not through our efforts, but through the efforts of their peers, a whole new group of students found the time to question racism and its effects on themselves and society.

21. Ask students if they are aware of similar activities in their own communities. Why would teenagers want to "hunt" undocumented persons? Use the above project description as a model for a class project. Ask students to choose a theme from all the issues discussed in this lesson. Ask them to create individual or group artworks addressing that issue. Students might then plan an exhibition in their school, and even travel the exhibition to another school.

Evaluation:

Do students have an understanding of issues of border politics, particularly those relating to the U.S.-Mexico border? Do they grasp the basic issues in the debate over government funding for public art, as well as who public art is created for?

Lesson 41: **The Vietnam Veterans Memorial**

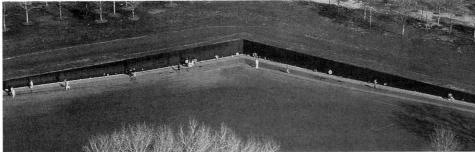

Maya Lin
Vietnam Veterans Memorial
Washington, DC, 1982
10′ × 250′
Black granite

Suggested Procedures:

1. Explain to students at the outset that after discussing the *Vietnam Veterans Memorial,* they will design memorials of their own. Ask students if they ever created a memorial of any kind. If so, to whom? What was its main purpose? Was it a public or private memorial? How did it make them feel? How did other people respond?

2. When **Maya Lin**'s design for the *Vietnam Veterans Memorial* was revealed, the proposed memorial was referred to as a "black ditch," "antiheroic," and a "black gash of sorrow and shame." (By contrast, Maya Lin has discussed her choice of black granite using words such as "peaceful," "comforting," and "gentle.") Ask students why the association of the color black with the veterans memorial was unacceptable to some politicians and veterans. Why would anyone refer to Lin's design as "antiheroic"? What is a hero? What is the role of war "heros" in memorials? Are all those who die in a war heros?

3. Explain that when it became known that the winning design for the memorial was a 21-year-old woman of Chinese descent, some people expressed outrage. Does this matter in deciding who should design the *Vietnam Veterans Memorial*? What may have motivated the angry reactions? Should ethnic background, gender, or age qualify or disqualify someone from creating a memorial to veterans of a war?

Background Information:
The Vietnam War represents one of the lowest points in United States history. It was this country's longest war, with the U.S. supplying troops from 1961 to 1975. Among the 2.7 million U.S. citizens who served in the war zone, 300,000 were wounded, 75,000 were permanently disabled, and nearly 60,000 were killed.[4] The United States' failure to "win" the war and the American public's awareness of atrocities committed by U.S. troops led to widespread hostility; the Vietnam War represented an ugly episode most of the country wanted to forget.

In the twenty years since the troops were brought home, approximately 100,000 have committed suicide, 40,000 more than were killed in combat during the war.[5] Thousands more continue to suffer from what is now called "post-traumatic stress disorder," unusually high levels of cancer, and birth defects in their children possibly caused by exposure to the herbicide "Agent Orange."

The end of the war did not represent an end to the emotional turmoil it created, much of which was rekindled in 1979 when a private organization led by veteran Jan Scruggs announced plans to create a veterans memorial.

The controversy surrounding the selection in 1981 and eventual realization of **Maya Lin**'s *Vietnam Veterans Memorial* design in 1982 was intense. The story of the memorial serves as a powerful example of the role of the public (as opposed to politicians, the media, and art critics) in shaping how the Wall—the most visited memorial in the United States—has come to be received.

Objective:
Students will examine the history of and public controversy over the *Vietnam Veterans Memorial* and create a memorial.

☑

Resources:
Slides:
Maya Lin: *Vietnam Veterans Memorial* (pp. 79, 345–346), *Civil Rights Memorial* (p. 324)

4. Central to the founder of the Vietnam Veterans Memorial Fund, Jan Scruggs, was the idea of raising the funds for the memorial from the public rather than from the federal government. Over half a million individual contributions were made, many in denominations of $5 or $10. Ask students what, for Scruggs, might have been the difference between having the government pay for the memorial versus raising money from private citizens? To whom does a memorial belong?

5. Read to students the following statement about the *Vietnam Veterans Memorial*: "It is literally one of the few art objects you can touch.... This work allows you to engage in ritual grief and loss through an interaction with historical process in which you alone, and maybe the people you come with, are the people whose version of history is important."[6] Based on this statement, what are some of the purposes of a memorial?

Vietnam Veterans Memorial

6. Over 25,000 objects and mementos have been left at the Wall in memory of the dead and missing. These objects are collected by the National Park Service and stored in a warehouse. In November 1992, on the tenth anniversary of the dedication of the Wall, an

Vietnam Veterans Memorial

exhibit of these objects, "Personal Legacy: The Healing of a Nation," was mounted at the Smithsonian Museum of American History. What is the relationship of these private objects to the public memorial? Once the mementos have been left behind, are they part of the memorial?

7. Are students aware of any memorials in their own communities? What kind? Who made them? Are they meaningful to the local community? What purposes do they serve? How do people in the neighborhood respond to them? Are they reminders of something positive or negative, or both? Do they carry a message?

8. As a warm-up exercise, consider designing a Vietnam memorial from different points of view. For example, artist Chris Burden created a work in 1991 entitled *The Other Vietnam Memorial*, which consisted

Art in the Public Realm

Lesson 41: **The Vietnam Veterans Memorial**

of panels containing scrambled names of Vietnamese casualties of the war. Ask students what a memorial designed by medics or nurses might look like. How about a memorial designed by the families of those who didn't return? Show students the slide of Lin's Civil Rights Memorial, created in 1989, as another example.[7]

9. Based on their responses to the above questions, assign students to design a war memorial reflecting their own feelings about the Vietnam War, or any war they've studied or experienced personally. If students have relatives or know anyone who has experienced a particular war, they could ask them what kind of memorial would meaningfully represent it.

10. In the *Vietnam Veterans Memorial* design competition, contestants were required to adhere to several guidelines. Among them, the names of all Americans who died or are still missing in the Vietnam War had to be engraved on the monument; designs had to be sensitive to the nearby Lincoln Memorial and Washington Monument; and the memorial was to refrain from making any political statement about the war. Ask students to create a list of guidelines for their memorial projects. Begin by asking them to decide who or what they intend to memorialize. (Give students the option to work in groups if they prefer.)

11. Maya Lin asked herself the following questions to focus her ideas for the Vietnam memorial: "How are all these people going to overcome the pain of losing something? How do you really overcome death?"[8] Suggest that students, after they decide on the subject of their memorial, ask themselves the same questions.

12. Have students create scale models of their proposed memorials. When complete, they should present them to the rest of the class.

Evaluation:

Do students know the basic history surrounding the Vietnam War? Do they understand the controversy caused by Lin's memorial? Do they have a better understanding of the purposes of memorials?

Lesson 42: **Colorado Panorama:**
A People's History of Colorado

Background Information:

In the same way that Maya Lin's Vietnam memorial questions traditionally heroic, glorified representations of wars and creates a space for individual experience of history versus a single, prescribed version, and Sisco, Hock, and Avalos's poster questions official policy about who "belongs" in the United States, Barbara Jo Revelle's tile photo-mural questions the usual textbook versions of history. She has created an artwork depicting a version of Colorado history including many people who are omitted from "official" history books, echoing Sisco's strategy of "putting back on the bus" people who have been taken off by those more powerful. Among those represented in Revelle's mural are miners, labor activists, civil rights leaders, and suffragettes–all of whom shaped and contributed to the history of Colorado. Revelle's vision conflicted with the views of those who believe that Colorado and its history "belongs" only to male, European American settlers and their descendants.

Installed on an outside wall of the Colorado Convention Center in Denver, Revelle's mural consists of photo-based computer-generated images translated into 300,000 tiles. Stretching for 600 feet, it contains the faces

Suggested Procedures:

Barbara Jo Revelle
Colorado Panorama: A People's History of Colorado,
1991
Computer screen scanned image/tile mural
8' × 600'

1. Provide students with a copy of the mural key for section 13 featured on p. 350. Ask them to read it and note which inclusions surprised them or puzzled them. Ask them to explain their reactions. Did the subjects selected by Revelle and her advisors represent characters typically found in history books? Explain. In a public art work commemorating the history of a place, how should the people who will represent this history be chosen? Who writes history? What is the purpose of a public artwork such as Revelle's?

2. Revelle's mural was inspired in part by Howard Zinn's *A People's History of the United States* (see American Identity lessons, chapter 7). Ask students if they are familiar with any artists who have used historical subject matter as an inspiration for their art. You may wish to introduce a sample of artworks with historical subject matter: ask students to compare the portraits of Eugene Delacroix or John Singleton Copley for example, with Revelle's "portraits." Are there differences in the types of the subjects represented?

Are there differences in how the subjects are portrayed? Were they painted with the same purposes as Revelle's art?

3. Revelle digitized the photographs used in the mural, in some cases dramatically altering them for aesthetic and historical reasons. For example, she created an image of a black woman shearing sheep by combining two photographs because no photos documenting that past were ever made. Does the computerized alteration of the photographic images affect the content of the mural in any way? Does it affect the historical authenticity of the mural? Does an artist have the right to alter images in order to communicate a point?

?

Objective:
Students will explore how one artist interpreted Colorado's history through a large-scale public artwork and they will examine the process of deciding whose history is legitimate to record.

✓

Resources:
Slides:

Barbara Jo Revelle: *Colorado Panorama: A People's History of Colorado* (p. 87, 348–349)

4. Denver city officials fought unsuccessfully to have two figures, Corky Gonzalez and Lauren Watson, removed from the mural. Watson founded the Black Panther Party in Denver and was an integration advocate, and Gonzalez was a boxing champion, poet, and crusader for the human and civil rights of Chicanos. Why do you think city officials objected to the inclusion of these two people in the mural? Do you think they should be included? Why or why not?

Art in the Public Realm

Women's Wall, Mural Section #13

1A Pinnelo, Blanche–1881-1970, El Paso County, Italian Immigrant

1B Roach, Josephine–1886-1976, Denver, progressive owner of Columbine mines, fought exploitation of women

1C Lathrop, Mary–1865-1951, Denver, first woman admitted to Colorado Bar Association

1D Garcia, Theresa–1896-1980, Huerfano County, cook, housekeeper

2A Smedley, Agnes–Western Colorado, journalist, writer

2B Flowers, Ruth Cave–African American denied a high school diploma because of her race, went on to get her doctorate and law degree

2C Red Feather–Native American turn-of-the-century Denver opera singer, entertained World War I soldiers, toured France

2D Decker, Sarah Platte–Denver, Suffragette

3A Jones, Mother–1843-1930, toured Southern Colorado, labor activist

3B Magee, Sven–Swedish, 1881-1976, El Paso County, mother

3C Loy, Mina–Aspen, accomplished poet

3D Drewlow, Eve–1899-1988, Boulder/Denver, painter

Art in the Public Realm

Lesson 42: **Colorado Panorama**

5. Other figures considered controversial by some were AIDS activist Michael Ryan, Colorado's first known Person with AIDS; Gavin Lodge, a Vietnam veteran whose death was caused by Agent Orange; and victims of the Sand Creek and Ludlow massacres. Is it legitimate to exclude people who have suffered injustices, or who represent tragic or ugly events that we are not proud of?

Assignment:

Research the history of your own area. Choose a geographical area of any kind (state, city, neighborhood, your own street or block). Decide what kind of history and whose history you want to present. Research local historical and contemporary figures in your library and community newspapers. If you want to include people about whom nothing is recorded, conduct interviews (audio or video) with the subjects (or those who knew them). Take photographs if possible, or create images. Think of a creative format in which to present your local history. If you like, design and make a scale model of your history in the form of a public artwork. Include in your plan the following: content and objectives, consultants or collaborators (if you choose), a design sketch and/or scale model, a list of materials, your intended audience, and a proposed location.

To help begin the research process, provide students with the following biographies of two of Barbara Jo Revelle's historical subjects:

Senon Martinez (1900–1986)

Senon Martinez was a Hispanic and Cherokee farmer and rancher from the Huerfano Valley in southern Colorado.

Senon Martinez was born on June 23, 1900, at Mavricio Canyon, in the mountains west of Aguilar, Colorado. His father, whose Cherokee ancestors had fled Oklahoma for the Huerfano Valley, was a bootlegger, gambler, farmer, and rancher. Martinez was the oldest of fourteen children, and he quickly learned to survive.

Martinez was a very inventive man. In his early teens he built an operable hay baler which was pulled by dogs. He also built a helicopter using parts of a milk separator, but was unable to stabilize the engine; although the helicopter did get airborne, it went in circles.

Martinez completed the fifth grade, and devoted himself to education for his family and his community; in 1937 he served on the Rouse School Board. Martinez taught himself to read and also taught himself to do sums. With the help of his wife and children, he learned to speak English. Martinez also helped less fortunate neighbors whenever possible. Many times Martinez bought shoes, rubber boots, and coats for poor children in the winter. On many occasions he built coffins for poor families that could not afford to buy them.

Throughout his life, Martinez kept a farm and ranch as well as a sawmill. He hauled timber and lumber for Colorado Fuel & Iron for thirty years in round trips that took three days or more. For nine years he also worked in the coal mines as an explosives expert and mule trainer. He also built roads through the mountains, some of which were emergency access fire roads for the U.S. Forest Service.

When he was 21, Martinez married Sarefina Garcia, who was 14. Together they had eleven children. Senon and Sarefina raised their family with a pride in their culture, with a deep respect for nature, and with great optimism. Even today, Martinez's friends and family recall that he began each day as the "first day of the rest of his life." Senon Martinez died on July 13, 1986.

Susan Anderson, M.D. (1870–1960)

Susan Anderson, known to her patients as "Doc Susie," was a physician who served the community of Framer in the Rocky Mountains for fifty years.

Born in Monroeville, Indiana, on January 29, 1870, Anderson spent most of her youth in Kansas. Encouraged by her father, she enrolled in the Medical School at the University of Michigan and received her degree in 1897. She then went to Cripple Creek to join her father and brother and opened up a medical practice in the booming mining town. Anderson found the miners accepted a "lady doctor," since the alternative was sewing up their own barroom wounds. However, her father felt the boom town was hardly the place for a young woman, and he prevailed upon her to move to Denver. Anderson moved to Denver in 1900, but found that a woman doctor was not accepted there. She moved north to Greeley, but found doors closed

to her there as well. Forced to work as a nurse, Anderson grew increasingly discouraged and fell ill with what she diagnosed as tuberculosis. She decided to move to the mountain community of Framer for her health.

In December of 1907, Anderson took the Moffat train over Rollins Pass and arrived in the two-year old town. She took a job as grocery clerk, but word soon got out that she was a physician. Soon the people of Framer began to ask her to treat emergency cases. She even found herself acting as a veterinarian. After an initial period of resistance to the idea of a woman doctor, Anderson found herself with an established practice and a town full of patients.

"Doc Susie," as she came to be called, was known for skiing through blizzards to treat patients in outlying areas. She was also famous for refusing to use anesthetics during medical procedures; she feared that if she kept them around, someone might be encouraged to break into her house to get them. She rarely wrote prescriptions but gave away the free samples sent her by drug companies. She served the community of Framer for nearly half a century, until a stroke partially paralyzed her in 1956. She lived in Denver from 1956 until her death in 1960.

Note: The above biographies, and those of all the individuals represented in "A Colorado Panorama" have been compiled by Revelle and her research assistants and are available in a newspaper format. To obtain a copy, contact: Barbara Jo Revelle, (303) 494-8822.

7. Present finished proposals to the rest of the class. If any of the proposed projects are feasible to implement, have students choose the strongest one and make the project as proposed.

Evaluation:

Are students more aware of how choices are made as to who is represented in history texts? Has students' definition of "history" broadened? Did students successfully record their own local history?

Objective:

Students will survey a range of public artworks and their purposes.

Resources:

Slides:

John Ahearn and Rigoberto Torres: *Banana Kelly Double Dutch* (p. 51)

Melissa Antonow: *Come to Where the Cancer Is* (p. 52)

Houston Conwill, Joseph DePace, Estella Conwill Majozo: *The New Ring Shout* (p. 63)

Gran Fury: *Women Don't Get AIDS, They Just Die From It* (p. 286); *Welcome to America; Kissing Doesn't Kill: Greed and Indifference Do* (p. 298)

Guerrilla Girls: *Do Women Have to be Naked to Get Into the Met? Pop Quiz* (p. 70), *Women Earn 2/3 of What Men Do*

David Hammons: *Higher Goals* (p. 72)

Keith Haring: *Crack is Wack* (p. 73), *Untitled* (p. 129)

Elizabeth Sisco, Deborah Small, Scott Kessler and Louis Hock: *America's Finest?*

Krzysztof Wodiczko: *Homeless Vehicle, Arco de la Victoria, Madrid*

Lesson 43: **More Examples of Public Art**

Suggested Procedures:

1. View each of the slides listed on this page. For each one, ask:

a. What are the artists communicating through the work?

b. What methods or techniques do they use to communicate their points of view?

c. Why did the artists choose the medium of public art?

d. Does the artwork express its point of view effectively?

e. Is art a good way to get across these artists' concerns?

Evaluation:

Are students more aware than before of the different forms of contemporary art which address the general public? Are they capable of analyzing such works taking into account both content and aesthetic considerations?

Notes

1. Transcribed from "Face to Face," a San Diego television talk show hosted by David Santos, aired on January 26, 1988, Southwest Cable, Cox Cable.
2. Ibid.
3. From documentation compiled by the artists.
4. *Reflections on the Wall: The Vietnam Veterans Memorial,* introduction and narration by Edward Clinton Ezell (Harrisburg, PA: Stackpole Books, 1987).
5. Martha Voutas Creamer, panel discussion "Regret To Inform" held at The New Museum of Contemporary Art on October 29, 1991.
6. Rayna Green, Interview with Susan Cahan, July 8, 1991.
7. For more information on *The Other Vietnam Memorial* by Chris Burden see *Dislocations* exhibition catalogue by Robert Storr, The Museum of Modern Art, New York, 1991.
8. Peter Tauber, Monument Maker," *New York Times Sunday Magazine,* February 24, 1991, p. 54.

Part 5:

Resources

Annotated Bibliography

Compiled and Annotated by

Eduardo Aparicio

Art Education

The Art of Education. *Heresies* #25, Vol. 7, No. 1.

The journal *Heresies* was dedicated to art and politics from a feminist perspective. This special issue contains articles on the effect of education on women. Teachers will find Carolien Stikker's "Children's Lives as Curriculum" helpful for her ideas on how to create a responsive curriculum based on the needs of the community. Other essays of interest to teachers are: Lucy Lippard's "Women, Art, and Cross-Cultural Issues"; Sheila Pinke's "Toward a Synthetic Art Education"; Clarissa T. Sligh's "On Being An American Black Student." This issue is out of print, but available in many libraries. A few reprints are also available at $6.75 from: Printed Matter, 77 Wooster Street, New York, NY 10012. Telephone: (212) 925-0325. Fax: (212) 925-0464.

Ellyn Berk, ed. *A Framework for Multicultural Arts Education.* Volumes I, II, and III. New York: National Arts Education Research Center, 1989 and 1991.

These three very practical volumes present a survey of the current status of multicultural arts education in each of the fifty states and an annotated bibliography of selected books and essays. Volume I defines goals and objectives for art education from a multicultural perspective and includes recommendations for curriculum development. Volumes II and III provide multicultural and interdisciplinary lesson plans. Each $16.00 volume can be ordered from: National Arts Education Research Center, 32 Washington Place #51, New York, NY 10003. Telephone: (212) 998-5050.

Robert Bersson. "Why Art Education Lacks Social Relevance: A Contextual Analysis." In *Art Education,* Vol. 39, No. 4, pages 41–45.

This essay contains a critique of individual-centered approaches to art education and Discipline-Based Art Education. The latter, also known as DBAE, aims to teach art as a balanced presentation of four disciplines: art history, art criticism, aesthetics, and art production. Although it has gained a following, DBAE is criticized by many educators and artists, as Bersson does here, for not being concerned with the social dimensions of art and for its lack of relevance in an increasingly pluralistic society. Bersson calls for an art education that concerns itself with applied grassroots-based art.

Howard Gardner. " Multiple Intelligences: Implications for Art and Creativity." In William J. Moody, ed. *Artistic Intelligences: Implications for Education.* New York: Teachers College Press, 1990.

Psychologist Howard Gardner questions the concept of a single intelligence. Building on the findings of psycho-pedagogue Jean Piaget, Gardner further develops his own theory of multiple intelligences as defined in his earlier book *Frames of Mind: The Theory of Multiple Intelligences* (New York: Basic Books, 1983). Seven types of intelligence are defined: linguistic, logical-mathematical, musical, spatial, bodily kinesthetic, interpersonal, and intrapersonal. The author discusses the implications of these concepts for art, creativity, education, and student assessment. Other relevant essays by Cinthia Colbert and Larry Kantner appear in Chapter 8 of this anthology.

Journal of Multi-cultural and Cross-cultural Research in Art Education.

This journal, focusing on art education from a multicultural perspective, is published once a year. One particularly useful article is Mary Stokrocki's "Teaching Art to Students of Minority Cultures" (Vol. 6, No. 1). Stokrocki discusses teaching as a process of human interaction. She calls for a polymodal approach to art education to meet the needs and preferences of culturally diverse students. The author cites concrete examples of successful adaptive teaching strategies. Teachers will also find Nancy R. Johnson's discussion of Discipline-Based Art Education interesting (Vol. 6, No. 1). Back issues are avail-

able at $13.00 for individuals or $20.50 for institutions. Contact Dr. Lois Petrovich-Mwaniki, Department of Art, Western Carolina University, Cullowhee, NC 28723-9029. Telephone: (704) 227-7272.

Studies in Art Education: A Journal of Issues and Research

Selected essays from this publication can be useful. A quarterly publication, *Studies in Art Education* contains articles that explore practical aspects of art curriculum and program development. The Summer 1990 issue (Vol. 31, Issue 4) deals with culture, society, and art education. The essays by Janet Wolff and Paul Duncum on art, education, and ideology are particularly illuminating. Another helpful article in the same issue is "Teaching Art in the Multicultural Classroom: Six Position Statements," by Wasson, Stuhr, and Petrovich-Mwaniki. Teachers will also want to refer to Lynn M. Hart's "Aesthetic Pluralism and Multicultural Art Education" (Vol. 32, Issue 3, Spring 1991). Contact the National Art Education Association, 1916 Association Drive, Reston, VA 22091-1590 Telephone: (703) 860-8000.

Bilingual and Multicultural Education

Edna Acosta-Belén and Barbara R. Sjostrom. *The Hispanic Experience in the United States: Contemporary Issues and Perspectives*. New York: Praeger Publishers, 1988. (259 pages)

This collection of essays by leading scholars of the Hispanic experience in the United States examines the history of community development as well as cultural, social, and economic aspects of Hispanic immigration. Some essays address racism, discrimination, and cultural identity. The book also gathers demographic and socioeconomic data on U.S. Hispanics.

James A. Banks and Cherry A. McGee Banks, eds. *Multicultural Education: Issues and Perspectives*. Boston: Allyn and Bacon, 1989. (337 pages)

Educational experts provide a variety of perspectives and conceptual frameworks for implementing a multicultural approach in schools. Part I, "Issues and Concepts," defines basic goals. Parts II, III, and IV explore the complexities of class, gender, and ethnic differences, and how to foster equity. Questions and activities at the end of every chapter offer good tools for teachers. Includes bibliography, glossary, and index.

James A. Banks and Cherry A. McGee Banks, eds. *Teaching Strategies for Ethnic Studies*. Fifth Edition. Boston: Allyn and Bacon, 1991. (538 pages)

This book contains whole chapters on specific ethnic groups: Native North American, Hawaiian, African, Jewish, Mexican, Puerto Rican, Cuban, Chinese, Japanese, Filipino, and Indochinese. Each chapter provides historical and cultural information, appropriate teaching strategies, suggested activities, and readings for students and teachers. Part I presents strategies for integrating content about ethnicity into curriculum. Teachers will find a sample multicultural unit in Chapter 15. The book includes a thematic annotated bibliography and an index.

L. D. Delpit. "The Silenced Dialogue: Power and Pedagogy in Educating Other People's Children." *Harvard Educational Review*. Vol. 58, No. 3, August 1988, pages 280–298.

Delpit examines the culture of power in society and, particularly, in the educational system. Using examples of process-oriented versus skills-oriented writing instruction, the author analyzes rules of power that dominate present discussions about the education of poor children and children of color. Delpit calls for teachers to teach all students explicitly the rules of power as a first step towards a more just society.

Marge C. Gianelli. "Thematic Units for Creating an Environment for Learning." *TESOL Journal,* Vol. 1, No. 1, August 1991, pages 13–17.

Gianelli's thematic approach applies methods and language from more than one discipline to examine a specific topic. This article provides models for developed thematic units of study applicable to elementary and junior high school, incorporating English as a second language, social studies, science, math, art, music, and health. Models are based on successful programs created in the author's school district in Texas. One-year subscriptions to *TESOL Journal* are available to members of TESOL (Teachers of English to Speakers of Other Languages) for $20. Address inquiries to: TESOL, 1600 Cameron Street, Suite 300, Alexandria, VA 22314.
Telephone: (703) 836-0774
Fax: (703) 836-7864.

Carl Grant and Christine Sleeter. *Turning on Learning: Five Approaches for Multicultural Teaching Plans for Race, Class, Gender, and Disability.* New York: Merril/Macmillan, 1989. (276 pages)

The forty-eight lesson plans for grades 1–12 in this book cover a range of subject areas, including art, language arts, mathematics, science, and social studies. Each lesson plan is presented in two versions: the "before" version reflects a traditional approach, while the "after" version is greatly improved by applying a multicultural approach to the subject matter. The book provides many practical ideas for successful teaching, addressing student diversity based on race, ethnicity, gender, social class, and disability. Chapter 3, "Human Relations," offers suggestions to foster nondiscriminatory interaction among students of different groups. The book includes an index.

Sonia Nieto. *Affirming Diversity: The Sociopolitical Context of Multicultural Education.* New York: Longman, 1992. (335 pages)

Multicultural education is presented as a comprehensive plan to combat racism, other forms of discrimination, cultural differences, and structural factors in school that prevent student success. Section I provides an understanding of the many factors that have a bearing on the achievement of students from different backgrounds. Section II includes ten case studies, with testimonials from students. Teachers will find many suggestions in Chapter 12 to put multicultural education into practice. Includes bibliography and index.

John Ogbu. "Cultural Discontinuities and Schooling." *Anthropology and Education Quarterly.* Vol. 13, No. 4, 1982, pages 290–307.

Anthropological research on cultural discontinuities focuses on differences in cultural values, as well as differences in cognitive, motivational, communicative, and interactional behaviors. Anthropologists have studied how some groups do well in school because school culture is congruent with their culture, while other groups do poorly due to cultural discontinuities. Ogbu distinguishes three types of discontinuities: universal, primary, and secondary. He discusses how problems of specific student populations are related to specific types of discontinuities, particularly secondary cultural discontinuities, which develop when a population participates in an institution controlled by another group.

Alba A. Ortiz and Elba Maldonado-Colón. "Reducing Inappropriate Referrals of Language Minority Students in Special Education." In A. C. Willig and H. F. Greenberg, eds., *Bilingualism and Learning Disabilities.* New York: American Library Publishing Company, 1986, pages 37–50.

This essay takes a critical look at assessment and placement procedures for limited English proficient (LEP) students. The authors examine normal behaviors that might be misinterpreted as warranting special education intervention when they are, in fact, related to linguistic differences rather than language or learning disabilities. The authors include a Student Behavior Checklist to help teachers assess possible incompatibilities between the way they teach and the way some student groups learn.

Bertha Pérez and María E. Torres-Guzmán. *Learning in Two Worlds: An Integrated Spanish/English Biliteracy Approach*. New York: Longman, 1992. (215 pages)

In this book teachers will find suggestions for organizing the curriculum and the learning environment to promote literacy in English and the student's home language. Particular emphasis is placed on the needs of young Spanish-speaking children. Activities suggested at the end of every chapter will facilitate integrating literacy with cultural knowledge. Lesson plans generated by eliciting students' interest will lead to more effective teacher-student interaction. The book includes a whole chapter of resources, an excellent bibliography, and an index.

N. Schniedewind and E. Davidson. *Open Minds to Equality: A Sourcebook of Learning Activities to Promote Race, Sex, Class, and Age Equity*. Englewood Cliffs, NJ: Prentice Hall, 1983. (273 pages)

This is a resource book intended to help teachers promote equality in the classroom. It contains games, projects, and other activities designed to raise students' awareness of different racial and ethnic groups and to avoid stereotyping. Each of the ten chapters contains material that can be integrated into different subject areas, such as math and social studies. The book includes a bibliography.

Tove Skutnabb-Kangas and Jim Cummins, eds. *Minority Education: From Shame to Struggle*. Philadelphia: Multilingual Matters, 1988. (410 pages)

The essays in this volume provide a theoretical context for understanding the issues surrounding the education of minority students in international settings, and strategies for reversing the current trends of institutionalized racism, ethnicism, classism and linguism. Skutnabb-Kangas and Cummins argue that strategies for reversing educational failure among minority students are futile unless they are founded in a theoretically coherent understanding of the historical and current power relations between dominant and dominated groups. A wide range of disciplinary and experiential perspectives are represented.

Christine E. Sleeter, ed. *Empowerment through Multicultural Education*. Albany: State University of New York Press, 1991. (340 pages)

This anthology gathers the work of leading educators on multicultural education as a tool for school reform and social change. An excellent introduction by Sleeter offers an overview of the prevailing approaches to multicultural education and their flaws, while defining her own vision of education that is multicultural and social reconstructionist. Part I describes various specific cases of how schools disable female students and young members of oppressed groups. Part II offers strategies for empowerment, advancing the approach of a multicultural and social reconstructionist education, with essays by James A. Banks on transformative curriculum, Lee Anne Bell on group consciousness raising with elementary school girls, and Richard Ruiz on the empowerment of language-minority students. Part III contains two chapters on teacher education for multicultural teaching. The anthology includes an index, notes, and references.

Lily Wong-Fillmore and Concepción Valadez. "Teaching Bilingual Learners." In M. Wittrock, ed., *Handbook of Research in Teaching*, 3rd edition, pages 655–667. Washington, DC: American Education Research Association, 1986.

The authors discuss instructional issues related to the education of students who are limited in English proficiency (LEP). The essay concentrates on central issues to be considered by educators when assessing the appropriateness of instructional methods to be used with LEP students. Based on a partial review of research in bilingual education, the authors address how to implement bilingual education so that it will work as it should.

Democracy and Education

John Dewey. Democracy and Education in *John Dewey: The Middle Works, 1899–1924*, Volume 9: 1916, edited by Jo Ann Boydston. Carbondale: Southern Illinois University Press, 1978. (420 pages)

Considered still relevant today by many educators for his views on education as personal growth, Dewey's major statement of his educational doctrines stimulated the Progressive Education movement in the 1930s and was influential in the 1960s. Teachers will find the following sections engaging: Chapter 7, "The Democratic Conception in Education"; Chapter 11, "Experience and Thinking"; and Chapter 18, "Educational Values." Also available as *Democracy and Education,* New York: Macmillan, 1916 (Paperback edition, 1966).

Jonathan Kozol. *Savage Inequalities: Children in America's Schools.* New York: HarperCollins, 1992. (262 pages)

Based largely on interviews with school children conducted throughout the U.S. in 1988 through 1990, Kozol denounces racial segregation, economic injustice, and government neglect of U.S. public schools in poor urban areas. Kozol reveals the direct connections between racism, economic exploitation, and lack of educational resources for children of the urban poor. An appendix at the end of the book provides supporting statistical data indicating the erosion of funding for public schools attended by poor children vs. increased funding of public schools for children of the financially advantaged in the late 1980s. The book includes an index.

Brian Wallis, ed. *Democracy: A Project by Group Material.* Dia Art Foundation Discussions in Contemporary Culture, Number 5. Seattle: Bay Press, 1990. (312 pages)

Within this collection of debates and essays on issues concerning culture, art, politics, and education, teachers will find the sections "Education and Democracy" and "Cultural Participation" informative and engaging. In the roundatable on public education, beginning on page 47, artists and educators present different arguments concerning aspects of the condition of democracy in the U.S. and proposals for teacher empowerment and learner-centered education. Catherine Lord's "Letter to Group Material" provides a good analysis of federal policy in education and its effect on art education.

Critical Pedagogy and Educational Theory

Mary Field Belenky, et al., eds. *Women's Ways of Knowing: The Development of Self, Voice, and Mind.* New York: Basic Books, 1986. (256 pages)

This book is the result of in-depth interviews with 135 women. Concerned with education and women's ways of knowing, it puts the ideas of Paulo Freire in a new, feminist context. The authors substantiate their support in favor of student-based education that emphasizes student competence, in opposition to banking education, where students are treated as mere receptacles to be filled with information. Chapter 9, "Towards an Education for Women," denounces institutions of higher learning in the U.S. as patriarchal, and calls for greater decision-making involvement by women in their own educational process. The book includes references and an index.

Paulo Freire. *Pedagogy of the Oppressed.* Trans. Myra Bergman Ramos. New York: The Continuum Publishing Company, 1990. (186 pages)

Freire's book has become a model among U.S. educators seeking ways to help young people of all races become free subjects who will participate in the transformation of their society. Education is understood as a mutual process where students and teachers learn from each other. Freire's immediate pedagogical objective is literacy as a practice of freedom, a tool that empowers the oppressed to change the structures of society serving the forces of oppression. Chapter 3 reflects on the importance of honest dialogue and critical thinking. Originally written in Portuguese, it is also available in Spanish as

Pedagogía del oprimido (Mexico: Siglo Veintiuno Editores, 1970). Freire revisits the themes addressed here in *Pedagogy of Hope*. Trans. Robert R. Barr. New York: The Continuum Publishing Company, 1994. (240 pages)

Paulo Freire. *The Politics of Education: Culture, Power, and Liberation*. Trans. Donaldo Macedo. Granby, MA: Bergin & Garvey, 1985. (209 pages)

Drawing from his experience in the United States, Africa, and Latin America, Freire presents his views on culture, education, and literacy. His purpose is to promote a critical attitude in education where learners and readers are recognized as intellectuals. Studying is thus revealed as an expression of the reader's attitude toward the world, a process by which the learner becomes aware of her or his own thoughts about reality. Freire expresses the need for educators to work with the experiences that learners bring to school. An index is included.

Henry A. Giroux and Roger I. Simon, eds. *Popular Culture: Schooling and Everyday Life*. New York: Bergin & Garvey, 1989. (244 pages)

Edited by prominent critical pedagogues Henry Giroux and Roger Simon, this anthology of highly theoretical texts gathers the writings of a team of international scholars specializing in popular culture and criti-

cal pedagogy. The following writers deal with cultural forms that greatly influence the education of young people: Elizabeth Ellsworth on the application of popular cultural forms to educational films; R. W. Connell on educational inequality; Mimi White on the subject of couples in daytime television; Paul Smith on the meaning of Hollywood action films; Paul Willis on young people's perception of art, reversing the cliché that art produces culture to state that cultures produce different forms of art. Each essay provides a bibliography. An index is included.

bell hooks. *Teaching to Transgress: Education as the Practice of Freedom*. New York: Routledge, 1994. (224 pages)

Written in enthusiastic, engaging language, *Teaching to Transgress* conveys a sense of immediacy, presenting in practical terms much of the advice given to teachers in the more theoretical books listed elsewhere in this bibliography. Here, bell hooks reflects on her own experiences as a teacher in higher education and shares with readers her record of her own struggle to make classrooms work, to deal with racism and sexism in the classroom, and to counter the overwhelming boredom, disinterest, and apathy that so often characterize the way professors and students feel about the classroom experience. hooks shares insights, strategies, and critical reflections on pedagogical

practice that convey the pleasure, hopefulness, and joy of teaching as an act of resistance.

Cameron McCarthy and Warren Crichlow, eds. *Race, Identity, and Representation in Education*. New York: Routledge, 1993. (329 pages)

This anthology gathers twenty-four essays on issues of race, class, gender, and nationality. An important aspect of this anthology is that, although the essays share a common opposition to racial inequality, they highlight differing views on the issues presented. The result is a successful effort to reveal race and ethnicity as very complex, shifting, unstable categories. The book is divided into three parts. Part One, "The Problem of Race," offers a selection of mostly theoretical writings about present-day racism and its history. Part Two concentrates on how schools produce racial inequality, using examples mostly from the United States. In this section, Christine E. Sleeter examines how the predominantly white teaching force processes education about race. Glenn M. Hudak compares racial formation in two high school male students, one Latino and one white. Elizabeth Ellsworth examines how educational films, far from being neutral conveyors of truth, in actuality promote specific gender, race, and class interests. Part Three critically reflects on the problems and challenges of multiculturalism as a strategy for change. An index is included.

Susan Gushee O'Malley, Robert C. Rosen, and Leonard Vogt, eds. *Politics of Education: Essays from Radical Teacher.* Albany: State University of New York Press, 1990. (357 pages)

These thirty essays were selected from *Radical Teacher,* a socialist and feminist journal on the theory and practice of teaching. Emphasizing an interdisciplinary approach, it includes articles on teaching women's studies, history, literature, math, science, and revising the canon. These essays also offer concrete examples of how teachers are building more democratic forms of education to awaken in students a critical understanding of society. An index is included. Subscriptions to the triannual journal are available from: *Radical Teacher,* P.O. Box 102, Kendall Square Post Office, Cambridge, MA 02142.

David Trend. *Cultural Pedagogy: Art/Education/Politics.* New York: Bergin & Garvey, 1992. (178 pages)

Calling for a new cultural pedagogy, Trend presents strong arguments in favor of integrating education and the arts. The function of education is examined in the larger context of cultural work and democracy. Chapter 4, "Community and Agency: The Ties that Bind" and Chapter 5, "New Discursive Spaces: Reinventing the Public Sphere" are particularly inspiring in their discussion of innovative community pro-

grams built around the needs of schools. A bibliography and index are included.

Practical Guides and Teaching Tools

John Collier and Malcolm Collier. *Visual Anthropology: Photography as a Research Method.* Albuquerque: University of New Mexico Press, 1986. (248 pages)

This is a valuable guide for students and teachers using photography, film, and video to understand human behavior and culture. Chapter 5, "The Cultural Inventory," and Chapter 7, "Photographing Social Circumstance and Interaction," are particularly helpful in triggering intense involvement and study of a subject through the use of photographs, film, or video. Emphasis is placed on developing skills of observation and on understanding visual information as conditioned by cultural context. A list of references and an index are included.

Barbara A. Lewis. *The Kid's Guide to Social Action: How to Solve the Social Problems You Choose—and Turn Creative Thinking into Positive Action.* Minneapolis: Free Spirit Publishing, 1991. (185 pages)

Lewis's well-organized, action-oriented guide and sourcebook for young people (ages ten and up) shows how to get involved in community action and get results. Social service projects for schools and

groups include how to write petitions, proclamations, and letters to political leaders. It provides a list of addresses and phone numbers for government offices and social action groups. Free Spirit also publishes a catalogue of learning skills and life skills materials for children, teens, teachers, and parents that can be ordered from: Free Spirit Publishing, Inc., 400 First Avenue N. #616, Minneapolis, MN 55401. Telephone: (800) 735-7323. Fax: (612) 337-5050.

Media & Values

Published quarterly by the Center for Media and Values, an educational not-for-profit membership organization, Media & Values provides resources for critical awareness about media. Each issue centers around a specific topic and includes activity sheets for group discussion and resources for follow-up. Teachers will find the following back issues useful: Number 57, "Impact of Images: Life and Culture in the Media Age," and Number 43, "Ethnic Diversity: Challenging the Media." The Center also publishes Values in the Media Age, a kit intended as an introduction to media literacy, comprising a 28-page step-by-step teacher's guide and a series of illustrated hand-out masters for use with teens and adults. For more information, contact the Center for Media and Values, 1962 South Shenandoah Street, Los Angeles, CA 90034. Telephone: (310) 559-2944

Rethinking Schools: An Urban Education Journal
This independent educational journal published bimonthly by Milwaukee-area teachers and educators focuses on a wide range of educational concerns. The October/November 1991 issue featured multicultural education. The special issue *Rethinking Columbus: Teaching About the 500th Anniversary of Columbus's Arrival in America* challenges the myth of Columbus and places European colonialism in its proper context. For more information, write or call: 1001 East Keefe Avenue, Milwaukee, WI 53212. Telephone: (414) 964-9646.

Teaching Tolerance
Published twice a year by the education department of the Southern Poverty Law Center, this publication will help elementary and secondary teachers promote interracial and intercultural understanding in the classroom. The magazine includes articles, art, teaching ideas, and reviews of other resources available. The Center also provides *America's Civil Rights Movement,* a curriculum package developed for grades 6 through 12 which includes a 38-minute video, lesson plans, and a teacher's guide. Both the magazine and the curriculum package are available at no charge to any teacher or educator making a request on official letter-head. Contact them at 400 Washington Avenue, Montgomery, AL 36104. Telephone: (205) 264-0286 Fax: (205) 264-0629

Contemporary Art

The Decade Show: Frameworks of Identity in the 1980s. New York: Museum of Contemporary Hispanic Art, The New Museum, The Studio Museum in Harlem, 1990. (364 pages)

In *The Decade Show* teachers will find additional information on twenty-five of the artists included in the present guide. *The Decade Show* was a multiethnic art exhibition held collaboratively by the three museums listed above. Among the fourteen essays included, Sharon F. Patton examines socially conscious art, with emphasis on the work of African American artists. The essays by Guillermo Gómez-Peña and Susana Torruella-Leval reflect on the conditions of Latinos in the United States. Margo Machida surveys Asian American cultural production. The book includes a conversation among the three museum directors concerning recent art in the United States. Other sections included in the book are a chronology of the 1980s, artists' biographies, and a bibliography. It can be ordered from: The New Museum of Contemporary Art, 583 Broadway, New York, NY 10012. Telephone: (212) 219-1222.

Lucy R. Lippard. *Get the Message? A Decade of Art for Social Change.* New York: E. P. Dutton, 1984. (343 pages)

This collection of essays integrates Lippard's views on art, feminism, and progressive politics. Most essays are short, direct, and are written in a witty, often refreshingly irreverent tone. Dealing with art production from the '70s and early '80s, these writings provide a good background for a better understanding of the cultural and social issues that inform more recent work. Section III concentrates on art and feminism. Section VI deals with activist art. "Some Propaganda for Propaganda" (p. 114) reflects on the value of art that combines images with words. Each essay provides bibliographical notes or references. An index is included.

Lucy R. Lippard. *Mixed Blessings: New Art in Multicultural America.* New York: Pantheon, 1990. (280 pages)

This is an indispensable and very influential text on contemporary art in the United States. Lippard explores the role of images in our changing society using nonhierarchical categories. Profusely illustrated with art reproductions in many mediums, *Mixed Blessings* provides information on thirty-eight of the artists and essayists included in the present guide. Lippard also offers insights into the crosscultural

processes in the work of African, Asian, Latino, and Native American artists. An index and bibliography are included.

The Mind's I. Introduction by curator Robert Lee. New York: Asian American Arts Centre, 1987. (Four volumes, about 20 pages each.)

This exhibition catalogue brings together the work of fourteen artists of diverse ethnic and cultural backgrounds, shown at the Asian American Arts Centre in 1987. Some of the artists included are: Chiu Ya-Tsai, Martin Wong, Luis Cruz Azaceta, Margo Machida, Jorge Tacla, Linda Peer, Alison Saar, and Patti Warashina. Their work addresses issues of gender, ethnicity, and cultural identity in the modern world. Each of the four volumes is $5.00 and can be ordered from: Asian American Arts Centre, 26 Bowery, New York, NY 10013. Telephone: (212) 233-2154. (The Asian American Arts Center also produces ARTSPIRAL, a biannual publication that concentrates on art from Asia and by Asian American artists.)

The Next Generation: Southern Black Aesthetic. Winston-Salem, NC: Southeastern Center for Contemporary Art, 1990. (164 pages)

Twenty-one African American artists are included in this illustrated exhibition catalogue. The book also contains transcriptions of several panel discussions and interviews that were organized in conjunction with the exhibition. These interviews function as engaging conversations among artists and critics. In the panel "In Our Own Voices" writer and curator Coco Fusco, artist Adrian Piper, and educator Dr. Leslie King-Hammond discuss the role of women artists of color and the politics of sexual identity. In an interview beginning on page 157 artists Joyce Scott, Winnie R. Owens-Hard, Martha Jackson-Jarvis, and Pat Ward Williams, discuss how art education affected their lives and work. Artist biographies are included.

The Submuloc Show/Columbus Wohs (80 pages) and *Women of Sweetgrass, Cedar and Sage: Contemporary Art by Native American Women* (88 pages).

The Submuloc Show/Columbus Wohs is a catalogue with black-and-white reproductions of works by the thirty-five Native American artists who participated in this exhibition. Defined as a Native American response to the 1992 Columbian Quincentennial, this book includes works by Native American writers Charlotte DeClue, Joy Harjo, Dunae Niatum, and Elizabeth Woody. Lucy R. Lippard and Jaune Quick-to-See Smith contributed with critical commentary. Native American cultures are revealed as dynamic and contemporary. An accompanying set of thirty-six color slides is available for $60.00. *Women of Sweetgrass, Cedar and Sage* is the catalogue for a 1985 exhibit of contemporary art by Native American women, curated by Jaune Quick-to-See Smith and Harmony Hammond. Although it is out-of-print, a photocopy is available for $15.00. A corresponding set of twenty color slides sells for $30.00. Inquiries should be addressed to ATLATL, 402 West Roosevelt, Phoenix, Arizona 85003. Telephone: (602) 253-2731.

Uncommon Ground: 23 Latin American Artists. Essays by curator Carla Stellweg and Berta Sichel. New York: College Art Gallery The College at New Paltz, State University of New York, 1992. (51 pages)

The majority of the artists in this exhibition catalogue live and work in different parts of the United States. The focus of the selection is to undermine misconceptions of "otherness" or "fantastic" often associated with work by artists of Latin American origin. Some of the artists included are: Juan Sánchez, Ana Mendieta, Shenge Ka Pharaoh, Nereyda García-Ferraz, and Julio Galán. Copies of this $15.00 catalogue can be ordered from: College Art Gallery, College at New Paltz, New Paltz, NY 12561. Telephone: (914) 257-3844.

Critical Art Issues

Robert Atkins. *ArtSpeak: A Guide to Contemporary Ideas, Movements, and Buzzwords.* New York: Abbeville Press, 1990. (175 pages)

Handy and useful, this book provides definitions of key terms related to contemporary art, understood as art produced since the end of World War II to the present. Organized as a quick-reference guide, each key art term is presented as an entry in alphabetical order. Some of the terms included are: graffiti art, multiculturalism, performance art, postmodernism, and popular culture. A short section titled "User's Manual" offers an explanation of how best to use the book. Since this book is organized by key terms, not by names of individuals, the best way to find a proper name or a specific artist is by referring to the index.

Carol Becker, ed. *The Subversive Imagination: Artists, Society, and Social Responsibility.* New York: Routledge, 1994. (258 pages)

In the introduction, editor Carol Becker reflects on the relationship between the artist and society, calling for a stop to the isolation and marginality that artists have been relegated to, based on romantic notions abut artistic freedom. She argues in favor of an ongoing dialogue between artists and society where artists would assume their rightful role as the voices of democracy, integral to daily life, and confronting contradictions in our society. Other essays include: reflections by Martha Rosler on the complex issues of cultural identity in art work; Coco Fusco on Cuban artists and their relationship to their nation of origin; Henry A. Giroux on the deeper meanings of advertising by Benetton; and Michael Eric Dyson on black masculinity and the ghetto in films.

John Berger. *Ways of Seeing.* New York: Viking Penguin, 1977. (166 pages)

Berger uses a lean writing style to raise questions about our learned habits of perception and accepted conventions in art. Each of the seven essays in this book touches on different aspects of art: the gap between written and visual information, and distortions of art history (first essay); ways of seeing women and the representation of gender in art (second and third essays); the historical relationship between oil painting and property (fifth essay); commercial advertising (seventh essay). The book is constructed in such a way that the essays can be read in any order.

Lawrence Grossberg, et al., eds. *Cultural Studies.* New York: Routledge, 1992. (788 pages)

Cultural studies is a fairly new interdisciplinary field that looks at a variety of cultural manifestations, including art, literature, belief systems, institutions, and communicative practices. Some of the forty essays included are: Douglas Crimp's "Portraits of People with AIDS," Marcos Sanchez-Tranquilino and John Tagg on Chicano art activism, and Michele Wallace on black feminist cultural criticism. An interesting feature of this anthology is that each essay is followed by an interview/discussion with the writer to further clarify the issues and ideas presented in the essay. References and an index are included.

Ivan Karp and Steven D. Lavine. *Exhibiting Cultures: The Poetics and Politics of Museum Display.* Washington: Smithsonian, 1991. (468 pages)

This collection of twenty-seven essays by museum directors, curators, and scholars examines the role of museums in culture. Part 2 presents four essays on the relationship of art museums to national identity and cultural participation. Two particularly relevant essays are: Carol Duncan's "Art Museums and the Ritual of Citizenship" and Tomás Ybarra-Frausto's "The Chicano Movement/The Movement of Chicano Art." Karp and Lavine have also edited, with Christine Mullen Kreamer, *Museums and Communities: The Politics of Public Culture* (Washington, DC: Smithsonian Institution Press, 1992), an anthology on the role of museums in cultural representation and their relationship to the communities they serve.

Linda Nochlin. *Women, Art, and Power and Other Essays*. New York: Harper & Row, 1988. (181 pages)

The seven essays in this collection discuss the representation of women in art through history. Included in this anthology is Nochlin's landmark 1971 essay "Why Have There Been No Great Women Artists?" This is generally considered the groundbreaking essay in the field of feminist art history. Teachers might want to complement these readings with a critique of the concept of greatness in Chapter 2 of Griselda Pollock's *Vision & Difference: Femininity, Feminism and the Histories of Art* (New York: Routledge, 1988).

Mark O'Brien and Craig Little. *Reimaging America: The Arts of Social Change*. Philadelphia: New Society Publishers, 1990. (374 pages)

Citing examples of grassroots based art, the short essays in this collection by more than fifty artists and writers discuss the impact of art on society. This anthology contains writings by Lucy Lippard, Adrian Piper, Tim Rollins and Kids of Survival, and three of the artists and essayists included in the present volume: Gran Fury, Amalia Mesa-Bains, and Krzysztof Wodiczko. A list of community organizations and an index are included.

Mary Ann Staniszewski. *Believing is Seeing: Creating the Culture of Art*. New York: Penguin, 1994. (310 pages)

Written in a capsulized style, Staniszewski's book summarizes and questions traditional Western concepts of what is or isn't art. It addresses the question: What is art? To this end, well-known, canonical images taken from the Western art tradition serve to reframe the way in which we look at those images and at art production in general. At other times, recent images taken from popular culture and the music industry are used to discuss some art concepts, making the discussion more accessible and appealing for younger audiences. *Believing Is Seeing* can be read as a companion to, or updated version of, John Berger's *Ways of Seeing*.

Cultural Identity, Gender, and Ethnicity

Gloria Anzaldúa, ed. *Making Face, Making Soul: Haciendo Caras— Creative and Critical Perspectives by Women of Color*. San Francisco: Aunt Lute Books, 1990. (402 pages)

Among this compilation of testimonials, essays, poetry, and fiction, teachers will find affirmative texts that will help them empower young female students. In many of these pieces, all written by women of color, the writer denounces the difficulties she had to confront to find her own voice and be heard. Teachers might want to recommend to their students the pieces by the following writers: Gloria Yamato (p. 20), Barbara Smith (p. 25), Canéla Jaramillo (p. 77), Siu Wai Anderson's "A Letter to My Daughter" (p. 156), Sucheng Chan (p. 162), Jewelle Gomez (p. 203), bell hooks (p. 207), Kit Yuen Quan (p. 212), Julia de Burgos (p. 227), Carmen Morones (p. 231), and Pat Mora (p. 376). These readings can also benefit male students by raising their awareness, thus empowering them to combat sexism and racism within themselves and in their social environment.

Sasha Alyson. *Young, Gay & Proud*. Boston: Alyson Publications, Inc., 1991. (119 pages)

Recommended for teachers, counselors, parents, and lesbian and gay youth, this affordable ($3.95) book provides an honest look at what it is like to be a lesbian or gay teenager. In a readable and engaging tone, the text provides advice to teens on family relationships, friends, sex, health, and how to deal with prejudice and homophobia. It includes a bibliography and information on a pen-pal service for gay teens. The list of "Gay People in History" might be a good eye-opener for gays and nongays alike, but does not include enough women and it is lacking in ethnic diversity.

Teachers and students looking for a more diverse and complete account of gay and lesbian cultural history will find it in Judy Grahn's *Another Mother Tongue: Gay Words, Gay Worlds* (Boston: Beacon Press, 1984).

Russell Ferguson, Martha Gever, et al., eds. *Out There: Marginalization and Contemporary Cultures*. New York: The New Museum of Contemporary Art, 1990. (446 pages)

Essays in this anthology address cultural marginalization and visual representation, as well as social and psychological aspects of cultural identity. Writers deal with written and visual cultural production. Some key writings are: Edward Said on exile; Cornel West on the cultural politics of difference; bell hooks on moving from silence to speech as a young woman and on marginality as site of resistance; Monique Wittig's "The Straight Mind"; Douglas Crimp on AIDS, activist art, and political militancy; Teshome H. Gabriel on black independent cinema. An index and bibliography are included.

Ann Heron, ed. *One Teenager in 10: Writings by Gay and Lesbian Youth*. Boston: Alyson Publications, Inc., 1983. (114 pages)

It is generally estimated that 10 percent of high school students are lesbian or gay. Most of them face unfounded, harmful prejudice and rejection by peers and family. In this collection of first-person testimonials, eleven young women and sixteen young men, mostly in their teens, tell their stories of sexual awakening and how they faced it. The emphasis is on love, affection, and positive acceptance by self and others. Although not representative of all gay youth, these stories will help gay teens, or teens who think they might be gay, realize that they are not alone. Teachers, adults who work with young people, and teens who are not gay will also find these stories helpful to better understand gay teens.

Rick Simonson and Scott Walker, eds. *Multi-Cultural Literacy: The Graywolf Annual Five*. Saint Paul: Graywolf Press, 1988. (204 pages)

In this collection of indispensable readings, thirteen different writers offer their viewpoints on self, society, art, community, education, and culture. Three key essays are: James Baldwin's "A Talk to Teachers," in which he praises teachers for their cultural work and exhorts them to empower children as social participants; Guillermo Gómez-Peña's "Documented/Undocumented," a reflection on the modern condition, and more particularly, on the act of living in the United States through the exemplary cultural experience of the Chicano; and Michele Wallace's "Invisibility Blues," on the omission and misrepresentation of blacks on television, using the specific example of Jesse Jackson's 1988 presidential campaign.

Scott Walker, ed. *Stories from the American Mosaic*. Saint Paul: Graywolf Press, 1990. (209 pages)

Intended as a companion to Graywolf's Multi-Cultural Literacy, this collection of fifteen short stories reveals cultural diversity in the U.S. through literature. The cultures that make up the United States are presented as part of a mosaic where each retains its particular traits while contributing to the richness of the whole. These engaging and entertaining stories will help foster an open attitude among students to the many cultures of the U.S. and a better understanding of how they intersect with official culture. Some of the stories include childhood memories and interaction between young people and adults.

Art Journals

There are many art journals currently being published in the United States. The following short list is intended as a small sampling of journals dealing with different aspects of contemporary art. These four journals were selected to represent four regions: New York City, the Midwest, the Southeast, and California.

Art in America
Customer Service
542 Pacific Avenue, Marion, OH 43306
Telephone: (800) 347-6969

Art in America is published monthly in New York. The September 1991 special issue, titled "Art and National Identity," includes comments by critics Edward Said and Coco Fusco, and artists Guillermo Gómez-Peña, Jenny Holzer, and Maya Lin. Every year, the August issue provides an index to all articles it has published the previous year, plus a guide to galleries, museums, and artists for the previous year. The August issue also includes a preview for the upcoming year.

Dialogue
P.O. Box 2572, Columbus, OH 43216-2572
Telelphone: (614) 621-3704
Fax: (624) 621-2448

Subtitled "Arts in the Midwest," this publication is dedicated to examining and promoting arts in the region. *Dialogue* consistently publishes reviews of exhibitions held in Chicago and in the states of Ohio, Indiana, and Kentucky. In addition, each issue includes a feature essay on a specific artist or topic in art, such as Amy Sparks on performance art (March/April 1994), censorship (November/December 1993), Guerrilla Girls (September/October 1992). *Dialogue* is published every two months. The July/August issue carries "The Annual Arts Guide to the Region," a listing of galleries with addresses and phone numbers for the four states it covers.

Art Papers
P. O. Box 77348, Atlanta, GA 30357
Telephone: (404) 588-1837

In addition to covering art from the Southeast of the United States, each issue of *Art Papers* concentrates on a specific topic in art. Following is a description of some back issues that teachers will find helpful. "Art & Education" (Vol. 14, No. 5, September/October, 1990) contains several articles about teaching art, and interviews with Ida Applebroog and Andres Serrano. "Boundary Crossings" (Vol. 16, No. 4, July/August, 1992), guest edited by Cindy Patton, addresses questions of identity in art and language. The July/August 1990 issue (Vol. 14, No. 4) discusses the idea of black aesthetics with essays by bell hooks and Adrian Piper, among others. The "Craft Issue" (Vol. 16, No. 6, November/December, 1992) concentrates on folk art, fiber arts, clothing, and furniture. "Interventionist Art" (Vol. 14, No. 1, January/February, 1990) considers art as social practice. Back issues are available for $4.50 per single copy. *Art Papers* is published six times a year.

High Performance
1641 18th Street, Santa Monica, CA 90404
Telephone: (310) 315-9383
Fax: (310) 453-4347

Devoted to progressive thinking in the arts, *High Performance* is a quarterly publication that presents works by artists and writers concerned with their cultural environment. A special issue on the Los Angeles riots of 1992 was published in the summer of 1992. Issue No. 47 (Volume 12, No. 3, Fall 1989), dedicated to a discussion of multiculturalism, includes an essay by Guillermo Gómez-Peña. Back issues have included essays on the following artists or topics: Yong Soon Min and David Wojnarowicz (Issue 51, Volume 13, No. 3, Fall 1990); AIDS, Group Material, and African Aesthetic (Issue 52, Volume 13, No. 4, Winter 1990); Andres Serrano interviewed by Coco Fusco (Issue 55, Volume 14, Number 3, Fall 1991).

Arts and Media Organizations

Compiled and Annotated by
Alyosha Goldstein

AIDSFilms
50 West 34th Street, Suite 6B6
New York, NY 10001
Telephone: (212) 629-7426
Fax: (212) 629-7413

AIDSFilms produces culturally specific educational film and video relating to HIV and AIDS. Of particular interest to teachers are a series of short narratives by, for, and about communities of color dealing with HIV/AIDS prevention. African American male teens, African American women, and Latinas are each individually addressed. Films in the AIDSFilms Library series (Spanish and English) are available through Select Media (see below).

Alliance for Cultural Democracy
P.O. Box 7591
Minneapolis, MN 55407

Established in 1975, the Alliance for Cultural Democracy forms linkages between artists, writers, educators, and cultural activists working at local, national, and international levels. ACD publishes *HURACAN*, a newspaper providing networks for cultural resistance; *Regional Bulletins*; *Cultural Democracy*, a journal featuring articles on cultural work and organizing; and the ACD Membership Directory.

Alternate ROOTS
1083 Austin Avenue
Atlanta, GA 30307
Telephone: (404) 577-1079
Fax: (404) 577-7991

Organized in 1976 at the Highlander Center (see below), Alternate ROOTS (Regional Organization of Theatres South) builds partnerships, primarily in the Southeast, between performing artists and the communities in which they live and work. ROOTS helps link a variety of constituencies, including people located in rural areas not served by established arts institutions, through outreach, networking, and sponsored projects. Publications include a bimonthly bulletin, quarterly newsletter, anthology of Southeastern plays, and special projects such as *Help Yourself: A Cultural Workbook*.

American Indian Contemporary Arts
685 Market Street, Suite 250
Monadnock Building
San Francisco, CA 94105-4212
Telephone: (415) 495-7600
Fax: (415) 495-7781

American Indian Contemporary Arts, established in 1983, offers a comprehensive program of exhibition and educational outreach programs intended to reshape dominant culture's understanding of contemporary American Indian art. AICA publishes *Portfolio,* a series of exhibition catalogues and resources for educators. These publications include artists' profiles, color reproductions, biographical sketches and artists' statements.

Appalshop
306 Madison Street
Whitesburg, KY 41858
Telephone: (800) 545-7467; in Kentucky (606) 633-0108
Fax: (606) 633-1009

Appalshop, founded in 1969, offers an extraordinary variety of programs including a film and video production group, radio station, theater group, record label, institute for media, the Community Arts program, and the Appalshop School Initiative which uses media to address issues in the public school curriculum. A prominent national force in media, educational community work, and advocacy for the culture and people of the Appalachian region, Appalshop is an excellent source of progressive film and video, and one of the key places in the country where culturally-based community work is being done successfully. Videotapes address the diversity of experience and culture in the Appalachian region and issues facing rural America in general. Catalogues are available.

Arlington Arts Center
3550 Wilson Boulevard
Arlington, VA 22201
Telephone: (703) 524-1494

Founded in 1976, Arlington Arts Center sponsors educational programs, exhibitions, and "Artist's Visions: Inspiration from Other Cultures," a video project organized in cooperation with the Fairfax

County school system. Each year a group of high-school students works with the center to produce videotapes which document the work and working processes of artists from various ethnic and cultural backgrounds. These videotapes are distributed by AAC.

Asian American Arts Centre
26 Bowery
New York, NY 10013
Telephone: (212) 233-2154

Established in 1974, the Asian American Arts Centre is an important resource to both its immediate community in New York City's Chinatown and for people across the United States. The Centre exhibits contemporary Asian American and other culturally diverse art and performance work, and maintains a program devoted to Folk Arts Research and Documentation. *Artspiral,* the Arts Centre's biannual publication, is a superb source of information on the Asian Arts community, with previous issues on such topics as international censorship policies, and artists and the student movement in China. Of considerable value for teachers is the one-hour slide show with accompanying audio cassette lecture entitled "The Art of Asian American Artists: Reflections of the Cultural Issues in Asian American Life," which documents the work of over one hundred and fifty artists. The Centre also sponsors education programs with New York public schools.

Asian American Women Artists
Association
P.O. Box 20712
Oakland, CA 94620

The Asian American Women Artist Association's (AAWAA) members are a diverse group of visual, performing, and literary arts professionals based in Northern California. Established in 1989, AAWAA offers slide sets of members' work accompanied by artists' statements.

Association of Hispanic Arts
173 East 116th Street, 2nd Floor
New York, NY 10029
Telephone: (212) 860-5445
Fax: (212) 427-2787

Founded in 1975, the Association of Hispanic Arts (AHA) is dedicated to the advancement of Latino art and culture as an integral part of the cultural life of the United States. AHA publishes a newsletter and a Directory of Hispanic Arts Organizations in the New York tristate region. AHA maintains a computerized database of information on thousands of artists and organizations.

Atlatl
402 West Roosevelt, Suite C
Phoenix, AZ 85003
Telephone: (602) 253-2731
Fax: (602) 256-6385

Atlatl, the National Service Organization for Native American Arts is a nonprofit corporation formed in 1977. Atlatl publishes a quarterly newsletter, operates a traveling exhibit service, and distributes audiovisual materials such as slide sets and videotapes produced by Native American artists. Slide sets include *Contemporary Native American Masks, Women of Sweetgrass, Cedar, and Sage: Contemporary Art by Native American Women,* and *The Submuloc Show/Columbus Wohs,* based on an exhibition organized for the Quincentenary. Videotapes, most of which are in Native languages with English subtitles, are on subjects such as Native literature, storytelling and poetry. Catalogues are available.

Black Filmmaker Foundation
Tribeca Film Center
375 Greenwich Street
New York, NY 10013
Telephone: (212) 941-3944
Fax: (212) 941-4943

Black Filmmaker Foundation (BFF) was established in 1978 to support emerging African American film/video artists and to build audiences for their work. BFF conducts a monthly Guest Speaker and Workshop Series, a monthly Screening Series, and a talent showcase. BFF also publishes a monthly newsletter, a biannual journal entitled *Blackface,* maintains SkillsBank, a job referral program and also sponsors an Acting Ensemble company.

California Newsreel
149 Ninth Street, #420
San Francisco, CA 94103
Telephone: (415) 621-6196
Fax: (415) 621-6522

California Newsreel is a not-for-profit media resource center which distributes educational films and videos on African American history and culture, Africa, and media education. The videos in the *African American Perspectives* collection range from conversations with prominent African American authors to examinations of the historical roots of racism and the representation of black Americans in prime-time television. *The Library of African Cinema* is the first collection of African feature films and documentaries on video, many of them in French with English subtitles. This collection is the largest source of media on apartheid. Catalogues and brochures are available.

The Caribbean Cultural Center
408 West 58th Street
New York, NY 10019
Telephone: (212) 307-7420

The Caribbean Cultural Center was founded in 1976 as an exhibition and resource center representing the cultural heritage and artistic practices of peoples of African descent throughout South and Central America, the United States and the Caribbean. The Center presents performances, film programs, art exhibitions, and education programs which focus on both contemporary and traditional work. Ongoing activities include the annual festival and conference, "Tribute to African Diaspora Women," celebrating the contributions of women of color. *Achieving Cultural Equality: Voices from the Battlefront,* edited by Director Marta M. Vega, examines the struggle for cultural equity in the United States.

Center for Cuban Studies
124 West 23rd Street
New York, NY 10011
Telephone: (212) 242-0559
Fax: (212) 242-1937

The Center for Cuban Studies was initiated in 1972 by scholars, writers and other professionals, to establish communication between people in Cuba and the U.S. and to combat the lack of information about Cuban culture in the U.S. due to the ban on trade and travel. The Center offers many educational and cultural programs including an exchange program assisting cultural producers and scholars traveling to Cuba. Books, magazines, records, slides, and videos in both Spanish and English are distributed by the Center. The Center publishes the quarterly journal *CUBA Update,* the *CCS Newsletter,* and occasional monographs, bibliographic lists and information packets. Catalogue available.

Center for Media and Values
1962 Shenandoah Street
Los Angeles, CA 90024
Telephone: (310) 559-2944
Fax: (310) 559-9396

The Center for Media and Values promotes media literacy and critical viewing skills. Media Literacy Workshop Kits™, based on the Center's quarterly magazine *Media &Values,* are short curriculum units designed for use with adult or youth groups. For example, *Images of Conflict,* an analysis of the Gulf War, includes a videotape, guides for classroom discussion, illustrated handouts for students, a special issue of *Media &Values* magazine and a booklet on strategies for teaching youth about the media. Other kits cover sexism in the media, parenting and TV, and tobacco and alcohol advertising.

Centro Cultural de la Raza
2130-1 Pan American Plaza, #1
Balboa Park
San Diego, CA 92101
Telephone: (619) 235-6135
Fax: (619) 595-0034

Since 1970 Centro Cultural de la Raza has actively promoted and exhibited indigenous, Mexican and Chicano art and culture. As a multidisciplinary cultural arts center, the Centro provides workshops and classes, exhibitions, publications, and performing and literary arts presentations. A key institution for the work of such artists as Amalia Mesa-

Bains and Border Art Workshop/ Taller de Arte Fronterizo, the Centro is an important site for the advancement of Latino and multicultural art. Teachers will find *Made in Aztlan*, the Centro's fifteenth anniversary catalogue, an excellent resource. The catalogue includes essays on the Centro and historical and contemporary investigations of Chicano art by Guillermo Gómez-Peña, Tomas Ybárra-Frausto, and Shifra M. Goldman, among others.

Daybreak Star Arts Center
Sacred Circle Gallery of American Indian Art
Discovery Park
P.O. Box 99100
Seattle, WA 98199
Telephone: (206) 285-4425
Fax: (206) 282-3640

Daybreak Star Arts Center, managed by the United Indians of All Tribes foundation, was established in 1977. The Center maintains a permanent collection of Native American artists' murals, organizes exhibitions of contemporary Native American artists in the Sacred Circle Gallery, and offers activities for the Native community, including counseling services to encourage young people to stay in school and nutritional programs for the elderly. This important mixture of community and cultural services situates contemporary art in the broader context of community life. The Center offers a slide set and catalogue describing the history of the organization and the artists in its permanent collection.

Deep Dish Television Network
339 Lafayette Street
New York, NY 10012
Telephone: (212) 473-8992
Fax: (212) 420-8223

Deep Dish Television Network offers an alternative programming service to community access cable systems nationwide via satellite. Deep Dish develops series based on current social and political issues, working with community-based producers and media activists to produce shows. Educators will find a range of scholarly and provocative subjects, such as Native American sovereignty, the 1992 Los Angeles uprising, a portrait of Salvadoran refugees living in the U.S., and television made in Cuba. Catalogues are available. Distribution arrangements vary; call or write for information.

Downtown Community Television
87 Lafayette Street
New York, NY 10013
Telephone: (212) 966-4510
Fax: (212) 219-0248

Begun in 1972, Downtown Community Television operates several exemplary media programs including technical workshops, youth programs, an equipment bank, screenings and seminars, and a distribution library containing documentaries made by DCTV affiliates on national and international social and political issues. Topics include Asian American immigration, labor issues, urban issues, and more. Catalogues are available.

Educational Video Center
55 East 25th Street, Suite 407
New York, NY 10010
Telephone: (212) 725-3534
Fax: (212) 725-6501

Educational Video Center, founded in 1984, is dedicated to empowering New York City public highschool students through the creative use of media. EVC is a leader in providing training and support services in documentary production and media literacy to high school students and their teachers. Through the process of producing documentaries on youth and community issues, students gain valuable skills and a more profound understanding of the world around them. A student newsletter highlights recent tapes and news pertaining to youth, media, and EVC. A catalogue of EVC youth-produced videos is available, as well as the *YO-TV Production Handbook: A Guide to Video by Students for Students.*

Educators for Social Responsibility
23 Garden Street
Cambridge, MA 02138
Telephone: (617) 492-1764
Fax: (617) 864-5164

Educators for Social Responsibility is a national organiza-

tion with sixty local chapters offering teaching guides on conflict resolution, ecological education, multicultural education, and democratic classroom practices, as well as textbooks, educational pamphlets, and videos. Videotapes are available through the Resolving Conflict Creatively Program, a collaborative effort between the New York City Public Schools and ESR. Publications include *Designing Groupwork: Strategies for the Heterogeneous Classroom* and *Dealing with Differences: Conflict Resolution in our Schools*. ESR also publishes a newsletter entitled *Forum*, and a catalogue of curriculum materials, videos, professional workshops, and other publications.

Fairness and Accuracy In Reporting (FAIR)
130 West 25th Street
New York, NY 10001
Telephone: (212) 633-6700
Fax: (212) 727-7668
e-mail: fair-info@igc.apc.org

As a national media watchdog group, Fairness and Accuracy in Reporting offers teachers excellent tools for critically addressing dominant representations in print and television news. *Extra!,* FAIR's bimonthly publication, includes special issues on "Racism in the Media" and women in the media. Bulk orders for classroom use are available at discounted rates.

Filmmaker's Library
124 East 40th Street
New York, NY 10016
Telephone: (212) 808-4980
Fax: (212) 808-4983

Begun in 1972, the Filmmaker's Library is an important resource for teachers, providing a broad range of titles of independently produced work on social and political issues. Catalogue headings include "African American Studies," "Native American Studies," "Global Issues," "Multiculturalism," "Jewish Studies," and "Art and Contemporary Culture."

Frameline
346 Ninth Street
San Francisco, CA 94103
Telephone: (415) 703-8650
Fax: (415) 861-1404

Frameline is the only national distributor solely devoted to the promotion and exhibition of lesbian and gay films and videotapes. A significant force in the dissemination of media produced by lesbians and gays, Frameline also operates an information center on lesbian and gay media throughout the world. Catalogues are available.

Galeria de la Raza/Studio 24
2857 24th Street
San Francisco, CA 94110
Telephone: (415) 826-8009
Fax: (415) 826-5128

Galeria de la Raza/Studio 24, established in 1970, is a cross-cultural arts and educational resource center recognized as a leader in the Chicano and Latino arts movement in the United States. Exhibitions reflect current regional, social, and political issues facing Chicano and Latino communities, and often extend beyond the gallery through community mural programs and the *Dia De Los Muertos* (Day of the Dead) celebration. The Galeria has produced collaborative cross-cultural exhibitions with Asian American, black, and Native American artists. *Ambiente*, a quarterly publication of Galeria de la Raza/Studio 24, addresses Chicano and Latino arts and culture in the San Francisco area. Exhibition catalogues are available.

Gay Men's Health Crisis
129 West 20th Street
New York, NY 10011
Telephone: (212) 807-7517
Fax: (212) 337-3656

Gay Men's Health Crisis develops and distributes materials that meet the needs of different audiences, addressing aspects of HIV and AIDS such as risk reduction, medical and psychological issues, and testing. The Audio-Visual Program of the Education Department produces a weekly program for cable television entitled *Living With AIDS*, as well as special video projects, such as *It Is What It Is,* an educational tape addressing teen sexual identity, homophobia, and HIV prevention. A catalogue of AIDS-related educational resources available for rental or purchase can be obtained by calling or writing GMHC.

Guadalupe Cultural Arts Center
1300 Guadalupe Street
San Antonio, TX 78207-5519
Telephone: (512) 271-3151

Founded in 1979, the Guadalupe Cultural Arts Center is a highly esteemed Latino art center and resource for information on events and work being done in local and national Latino communities. GCAC operates a Visual Arts Program, Literature Program, and the Xicano Music Program. The Cinefestival, the Inter-American Book Fair, and the Tejano Conjunto Festival en San Antonio are major festivals sponsored by GCAC. A monthly newsletter and *TONANTZIN*, a program and information booklet, are produced in conjunction with the Center's major events.

Highlander Research and Education Center
1959 Highlander Way
New Market, TN 37820
Telephone: (615) 933-3443
Fax: (615) 933-3424

Founded in 1932, Highlander Research and Education Center works with community groups in Appalachia and the deep South to organize, educate and promote linkages with national and international groups. A library and audiovisual resource center offers over six hundred videotapes and other materials for distribution and sale. The collection includes such titles as *Myles Horton, Paulo Freire and Friends ... Gather at Highlander* and

No Promise for Tomorrow: Southern Communities Respond to the Bhopal Tragedy. Also available are *Highlander Reports*, the Center's newsletter, and brochures.

Institute of American Indian Arts
1600 St. Michael's Drive
Box 20007
Santa Fe, NM 87504
Telephone: (505) 988-6440

The Institute of American Indian and Alaska Native Culture and Arts Development was founded in 1962 and is the only fine arts college devoted solely to the study and practice of the artistic and cultural traditions of all American Indian and Alaskan Natives. IAIA is comprised of four centers: the Center for Fine Art and Cultural Studies, an accredited fine arts college; the Institute of American Indian Arts Museum, which houses the National Collection of Contemporary Indian Art; the National Center for the Production of Native Images, a film and video production facility; and the National Center for Research and Cultural Exchange, an international cultural resource center. The Institute publishes *Art Winds*, a quarterly newsletter.

Labor Heritage Foundation
815 16th Street, NW, Room 301
Washington, DC 20006
Telephone: (202) 842-7880

The Labor Heritage Foundation helps unions and their members communicate, educate, and build

solidarity through the use of music, drama, painting, poetry, and prose. The foundation distributes CDs, records, songbooks, audiotapes, videotapes, and publishes the labor arts newsletter, ART WORKS. Information on lists of available materials can be obtained by contacting the Foundation.

The Latino Collaborative
280 Broadway, Suite 412
New York, NY 10007
Telephone: (212) 732-1121
Fax: (212) 732-1297

The Latino Collaborative is a membership organization which produces exhibitions and assists members in various aspects of film and video production. It is a good resource for information on Latino media. The collaborative publishes a bimonthly newsletter and a free film and video directory with titles on subjects such as the unionization of black and Latino housekeepers, contemporary Cuban art, and the struggles of the Yanomami people of South America.

Media Network/Alternative Media Information Center
39 West 14th Street, Suite 403
New York, NY 10011
Telephone: (212) 929-2663
Fax: (212) 929-2732

Founded in 1979, Media Network plays a crucial role in realizing media's potential as a progressive political force. It provides an information service network on alterna-

tive media, publishes film and video guides, and maintains a computer database on social issue media. Its annotated thematic Media Guides (on topics such as AIDS, the environment, peace and disarmament, women's rights, labor related media, and multicultural media) and *Mediactive*, a quarterly magazine, are excellent sources of information for teachers.

MEXIC-ARTE Museum
P. O. Box 2632
Austin, TX 78768
Telephone: (512) 480-9373
Fax: (512) 480-8626

Founded in 1983, MEXIC-ARTE Museum was the first organization to promote multicultural contemporary art in Austin. A nationally recognized community-based arts institution, MEXIC-ARTE develops programs and exhibitions with local organizations, schools, and arts organizations throughout the country. Previous exhibitions include *Myths Redefined: Contemporary Art from Haiti* and *Counter Colon-ialismo*. The permanent collections on rotation in the gallery provide an historical and cultural context for the contemporary exhibitions.

Mission Cultural Center
2868 Mission Street
San Francisco, CA 94110
Telephone: (415) 821-1155
Fax: (415) 648-0933

The Mission Cultural Center was established in 1977 by artists, community members, and activists as a multidisciplinary Latino arts center. The MCC is comprised of four main programs: The Galeria/Museo, an exhibition space; Mission Grafica, a screen-printing and design facility providing services to artists and nonprofit community organizations; Teatro Mission, sponsoring local, national, and international dance and theater performances; and a highly developed and diversified educational arts program including classes in both traditional and contemporary areas.

El Museo del Barrio
1230 Fifth Avenue
New York, NY 10029-4496
Telephone: (212) 831-7272
Fax: (212) 831-7927

The only museum in the United States to focus extensively on the arts and culture of Puerto Rico, El Museo del Barrio is one of the foremost Latin American cultural institutions in the country. El Museo presents art exhibitions of contemporary and historical scope, such as *The Commemoration of the Abolition of Slavery Portfolio, Caras y Suenos/Faces & Dreams: A Selection of Work by Children from the Education Program,* and *Voyages to Freedom: 500 Years of Jewish History in Latin America and the Caribbean,* as well as film festivals, performances, and symposia. Education programs include workshops for school groups and residence programs for artists and writers. El

Museo encourages the use of its facilities by neighborhood and city-wide groups serving the community.

The National Afro-American Museum and Cultural Center
P.O. Box 578
Wilberforce, OH 45384
Telephone: (513) 376-4944
Fax: (513) 376-2007

Opened in 1988 with the assistance of The Ohio Historical Society, The National Afro-American Museum and Cultural Center includes exhibition galleries, a theater, a smaller children's museum, and a library/manuscript facility. Dedicated to the preservation and fostering of the history and culture of African American peoples, the Museum maintains one of the largest collections of artifacts, manuscripts, and photographs in the United States. Of particular interest to teachers is *From Victory to Freedom: The African-American Experience*, a two-volume black history curriculum, structured for incorporation into any subject area. The second volume is specifically intended for use with high-school students.

National Alliance for Media Arts and Culture
1212 Broadway, Suite 816
Oakland, CA 94612
Telephone: (510) 451-2717
Fax: (510) 451-2715

The National Alliance for Media Arts and Culture is a national association of organizations and individuals in the field of media arts. NAMAC

works closely with its constituencies on media advocacy, production, exhibition, distribution, education and collection. The National Alliance of Media Educators is an advocacy project of NAMAC involved with media literacy strategies, and can be contacted at the phone number and address above. NAMAC publishes a monthly newsletter, *MAIN* (Media Arts Information Network), and an annotated members directory.

National Asian American Telecommunications Association
346 Ninth Street, 2nd Floor
San Francisco, CA 94103
Telephone: (415) 863-0814
Fax: (415) 863-7428

The National Asian American Telecommunications Association was created in 1980 to address Asian representation in film and television. One of the Corporation for Public Broadcasting's five National Minority Consortia, NAATA acquires, packages, and distributes television and radio programs related to Asian American experiences, and produces a quarterly publication, *Network*. Of particular interest to teachers is CrossCurrent Media, NAATA's non-broadcast distribution service, with a collection of over sixty titles on topics such as history, identity, Asian American women at work, analyses of media images, and performance. To contact CrossCurrent Media call (415) 552-9550 or fax (415) 863-7428.

National Black Programming Consortium
929 Harrison Avenue, Suite 101
Columbus, OH 43215
Telephone: (614) 299-5355
Fax: (614) 299-4761

Founded in 1980, The National Black Programming Consortium is one of the largest centers for the distribution and archiving of socially significant African American television and film programs. NBPC, also a constituent of the National Minority Consortia begun by the Corporation for Public Broadcasting, links member PBS stations, independent producers, and viewing publics to promote a diverse body of black programming. In addition to its on-site education, technical assistance, and exhibition programs, and the annual international competition and festival *Prized Pieces*, NBPC publishes *Take One*, a newsletter which includes articles on activities in the African American media community. A catalogue of tapes distributed by NBPC is available.

National Clearinghouse for Bilingual Education
1118 22nd Street, NW
Washington, DC 20037
Telephone: (800) 321-NCBE or (202) 467-0867
Fax: (202) 429-9766

The National Clearinghouse for Bilingual Education was founded in 1977 to provide information on the educational needs of limited-English proficient students. Funded by the U.S. Department of Education, Office of Bilingual Education and Minority Languages Affairs, NCBE maintains a Computer Information System database, accessible free of charge, comprised of three searchable databases: bibliographic (citations and abstracts); resource (profiles of research centers, professional associations, advocacy groups); and publishers. NCBE publishes a free bimonthly newsletter, *Forum;* the journal *Focus;* and a series of Information Guides for Practitioners.

National Museum of the American Indian
The Film and Video Center
One Bowling Green
New York, NY 10004
Telephone: (212) 283-2420
Fax: (212) 694-1970

The National Museum of the American Indian presents works of art through the Native American voice. The Museum has a collection of over 1 million items and mounts exhibitions and programs on an ongoing basis. The Museum's Film and Video Center was established in 1981 to promote, collect, and program film and videotapes by and about Native American people. The Center organizes The Native American Film and Video Festival biannually, and has programmed two traveling exhibitions, "Native America Now: A Festival of Films," and "Video Native America." The Center's

catalogue, Native Americans on Film and Video, contains annotated entries and distributors of eight hundred films and videotapes. Volume II (1988) and a supplement (1993) are available.

National Telemedia Council, Inc.
120 East Wilson Street
Madison, WI 53703-3423
Telephone: (608) 257-7712
Fax: (608) 257-7714

Established in 1953, the National Telemedia Council is devoted to the advancement of media literacy. NTC offers media analysis teaching aids and is developing an information clearinghouse on media literacy. The Teacher Idea Exchange promotes access and exchange of media literacy educational strategies. NTC's publications include *Telemedium* and *Telemedium Update*. A brochure is available listing additional materials available from NTC.

The Native American Center for the Living Arts, Inc. (The Turtle)
25 Rainbow Mall
Niagara Falls, NY 14303
Telephone: (716) 284-2427
Fax: (716) 282-5138

The Native American Center for the Living Arts (also known as The Turtle) was established in 1970. NACLA is an Iroquois nonprofit cultural institution dedicated to the preservation and display of the traditional arts and cultures of the Native peoples of North America, and the development of contemporary forms of artistic and cultural expression that represent new perspectives on tribal values. Exhibition catalogues available for sale include: *Turtle Arts '84,* featuring nine artists from NACLA's Artist-in-Residence program, and *American Indian Art in the 1980's.* NACLA also publishes *Turtle Quarterly Magazine,* an excellent resource for teachers. Available back issues include: "James Bay Special Report," "Words & Portraits: Seven Native American Women," and "Inuit Whale Hunting Traditions."

Native Arts Circle
1433 East Franklin Avenue
Minneapolis, MN 55404
Telephone: (612) 870-7173
Fax: (612) 870-0327

Founded in 1987, the Native Arts Circle is a multidisciplinary native arts agency advocating for and working with Native artists in Minnesota. NAC sponsors collaborative projects, such as the "Two Rivers Native Film and Video Festival," a summer youth art program; conducts a variety of Native Voices Series annually; and publishes a quarterly newsletter for artists and a broader public. NAC also makes available a *Directory of Minnesota Native Artists* with information on hundreds of artists.

North Carolina Indian Cultural Center
P.O. Box 2410
Pembroke, NC 28372
Telephone: (919) 521-2433
Fax: (910) 521-0394

The North Carolina Indian Cultural Center sponsors programs and activities to increase the visibility and understanding of Native American tribes of the Southeastern United States, and provides a regional center for the preservation and advocacy of their history, heritage, and culture. The reference library holds books, videotapes, and cassettes that focus on Southeastern Native Americans. Videotapes cover a broad range of subjects, including events sponsored by the Center such as "The Carolinas' Indian Gathering" (a celebration and gathering of many tribes and urban Indian organizations of the region to share cultural traditions and teachings). Contact the Center for information on programs, materials and the Center's quarterly newsletter, *The Shield.*

Paper Tiger Television
339 Lafayette Street
New York, NY 10012
Telephone: (212) 420-9045

Paper Tiger is a video collective begun in 1981 to produce public-access television programming that analyzes and critiques mainstream media. Each half-hour tape in the collection of over 225 titles examines

a different aspect of the communications industry, from print media to TV and movies, from the media industry's corporate structures to the representations they produce. Many of these titles are specifically devoted to issues of racism, cultural politics, colonialism, and class struggle. Contact Paper Tiger for a catalogue containing complete annotated listings.

Schomburg Center for Research in Black Culture
The New York Public Library
515 Malcolm X Boulevard
New York, NY 10037-1801
Telephone: (212) 491-2200
Fax: (212) 491-6760

The Schomburg Center provides access to research materials pertaining to the history and culture of people of African descent throughout the world. The Center offers seminars, forums, exhibitions, and performing arts presentations for scholars and the general public drawing on its collections and archives. The Center publishes books, exhibition catalogues and a quarterly newsletter, *The Schomburg Center Journal*. Most relevant for teachers is the Schools Program, which distributes exhibition portfolios and videotapes for classroom use, and offers curriculum development and teacher training. Class visits to the Center are also available by contacting the Education Programs Manager.

The Scribe Video Center
1342 Cypress Street
Philadelphia, PA 19107
Telephone: (215) 735-3785
Fax: (215) 763-1903

The Scribe Video Center provides independent producers, emerging video artists, and members from community-based organizations access to video equipment and instruction. Scribe's *Community Visions* project provides free access to community groups wishing to produce videotapes addressing issues of social concern and the community's cultural life. Compilation tapes available for distribution, include the *Shelter* series on housing and activism; the *Personal History* series on contemporary African American life and communities; the *ID* series on women's struggles and explorations; and the *Community Visions* programs.

Select Media
Educational Film and Video
74 Varick Street, Suite 303
New York, NY 10013
Telephone: (212) 431-8923
Fax: (212) 431-8946

Select Media is a distributor of health, education, and social issue media for children, youth, adult, and professional audiences. Select Media is the distributor for films produced by AIDSFilms. Topics include "Youth-at-Risk" (covering issues ranging from sexual decision-making to drug-use prevention to skills development), "Child Abuse," "Family Violence," and "HIV and AIDS Education." Annotated catalogues are available.

SEORO Korean Cultural Network
39 Bowery, Box 671
New York, NY 10002

SEORO Korean Cultural Network is a progressive cultural organization established in 1990 by New York Korean artists and activists to address and promote issues relevant to Korean immigrant culture. SKCN works to form supportive and cooperative networks with other cultural organizations within and outside the Korean community. *SEORO Bulletin*, a dynamic quarterly newsletter, brings together cultural criticism, members' writings, and announcements.

Social and Public Art Resource Center (SPARC)
685 Venice Boulevard
Venice, CA 90291-4897
Telephone: (310) 822-9560
Fax: (310) 827-8717

Founded in 1976, the Social and Public Art Resource Center is a nonprofit multicultural arts organization known for creating murals in the Los Angeles area. Among SPARC's programs are *Great Walls Unlimited: Neighborhood Pride Mural Production Program*; the Mural Resource Center for international mural documentation (which main-

tains a slide archive); and a publications series including books, catalogues, and magazines on public art. The newsletter *SPARCplug* covers activities of the center and related topics.

Strategies for Media Literacy
1095 Market Street, Suite 410
San Francisco, CA 94103
Telephone: (415) 621-2911

A national nonprofit organization that promotes media literacy education, Strategies for Media Literacy provides publications, resources, workshops, and serves as a center of support and contact for teachers of media in the United States. As a leader in the development of media literacy, and an organizing member of NAMAC's coalition of media educators (NAME), SML is a crucial resource for media literacy information. *Strategies*, SML's quarterly newsletter, includes interviews, articles, and study guides. Listings of books, videos, and curriculum guides for teaching about media at the elementary and high-school levels are available.

The Studio Museum in Harlem
144 West 125th Street
New York, NY 10027
Telephone: (212) 864-4500
Fax: (212) 666-5753

Founded in 1967, The Studio Museum in Harlem is the first accredited African American fine arts museum in the country. Its per-manent collection includes works by such artists as Romare Bearden, Sam Gilliam, Jacob Lawrence, Faith Ringgold, and Betye Saar. Its wide-ranging exhibition program has included *Five Contemporary African Artists*, exhibited at the 1990 Venice Bienale; *The Decade Show: Frameworks of Identity in the 1980s*, co-organized with The New Museum of Contemporary Art and the Museum of Contemporary Hispanic Art; and *Memory and Metaphor: The Art of Romare Bearden, 1940–1987*. The Museum offers a national Artists-In-Residence program; the Community School Project, a multidisciplinary arts program in collaboration with public elementary schools; and the Cooperative School Program, an outreach program providing fine arts instruction with professional artists to school age youth. The Museum publishes brochures, exhibition catalogues, and other literature on African American Art.

Teaching Tolerance
Southern Poverty Law Center
400 Washington Avenue
Montgomery, AL 36104
Telephone: (205) 264-0286
Fax: (205) 264-3121

Teaching Tolerance was founded in 1991 by the Southern Poverty Law Center to provide teachers with resources and ideas for promoting interracial and intercultural understanding in the classroom. They have a range of targeted antiracist educational materials including a video and curriculum guide on the civil rights movement. Videos and curriculum guides exploring historic and contemporary forms of bigotry and successful antibias education programs are currently in production. Teaching Tolerance publishes a free semiannual magazine which includes innovative curricular ideas and teaching tools. To receive a free subscription send your request on school letterhead.

Third World Newsreel
335 West 38th Street, 5th Floor
New York, NY 10018
Telephone: (212) 947-9277
Fax: (212) 594-6417

Established in 1967, Third World Newsreel provides an exceptional combination of information, distribution, technical assistance, and programming. The Film Exhibition Program offers presentation packages for rental or purchase. Production workshops provide training with an emphasis on making video technology available to people of color and women. Third World Newsreel distributes an extensive collection of films and videotapes focusing on social, political, and cultural issues throughout the world, including documentaries dealing with artistic and cultural expression. Catalogues are available.

Video Data Bank
School of the Art Institute of
Chicago
37 South Wabash Avenue
Chicago, IL 60603
Telephone: (312) 345-3550
Fax: (312) 541-8072

Video Data Bank, founded in 1976 at the School of the Art Institute of Chicago, is the largest distributor in the U.S. of videotapes by and about contemporary artists. Three collections—*On Art and Artists, Early Video History,* and *Independent Video*—include a wide range of tapes from interviews with internationally known artists to documentation of artists' work in the medium of performance art. Of special interest is a program of video produced by teen videomakers, *Teen Powered TV.*

Visual Communications/Southern California Asian American Studies Central
263 South Los Angeles Street, #307
Los Angeles, CA 90012
Telephone: (213) 680-4462
Fax(213) 687-4848

Visual Communications is dedicated to the preservation, production and presentation of the history, culture and experiences of Asian Pacific communities. Founded in 1970, its programs include exhibitions, publications, production, and collecting. Publications include *Moving the Image: Independent Asian American Media Arts* and the quarterly newsletter *IN FOCUS,* with historical and contemporary media and cultural criticism.

Women Make Movies
462 Broadway
New York, NY 10013
Telephone: (212) 925-0606
Fax: (212) 925-2052

Founded in 1972, Women Make Movies is the only national, non-profit, feminist, media arts organization dedicated to the promotion, exhibition, and distribution of films and videotapes by and about women. WMM has played an historically significant role in women's media by both supporting production and distribution of single titles and touring programs, such as *Changing the Subject: An International Exhibition of Films by Women of Color.* A comprehensive catalogue includes a current collection of over three hundred films and videotapes.

Checklist

John Ahearn
Maria's Mother, 1987
Oil on fiberglass
51″ × 52″ × 48″
Courtesy of Brooke Alexander
Gallery, New York

John Ahearn and Rigoberto Torres
Banana Kelly Double Dutch, 1981–82
Mural, Oil on cast fiberglass
54″ × 54″ × 12″ (each figure)
Photo: ©1983 Martha Cooper
Courtesy of Brooke Alexander
Gallery, New York

Walton Avenue Block Party,
September 1985
Casting process
Courtesy of Brooke Alexander
Gallery, New York
Photo: Ivan Dalla Tana

Melissa Antonow
Come to Where the Cancer Is, 1989
Subway car poster, Advertisement:
Kids Say Don't Smoke Book
21″ × 22″
Collection of Coalition for a Smoke
Free City
Photo: Fred Scruton

Kristine Yuki Aono
Deru Kugi Utareru, 1984
Mixed media
37″ × 24″ × 3″
Collection of Dr. L. V. Giddings
Photo: Kristine Yuki Aono

Hashi/Fork, 1984
Wood, paper
44″ × 7″ × 4″
Photo: Mark Gulezian/Quicksilver
Photographers

Issei, Nisei, Sansei, . . . , 1990
Mixed media installation
28′ × 16′ × 8′6″
Commissioned by The Washington
Project for the Arts
Photo: Oi Jakrarat Veerasarn

Eduardo Aparicio
La Hacienda
911 North Ashland Ave,
Chicago, 1989
Cibachrome Print
19″ × 15″
Collection of the Chicago
Historical Society
Photo: Eduardo Aparicio

Paletería Lulu
1249 West 18th Street,
Chicago, 1989
Cibachrome Print
19″ × 15″
Collection of the artist
Photo: Eduardo Aparicio

Rinconcito Sudamericano
2529 North Milwaukee Ave,
Chicago, 1989
Cibachrome print
19″ × 15″
Private collection
Photo: Eduardo Aparicio

Ida Applebroog
Promise I Won't Die?, 1987
Limited edition lithograph with
linocut and hand coloring
38″ × 48″
Courtesy of Ronald Feldman Fine
Arts, New York
Photo: D. James Dee

Riverdale Home for the Aged, 1984
Oil on 2 canvases
100″ × 100″
Courtesy of Ronald Feldman
Fine Arts, New York
Photo: Eric Landsberg

Thank You, Mr. President, 1983
Enamel and Rhoplex on canvas
12″ × 66″
Courtesy of Ronald Feldman
Fine Arts, New York
Photo: D. James Dee

Tomie Arai
Chinatown, 1990
Silkscreen construction mixed media
22″ × 40″
Courtesy of the artist
Photo: Fred Scruton

Luis Cruz Azaceta
Babies with AIDS, 1989
Acrylic on canvas
10′ × 10′
Courtesy of Frumkin/Adams
Gallery, New York
Collection of the Artist
Photo: Adam Reich

Lotto: American Dream, 1989
Acrylic on canvas
77 1/2″ × 144″
Collection of the Artist
Courtesy of Frumkin/Adams
Gallery, New York
Photo: Ken Showell

Border Art Workshop/Taller de Arte Fronterizo
Whitewash(ed) Portable exhibition,
May 1991
San Diego High School Students,
BAW/TAF - artists
Overview of High School Students
Photo: Carmela Castrejn

Coqui Calderon
Marcha de Pañuelos Abriendo el Camino, 1987
Acrylic on canvas
46″ × 60″
Private Collection
Photo: Patty Fisher

Ken Chu
I Need Some More Hair Products, 1988
Acrylic on Foamcore
21″ × 25″ × 5″
Private Collection of Leah Ollman
Photo: Philipp Scholz Rittermann

Houston Conwill, Joseph DePace, Estella Conwill Majozo
The New Ring Shout, 1995
Illuminated polished brass and terrazzo floor
40′ diameter in 36′ high rotunda
Commissioned by the U.S. General Services Administration Art-in-Architecture Program
Photo: Bernstein Associates

Jimmie Durham
Self Portrait, 1986
Mixed media
78″ × 32″ × 5″
Private collection of Jean Fisher, London
Photo: Fred Scruton

Epoxy Art Group
36 Tactics, 1988
Epoxy over Xerox
36 prints each:
22″ × 34″
Collection of The New Museum of Contemporary Art, New York
Photo: Fred Scruton

36 Tactics–Guest Becomes Host, 1988
Epoxy over xerox
22″ × 34″
Collection of The New Museum of Contemporary Art, New York
Photo: Fred Scruton

Guillermo Gómez-Peña
Border Brujo, 1989
Performance Still
Courtesy of the artist
Photo: Max Aguilera-Hellweg

Gran Fury
Kissing Doesn't Kill: Greed and Indifference Do, 1989
Busboard advertisement and poster, offset lithography
Courtesy of the artists

Welcome to America, December 1989
Laserprinted billboard
Courtesy of the artists
Photo: Gran Fury

Women Don't Get AIDS, They Just Die From It, January 1991
Offset lithography
Busboard ad and poster (Outdoors)
Courtesy of the artists
Photo: Fred Scruton

Group Material
AIDS Timeline, 1989
Mixed media installation
Courtesy of the University Art Museum, University of California at Berkeley, CA

Dolores Guerrero-cruz
Clarence Thomas and Members of Senate, 1991
Mono silkscreen
35 1/2″ × 25″
Courtesy of the artist
Photo: Rick Meyers

Guerrilla Girls
Pop Quiz, 1990
Poster
17″ × 22″
Courtesy of the artists
Photo: Fred Scruton

Marina Gutierrez
Isla del Encanto, 1986
Acrylic on canvas
60″ × 30″
Courtesy of the artist
Collection of El Museo del Barrio,
New York

David Hammons
Higher Goals, 1990
40-foot tall basketball hoops, bottle
caps, mixed media.
Courtesy of Jack Tilton Gallery,
New York
Photo: Dawoud Bey

Spade with Chains, 1973
Mixed media
24″ × 10″ × 5″
Courtesy of Jack Tilton Gallery,
New York
Photo: Dawoud Bey

Keith Haring
Crack is Wack, 1986
Mural, industrial paint on concrete
15′ × 30′ approx.
FDR and 128th St., New York City
Handball court
©1986 The Estate of Keith Haring

Ignorance = Fear / Silence = Death,
1989
Poster for ACT UP
20″ × 38″
©1989 The Estate of Keith Haring

Stop AIDS, 1989
Sticker
©1989 The Estate of Keith Haring

Untitled, 1983
Chalk on black subway paper
©1983 The Estate of Keith Haring
and Tseng Kwong Chi
Photo: Tseng Kwong Chi

Richard Hill
My Father, My Friend, 1972
Silver gelatin print 35mm
9 1/2″ × 6 1/2″
Courtesy of the artist

My Grandmother (Charlotte Hill),
1976
Silver gelatin print 35mm
9 1/2″ × 6 1/2″
Courtesy of the artist

My Son Randy, 1974
Silver gelatin print 35mm
9 1/2″ × 6 1/2″
Courtesy of the artist

Urbanized (Dave Elliot), 1973
Silver gelatin print 35mm
9 1/2″ × 6 1/2″
Courtesy of the artist

Jean LaMarr
Some Kind of Buckaroo, 1990
Serigraph
24″ × 36″
Courtesy of the artist
Photo: Jean LaMarr

They're Going To Dump It Where?!?,
1984
Monoprint
18″ × 24″
Courtesy of the artist
Photo: Jean LaMarr

Elizabeth Layton
Buttons, 1982
Drawing: crayon, colored pencil.
22″ × 30″
Courtesy of Don Lambert

Dinh Le
*Altar Piece: "The Temptation of Saint
Anthony,"* 1991
C-print, archival and scotch tape
40″ × 57″
Courtesy of Steinbaum Kraus
Gallery
Photo: Albert Huang

Maya Lin
Civil Rights Memorial, 1989–1990
Black granite, palladium leaf, water
Courtesy of the artist

Vietnam Veterans Memorial
Washington, D.C, 1982
10′ × 250′
Black granite
Courtesy of the artist

Vietnam Veterans Memorial (details)
Washington, D.C, 1982
10′ × 250′
Black granite
Courtesy of the artist
Photos: Lawrence McKenna

Yolanda M. López
*Portrait of the Artist as the Virgin of
Guadalupe,* 1978
Oil pastel on paper
28″ × 32″
Collection of the artist
Photo: Yolanda M. López

*Things I Never Told My Son about
Being a Mexican,* 1984
Mixed media installation
96″ × 144″
Collection of the artist
Photo: Yolanda M. López

Who's the Illegal Alien, Pilgrim?, 1978
Ink on paper
28″ × 32″
Collection of the artist
Photo: Yolanda M. López

James Luna
The Artifact Piece, 1990
Performance and mixed media,
Installation shot
Dimensions variable
Courtesy of the artist
Photo: John Erikson

Take a Picture with an Indian, 1991
Polaroid photographs, three life-size
photographic cutouts, and signage
Dimensions variable
Collection of the artist
Photo: Richard Lou

Amalia Mesa-Bains
Dolores del Rio VI, 1990
Mixed media installation
6′ × 10′ × 4′
Collection of the artist
Photo: Gia Roland

Kay Miller
Seeds, 1992
Oil on canvas
48″ × 60″
Collection of the artist
Photo: Ken Abbott

Yong Soon Min
Make Me, 1989
Photograph with incised text
8 panels, overall 96″ × 120″
Collection of the artist
Photo: Jung Jincee/Karen Bell

Lorraine O'Grady
Sisters I, 1980/88
from Miscegenated Family Album
Left: Queen Nefernefruaten Nefertiti
Right: Devonia O'Grady Allen
Cibachrome, 28″ × 39″
Collection of the Davis Museum and
Cultural Center, Wellesley College
Photo: Howard Ehrenfeld

Ceremonial Occasion, 1980/88
from Miscegenated Family Album
Left: Devonia O'Grady Allen
attending a wedding
Right: Queen Nefertiti performing
an Aten ritual
Cibachrome, 28″ × 39″
Collection of Peter and Eileen
Norton

Barbara Jo Revelle
*Colorado Panorama: A People's
History of Colorado,* 1991
Computer screen scanned image/
tile mural
8′ × 600′
Courtesy of the artist
Photo: Barbara Jo Revelle

Jolene Rickard
3 Sisters, 1989
Black and white photo and
color Xerox
Courtesy of the artist
Photo: Jolene Rickard

Faith Ringgold
*Dancing on the George Washington
Bridge,* 1988
Acrylic on canvas, dyed and pieced
fabric
68″ × 68″
Collection of Roy Eaton
Courtesy of the artist

*Street Story Part III: The
Homecoming,* 1985
Acrylic on canvas, dyed and pieced
fabric
90″ × 48″
Collection of The Metropolitan
Museum of Art, New York
Courtesy of the artist

Erika Rothenberg
*There Are Still Traditional
Families,* 1990
Billboard
14′ × 48′
Photo courtesy of the artist

Juan Sánchez
The Bandera Series (The Flag Series),
1982
*Danza Guerrera (War Dance); The
Old Building; The World Belongs to
the People; Willie Escapes!*
Oil, mixed media on canvas
4 panels, 28″ × 66″ each
Collection of the artist/Guariquén,
Inc., New York
Photo: Juan Sánchez

NeoRican Convictions, 1989
Oil, mixed media on canvas
42″ × 66″
Collection of Mauricio Fernandez,
Monterrey, Mexico
Photo: Juan Sánchez

Andres Serrano
Klansman (Imperial Wizard), 1990
Cibachrome, silicone, Plexiglas,
wood frame
60″ × 49 1/2″ Edition of 4
Courtesy of Paula Cooper Gallery,
New York

Helen Zughaib Shoreman
Lincoln Memorial, 1990
Gouache and ink
19 1/2″ × 27 1/2″
Courtesy of the artist
Photo: Fred Scruton

Coreen Simpson
Vic, 1986
Silver gelatin print
20″ × 24″
Courtesy of the artist
Photo: Coreen Simpson

**Elizabeth Sisco, Louis Hock, David
Avalos**
*Welcome to America's Finest Tourist
Plantation,* 1988
Commercial silkscreen
photo-montage w/text
21″ × 72″
External bus poster
Courtesy of the artists
Photo: Louis Hock

Clarissa Sligh
What's Happening with Momma?,
1987
Van Dyke Brown print
11″ × 36″
Collection of Museum of Modern
Art, New York, and others (editions)
Photo: Clarissa Sligh

Wonderful Uncle, 1988
Van Dyke Brown print
11″ × 14″
Private collection of Lillian
Thompson
Photo: Clarissa Sligh

Diosa Summers
Ghost Dance I, 1989
Water color, pen ink, collage
27 1/2″ × 22″
Courtesy of the artist

Masami Teraoka
AIDS Series/Vaccine Day Celebration,
1990
Watercolor study on paper
29 11/16″ × 43 13/16″
Courtesy of Pamela Auchincloss
Gallery, New York
Photo: Lynda Hess

Tale of a Thousand Condoms/Mates,
1989
Watercolor on canvas
81 1/2″ × 136″
Courtesy of Pamela Auchincloss
Gallery, New York
Photo: Lynda Hess

Danny Tisdale
*The Black Power Glove, The Black
Museum,* 1990
Mixed media installation
18 1/2″ × 25 1/2″
Collection of the artist
Photo: Harvey Wiess

Afro Combs, The Black Museum,
1990
Wood, plastic, steel and jade
30″ × 24″
Collection of the artist
Photo: Harvey Wiess

Rigoberto Torres
Julio, Jose, Junito, 1991
Oil on fiberglass
105″ × 26″ × 9 1/2″
Courtesy of Brooke Alexander
Gallery, New York
Photo: D. James Dee

Richard Ray Whitman
Dancing Back Strong, 1989
Photo-emulsion transfer, hand-tinted
26″ × 34″
Photo: Richard Ray Whitman

Pat Ward Williams
Accused, Blowtorch, Padlock, 1986
Magazine page, silver prints, win-
dow frame, film positive, text
6′ × 5′
Courtesy of the artist

Sibling Rivalry, 1987
Cyanotype, mixed media
9″ × 23″
Courtesy of the artist

Krzysztof Wodiczko
Arco de la Victoria, Madrid, 1991
Organized by the Circulo de Bellas
Artes, Madrid, in conjunction with
the exhibition *El Sueno Imperativo*
(The Imperative Dream).
Images projected on the Arco de La
Victoria, Madrid, with the use of
four 9,000 watt slide projectors.
Courtesy of Galerie Lelong,
New York

David Wojnarowicz
Untitled, 1990
Photostat
30″ × 40″
Courtesy of the Estate of David
Wojnarowicz and PPOW Gallery,
New York

Where I'll Go After I'm Gone,
1988–90
Acrylic, b/w photo on canvas
45″ × 64″
Courtesy of the Estate of David
Wojnarowicz and PPOW Gallery,
New York

YA/YA, Inc.
Darlene Marie Francis
The Magic Carpet Ride, 1990
Latex acrylic on wood,
polyurethane coating
35″ × 17″ × 17″
Private Collection of Whoopi
Goldberg
Photo: Michael P. Smith

Contributors

Eduardo Aparicio was born in Guanabacoa, Cuba, and is an artist and writer. His visual work and critical writings deal with issues of nationhood, cultural identity, and gender politics. He holds a B.S. in Linguistics and French from Georgetown University and an M.A. in Photography from Columbia College, Chicago. His work is included in collections at the Museum of Contemporary Photography (Chicago), The Library of Congress, Centro de Estudios Avanzados de Puerto Rico y el Caribe, and Union de Periodistas de Cuba.

Carmen Bardeguez is a poet, activist, and history teacher at Satellite Academy High School in Queens, New York. She has developed curricula and conducted numerous workshops for educational and cultural organizations including Educators for Social Responsibility, The New School for Social Research, and People About Changing Education (PACE).

Susan Cahan is an art historian, educator, currently the Deputy Director at The New Museum of Contemporary Art. She has been a museum educator for fourteen years, working to promote public participation in cultural institutions, and feminist and antiracist approaches to education. She is a faculty member of the Center for Curatorial Studies at Bard College.

Raphaela Francis is a student at the State University of New York at Purchase where she is pursuing premedical studies.

Alyosha Goldstein is an independent videomaker and writer. He is currently working at the Center for New American Media, and is a graduate student in Liberal Studies at the City University of New York.

Steven Goodman is the founding director of Educational Video Center (EVC), a nonprofit media arts center in New York City which provides high-school students and their teachers with training and support services in documentary production and media arts analysis. He has been a media educator and producer for fifteen years and has spoken widely and written essays on media and education for numerous books and journals, including Bank Street College of Education's *Experiencing Diversity,* the Foundation for Independent Video and Film's *The Independent,* Media Network's *ImMediate Impact,* and the National Council of Teachers of English's *Encyclopedia of English Studies and Language Arts.*

Rayna Green is a folklorist, cultural historian, and producer of documentary films and museum exhibitions. She is widely known as a writer, researcher, and lecturer on Native American women, women's expressive culture, American folk and popular material culture, and contemporary Native literature and art. Presently Director of the American Indian Program for the National Museum of American History, she is the author of three books on Native women and the producer of the recent audio recording, *Heartbeat: The Voices of First Nation Women.*

Zoya Kocur is an educator, artist, and community activist. She holds an A.B. degree in Anthropology from Harvard University and an M.A. in Studio Art from New York University and the International Center of Photography. Formerly Associate Curator of Education at The New Museum of Contemporary Art, she is an education and managerial consultant to museums and other cultural and nonprofit organizations in New York City.

Simon Leung is an educator and internationally exhibiting artist whose work addresses the issues of sexuality, and postcolonial history and theory. Since 1990 he has taught in The New Museum of Contemporary Art's High School Art Program.

Amalia Mesa-Bains is an artist, curator, and educator specializing in cultural diversity studies, teacher preparation and professional development, interdisciplinary curriculum development, and art education and

criticism. She has twenty years experience as a teacher in Bilingual, English as a Second Language, and Multicultural Education in the San Francisco Unified School District and has written several curriculum guides on art, language acquisition, and social and cultural history. She is the editor of *Diversity in the Classroom: A Casebook for Teachers and Teacher Education.* She received a Distinguished MacArthur Fellowship in 1992.

Elyse Rivin is an art educator and teacher of language working in interdisciplinary programming at International High School at LaGuardia Community College in New York City. She has lived, taught, and shown her artwork in both the United States and Europe. She is currently developing a curriculum which places art at the core of interdisciplinary studies.

Adelaide Sanford is a preeminent educator with over forty years teaching experience. Sanford's leadership in education has earned her numerous awards and appointments, including serving as chair of the First International Conference on the Education of Black Peoples sponsored by the National Alliance of Black School Educators in 1985. In addition to her work in education, she is a speaker for civic, social, professional educational, and philanthropic organizations throughout

the United States. Currently, she teaches at Baruch College of the City University of New York and is a Member-At-Large of the Board of Regents of The University of the State of New York.

Christine Sleeter is a professor at California State University, Monterey Bay. She has written numerous books and articles about multicultural education. Her most recent books include *Keepers of the American Dream, Multicultural Education, Critical Pedagogy, and the Politics of Difference* (co-edited with Peter McLaren), and *Developing Multicultural Teacher Education Curricula* co-edited with Joe Larkin.

Pam Sporn is a videomaker and educator who has been teaching in the New York City school system since 1978. For many years she was the Program Director of the Documentary Workshop at Educational Video Center. Before joining EVC she developed the Through Our Eyes Video and History Project at Satellite Academy High School. Her students' award-winning tapes include *The Road to Mississippi: Reclaiming Our History* (1990); *Blacks and Jews: Are They Really Sworn Enemies?* (1992); and *Rap It Up!* (1994). She directed *Disobeying Orders: GI Resistance to the Vietnam War* (1989) and is producing/directing *Cuban Roots/Bronx Stories.*

Marcia Tucker is the founder and director of The New Museum of Contemporary Art, established in 1977 as an institution devoted exclusively to the art and ideas of our time. She has organized many major exhibitions of contemporary art, and lectured and published widely in the United States and abroad. She is the series editor of *Documentary Sources in Contemporary Art,* four books of theory and criticism published by The New Museum.